Jan van Hemessen

An Antwerp Painter between Reform and Counter-Reform

Studies in Renaissance Art History, No. 2

Ann Sutherland Harris, Series Editor

Chair for Academic Affairs
Metropolitan Museum of Art

Other Titles in This Series

Jan van Hemessen
An Antwerp Painter between Reform and Counter-Reform

by
Burr Wallen

UMI RESEARCH PRESS
Ann Arbor, Michigan

Produced and distributed by
UMI Research Press
an imprint of
University Microfilms International
Ann Arbor, Michigan 48106

Library of Congress Cataloging in Publication Data

Wallen, Burr.
　　Jan van Hemessen : an Antwerp painter
between reform and counter-reform.

　　(Studies in Renaissance art history ; no. 3)
　　Revision of thesis (Ph.D.)–New York University,
1976.
　　Bibliography : p.
　　Includes index.
　　1. Hemessen, Jan Sanders van, ca. 1500-1563.
2. Painters–Belgium–Flanders–Biography. 3. Mannerism
(Art)–Belgium–Flanders. I. Title. II. Series.

ND673.H38W3 1983　　　　759.9493　　　　83-18316
ISBN 0-8357-1517-5

Contents

Catalogue

List of Illustrations

Preface

This study of the Netherlandish sixteenth-century painter Jan Sanders van Hemessen derives from a Ph.D. dissertation written under Professor Colin Eisler at the Institute of Fine Arts, New York University. Hemessen was a prominent painter of religious subjects and secular moralities at Antwerp from ca. 1520 to 1556, during the phase that bridged the art of Quentin Massys and Pieter Bruegel. Chiefly remembered for his contributions to Flemish realism, he was also a remarkably eclectic student of the Italian High Renaissance and Mannerism. The principal goal of this monograph is the reconstruction of Hemessen's artistic evolution, based on a study of a solid core of twenty signed and dated panels. The Catalogue revises M. J. Friedländer's basic list published in the twelfth volume of *Die Altniederländische Malerei* (1935), adding information that has since come to light. Every effort has been made to establish a clear definition of copies and variants as they relate to panels by the hand of the artist. In several cases I have identified copies after lost originals: these are included in a separate section of the Catalogue.

One of the difficult problems confronting Hemessen scholarship has been the unfortunate tendency to confuse his work with that of the Brunswick Monogrammist, whose *Feast of the Poor*, at Brunswick, bears a cryptic monogram that was at one time wrongly thought to refer to Hemessen. This misbegotten thesis was developed by F. Graefe in a study entitled, *Jan Sanders van Hemessen und seine Identification mit dem Braunschweiger Monogrammisten* (Leipzig, 1909). Close study of the small figures by the Monogrammist and comparison with the background staffage of Hemessen's panels makes it clear that we are dealing with entirely different hands. A much more attractive identification of Hemessen's talented collaborator is proposed in these pages: Jan Swart van Groningen. Though Swart's prints and drawings are well known, his style of painting has not yet been firmly established. The Hemessen background scenes provide a valuable group of pictures that closely correspond to Swart's graphic manner, and

help to confirm the perceptive attribution to this interesting artist of a large panel painting of *The Fall of Man* (Minneapolis Institute of Arts), which was advanced a few years ago by Colin Eisler.

In addition to stylistic matters, a large part of this text discusses the provocative and often complex iconographical issues raised by Hemessen's paintings. Since the artist dealt chiefly with religious themes, it has been necessary to define his attitude towards the religious crisis of the sixteenth century. The strong accent upon pietism in his work suggests a deep involvement with the Christian search for redemption. While Hemessen responded to the Protestant call for reform of outworn approaches to the quest for faith, his fervent religiosity and heroic penitential imagery align him with the crusading spirit of the Counter-Reformation, the widespread movement to combat Protestantism that began well before the Council of Trent and was first instilled at Antwerp during early visits of the fiery young Ignatius Loyola. The Counter-Reformation resulted in new approaches towards Christian iconography just as did the Reformation. One of the most important areas of concern was the Sacrament of Penance — reaffirmed at the Council of Trent as official church doctrine. Hemessen's preoccupation with the theme of penitence will be examined at some length in these pages.

One of the most striking aspects of the artist's work is a strong sense of anxiety, a disquiet expressed not only on the faces of his subjects but also by their tense gestures and awkward, frequently unstable postures. While Hemessen, like so many other sixteenth-century artists, may well have been "born under Saturn," his apprehensiveness was shared by many contemporaries dismayed by the rapid spread of heretical sects, growth of popular rebellions and the fearful threat posed by the Turks to the entire land of Christendom. This was an age of crisis, and Hemessen was one of the most fervid exponents of the widespread perturbations of his times. As the repressive forces of the Inquisition triumphed in the Lowlands in the late 1540s and 1550s, his art became increasingly frenetic and suffered from a disconcerting formal degeneration. Hemessen's late work is of particular interest since it was produced at the same time Pieter Bruegel was beginning his career and provides us with intriguing clues to the formation of Bruegel's revolutionary artistic outlook.

This study would not have been possible without the generous, unflagging support of Professor Colin Eisler, who originally suggested the topic to me and proved a patient adviser. I also received friendly encouragement from Professor Robert Koch at Princeton University and Professor Charles Sterling at the Institute of Fine Arts, New York University. Professors Gert Schiff and Jonathan Brown read my dissertation and made a number of helpful suggestions for improvement.

The photo archives and research libraries of both New York University and Princeton provided invaluable reference material, as well as the following centers here and abroad: the Metropolitan Museum of Art Library, the Frick Art Reference Library, the New York Public Library, the National Gallery of Art, the Library of Congress, the British Library, the Bibliothèque Nationale, the Witt Library of the Courtauld Institute of Art, the Rijksbureau voor Kunsthistorisch Documentatie at The Hague, the Archives Centrales at Brussels, the Musée du Louvre, the Kunsthistorisches Museum at Vienna, the Prado and Alte Pinakothek. In addition, I would like to cite the helpful assistance of Dr. Henri Pauwels and the editorial staff for the new edition of Friedländer's *Early Netherlandish Painting*, who made their extensive annotations freely available prior to publication.

Special contributions to this study were made by a number of individuals, including Georges Marlier, Horst Gerson, René Huyghe, Gert von der Osten, John Hand, Cara Denison, Ernst Brochhagen, Mary Buchan, Konrad Renger, the Earl of Crawford and Balcarres, Tim Wilkins, Malcolm Mills, Norman Leitman, Italo Faldi, John Rupert Martin, Oliver Millar, Harry Bailey, Dr. Robert Herzig, J. O. Leegenhoek, Dietrich Schubert, Paul Vanaise, Edith Greindl, Theodore A. Heinrich, Dr. Liselotte Camp, Dr. Klaus Demus, John Sunderland and Anabel J. Humphreys.

At Santa Barbara, I have profited from the stimulating observations of my colleagues Professors Peter Meller, Alfred Moir, Larry Ayres and Fikret Yegul. UCSB Arts Librarian William Treese has given time to a number of matters connected with this book, as has his assistant Erica Scranton and the helpful Inter-Library Loan staff. A generous grant from the research fund of the University of California made it possible to complete work on the project.

I am particularly grateful to Ann Sutherland Harris for selecting Hemessen to inaugurate this series of studies in Renaissance art history, and for her helpful editorial comments.

Burr Wallen
Santa Barbara, 1983

Introduction

Jan Sanders van Hemessen (ca. 1500–ca. 1556) remains one of the less familiar sixteenth-century Netherlandish masters in spite of his acknowledged importance for the development of painting at Antwerp during the critical phase following the death of Quentin Massys, the city's leading painter, in 1530. This was a time of rapid change in both style and subject, as the essentially conservative Bruges tradition gave way to an influx of new ideas from Italy and Fontainebleau reaching Antwerp, Liège, Brussels and other centers. Hemessen was one of the foremost among the generation of Romanist painters that followed Massys and Gossaert. His concentration on heroic posture, daring projections and dramatic gesture reflects an extensive involvement with the semantics of the *bella maniera* in the Lowlands. Hemessen's rude, vigorous models casually assume the classic poses of the Sistine Ceiling or mimic graceful figures of Venetian pastorals. An eclectic, he ranged far and wide for his borrowings, dotting his panels with contrived Mannerist concepts as well as grand devices of the High Renaissance.

Spelling the end to the tranquil outlook of fifteenth century Netherlandish art, this rampant Italianism has been looked upon with mixed emotions by historians of Northern Renaissance art. Despite its sometimes *outré* manifestations, Romanism, as we now realize, stimulated a renewed interest in native concerns of illusionism and symbolic reality.[1] Armed with advanced concepts of modelling, chiaroscuro and formal arrangement acquired from a dedicated study of masterworks of the South, Hemessen and painters like Pieter Aertsen and Jan Massys marshalled their powers of observation to recreate the tangible world of sixteenth-century Antwerp. The material preoccupations of a prosperous urban culture were of special interest to these artists, who had witnessed the spectacular growth of the port into the foremost trading center on the continent. Though there was considerable variance in individual responses to the moral issues posed by newfound wealth, their paintings convey the opulence and color of con-

temporary life, and their experimental fervor mirrors the energies and ambitions of a thriving merchant class of self-made men.[2]

The Antwerp Romanists' fascination with realism and the material world should not be construed in simplistic terms, however, for still life and genre were inextricably linked with symbolic expression in Netherlandish art. Building upon the satirical genre paintings of Lucas van Leyden and Quentin Massys, the Romanists developed an innovative type of moral allegory that is still very much an iconographic puzzle. The theatrical nature of many of these scenes suggests correspondences with the increasing use of genre devices and symbolic stage settings in Flemish drama of the day. Prints and illustrated books also made important contributions. Educated in a humanist milieu that placed great emphasis on concealed meanings, the Romanists understandably became eager students of Renaissance emblem literature. They paid considerable attention to imaginative allegories by Mannerist painters like Bronzino, Rosso and the Dossi brothers, though artificial motives were avoided in favor of the traditional Netherlandish perference for disguised symbols from everyday life.

Romanist involvement with trends of International Mannerism was more far-reaching than generally thought. Vermeyen's stress on linear elongation, Heemskerck's exaggerated musculature and Aertsen's ambiguous compositions and restless lighting all find parallels in style-conscious movements of the South. A similar love of elaboration may be observed in Hemessen's intertwined limbs and prolific expanses of rumpled drapery. Mannerist eccentricity was encouraged by the rapid growth of the Antwerp art market which accompanied the general growth of trade in the early sixteenth century. Large contingents of foreign merchants with a taste for the new and exotic helped to stimulate unusual artistic approaches. The so-called Antwerp Mannerist movement from the first third of the century — a group of still largely anonymous masters specializing in fanciful stylistic effects — paved the way for the idiosyncrasies of the Romanists.

Hemessen was by any standard the most bizarre. Challenging accepted norms of physical beauty, he went to unheard-of extremes in the juxtaposition of mannered *grazia* and freakish distortion. The sublime, *artifizioso* concept of *figura serpentinata* is expressed in his *Judith*, for instance, as an undulating giantess with fleshy hips and brazen muscles (figure 121). In his *Parable of the Prodigal Son* of 1536 (figure 46), the joyous rhythms of Venetian bacchanals are transferred to a ritual of lust and entrapment in a Flemish brothel. Always on the lookout for unusual subject matter, he borrowed the theme of the *Cure of Folly* from Bosch, turning a late medieval fantasy into a disturbingly real operation that emphasizes the painful surgical ordeal of the removal of the "stone of madness." (figure 137)

Some of the ambivalent look of Hemessen's panels can be ascribed to

the way Romanist impulses are interspersed with forms and impressions of his Netherlandish heritage: lyrical Gothic rhythms, Flémallesque perspective and sumptuous Burgundian costumes. Such archaizing quotations, which are also found in Jan Gossaert and Bernard van Orley as well as in some of the younger Romanists, may indeed have been encouraged by the growth of humanism in the North. As Panofsky and others have noticed, the "return to the founders" was a widespread phenomenon among Netherlandish painters at the turn of the century.[3] It is perhaps not insignificant that this nostalgic revival of the great masters of the past took place concurrently with the investigation of classical antiquity and the High Renaissance. Baldass and Panofsky have discussed the subtle interaction of Flemish archaism and Italianate sources in the work of Quentin Massys.[4] Hemessen characteristically takes a more extreme approach, juxtaposing past and future tenses, so to speak, in a mannered hybrid that looks strangely outmoded while at the same time very advanced.

There is evidence that the remarkable nature of Hemessen's panels was still appreciated in the late sixteenth and seventeenth centuries, even though his name was all but forgotten. As van Mander relates in the *Schilder-Boeck* (1604), Hemessen "painted large figures and was in various respects highly proficient and unusual" ("maeckte groote beelden en was in sommighe deelen seer net en curioos").[5] The word "curioos" (or "curieus") occurs again in reference to his work, in the records from 1668–70 of the Forchoudt brothers, prominent art dealers with offices at Antwerp and Vienna. A *Decent from the Cross* by the artist, valued at 250 guilders, is described as "originael, curieus en fraey gemaeckt" ("original, curious and beautifully done.")[6] In an age when strange and unusual works of art were avidly sought after, Hemessen's "curious" panels were prized by the great sixteenth- and seventeenth-century collectors in the North. Examples are recorded in several *Kunstkammers*, including the extraordinary collection of the Emperor Rudolph II. Rudolph owned no less than seven Hemessens, including the late *Isaac Blessing Jacob* (figure 124, Österby Church, Sweden) and the superb *Madonna of Humility* of 1544 (figure 109, Stockholm, Nationalmuseum), a *tour de force* of formal elaboration.[7] These works were sent to Sweden in 1648 along with numerous other paintings from Rudolph's collection after Prague fell to Queen Christina's forces.[8] Four panels by Hemessen were in the collection of the Elector Maximilian I of Bavaria (1597–1651), also an admirer of Dürer and Grünewald.[9] Another astute Baroque connoisseur, the Archduke Leopold Wilhelm of Austria (1614–1662), owned two important examples: the *Man of Sorrows* of 1540 (figure 100, now at Linz) and the *Calling of St. Matthew* (figure 66, Vienna, Kunsthistorisches Museum).[10] Several paintings by Hemessen were also recorded in Antwerp collections in the seventeenth century,

including a mysterious "portret van een Man met een grooten neus") ("portrait of a man with a large nose") owned by the painter Pieter Paul Rubens.[11]

By the middle of the nineteenth century, when serious art historical research on sixteenth-century Netherlandish paintings began, there were fine examples of Hemessen's work in major collections at Paris, Madrid and Lisbon, in addition to those remaining at Munich and Vienna. Important contributions to the understanding of his work and career were made by several scholars, especially Nagler, Hymans and Van den Branden.[12] Hemessen and other sixteenth-century Antwerp artists like Quentin Massys, Pieter Aertsen and Marinus van Roymerswaele were viewed chiefly as precursors of seventeenth-century genre painting. The Rubens scholar Max Rooses reflected this attitude, prevalent among Belgian and German art historians, in his *Flandre* (1913):

> A la suite de Martin de Roymerswaël..., se place toute une légion d'interprètes de la vie réelle, héritiers des primitifs par la conscience avec laquelle ils observent leurs modèles, par la jouissance qu'ils éprouvent à représenter leurs contemporains sous leurs aspects de tous les jours...Le premier de la série est Jan Sanders (Hemessen).[13]

Unfortunately, this limited approach encouraged a misunderstanding of the objectives of these Northern Renaissance artists and resulted in a regrettable tendency to denigrate their achievements in relation to Baroque genre masters. Waagen, in his popular *Handbuch der Deutschen und Niederländischen Malerschulen* (1862), which served as a basis for numerous later editions by Kugler and Crowe, calls Hemessen "häufig von einer furchtbaren Gemeinheit in Formen und Ausdruck, immer sehr hart in dem Umrissen und meist von einer schwer braunen Färbung" (translated by Crowe: "He displays usually a terrible vulgarity of forms and expression, is always hard in the outlines, and heavy brown coloring").[14] On another occasion, Waagen refers to the *Parable of the Unmerciful Servant* (figure 142), at that time owned by the British collector Sir Culling Eardley, as "an unusually good picture by this commonplace and tasteless painter; the heads are less vulgar; the coloring of great power; the execution hard, as usual, but careful."[15] The moralizing nature of Hemessen's genre scenes went unrecognized. His taut, allegorical bordello panels were called "Merry Companies" or "Festive Gatherings," misnomers that have persisted until comparatively recently. Even a perceptive scholar like Walter Friedlaender refers to Hemessen's late *Calling of St. Matthew* (figure 70) as "merely...a pretext for coarse carousing."[16]

Among nineteenth-century critics, it was Charles Blanc who first observed the expressionist force underlying Hemessen's peculiar style and technique. Blanc writes in his monumental *Ecole Flamande* of 1868, "Ses

types sont violents, son dessin exagéré et sauvage. Van Hemessen va, sans méthode et sans mesure, jusqu'aux confins de la laideur. Son coloris abonde en tons bruns et durs; ses ombres sont lourdes; mais il y a chez lui une certaine recherche de l'expression, et sa naive énergie ressemble à de l'originalité."[17] At the turn of the century another French writer, Louis Gonse, defends the savage energy of the *Expulsion of Merchants and Moneylenders from the Temple* (figure 140, Nancy, Musée des Beaux-Arts) and the startling verism of the *Cure of Folly* (figure 137, Prado) in *Les chefs-d'oeuvre des Musées de France*.

> On a le droit de ne pas aimer ces compositions toffues, rébarbatives, hétéroclites, ou les formes s'enchevêtrent dans un pêlemêle à peu près inextricable; on a le droit aussi de se faire violence pour y chercher, sous la rudesse expressive, le génie d'observation qui s'y condense et s'y cache. Je n'ai jamais pu oublier, pour ma part, l'extraordinaire tableau du Musée de Madrid. Celui de Nancy... n'est pas loin de l'égaler.[18]

The *Cure of Folly* also attracted Michel's attention in his *Histoire de l'Art*, published in 1912. He comments especially on the unsparing depiction of the surgical ordeal:

> Il a plu à Van Hemessen de peindre l'opération falote sous les apparences les plus réelles, voire les plus terrifiantes... Depuis les horribles supplices retracés avec tant de scrupuleuse rigeur par les Thierry Bouts et les Gérard David, personne n'a fait une telle part à l'expression de la douleur physique.[19]

As these critics rightly observe, Hemessen's powerful realism cannot be viewed apart from the highly emotional temperament that shaped his imagination. He employs caricatural exaggeration and expressive gesture to explore the psychology of the passions with deliberate fervor. His studies of physiognomy benefited from the investigations of Leonardo, Bosch and Massys. In addition, Hemessen drew deepfelt inspiration from the depictions of pathos by fifteenth-century Netherlandish forebears such as Roger van der Weyden, Dirk Bouts and Hugo van der Goes. Some of his works convey a Germanic preoccupation with horror and violence comparable to Grünewald or Hans Leinberger. The "vulgarity" of his low-life characters finds its roots in the jostling crowds of German late Gothic Crucifixions and the earthy prints by his contemporary Sebald Beham of Nuremberg. Logically, he responded most to monumental antique sculpture in which realism interacts with dramatic emotionalism. The Hellenistic *Laocoön* group is virtually a leitmotiv of his work.

Yet in spite of his concentration on extreme emotion, it would be a mistake to view Hemessen's art as a primitive form of Expressionism. For the Netherlandish artistic tradition, the objective world conceals a realm of symbolic implication that cannot be divorced from empiric reality. The dis-

guised symbolism shown by Panofsky to be fundamental to an understanding of early Netherlandish painting continued to preoccupy the painters of Hemessen's generation, though the nature of the symbols had been transformed to meet the demands of a more complex vision of human nature.[20] An increasing number of *Vanitas* genre motives (food, drink, games, musical instruments, pets, etc.) are depicted, along with worldly characters whose function is also largely symbolic. Costume and physiognomy provide clues to the roles played by these genre figures in the overall thematic structure. Furthermore, the inner reality—the states of mind denoted by facial expression and gesture—must not be neglected for their hidden revelations. The intricate web of relationships in Hemessen's work demands patient scrutiny and a delicate sifting of correspondences for their inner significance to emerge.

One of the keys to Hemessen's sensibility is a Mannerist preoccupation with formal and symbolic counterpoint, which gives his work an evasive, at times paradoxical quality. Genre situations are evoked not for their own sake, but to illustrate the obstacles to spiritual development confronting Everyman on his journey through life, as they were in the fifteenth century. Hemessen's corpulent, Rubensian nudes are rarely comfortable in their bodies. The Resurrected Dead of the *Last Judgment* (figure 74) appear bound to earth by the heavy weight of their flesh, while his *Susanna* (figure 101) is as much a hostage to her voluptuous, sensual nature as she is a victim of the grotesque elders. Frequently crowded together in a restrictive space, his figures gesticulate in a nervous, frantic manner, enmeshing themselves evermore in claustrophobic confusion.

Like Bosch, whose work he must have admired, Hemessen viewed the human condition in a negative, pessimistic light. Humanity, trapped by pride and sensuality, is easy prey in an evil world filled with temptations. Bosch's memorable image of moral degredation, the *Peddler* (Rotterdam, Boymans-van Beuningen Museum), is recalled in the wayfarer of Hemessen's Hartford *Brothel Scene* (figure 58), who foolishly allows himself to be seduced by Deadly Sins of Lust and Gluttony. For both artists, the denial of sin demands a heroic sacrifice like that of the ascetic hermit saints who renounced the world and scourged themselves in penance. Though Hemessen refrains from depicting the phantasmagorical apparitions that assaulted Bosch's renunciants, his representations of St. Jerome penitent, meditating on sin and death, express a profound sense of inner torment and isolation. His tragic view of human nature is bitterly portrayed in the *Mocking of Christ* of 1544, now at Munich (figure 111). Christ looks down sorrowfully at two little boys who join the grownup tormentors, mocking Him with coarse, blatantly obscene gestures.

In many ways, Hemessen's stress on extreme moral oppositions paral-

lels the approach of the father of the Jesuit Order, St. Ignatius Loyola, whose *Spiritual Exercises*, begun ca. 1522 and completed in 1535, dealt with the crisis posed by the spread of Protestantism by preaching militant asceticism and distrust of worldly values. Stressing the Augustinian concept of history as the struggle between rival camps of Christ and Satan in his *Meditations on the Kingdom of Christ and the Two Standards*, Loyola encouraged the aspiring exercitant to become a devoted "Knight of the Cross" in the service of Christ.[21] The spirit of the *Exercises* is already present in Hemessen's bold *St. Jerome Penitent* of 1531 (figure 27, Lisbon, Museu Nacional de Arte Antiga), posed like a defiant *Laocoön* in his rocky fortress. His portrayal of Christ as a standard-bearer in the *Man of Sorrows* of 1540 (figure 100, Linz, Landesmuseum) evokes the imagery of heroic panoply favored by the Jesuit reformer. Other aspects of Hemessen's work indicate that he was sympathetic to the spirit of the *Excercises* and may well have played a role in the dissemination of Jesuit ideas in the Lowlands.[22]

An artist of profound religious feeling, Hemessen clearly meant for his panels to be dwelt upon at length as *exempla* of the difficult path to redemption. The sad, troubled expressions and dreamlike gestures of his figures help to build up a mood of pensive melancholy conducive to serious contemplation, counterbalancing the harsh realities of penitence with a lyrical charm that harks back to Giorgione as well as to the evocative masterpieces of the early Netherlandish tradition.

1

Hemessen's Life and Times

Though Jan van Hemessen was one of the outstanding painters among the Antwerp Romanists, little is known about the facts of his life. A meager biography can be pieced together from documents in the Antwerp city archives and in the records (*Liggeren*) of the city artists' guild, the Guild of St. Luke, uncovered chiefly through the patient research of nineteenth-century archivists.[1] Luckily, Hemessen signed and dated many of his panels, providing a substantial guide to the chronology of his work: the first dated picture that survives is from 1525 and the last from 1556.[2]

Hemessen is cited by Vasari as one of the renowned sixteenth-century painters of the Lowlands, many of whom, like Jan van Scorel, Michiel Coxcie, Jan van Calcar and Maerten van Heemskerck, had spent substantial time in Italy.[3] No documents have been found to prove that Hemessen followed suit, but the wealth of Italianate influence in his *oeuvre* makes it clear that he must have done so. He probably travelled south at an early stage in his career, stopping at Florence and Rome and remaining for a longer time in Northern Italy, where he became familiar with the work of Moretto da Brescia, Romanino and Savoldo, whose contributions to his style and iconography are perceptible from his earliest dated work. There is also considerable evidence that Hemessen visited France during the 1530s and perhaps again in the late 1540s. A trip to Fontainebleau was not unusual for Antwerp painters, attracted by the recent achievements of the inventive school under Rosso and Primaticcio as well as by the stunning collection of High Renaissance masterpieces formed by Francis I.[4]

While Hemessen is mentioned by two standard sources for information on sixteenth-century Netherlandish art — Karel van Mander's *Schilder Boeck* (1604) and Ludovico Guicciardini's *Description de Tout le Pais Bas* (1567) — neither gives any firm biographical information. Van Mander calls Hemessen a citizen of Haarlem rather than Antwerp and treats him more like a forgotten artist from a remote time than a prominent master who was still very much alive when van Mander was a boy at Meulebeke, near

Courtrai.[5] The connection with Haarlem has never been documented and should be taken *cum grano salis*. Van den Branden's attempt to justify the assertion by hypothesizing that Hemessen moved north to Haarlem late in life to escape religious persecution is discounted by documents at Antwerp that make certain he was still a resident of the city in 1552 and 1555.[6] It is not surprising that van Mander should have known so little about Hemessen since local traditions had been severely disrupted by the religious wars that plagued the Lowlands in the second half of the century.[7] Antwerp, furthermore, was during Hemessen's lifetime a large, booming city boasting an extremely rich, multi-colored art world. Many talented painters, sculptors and craftsmen flocked there to take advantage of a rapidly expanding market. Careers skyrocketed and sometimes suddenly fizzled. Guicciardini remarks upon the vast dimensions of the local art scene. If his count is reliable, there were around three hundred masters in residence at Antwerp in 1560, almost twice the number of bakers and three times the number of butchers!

We know from Hemessen's signature, "Iohannes Sanders de Hemessen," or, more often, simply "Ioannes de Hemessen," that he was originally from the village of Hemishem (Hemixem) not far from Antwerp in the direction of Hoboken. The Sanders family were landed gentry of the town.[8] Hemessen's sensitive understanding of religious subjects suggests that he may have studied at one of the monastic schools in Brabant conducted by the influential Brethren of the Common Life.[9] As a youth he must have demonstrated artistic aptitude for in 1519 he was sent to Antwerp where he was apprenticed to "meester Heynderic van Cleve," an established member of the Guild of St. Luke for some thirty years.[10]

Heynderic van Cleve's work has not yet been identified. He may have been one of the numerous Antwerp masters from the first third of the century now known as Antwerp Mannerists, though there is little in Hemessen's mature style to indicate that he was trained by one of this group.[11] Heynderic's name tells us that he was originally from the Hohenzollern Duchy of Cleves in the Rhine valley, a prominent center that shared both German and Dutch cultures. A noticeable strain of German expressionism in Hemessen's painting could have been encouraged by his teacher. Also, through Heynderic he undoubtedly came into contact with Joos van Cleve (Joos van der Beke), whose productive Antwerp workshop rivalled that of Quentin Massys during the second and third decades of the century.[12] Joos' rich colorism and command of still life are important points of departure for Hemessen's work.

Hemessen's apprenticeship took place at a crucial phase in the maturation of Antwerp's art market. Prior to 1500 there is little evidence of artistic activity in the city. The situation changed dramatically in the first

two decades of the century, as Antwerp rapidly overtook Bruges as a great art center. Quentin Massys, who had moved to the city in 1491 from Louvain, and Joachim Patinir, documented there from 1515 until his death in 1524, were the two most prominent figures in the burgeoning movement.[13] The relocation—at least temporarily—of the established Bruges painter Gerard David to Antwerp in 1515 demonstrates the city's growing importance.[14] Artists associated with the Netherlands courts also appear in the guild records of these years. Jan Gossaert is documented there from 1503 to 1507. Bernard van Orley's father, Valentin, is listed as a Free Master in the *Liggeren* of the St. Luke's Guild from 1512 through 1517, and there is a good possibility that his talented son also worked at Antwerp during this time.[15] Bernard was certainly located at Antwerp at the time when Hemessen began his apprenticeship since he undertook a commission in 1519–20 to paint a *Last Judgment* for the Brotherhood of Almoners, producing a polished, Italianate masterpiece that updated standards for this traditional theme of Netherlandish painting.[16] This impressive work undoubtedly had a strong impact on Hemessen's developing interest in Romanist compositions and figures.

One event that took place during Hemessen's apprenticeship would have been especially significant for the young painter. In 1520 and 1521 the celebrated German artist Albrecht Dürer visited the city, where he was received with sumptuous honors by the Antwerp painters at a grand banquet held for him at the guild hall.[17] Dürer mentions in his Diary that he spent time with Patinir, the Bruges painter Jan Provost, and also the Dutch painter-engraver Lucas van Leyden, who was working at Antwerp at the time.[18] Dürer's presence must have been inspiring for Hemessen. His supreme craftsmanship, Renaissance humanism and deep religious fervor were models emulated by a generation of Antwerp artists. Julius Held has amply documented the rich impact of Dürer's prints, paintings and drawings on Netherlandish art.[19] Of particular importance for Antwerp was the memorable *St. Jerome Meditating on Death* (Lisbon, Museu Nacional) Dürer painted early in 1521 for Rodrigo of Portugal. This panel proved to have a profound influence on Hemessen as it did on many other young painters.

One should perhaps not yet refer to Hemessen as a painter, since guild records do not tell us exactly what craft he first mastered. In fact, there exists a document in the Antwerp city archives that a "Janne van Hemssen, beeldsnijder" purchased, on 15 April 1521, a house called the "Cranenborch" on the Naaldwijkstraat.[20] The document has been known for some time, but it seems to have so far escaped notice that Hemessen is named a sculptor ("beeldsnijder") rather than a painter ("scildere"). If not a scribal error, the 1521 notation indicates that Jan was first trained in the art of

sculpture, which of course always tended to work hand in hand with painting in northern art. Could his teacher Heynderic van Cleve have been a sculptor associated with Joos van Cleve's atelier? Familiarity with the art of sculpture would account for Hemessen's remarkable propensity for picturing chiselled, volumetric forms from the very beginning. He was to become one of the most plastic of all Flemish Romanist painters. Naturally, his idol was Michelangelo, who saw in painting a powerful vehicle for the expression of bold sculptural values.

In 1524 we find Hemessen already a master, taking on his first apprentice, a youth named Hennen van de Kerckhove.[21] He must have obtained Free Master status at some point prior to this notice, though there is no listing in the *Liggeren* of the St. Luke's Guild from the preceding years that can be connected to his name with certainty.[22] To 1525 belongs the artist's first signed and dated panel, a *Christ and the Adulteress* (figure 1, New York, Art Market).[23] This is a mature work displaying a strong measure of North Italian influence, suggesting that Jan had already travelled south by this time. It also links Hemessen's early style with a fascinating figure from the older generation of Netherlandish painters, the so-called Master of the Magdalen Legend, who was active primarily as a portraitist and painter of altarpieces at Brussels and other centers of the Netherlands court from ca. 1490 to just after 1526. Essentially a conservative painter, the Magdalen Master incorporated newer trends within a schematic, simplified idiom retaining fundamental values from the tradition descending from Roger van der Weyden. His impact upon Hemessen was strong enough to imply a teacher-pupil relationship.[24]

Another link between Hemessen and the court school is provided by two delightful little portraits of a young princess (figures 18 and 19, Worcester, Mass., and Berlin) painted ca. 1527–30. Borrowing an idea from the Master of the Female Half-Lengths, an anonymous painter who is thought to have worked at Bruges and Malines, Hemessen portrays the young girl demonstrating her recently-acquired talents. In the Berlin panel, she shows her skill at weighing gold coins with a small hand scale, while in the portrait at Worcester she plays a piece on a portable clavichord. A third Hemessen portrait of the same subject — known through a copy at London (figure 20) — shows her a bit older, after she had learned to write. Clearly the girl must be an aristocrat of some rank in order to have acquired such graces at so tender an age. An obvious candidate would be the young Margaret of Parma, illegitimate daughter of the Emperor Charles V, who spent her early years under the doting protection of her aunts Margaret of Austria and Mary of Hungary at the court of Malines, where she received a superb education.[25]

If Hemessen worked for a while at the Netherlands court, it would

explain the refined style of early works like the beautiful *Descent from the Cross* of ca. 1526–27 (figure 5), which updates a Netherlandish "two-ladder" format in terms of High Renaissance principles of symmetry and classic balance. Like the series of *Portraits of a Young Princess*, the *Descent* demonstrates a vivid appreciation of the style of Jan Gossaert, the inventive court artist who worked intermittently at Malines and Antwerp during the decade.[26] Hemessen's investigations of heroic nudes were encouraged by Gossaert's polished *tableaux* of antique mythological figures. While Hemessen did not paint any pagan subjects, he frequently drew poses from *all'antica* sources just as he borrowed from Michelangelo and Raphael. The splendid circle surrounding Margaret of Austria included a number of Italianate painters and sculptors like Bernard van Orley, Jean Mone and Guyot de Beaugrant, many of whom were widely travelled in the South. Centrally located "in the heart and very middle of Brabant," as the Florentine historian Guicciardini observed, Malines (or Mechlin) was convenient to Antwerp, Brussels and Louvain. A period of work and study at Malines would help to account for Hemessen's Italianate orientation.[27] Margaret's collection included paintings by Gossaert as well as examples by Jacopo de'Barbari (Jacob Walch), a Venetian artist originally from Germany who had worked at the court in his late years (1510–11).[28] The Brussels master Bernard van Orley was strongly influenced by Raphael and may have sparked Hemessen's love of the High Renaissance artist.[29] At Antwerp interest had centered chiefly around Leonardo da Vinci, whose disciple Andrea Solario had visited the city in 1509.[30]

Unfortunately, the Malines archives were destroyed during the religious wars, and there are only a few royal inventories and accounts left. These provide precious little information on specific artistic developments. One painter it would be helpful to know more about is Vincent Sellaer of Gelderland. Horb has adduced a number of similarities between Sellaer and Hemessen, who were both about the same age.[31] Sellaer fell under the spell of Leonardo during a prolonged stay in Northern Italy, developing a refined, classicizing style that achieved a certain vogue after his return to Malines sometime before 1544. His paintings possess an annoying distortion of scale also found in Hemessen's early work—a peculiarity which in both cases may be ascribed to an imperfect fusion of a northern approach with the tendency towards superhuman proportions that was prevalent in the South. Sellaer is known to have worked ca. 1522–24 at Brescia as Moretto's assistant.[32] Stylistic evidence to be examined later on suggests that Hemessen may also have been at Brescia at this time, perhaps associated with Romanino.

Despite lack of documents concerning Hemessen's *Wanderjahr*, the

strong impact of the High Renaissance on his art makes it almost certain that he travelled extensively in Italy, assimilating innovative concepts of painting that were the envy of transalpine artists. As Vasari remarks in the *Lives of the Artists*, innumerable young Flemings and Germans travelled south to learn from the "modern" works of the High Renaissance masters, returning to their homelands with "molti nuovi modi di pitture cavati d'Italia."[33] Rome, Florence, Milan and Venice were focal points for the itineraries of these aspiring northerners. Evidence that Hemessen must have visited Florence is found in a copy by his hand after Andrea del Sarto's fresco of *Charity* at the Chiostro dello Scalzo (figures 21–22).[34] Numerous borrowings from the Sistine Ceiling in Hemessen's *oeuvre* suggest that he also drew from Michelangelo's frescoes at Rome. The *Laocoön*, unearthed in 1504, had a great effect on his imagination. In addition, there is evidence that he was particularly struck by Raphael's *Transfiguration* and made a special effort to analyze its advanced treatment of form and chiaroscuro and to record expressive features and poses of several of the figures. A longer stay in Northern Italy probably complemented his visits to Florence and Rome.

Hemessen returned to Antwerp a full-fledged Romanist. This generic label has been used to group together a large number of sixteenth-century Netherlandish masters who infused new trends from Italy into their native artistic traditions.[35] Extending from Gossaert and van Orley through Frans Floris up to and including Stradanus and Blocklandt, Romanism was a broad movement that was centered mainly at Antwerp, Brussels, Utrecht and Leyden. It was also promulgated by Marten van Heemskerck at Haarlem and Lambert Lombard at Liège.[36] As Antal rightly stressed, individual Romanist artists differed widely in their reactions to what they found in Italy and were by no means confined to Rome in their borrowings. Some, like Lambert Lombard, opted for a relief-like classicism based on the late frescoes of Raphael and his school at Rome, while others, Heemskerck for example, derived an opulent plasticity from Michelangelo, Salviati and Giulio Romano. Venice was especially important for Frans Floris.[37] What is remarkable about Hemessen is the range of his Romanist borrowings. Bronzino, Rosso, Giulio, Titian and Tintoretto are all to be found in his work, in addition to Raphael, Michelangelo, Leonardo and North Italian painters like Romanino and Moretto. Hemessen was by far the most eclectic artist among the Romanists. He applied a traditional Flemish passion for detail to his search for Italianate poses, gestures and even entire scenarios. Much of these pages will be devoted to pinpointing these borrowings and examining how they are interpreted in their new guises. Hemessen's appropriations may appear capricious in comparison with

Baroque eclecticism, but in general they reveal a remarkably intelligent selectivity.

Hemessen's eclectic sensibility was by no means exclusively concentrated on Italy. The conventional notion that Romanists were busily rooting up and discarding moribund native artistic traditions, replacing them with freshly imported transplants, is belied by the fertile revival of ideas from early Netherlandish art occurring in his work from ca. 1525-35. At the same time that he incorporated advanced High Renaissance concepts of form, space and lighting, Hemessen also developed his powers of articulation of tangible reality based on a study of fifteenth-century masters like Van Eyck, Memling and Roger van der Weyden. This produced what might be called a "hybrid" approach that is noticeable in works such as the 1531 *St. Jerome Penitent* (figure 27) and the *Double-Portrait of a Husband and Wife Playing Tables* (figure 45) from the following year, both well-preserved, mature works.

Throughout his career Hemessen remained sensitive to the lyrical emotionalism of late Gothic art — delicate strains of tender sorrowing and moody disquiet which typify a great deal of early Netherlandish painting. These traditions had been preserved and transmitted by older masters trained in the fifteenth century, like Colyn de Coter at Brussels (ca. 1455-1538/39), Gerard David at Bruges (ca. 1484-1523) and, of course, Quentin Massys at Antwerp (ca. 1465-1530).[38] Late Gothic mannerisms flowering in the limewood sculptures of Tilman Riemenschneider and other German Renaissance masters contributed to the curiously outdated rhythms of some of Hemessen's compositions.[39] The archaizing aspect of Hemessen's work may not have gone unrecognized by his contemporaries. It certainly outweighed his Romanist accomplishments for van Mander, who calls him an artist "who possessed a style that followed to a great extent the old manner and diverged to a similar degree from the new..." ("de welcke een maniere hadde meer treckende nae d'Antycksche en meer afgheschepden van de moderne...").[40]

Documents of Hemessen's life and career resume in 1535, when it is recorded in the *Liggeren* that "Jan van Hemsich" apprenticed a student by the name of Machiel Huysmans.[41] Sometime before this year, he was married to Barbara de Fevere, the daughter of a prosperous Antwerp cloth merchant, Simon de Fevere.[42] Widowed in 1514, Barbara's mother, Christina van der Rijt, had raised a large family of five sons and two daughters. It is known that Barbara's older brother Simon came of age in 1515 and that in 1517 he was appointed canon at the cathedral of Middelburg. Barbara brought with her a generous dowry that included some profitable real estate.

The years 1535–40 mark an important stage in the artist's career. Numerous copies of his work from this phase attest to a large and prosperous atelier. In 1537 Hemessen engaged a third apprentice, Jorge de Nicole, and it was also at this time that the Brunswick Monogrammist (who was probably identical with Jan van Amstel) was connected with his workshop, where he made an abortive attempt to develop a "large-figure" style based on Hemessen's model.[43] A major undertaking of these years was a *Last Judgment* triptych commissioned by the eminent Antwerp burgher Adrien Rockox for his family chapel at the Sint Jacobskerk, executed ca. 1536–37, which included a large group of donor portraits (figures 71–74). Coming from a family that were to be major patrons of Rubens in the next century, this commission affirms Hemessen's position of importance in the Antwerp artistic community. The *Last Judgment* gave him the chance to challenge van Orley's Italianate treatment of the subject for the Brotherhood of Almoners at Antwerp ca. 1519–25, employing advanced concepts of monumental nudes, dramatic chiaroscuro and expressive gesture.

On January 8, 1539, Jan purchased a house on the Lombaardevest, named for the Lombard moneylenders whose pawnshops were located on the street. The house had the fetching name "het Lindeken" ("the little lime-tree")—an appropriate nickname for a *domus pictoris* since the hard wood of the lime tree had long been a popular support for panel paintings.[44] The following year he was involved in a lawsuit with the painter Jacob Cocx over 148 gold crowns, a not inconsequential sum, though the final disposition of the case is unclear. Little is known about Cocx. Only four years later, he was to be among a group of four Antwerp artists forced to flee the city because of suspect association with an extremist sect of religious libertines called the Loists.[45] Hemessen's finances must have improved by July, 1541, when he purchased another house, "De Faisant" ("The Pheasant"), this time on the fashionable Hochstetterstraat, named after a wealthy Germany banker family who had established themselves in the city. Later the same year he managed to sell "het Lindeken."[46]

The decade of 1530–40 was an active period for the thriving port of Antwerp, now established as the foremost mercantile center of Christendom. The city's prosperity accrued to a great extent from its virtual monopoly of trade in Portuguese spices, English woolen cloth and German bullion, as well as silks and other fine fabrics from Italy and precious stones and gold from Spain.[47] Originally attracted by the Fairs of Brabant held four times a year since the fourteenth century, many foreign merchants had settled there more or less permanently, including the Gualterotti, Buonvisi and Spinoli families. The most wealthy and powerful were the great German banking dynasties—the Fuggers, Welsers and Hochstetters—who made the Antwerp Bourse the financial hub of Europe. One of

the sights of the city was the baronial mansion of Lord Anton Fugger, "truly the prince of all merchants," located on the Steenhouwers Veste, just a block and a half down from the Lombaarde Veste where "het Lindeken" was situated.[48]

General prosperity stimulated a love of pomp and display that, by all accounts, was an ongoing phenomenon of Antwerp life. Guicciardini has left a lively description of the city that deserves to be quoted once again:

> Moreover, although a part of the lesser folk and some others more austere live in accordance with the old custom of eating sparingly, it is nonetheless a fact that at present the people live sumptuously, and perhaps better than is seemly. Both men and women of all ages go about very well dressed, each according to his resources and rank, always following new and tasteful fashions, but many of them more richly and more sumptuously than decorum and respectability can or should permit. You can see here at all hours weddings, feastings and dances. You can hear everywhere the sounds of instruments, songs, and the noise of merrymaking. To conclude, in all possible ways appear the wealth, power, pomp and magnificence of this city.[49]

Like Venice, Antwerp boasted a large and thriving community of artists who profited from a steadily expanding market. As Guicciardini observes, "They have artisans proficient in every kind of art and craft, for they work so well that they sell their products even before these are finished, and, as everyone knows, continual work brings perfection."[50] Paintings and tapestries were produced not only for the home market but also for a lucrative export trade, especially to Spain and Portugal, where Flemish masters had long been admired.[51] In return, Spain supplied large quantities of precious crimson dyes made from insects, called "cochineal," which were very popular in the Lowlands.

Hemessen's panels from 1535–40 increasingly focus upon secular aspects of Antwerp city life. This trend can be noted in biblical episodes portrayed in contemporary settings or ironical genre-moralities that picture the traditional struggle between the Virtues and the Vices in the earthly arena of the Flemish bordello (figures 46, 55, 63, 66). His depictions draw from the caricatural realism of Quentin Massys and Marinus van Roymerswaele as well as from informal compositions developed by the Dutch painter-printmaker Lucas van Leyden, incorporating the latest illusionistic and scenic devices from Titian and Giulio Romano. Their rich costumes and ample still-life details mirror the rich fabric of contemporary Antwerp life.

Assisted by a talented collaborator specializing in small-figure background scenes, Hemessen pictures the confrontation of the materialistic claims of a mercantile society with the transcendent goal of the Kingdom of God, a conflict all the more relevant in an age torn by religious strife. Men and women are surrounded by corrupt forces anxious to tempt them

to sinful behavior, the "tinselled joys and vain pretence" lamented by the Castilian poet Luis de Léon. The battle with the Devil is only to be won by penance and grace, symbolized by the Prodigal Son who finds forgiveness at his father's feet.

These were years when reformist concepts were popular at Antwerp, one of the most tolerant communities in all of Europe. Hemessen shared the Protestant desire to see the Scriptures "rightly interpreted" in the quest for salvation, but his approach is closer to Christian humanists influenced by the *Devotio Moderna* like Erasmus, who combined the New Learning with a return to the purity and simplicity of early Christianity. Understandably, his favorite saint was Jerome, the biblical scholar and "patron saint" of humanists, portrayed as a penitent hermit or an aged recluse desperately praying before a crucifix. Jerome's inner battle with sinful temptation and his heroic penance are leitmotivs of Hemessen's *oeuvre*, cropping up again and again.

The emergence of New Testament themes such as the *Parable of the Prodigal Son* (figure 46) or *Calling of St. Matthew* (figures 63 and 66) in Hemessen's painting of 1535–40 indicates the type of thoughtful study of the Bible that had been advocated by Erasmus. During the 1520s Antwerp had become the most important center for publication of vernacular Bibles in the Low Countries, and for this reason has sometimes been called the "Netherlandish Wittemberg." In 1523 Adriaen van Berghen "op die Camerpoort-brugge int Gulden Missael" printed a Netherlandish translation of the New Testament, based on Martin Luther's German text.[52] Another New Testament, containing Erasmian elements, appeared in 1525 and was reprinted in '26 and '28.[53] The first complete Netherlandish Bible was published at Antwerp in 1526 by Jacob van Liesveldt (*Dat oude ende dat niewe testament*), a printer of Protestant leanings whose workshop, the "Schilt van Artoys," was also located at the Camerpoortbrugge. Illustrated with over thirty woodcuts, the *Liesveldtsche Bybel*, as it came to be called, was reprinted in 1532 and again in 1534, 1535, 1538 and 1542.[54] Due to its Protestant orientation, however, it came under inquisitorial suspicion and as early as 1536 was burned at Antwerp along with other books from Liesveldt's press.[55]

The Netherlandish Bible printed in 1528 by Wilhelm Vorsterman at the "Gulden Eenhoren" in Antwerp was more satisfactory from the Catholic point of view. Corrected after Erasmus' scholarly Latin by Niclaes Coppijn, Dean of St. Peter's Church at Louvain and Chancellor of the University, the Vorsterman Bible was highly admired by adherents of the New Learning.[56] Its 97 woodcuts, mostly by Jan Swart van Groningen, complement the handsomely printed text.

In addition to vernacular Bibles, there were also numerous Protestant

texts published at Antwerp during these years. Luther's works first appeared in the city in 1518 and began to be reprinted as early as 1520. It has been estimated that from 1520 to 1541 over 85 editions of the reformer's writings were published there, as well as many treatises by other Protestants.[57] Lutheranism was promulgated within the city's walls by an active contingent of evangelical monks led by the prior of the Augustinian monastery, Jacobus Praepositus, and his successor, Hendrik van Zutfen. Dürer mentions dining on several occasions with the Augustinians, who were on friendly terms with the German merchant colony. Lutheran ideas spread rapidly in Netherlandish humanist circles and were at first treated with tolerance by the court of Margaret of Austria. At Antwerp the Latin school run by the humanist Nicolas Buscoducencis was an early center of reformist learning.[58]

The young Charles V, however, was from the outset of his career a champion of orthodoxy. He began to issue repressive placards against Protestantism in 1520 and enlisted the support of conservative doctors of the University of Louvain in the struggle against "heresy."[59] The following summer the Edict of Worms (May 8, 1521) was extended to the Burgundian provinces, resulting in widespread confiscation and burning of Lutheran texts.[60] Praepositus was brought before the inquisitors and forced to recant in a solemn ceremony of abjuration at the church of Sainte-Gudule at Brussels on February 9, 1522.[61] Two of the Augustinian monks perished at the stake while others fled to Bremen. Their monastery at Antwerp was closed. Buscoducensis was imprisoned in Brussels and his Latin school replaced by three others under the supervision of the authorities.

The penitential flavor of much of Hemessen's work may reflect these early measures of Counter-Reform repression, which took place during his formative years and undoubtedly had a strong impact on his outlook. Publicity surrounding the formal recantation of Praepositus (which was published and disseminated in 1522) and that of the Antwerp humanist Cornelius Grapheus (who was forced to abjure his Lutheran ideas in a humiliating ritual at the Cathedral of Notre-Dame on May 6, 1522) contributed to widespread soul-searching.[62] Protestantism had also found numerous adherents among Netherlandish artists.[63] In March of 1524, thirty-seven Antwerp craftsmen were summoned before the city magistrate to answer charges about holding illegal meetings on the "Eyckstraetken" to discuss the Gospels. Even if not among those named, Hemessen must have been aware of the event and shared the ensuing controversy among his fellow artists at the St. Luke's Guild.[64] And it cannot be discounted that he may, himself, have had youthful heterodox leanings which he came to repent during these years of self-recrimination.

The decade of 1540–50 witnessed momentous developments across Europe. Intensification of religious crisis was parallelled by a somber, reflective mood in Hemessen's art from these years. He concentrates on monumental devotional images viewed at close range, the figures pensive and withdrawn from contact with the viewer. While continuing to invoke High Renaissance formulas, he makes increasing use of *artifizioso* concepts preferred by International Mannerism. Stylistic concerns erupt in mannered surface effects: filigreed coiffures, convoluted expanses of drapery, the alternation of shiny, enamelled areas of paint with passages of tight detail and intricate patterning. A recently discovered *Portrait of a Magistrate* (figure 114), signed and dated 1543, presents the subject in three-quarter length against a dark background—an example of the severe style of Northern portraiture which was to become standard format for the second half of the century.

The accent on ornamental elaboration in Hemessen's work corresponds to contemporary developments in sculpture and decorative arts popularized by the inventive Flemish printmakers Cornelis Floris (1514–75) and Cornelis Bos (ca. 1506–56), who specialized in grotesques and strapwork patterning.[65] There was a plethora of artistic exchange between Antwerp and Fontainebleau, both now foremost centers of artistic activity in Northern Europe. Flemish masters working in France such as Joos van Cleve, the Clouets, Leonard Thiry and Jan Massys carried Netherlandish influences southwards, while the prolific Fontainebleau print ateliers made contributions in the opposite direction. Stylistic changes in Hemessen's work (as well as other indications discussed below) suggest that he visited France in the mid-1530s and again the next decade.

It is too bad that so little is known about a major aspect of artistic production of the Antwerp St. Luke's Guild: festival decoration. These periodic celebrations promoted a spirit of creative cooperation and interchange among the competitive Antwerp masters, giving them the opportunity to express themselves in colorful allegorical terms. The plays and tableaux staged by the Chambers of Rhetoric in conjunction with Antwerp artists provided outlets for new iconographical currents, encouraging indigenous trends of earthy realism and humor that can be seen entering the durable medium of panel painting in Massys, Hemessen and Bruegel.[66] Festivals were also persuasive tools of political propaganda, whether celebrating a royal marriage, commemorating a military victory or affirming the allegiance of the populace to a new ruler. Antwerp witnessed a splendid *Entrée* of Charles V in 1520, the settings for which were seen by Dürer in the painters' warehouse on his visit to the city.[67]

Another great triumph took place in 1549, when 235 artists were organized under the direction of the *pictor imperatoris* Pieter Coecke van

Aelst to prepare the sumptuous decorations for the Entry of Charles V and his son, the future Philip II. Only a small group of documents relating to the magnificent *Triunfo de Amberes* have survived, giving little information on who was involved in the project.[68] One younger master attracted much attention for his work on the decorations: Frans Floris. Recently returned from a long sojourn in Italy, Floris had developed a rapid technique at Venice under Tintoretto, and he put it to good use in creating 210 figures in five weeks.[69] The young Pieter Bruegel — serving his apprenticeship at just this time (probably with Pieter Coecke) — may well have taken part in the work.[70] Though Hemessen's role in the decorations is not known, it can be assumed that he participated actively in the arrangements since he held the important position of Dean of the Guild of St. Luke the preceding year.[71]

For Antwerp, the Entry of 1549 served as formal introduction to Prince Philip, the heir destined to take over the reins of power from his ailing father Charles V. The prospective succession was viewed with alarm by many Netherlanders. They regarded the reclusive, Spanish-speaking Philip with considerable suspicion. Perhaps the most pressing question facing the Emperor and his son was how to deal with the spread of the Reformation in the Lowlands, economically the jewel of the Hapsburg crown. While the Inquisitors appointed by the Regent Mary of Hungary had had a measure of success in suppressing extremist cults like the fiery Anabaptists, avoiding a communist debacle like that occurring at Münster in 1534–35, severe problems were posed at mid-century by the sudden rise of Calvinism.[72] The Interim of Augsburg — a compromise settlement of 1548 drawn up in Germany after the imperial victory over the Protestants at Mülhberg — was in no way a suitable model for the Netherlands, since the Emperor had been forced to capitulate to major demands of the reformers.

In 1550, Charles strengthened the Inquisition in the Lowlands with severely worded placards (the so-called Edicts of Blood) which clamped down on religious freedom, enforcing capital punishment for laymen who disputed the Scriptures. Though the general opposition that greeted these repressive measures served to temper their enforcement, at least for a while, they resulted in a critical loss of confidence in established authority, especially at Antwerp, where there was a marked exodus of foreign merchants during the early 1550s.[73]

Much of Hemessen's work from these years contains pessimistic undertones that reflect this unpleasant turn of events. Stylistic refinements are sacrificed for formal disintegration and aberrant iconographic interpretations focussing on moral decay, spiritual blindness and emotional instability. In some panels he concentrates on austere meditative formulas related to the ascetic, militant teachings of St. Ignatius Loyola, whose

Spiritual Exercises, published in Latin in 1548, were widely disseminated under papal imprimatur. Works like Hemessen's *St. Jerome* of 1548 (figure 116, Stockholm, private collection) or his *Christ Carrying the Cross* of the following year (figure 117, Toledo, Museo de Santa Cruz) — both probably painted for Spanish monastic orders — look forward to the highly emotional pietism of Morales, El Greco and Ribera.

Until now there has been an almost total lack of documentation concerning Hemessen's last years up to his death, which presumably occurred late in 1556 or 1557.[74] In extensive annotations to his translation of van Mander's *Schilder-Boeck*, Hymans points out a document that proves the artist was still at Antwerp in 1555, and not in Haarlem, where earlier archivists had sought to place him at this time, following van Mander's assertion that Hemessen had been a citizen of the Dutch city.[75] This is an act of legitimacy authorized by Philip II in 1579 on behalf of a bastard son of the artist named Peeter van Hemessen. Peter, then twenty-four years of age, complains that his father had left him no provision in his will and that he had "hardly known" his mother ("zyne voirschreve moeder nauwelyck gekent..."), a servant girl formerly in Hemessen's employ with the fetching name of "Betteken." It can be deduced from the Act that Peter was sired in 1555, and that Jan must have still been in the city at this time. Nothing else is known about his bastard son, who is inscribed as "schildere, vryegeselle" ("painter, bachelor"). The document describes Hemessen as "formerly a painter and a citizen of our city of Antwerp" ("oock schilder ende poirter onser stadt van Antwerpen").[76] There is no mention of resettlement at Haarlem.

A few years ago another document relating to Hemessen's late years was discovered in the Antwerp city archives by Mary Buchan, who kindly made it available to the writer. It is in the form of an application made by the artist at Antwerp in 1551 for permission for his two sons, Gillis and Hanse, to embark upon a trip to Italy.[77] The young men were to travel in the company of "Hanse van der Rivieren," a servant who had been employed in Hemessen's workshop (handel van schilderen") for about three years. The reason why Hemessen was sending his sons to Italy is given at the close of the document: they were to go "to learn and to hear and to see" ("se leerene ende se hooren ende se siene"). One can be fairly certain from this comment that both Gillis and Hanse were young artists trained in their father's workshop, though their occupations are not specified in the text. It would also imply that Hemessen must have, himself, travelled in the South "to learn and to hear and to see."

The document provides fascinating insight into Hemessen's inner circle of professional friends. It was witnessed by two fellow members of the Guild of St. Luke, "Wouter van der Elsmeer" (also cited in the text as

"Wouteren van Elsmaer") and "Jan van Doren," both of whom swear that "they know well and have known for many years...Jan van Hemessen, and that they have also known from childhood Gillis and Hanse van Hemessen" ("zy wel kennen ende over vele jaren wel gekent hebben...Janne van Hemishem, ende dar zy osen wel gekent hebben van joncse of Gillis ende Hanse van Hemishem"). Both of Hemessen's old friends were long-standing members of the artists' guild. Jan van Doren is cited in 1543 and again in 1552 as a "Bakmaker" (or a barrel-maker).[78] On the latter occasion, he apprenticed a pupil, Geert Jansen, who is called a "tafereelmaker" ("panel-maker") in the listing. In addition to making barrels, van Doren also specialized in fabricating the sturdy hardwood panels used by painters. He presumably provided these for Hemessen's workshop.

Wouter van der Elsmaer is even better documented. Originally from Diest, he was a prominent sculptor ("beeldsnyder") and furniture craftsman ("anttycksnyder") first enrolled as Free Master in the Guild in 1533.[79] Elsmaer ran a prosperous workshop and eventually became Dean of the Guild on two separate occasions, in 1560 and 1563.[80] There are records of payment to him from 1547–48 for having done "two Veronicas at the foot of the cross" for the Antwerp Cathedral, and for having made a pulpit for the parish altar.[81] His work has slipped into obscurity like so much sculpture from sixteenth-century Antwerp. Hemessen's association with Elsmaer further establishes his involvement with the art of carving. The two masters possibly collaborated on commissions involving both panel painting and wooden sculpture, or Elsmaer may have contributed carved frames for some of Hemessen's altarpieces.

Like the ateliers of other Netherlandish painters of the day, Hemessen's workshop must have been a salesroom as well. Most artists in the Northern Renaissance were their own dealers, or sometimes they were lucky enough to have an enterprising wife who supervised this aspect of the business.[82] We can assume that Hemessen was actively involved in arranging commissions and sales of his work—this is implied by the description of his workshop in the document as a "handel van schilderen" (literally translated as "commerce in painting"). Indeed, the use of the broad term "handel" suggests that Jan was involved in dealing paintings by other artists as well as his own, possibly works from Italy or coveted panels by early Netherlandish masters like Hieronymus Bosch.[83] This would tend to account for the remarkable variety of his eclectic borrowings.

While Hemessen's sons Gillis and Hanse are not heard of anymore, his daughter Caterina van Hemessen was to become one of the few successful women painters of the Renaissance. Born in 1528, she was a favorite of the Regent Mary of Hungary and accompanied her when she followed the Emperor Charles V into retirement in Spain in 1556. Caterina's association

with the Netherlands court confirms her father's contact with the Regent's circle. Cited both by Vasari and Guicciardini, Caterina achieved some fame as a painter of portraits and small devotional works for the court.[84] There are a number of portraits that bear her signature, including an interesting *Portrait of a Man* (London, National Gallery) with the inscription, "CATHARINA FILIA/IOANNIS DE HEMES/SEN PINGEBAT/1552," attesting filial duty and also implying that she had studied under her father.[85] Two signed religious pictures by Caterina (both in private collections in Mons, Belgium) appear considerably less successful than her portraits, which, though at times awkward, possess an undeniable appeal.[86]

In 1554, two years before she departed from Antwerp for good, Caterina married a talented organist at the Antwerp Cathedral, Chrétien de Morien (or Marin). According to Guicciardini, Morien was an "excellent jouer d'espinettes et d'autres instrumens."[87] Their marriage took place on February 23rd at the Sint Jacobskerk, for which Hemessen had painted the Rockox *Last Judgment* in the 1530s. Morien accompanied his wife to Spain, where they both had successful careers at the court. The Spanish historian Soriano refers to him as the "celebre clavichordista flamenco Christiano."[88] Mary of Hungary was so fond of the talented couple that, as Guicciardini relates, she left them "provision for their entire lives" upon her death.[89]

There is a good possibility that Hemessen commemorated the nuptials of Caterina and Chrétien in a witty allegorical panel in Toronto, stylistically dating from ca. 1554, which was formerly called the *Inspiration of a Musician* (figure 131). A handsome musician and lovely young woman wearing a laurel wreath are seated opposite one another in a serene pastoral landscape. The man offers his viol to his partner, who grasps it with one hand while gently baptizing the instrument with a stream of milk from her breast. The couple look fondly at each other, like the young lovers in Titian's *Three Ages of Man* (figure 132), which Hemessen must have known.[90] Winternitz interprets the young woman of Hemessen's panel as a crowned Muse who inspires the musician with her milk, in the same way that Muses in antiquity were thought to have nurtured epic poets.[91] In Dante's *Purgatorio,* for instance, Homer is described as "quel Greco che le Muse lattàr più ch'altro mai." Though this hypothesis is not unattractive, Winternitz concedes a lack of precedent for a musician shown "in the act of receiving the divine afflatus" for "it was not yet customary to depict a contemporary musician as an inspired being."[92]

The unusual elevation of the musician to the sacred groves of Parnassus in Hemessen's panel may well have been a conceit specifically devised for an allegorical marriage portrait, in which his daughter plays the role of a Muse showering her blessings upon her virtuoso spouse. While there is no

record of Morien's appearance, Caterina van Hemessen's features — known from a *Self-Portrait* of 1548 — are not dissimilar to the Muse. And, though perfectly correct for a Muse, the wreath of laurel, the "noble tree" that conferred honor on military victory and poetic distinction, was also associated with chastity at wedlock.[93] In Ripa's *Iconologia,* for instance, "Castità Matrimonale" holds a branch of laurel, "perche quest'albero hà grandissima simiglianza con la Castità."[94] Always associated with triumph, laurel symbolizes the felicitous triumph of love, as it does in Lorenzo Lotto's marriage portrait of *Messer Marsillo and his Bride* (1523, Madrid, Prado), who are united by a cupid sporting a wreath of bay leaves.[95]

Furthermore, the act of giving milk implies sustenance and nourishment of the musician's talents, an image not unrelated to the sacramental obligations of marriage. In Ripa, "Sostanza" is imaged as "gettando latte delle mammelle."[96] It was also a gallant poetic convention that feminine beauty was inspiring to musicians. Castiglione recommends in *The Courtier* that music "be practised in the presence of women, because those sights sweeten the minds of the hearers and make them more apt to be pierced with the pleasantness of music, and also they quicken the spirits of the very doers." In response, music was known to "please women withal, whose tender and soft breasts are soon pierced with melody and filled with sweetness."[97] His gaze fixed upon the lovely features of his Muse, who demurely lowers her eyes, the musician recalls the series of paintings by Titian and his school picturing a musician contemplating the stunning beauty of the goddess of love.[98]

The style of the Toronto panel would agree with a date of 1554, the year Caterina and Chrétien were married. It was very likely a wedding present from the painter to the talented couple who only two years later left Antwerp in the magnificent entourage following Charles V into retirement. The 56 ships carrying Mary of Hungary and her court sailed from Zeeland for Laredo on September 15, 1556. The exodus of the Hapsburg court to Spain marked a turning point for the Northern Renaissance, for there was no longer an active school of court artists in the Lowlands. What happened to Hemessen after their departure is not known. His last firmly dated panel is the dramatic *Expulsion of Merchants and Money-Lenders from the Temple* (figure 140, Nancy), signed and dated 1556. It is certain he was no longer alive in 1563, the year Guicciardini completed his book on the Lowlands.[99]

Many of the subjects Hemessen treated in his late years relate to contemporary efforts to develop an effective Counter-Reformation policy in the Netherlands. The *Expulsion,* pictured ironically within the Gothic interior of the Antwerp Cathedral, alludes to the pressing issue of ecclesiastical reform facing the Council of Trent. Panels such as the *Parable of the*

Unmerciful Servant (figure 142, Ann Arbor) and *Cure of Folly* (figure 137, Madrid, Prado), both done ca. 1555–56, comment on the growing tendency of the Inquisition to rely on harsh, intolerant methods in the fight against heresy. Hemessen's bold *Spätstil* places him at the forefront of artistic experimentation in the North. His courageous response to religious and political conflicts at mid-century anticipates Pieter Bruegel's outspoken commentaries on the worsening conditions under Spanish rule in the next two decades. Bruegel was certainly familiar with Hemessen's work and probably knew him personally.

The life of Jan Sanders van Hemessen was acted out against momentous currents of change in the intellectual and spiritual affairs of Northern Europe. Creative processes of painting proved no exception to the critical shift in values from Gothic ways of looking at the world to the more self-conscious age we call the Renaissance. The obsessions of Hemessen's pictures — the dualism between sensuality and mannered abstraction, an at times morbid lyricism, his love of caricature and distortion, the fascination with covert moral dilemma — all express the ambivalence of the artist's particular moment of history as well as the drama of his own personality.

2

Early Work (ca. 1525–30)

Jan Sanders' career as a painter had already begun by 1524, when he took on an apprentice as Free Master in the Antwerp Guild of St. Luke. Though a number of works have been assigned to Hemessen's early phase, the chronology of his artistic development during the 1520s remains largely conjectural due to the lack of any firmly dated panels prior to the Lisbon *St. Jerome Penitent* (figure 27) of 1531. The mature style of the *St. Jerome* must have been preceded by a considerable amount of work. Friedländer, Winkler, Reis-Santos and others have made convincing attributions to Hemessen's formative years based on the Lisbon panel and other signed panels from the 1530s. These include a striking *Descent from the Cross* at Brussels (figure 5), a *Madonna and Child* at Lisbon (figure 13), and the two *Portraits of a Young Princess* now at Worcester, Mass., and Berlin (figures 18–19).

To this list should be added a *Christ and the Adulteress* which has passed through several private collections in Europe and surfaced a few years ago on the New York art market (figure 1). Mentioned by Friedländer and others as an authentic Hemessen, the panel is inscribed on the front of the step below Christ's foot, "IOANNES DE HEME/SEN ME FECIT," followed by a date, which has been various read as "1575" (Hymans), "1575 (?), more likely 1535" (Friedländer), and "1535" (Fischel).[1] The disputed third digit admittedly looks like a "7" (figure 2). But this would not be possible, since Hemessen was already deceased by 1563, the year Guicciardini completed his book on the Low Countries. It is certainly not a "3," since it does not possess the vertical double structure characteristic of this numeral. The only alternative would be a "2." Possibly the truncated form is due to repainting of the area of the inscription. Also, in Medieval and Renaissance script it was not uncommon for a "2" to be written without a horizontal line at the base of the digit.[2]

There is good reason to believe that the date of the *Christ and the Adulteress* is 1525. An early dating is supported by obvious stylistic inade-

quacies that indicate the artist had not yet reached maturity, especially in handling foreshortening and perspective. The compressed forms and clumsy modelling of some of the heads is not seen in Hemessen's work from the 1530s. In addition, the slender, elongated heads and long noses differ from the type of features he preferred later on. The panel also displays a somewhat naive adaptation of German and Italian ideas that would be understandable from Hemessen at this stage. The calm, reserved pose of the adulteress — deriving from earlier versions of the subject by the North Italian painter Ludovico Mazzolino (figure 3) — contrasts sharply with the surging crowd of onlookers, whose repulsive grimaces hark back to German painting and sculpture. In the Mazzolino *Christ and the Adulteress* at London, the figures are arranged on a clearly defined plane. Rather than employing a similarly rational format, Hemessen hems in the adulteress with a chaotic swirl of figures resembling the frenzied swarm beneath the cross in Hans Leinberger's wood relief sculpture of the *Crucifixion* (figure 4) from 1516. The attempt to synthesize German and Italianate compositional ideas is not altogether successful and falls short of the integrated solutions he was later to achieve.

In spite of its failings, the *Christ and the Adulteress* contains many seeds of Hemessen's fully developed style. Animated movement plays an essential role in defining the composition: expressive heads bend in strong foreshortening, and hands and feet participate in a lively flow of forms in rapidly changing directions. Searching for a new concept of space to replace a basic frontal stage format, he adopts an unusual oblique recession that suggests the steps of a temple without defining its limits. The foreshortened figure of Christ is made to stand out by the use of a bird's-eye perspective and radical abridgement of the jutting stepped platform, so that the mystical characters inscribed by the Savior border the edge of the panel very close to the viewer. The use of an extremely tight frame for visual emphasis is common to much of Hemessen's *oeuvre*. It is another device he could have borrowed from German relief sculpture and may be observed in Leinberger.[3]

If the *Adulteress* shows Hemessen in the mid-1520s to be an ambitious and experimental young master concerned with recent developments in Italy and Germany, it also reveals his exposure to another tradition closer to home. The stylized drapery folds, slender hands and delicate, wispy filaments of hair demonstrate a miniaturist's approach that is quite different from the broadly chiselled style of the 1531 *St. Jerome*. On the whole the surfaces are carefully rendered with a smooth, enameled finish — unlike the roughhewn quality of the *Jerome*. These refinements suggest contact with artists working at the Netherlands court, especially Jan Gossaert (Mabuse),

whose elegant representations of religious and mythical subjects are highly admired for their sophisticated assimilation of classicizing influences. Gossaert would have sparked Hemessen's interest in unusual postures and fluid interactions of form. It is also relevant to the formative style of this work that Bernard van Orley, whose accomplished, elaborate paintings were popular at the court of the Regent Margaret of Austria, had only recently veered towards a dramatic, turbulent idiom in the *Job Altarpiece* of 1521 and *Last Judgment* (figure 75) for the Brotherhood of Almoners at Antwerp, completed in 1525. What Friedländer terms the "unexpected vehemence of expression" of van Orley's new manner of the 1520s may have encouraged the younger artist to embark upon a parallel course at the outset of his career.[4] The background figures in the Hemessen convey their excitement over the event with raised arms and bewildered looks, much like van Orley's animated, gesticulating figures in the two altarpieces.

A date of 1525 for the *Christ and the Adulteress* reinforces the attribution to Hemessen's early years of a beautiful *Descent from the Cross* (figure 5) acquired by the Brussels Museum in 1960.[5] The *Descent* contains similar slender, elongated figures with long noses and wistful haunted eyes. Unlike the *Adulteress*, however, an Italianate logic dominates the structure of the panel, and there is a seemingly effortless fusion of High Renaissance values of classic symmetry and repose with the refined pietism of early Netherlandish painting. The two-ladder format provides a graceful means for lowering the dead Christ from the cross. Employed by Gossaert a few years prior to the Hemessen in his *Deposition* of 1521 (Leningrad, Hermitage), the device is also found in a late fifteenth-century triptych by the Master of the St. Catharine Legend (Cologne, Wallraf-Richartz Museum) and may well derive from a lost work by Roger van der Weyden.[6] Hemessen's interpretation differs from these two examples and from Pieter Coecke van Aelst's subsequent two-ladder *Deposition* (Lisbon, Museu Nacional de Arte Antiga) in that the ladders are placed to form a roughly equilateral triangle with its apex positioned at the horizontal bar of the cross. This enabled him to dispose the figures in a unified pyramidal arrangement recalling the harmonious groupings of Leonardo and Raphael. In fact, Hemessen must have drawn the idea from a lost Raphael composition from ca. 1506–07 which is reproduced in an engraving by Marcantonio Raimondi (figure 6) as well as a chiaroscuro woodcut by Ugo da Carpi (figure 7).[7] Of the two, I would guess that Hemessen probably used the Ugo da Carpi, since it is the more compactly organized. Hemessen restructures Raphael's concept slightly by shifting the point of view so that the cross is seen from a gently oblique angle. This produces an interesting spatial play while preserving the essentially planar backdrop established by

the two ladders. The group of mourners at the foot of the cross form a shallow semicircular niche to receive the dead Christ, whose corpse is slowly lowered before them.

The Brussels *Descent* also acknowledges a debt to one of the supreme masterpieces of fifteenth-century Netherlandish art, Roger van der Weyden's *Decent from the Cross* from Louvain, now at the Prado. Like Roger, Hemessen reduces motion almost to a still point and presents the individual participants in the drama in telling attitudes of lyrical simplicity (figures 9–11). The pose of the Virgin fainting in grief clearly harks back to the Louvain panel. Hemessen devises a more graceful solution by cushioning her fall against her kneeling companion, who nestles the Virgin's hand in her own in a touching manner (figure 8). Roger's influence can also be discerned in the heightened realism of teardrops and rivulets of aqueous blood—their crystalline beauty symbolic of mystical transmutation of suffering. The tender, sorrowful mood is enhanced by the delicate style of the figures, slender and fragile like ivory statuettes, as well as by the deep emblematic coloring: predominantly rich carmines, dark blues and golden-orange tones set against an otherworldly greenish dawn.

The refined style of the *Descent* again suggests contact with Netherlandish court circles, though its accent on classic simplicity runs counter to trends of decorative embellishment favored by van Orley or by the youthful Bruges prodigy Lancelot Blondeel, whose work on the Entry of Charles V of 1520 had vaulted him to prominence.[8] Hemessen's approach can be better compared with the serene Italianate manner of Conrat Meit, court sculptor for Margaret of Austria. The sensitive features of female mourners in the *Descent* are reminiscent of Meit's marble *Madonna* for Sainte-Gudule at Brussels (figure 12), from ca. 1520–25, an important example of his classicizing manner. The polished elegance and restrained emotionalism of Hemessen's panel anticipate the magnificent marble and alabaster tombs of Margaret of Austria and Philibert the Fair of Savoy at Brou, executed by Meit and his assistants from 1526–1532.[9]

The Portuguese art historian Reis-Santos was responsible for assigning a fine *Madonna and Child with St. Joseph* (figure 13) at Lisbon to Hemessen's early period.[10] Closely resembling the figure style and colorism of the *Descent from the Cross*, the Lisbon panel is also very well preserved, especially in the luminous glazes of roseate flesh tones and sheer white veil worn by the Madonna. What is especially remarkable is its adaptation of monumental High Renaissance imagery to an intimate domestic scale. The compact forms and well-defined contrapposto of the Virgin recall sculptural prototypes such as Michelangelo's Bruges *Madonna*, while the energetic pose of the infant Christ resembles the God of Creation of the Sistine Ceiling. A similarly audacious Romanist pose can be seen in Gossaert's

infant Christ in the *Madonna and Child* now at Vienna, from about the same date.[11] In contrast to the bulging muscularity of the Gossaert, however, Hemessen's Christ child possesses a more boyish physique, and foreshortening is considerably restrained. Hemessen places his Italianate figures within a panelled interior harking back to fifteenth-century Northern prototypes like the Petrus Christus *Madonna and Child* at Kansas City.[12] A cozy domestic touch is added by the figure of St. Joseph cooking soup over the hearth in the background. Panofsky has traced this typically Netherlandish motif all the way back to the beginnings of the International Style, ca. 1375–80.[13]

The three works discussed so far give a fairly good idea of Hemessen's style of painting in the mid-1520s. What stands out above all is a desire to merge High Renaissance innovations with the humanly pietism of the Netherlandish tradition. The basic pattern for this initial phase of Flemish Romanism had been set a few years earlier by Quentin Massys in his delightful homage to Leonardo's *Madonna and Child with St. Anne,* the *Madonna and Child with a Lamb* (figure 14), now at Poznan.[14] Massys' almost casual presentation of mother and child in a tranquil Patiniresque landscape anticipates the sense of human intimacy of the Lisbon panel. Another early Hemessen *Madonna* (figure 15), formerly in the Von Hoschek collection at Prague and now lost, moves even further in the directions outlined by Massys. Based chiefly on Raphael, the youthful Madonna of Humility appears perfectly at ease in a placid outdoor setting, seated humbly in front of a tree covered with feathery vine leaves. The soft chiaroscuro and delicate forms suggest awareness of Leonardo as well as Raphael. Hemessen modelled the Christ child on the pensive infant who blesses St. John in Leonardo's *Virgin of the Rocks*, possibly by this time in the collection of Francis I.[15] Painted a few years after the Lisbon *Madonna and Child with St. Joseph*, the Von Hoschek *Madonna* looks forward to the broader forms of the next decade.

Even more ambitious was another lost work which was rightly attributed to Hemessen's early years by Winkler in 1924: a *Rest on the Flight to Egypt* formerly in the Dollfuss Collection at Paris (figure 16).[16] Hemessen experiments with more expansive forms and voluminous drapery, attempting to integrate High Renaissance ideas with a Rhenish Madonna tradition carried on in the Lowlands by Massys and Orley.[17] The results are not altogether satisfactory, particularly in the awkward foreshortenings and transitions of form. The Dollfuss *Rest on the Flight* is of considerable interest, however, because it serves to link Hemessen's stylistic origins to a distinguished master from the older generation: the anonymous Master of the Magdalen Legend. The appellation derives from a reconstructed triptych of the *Life of the Magdalen* dispersed among museums at Budapest, Phila-

delphia, Schwerin and Copenhagen. Having painted a portrait of Margaret of Austria when she was a young girl, the Magdalen Master had longstanding connections with the Netherlands court.[18] Schooled in the tradition of Roger van der Weyden, he gradually developed a more Italianate style under the influence of Orley and remained active at Brussels and probably also at Malines until ca. 1527.[19] The Dollfuss *Rest on the Flight* closely approximates schematic conventions of the *Life of the Magdalen* triptych. The treatment of the features and hands were modelled on figures like the Magdalen and St. Margaret (figure 17), though the younger artist's command of naturalism is already much more advanced. Similarly stereotyped forms and drapery can be noted in the *Meal at the House of Simon the Pharisee* (Budapest). A period of work under the Magdalen Master would help to account for the archaizing tendencies that continue to counterbalance Hemessen's penchant for Italianate innovation.

Hemessen may well have studied portraiture under the Magdalen Master, who painted many of the Hapsburgs over the years and was held in high esteem by the ruling family. Two important panels from the late 1520s have been tentatively identified as Hemessen portraits of the young Margaret of Parma (b. 1522), the illegitimate daughter of the Emperor Charles V who was raised at the Netherlands court under the care of Margaret of Austria and, upon her death, by Mary of Hungary (figures 18–19, Berlin and Worcester, Mass.).[20] Up to the age of four, she was reared along with the three children of the King of Denmark, Christian II, painted by Gossaert in a memorable group portrait now at Hampton Court.[21] The hypothesis that Hemessen's appealing portraits of a young girl represent Margaret of Parma is made attractive by evident stylistic similarities of the Berlin and Worcester panels to the Gossaert. The sumptuous costumes certainly denote high rank, and her skillful use of the clavichord and scales indicate exceptional cultivation for one so young. Margaret was given an outstanding education befitting a Renaissance princess who was being groomed for a major role in the political affairs of the Empire. Her special tutor was Jean Beauvalet, chaplain of Sainte-Gudule, who is recorded to have taught her to read and write. There are also accounts of payments for lessons in music and dance.[22] A third Hemessen portrait of the same princess is reflected by a copy at the National Gallery, London, which pictures her writing (figure 20). Hemessen probably adapted the genre presentations from popular pictures of aristocratic young women by an anonymous artist of the 1520s, the so-called Master of the Female Half-Lengths. In contrast to the Hemessens, however, most of the depictions by this master are not specific enough to be regarded as portraits.[23]

As mentioned earlier, three portraits of the young Margaret of Parma are documented to have been done at Malines in the late 1520s while Jan

Vermeyen was in charge of the Regent's artistic workshop. Since the document does not specify that Vermeyen executed the portraits himself, it is possible that the entry refers to the Hemessen panels at Worcester and Berlin, and also to the lost model for the London copy.[24] As a number of scholars have noted, the lively features and poses of the Hemessen princess demonstrate awareness of recent trends of Dutch realism that could have been transmitted to the Antwerp painter via Vermeyen. In fact, the portraits are close enough to Vermeyen that for a while they were attributed to him, though the fleshy treatment of the features and detailing of the costumes is now rightly seen to coincide with Hemessen's style in the late 1520s.[25]

Hemessen's interest in High Renaissance concepts during his early years signals an increasing Romanist dependence on Leonardo, Raphael and Michelangelo in the third decade of the century. Like other Northern artists of his era, Jan was increasingly turning to the South for inspiration. Travel to Italy was becoming a *sine qua non* of a Netherlander's artistic education. There is little doubt that Hemessen took part in at least one (and perhaps two) expeditions across the Alps. A copy of Andrea del Sarto's fresco of *Charity* at Florence (figure 22) first assigned to Hemessen by Winkler is now generally accepted as proof of his travels (figure 21).[26] Unfortunately it is known only through an old photograph taken when it surfaced on the Vienna art market at the turn of the century. The photo reveals a startling transformation of the Florentine's ethereal grisaille into a group of solid, fleshy figures. A study piece rather than a true copy, Hemessen's *Charity* was clearly done to record the dynamic interplay of forms underlying Sarto's composition, especially the vigorous movements of the infants. Hemessen sharpens the contrast of light and shade to accentuate the bulging plasticity of the figures, which are bolder and considerably more powerful than those found in his work discussed so far. This would indicate that the copy was made on a trip to Florence towards the end of the 1520s, though it is also likely that Hemessen had made an earlier visit to Italy during his student years. He must have done several copies of this sort to bring back with him and probably also drawings of things that struck his eye, though none have so far been identified.[27]

A trip to Florence and Rome in the late twenties would tend to account for the monumental directions of his work at the outset of the next decade, as revealed by the Lisbon *St. Jerome Penitent* of 1531. To this phase can be assigned a lost *Pietà* that is known through a good studio copy at Mainz attributed to the Brunswick Monogrammist (figure 23).[28] The muscular body of Christ anticipates the Michelangelesque figure of St. Jerome in the Lisbon panel. One arm of the dead Christ oddly extends outwards in rigor mortis, the limp hand recalling the famous gesture of Adam

receiving the divine impulse from God the Father on the Sistine Ceiling. This rather macabre homage to Michelangelo is merged with a daring pose of a winged victory—an antique sarcophagus motif frequently employed by Raphael and his school. The general format of the panel follows a north Italian type of *Pietà* exemplified by a Romanino at Brescia (Pinacoteca Tosio Martinengo), which contains a similarly stocky Michelangelesque Christ and the Albertian motif of a saint looking directly out at the viewer from beneath a stark silhouette of Calvary. The Brescian source again indicates that Hemessen spent time there on his travels, perhaps even working for a while in Romanino's workshop.

It is likely that in the original Hemessen *Pietà* the rhythms of the figure of Christ would have been considerably more lyrical and graceful than in this awkward copy, painted by an artist who was clearly out of his element. A better idea of Hemessen's fusion of Italianate and Northern ideas at this stage in his career can be obtained from an impressive triptych formerly in the O'Campo Collection which is now on view at the Petit Palais in Paris (figure 24). Probably originally commissioned for a hospital chapel ca. 1530, the triptych figures the *Martyrdom of St. Sebastian* and, on the wings, St. Roch, a healer saint often invoked against disease (especially the plague), and the hirsute St. Onuphrius, who protected against the peril of sudden death.[29] The hairy anchorite is accompanied by the two lions that assisted St. Paphnutius to dig his grave. St. Roch is shown in the customary manner with an angel kneeling at his side and the faithful dog who succored him when he had the plague.

The central panel is dominated by the figure of St. Sebastian, pictured from a slightly oblique angle. His head gracefully framed by upraised arms, he shifts back and forth in a nervous dance as he undergoes his martyrdom. The close juxtaposition of the archers builds up a sense of threatening forces surrounding the saint; the curves of their bows are accentuated by the taut rhythms of the figures. The configuration of the tree above the head of the saint makes an unmistakeable reference to the Crucifixion. Hemessen may well have drawn the general composition of the central panel from the Augsburg altarpiece by Hans Holbein the Elder, painted ca. 1516 (Munich, Alte Pinakothek), a work the young Antwerp painter could have seen on his *Wanderjahr*.[30] In contrast to Holbein, he injects more movement into the scene, replacing the essentially static and conservative composition with a lively interplay of rhythmic arcs and diagonals. It is possible that the device of the two raised arms framing the head of the saint was borrowed from an engraving of *St. Sebastian* by Jacopo de'Barbari, who had worked at the court of Margaret of Austria (figure 25). The archer at the left shares the sinuous form of Barbari's *Apollo* as well.[31] Hemessen's analysis of the male nude in motion also

reflects Florentine graphic concerns. One wonders whether he had not seen an impression of Antonio del Pollaiuolo's *Battle of Ten Nude Men* and, like Dürer, been struck by the wiry musculature and twisting postures.

The outer wings of the O'Campo triptych—representing Peter and Stephen (figure 26)—are painted in a restrained miniaturist style quite unlike the inside panels. Though the wistful expressions and graceful poses relate to Hemessen's lyricism, the reticent approach towards anatomy is clearly very different. Fashioned from smooth, starched cloth, the drapery hardly reflects the forms underneath. A talented artist in his own right, Hemessen's collaborator on the wings of the *St. Sebastian* triptych was connected with his workshop for several years during the 1530s. His diminutive background scenes complement the bold scale of Hemessen's large figures. A later chapter examines this interesting association of contrary artistic temperaments and advances a new identification of the small-figure master.[32]

While large gaps remain in Hemessen's production from the 1520s, the panels that have been grouped together around the *Christ and the Adulteress* establish a convincing framework for assessing his formative years. They indicate that Jan trained in a courtly environment that placed strong emphasis on a refined style of painting. His association with the Master of the Life of the Magdalen can be gathered from numerous Morellian similarities. Hemessen's response to High Renaissance innovations is counterbalanced by a sensitive assimilation of lyrical and emotional values of Netherlandish and German art. Experimenting with varied combinations of imagery to suit his subjects, he finds distinctive solutions that set him apart from Romanist idioms cultivated by Gossaert and Orley. A growing penchant for monumentality and expressive realism towards the close of the decade signals creative directions he is to pursue during the 1530s.

3

Hemessen and St. Jerome

Like many Northern Renaissance artists, Hemessen especially revered the early church father St. Jerome. He painted numerous representations of the saint during the course of his career. Jerome was the humanist saint par excellence. His monumental translation of the Bible from Greek and Hebrew into Latin (the Vulgate) was a model for humanist theologians, as were his numerous biblical commentaries and exegeses. Jerome's command of classical languages and learning made him particularly attractive to Renaissance scholars, who admired his elegant style of writing and success at placing classical learning at the service of Christianity. One of his most influential advocates, the Dutch humanist Desiderius Erasmus, compiled the first collected edition of St. Jerome's writings in nine volumes, prefaced by a reverential life of the saint.[1]

In addition to his scholarly role, Jerome was a paradigm of the rigors of penance. The great ascetic had spent several years in seclusion in the desert, where he practised a strict regime of prayer and self-mortification, albeit accompanied by a sizeable private library. The saint was so moved during the course of his penitential discipline that he repeatedly struck his chest with a stone. As Jerome wrote in one of his letters, "I call to mind how oftentimes, when calling and praying to Heaven, I joined day with night, and did not cease to strike my breast until, by command of the Lord, my soul would be calmed."[2] The spiritual exercises he practised at this time were to inspire a host of Christian penitents to "beat their breasts" in their struggle for redemption.

Two major themes dominated the iconography of St. Jerome in the Renaissance: the image of the cardinal-scholar tucked away in his study, hard at work on his writings, and the wilderness scene of the saint striking his chest with a rock in atonement for his sins.[3] Usually the saint is pictured as an old man nearing death. He is frequently shown with a skull and hourglass — traditional emblems of mortality. Sometimes a vision of the Last Judgment appears nearby. Hemessen painted several versions of each

of the two major iconographical types. His representations of St. Jerome chart an interesting evolution that expresses deep personal identification with the church father.

Hemessen's first known interpretation of the saint is his *St. Jerome Penitent* from 1531 (figure 27), a large, impressive panel at Lisbon that was admired by Orlandi and Guarienti in their eighteenth-century *Abecedario Pittorico* for its "buon disegno e vago colorito."[4] A spiritual athlete of heroic proportions, Jerome is shown kneeling at the entrance to his hermit's retreat. One hand clutches the stone of penance while the other fingers a bleached, jawless skull. The powerfully muscular nude is illumined by a bold lighting from the upper right, making him project dramatically from the murky crevices and recesses of the cave. The daring pose derives from a famous work from antiquity: the central figure of the *Laocoön* group sculpture, discovered at Rome only a quarter-century before.[5] If Hemessen had not seen the *Laocoön* in person (though the profound influence of the ancient sculpture on his *oeuvre* suggests that he had done so), he could have known it through prints by Marco Dente (figure 28).[6] One of Dente's versions (B.XIV.194.243) interprets the figure of the doomed Trojan priest in a way similar to the Jerome, with a lighter, more graceful formal rhythm than the sculpture. Michelangelo was another essential Romanist model. The youthful proportions and muscularity of Hemessen's nude are reminiscent of Michelangelo's *David*, and the taut modelling of the chest and bony neck derive from the chiselled male nudes of the *Battle of Cascina* cartoon, transmitted to the North by the prints of Marcantonio Raimondi (figure 29). The verism of the emaciated chest and swollen veins of the St. Jerome also suggest acquaintance with the work of Michelangelo's youthful rival Torrigiano and can be compared with the latter's expressive sculpture of the *Penitent St. Jerome* at Seville. Torrigiano worked at the court of Margaret of Austria in 1509–10 and, like Jacopo de'Barbari, may have left models and drawings behind.[7] Hemessen's anatomical interests may imply that he practised dissection as part of his artistic training, similar to Italian Renaissance artists, though this practice was limited in the North due to religious restrictions.[8]

The monumental format of the Lisbon *St. Jerome* marks a new departure in Netherlandish painting, which had hitherto represented the penitent saint on a much less heroic scale. Bosch and Patinir preferred to stress the saint's frailty in his agonizing quest for redemption.[9] A more athletic rendering of the saint can be seen in Gossaert's sensitive *grisaille* panels now at the National Gallery in Washington, though the figure lacks the statuesque quality of the artist's pagan gods.[10] Closer to Hemessen's approach is a panel by Memling now at Basle (figure 30), in which Jerome is shown at close range posed against a massive stone outcropping, his cardinal's robe

spread out on the ground beside him. Like Memling, Hemessen accentuates the expressive features of the saint, and his figure is similarly anguished and tormented. The rocks in the Lisbon panel are even more crudely chiselled to form sharp ridges and tight, erratic fissures that counterpoint the penitent's emotional dilemma. Hemessen's lion looks inscrutably fearsome, unlike the gentle beast of the Basle panel. Dürer's formidable protector in the 1514 engraving of *St. Jerome in the Study* has clearly intervened.

The variety of flowering plants in the Memling have been replaced by a single large clump of rather poisonous looking dark green foliage in the lower left-hand corner. The plant can be identified as a *Geranium Robertianum*, called in English Crane's-Bill, or, in German, "Storchschnabel," from the pairs of curved, elongated seed-pods that jut out next to the tiny blossoms. As Behling observes, according to Hildegard of Bingen (twelfth century) and the *Gart der Gesundheit* (Mainz, 1485), the herb is a cure for sadness. In the Hemessen it thus evokes penance and the longed-for reward of grace.[11] The slender conical projections symbolize temptation as well, for the Devil was traditionally associated with horns.

The bold pose of the Lisbon St. Jerome is far removed from the figures of Hemessen's Netherlandish predecessors. Jan employs strong diagonals and a harsh chiaroscuro to build up a powerful sense of drama. The saint's torso is wrenched sideways in a slung contrapposto, and the rugged chest bulges out audaciously to receive the blow. The hand holding the stone extends far back, too far, in fact, to be realistic, for it is a gesture more suitable for throwing than breast-beating. Hemessen's oblong composition may well have been drawn from North Italian prototypes like Savoldo's *Penitent St. Jerome* (figure 31), a work that contains a comparable diagonal thrust, sidelong gesture and device of resting one elbow on a shelf hewn from solid rock.[12]

Hemessen injects a new militancy and immediacy into the iconography of the penitent saint. It is tempting to relate his interpretation to the debate over penance that seriously divided Protestant and Catholic theologians. Martin Luther, in his rejection of the necessity of confession and de-emphasis of the role of guilt and the examination of conscience, had struck a direct blow against the Catholic doctrine of Penance. As Thomas Tentler rightly points out in his exhaustive study of confession at the close of the Middle Ages, Luther redefined contrition to place chief reliance on faith and forgiveness rather than on disciplinary acts of confession and self-mortification:

> Only the recognition that one can do nothing on one's own is a part of contrition that might be described as a work of the penitent. Certainly there is no room for discussions of the quality, intensity, or perfection of the penitent's sorrow. The contrite man need

do only one thing: believe the promise of forgiveness, for that belief constitutes forgive-
ness itself.[13]

For Luther, "fear and anguish of conscience" tended to divert fallen man
from the Sacrament of the Altar by causing him to become unduly
obsessed with his sins. A firm belief in the promise of forgiveness became
the Protestant imperative, not the severe duty of penance.[14]

The Counter-Reformation responded with a renewed affirmation of
penitential regimen as a fundamental part of the path to salvation. Ignatius
Loyola began his *Spiritual Exercises* with a full week of austere
meditations upon sin and damnation designed to arouse sorrow and
contrition. The *Exercises* were largely composed during Loyola's own
harsh years of penance in 1522–23 in a cave at Manresa in Spain, not far
from the famous Benedictine monastery of Montserrat. Loyola had been
greatly inspired by the courageous acts of renunciation practised by the
desert fathers, whom he regarded as true "knights of the Cross."[15] The
Ignatian spirit is expressed by an account of these years from the Jesuit's
memoirs:

> So he [Loyola] determined to perform great penances, not so much now with a view to
> making satisfaction for his sins, as to please God...Accordingly, when he resolved to
> do some penance that the saints had done, he would carry it out as fully as they, or even
> more fully...All his idea was to perform those greater exterior works because the saints
> had so done in order to glorify God.[16]

For the Counter-Reformation church, penance was a formidable wea-
pon against the author of evil, the Devil. A late sixteenth-century biogra-
phy of St. Jerome written by Fra José de Sigüenza, spiritual adviser to
Philip II of Spain, stresses the militant nature of the saint's feats of prayer
and penance, which were, in effect, inspiring victories over the Adversary.
Sigüenza views Jerome's breast-beating not simply as an act of atonement,
but a direct assault on the seat of temptation: "As Jerome says in Epistle 9,
the breast is root and spring of all our evil thoughts, and there is the
seat of the heart whence we are conceived, accordingly as our Lord teaches
us, the evils which render us abhorrent in his presence."[17] Penitential aus-
terities were thus an essential weapon in the ongoing combat with Satan:

> With the pains of his bodily wounds he [Jerome] startled away the softness and delight
> of the evil thought, which rising from the sensitive part of the rational, was like a bad
> serpent struck on the head by the stone, and fell to the ground.[18]

For the Counter-Reformation theologian, the church father was a warrior
for God, and his red cardinal's hat (*pileus*) signified "by it that should it be

necessary to lay down life and limb and shed blood for the church, by fighting for her, the office held by the cardinal would compel him to do so."[19]

Hemessen's 1531 panel anticipates this agressive Counter-Reformation stance towards penance in striking visual terms. Ruggedly energetic, the saint flagellates himself with combative ardor, as if prepared to hurl the stone at an unseen foe lurking in his chest. Concealed references to the satanic Adversary are to be recognized not only in the symbolic "horned" *Storchschnabel* plant, but also in numerous writhing, snake-like forms visible in the drapery folds, lion's tail and even the cords of the cardinal's hat. The *Laocoön* quotation assumes deeper significance in light of these recurrent motives. One wonders whether Hemessen may not have associated the snakes fatally encircling the Trojan priest with the forces of evil surrounding the Christian aspirant. The tragic message of the Hellenistic sculpture must have elicited a heartfelt response in the young artist.

The Lisbon panel provides an important visual document of militant Counter-Reformation piety at the beginning of the fourth decade of the century, some years before a broad movement of artists concerned with such preoccupations can be discerned. Is it possible that Hemessen came into contact with Loyola or his colleagues at this early stage? A meeting is not inconceivable, since Loyola is recorded to have visited the Lowlands on several occasions during his summer breaks when he was a student at Paris from 1528 through 1532. On these occasions he was able to secure valuable financial support for his crusade among the Spanish mercantile community at Antwerp. He impressed the Spanish humanist Juan Luis Vives at Bruges in 1528 with his learning and deep convictions. Penance was a recurring theme of Loyola's discussions: witness the account of his dinner with Vives at Bruges, recorded by his secretary Juan Polanco.

> I must not omit to mention that when Ignatius was in Bruges he was invited to dinner by Luis Vives. Others were also present on the occasion, and it being Lent, the conversation came round to the subject of Lenten fare. Luis appeared to think that it was not much of a mortification because the foods permitted could be quite tasty and appetizing, especially if spices were used in their preparation as is commonly done in Flanders. Ignatius, thinking that such a way of speaking went counter to the Church's traditions, took up Luis Vives with spirit. 'You and others,' he said, 'who can dine sumptuously will not, perhaps, find in this abstinence much help towards the end intended by the Church, but men and women in general, whose interests the Church must primarily consult, are not so nicely fed but that they have in the law of abstinence an opportunity of chastising the body and performing a work of penance.' He came out with many other arguments to the same effect.[20]

If Hemessen encountered Loyola during one of his stays at Antwerp, it would help to explain the bold spirit of the Lisbon panel of 1531, which

parallels the Jesuit's emphasis on performing works of heroic penance. Other aspects of Hemessen's painting to be explored in this study confirm his sympathy with militant Counter-Reformation doctrines championed by the Jesuits. The Lisbon *Jerome* — which has an old provenance in Portugal — may even make specific reference to the Jesuit.[21] The astonishing similarity of the beak-like nose and chiselled brow of Hemessen's saint (figure 32) to Loyola's angular features (figure 33) suggests that the panel is a disguised portrait.[22] This hypothesis is corroborated by the view at the left of a distinctive group of rock formations behind a broad group of buildings nestled in a valley. The setting closely resembles that of the great Benedictine monastery at Montserrat in northern Spain, near which Loyola spent his years of self-chastisement (1522–23) in a secluded mountain cave (figure 34).[23]

Next in importance to Santiago da Compostela as a Spanish pilgrimage shrine, Montserrat derives its name from a peculiar series of pinnacles resembling the jagged teeth of a saw. The monastery, situated at the base of the mountains, is the site of a miraculous image of the Virgin said to have been carved by St. Luke and originally transported to Barcelona by St. Peter. An anonymous sixteenth-century woodcut shows a monk kneeling in prayer before the Madonna and Child, with the monastery and sawtooth peaks of Montserrat in the background (figure 35). The highest pinnacle is the Turó de San Jeronimo, a lofty peak which once boasted eleven solitary hermitages linking a *via sacra* terminating at the summit. The setting was thus traditionally linked to the austerities of St. Jerome and was appropriate iconographically to a depiction of the penitent saint.

Hemessen was to return to the subject of the *Penitent St. Jerome* twelve years later, in a panel from 1543 now at the Hermitage (figure 106). Hunched to the ground, the saint is now considerably more Herculean, with an impressive development of massive calves and thighs, powerful arms and bulging back muscles. Hemessen responds again to Michelangelo's *Battle of Cascina* and the nudes of the Sistine Ceiling, and through Michelangelo to antique prototypes of heroic labor like the *Torso Belvedere*, regarded in the Renaissance as a representation of Hercules resting after his labors. The *Torso* was extremely popular among Northern Romanists. The rippling muscles of the saint's back can be compared with a drawing of the sculpture from the Roman sketchbook of Maerten van Heemskerck (figure 107). Extending the theme of the penitent Christian athlete first stated by Hemessen in the Lisbon panel, the Hermitage Saint Jerome carries the idea to almost absurd dimensions of brutish muscularity, though, as we shall see, it shares a sense of Mannerist ambiguity and paradox with other works by the artist from the 1540s.

In addition to depictions of St. Jerome Penitent, Hemessen also

painted several versions of the aging church father in his study, contemplating the Last Things before a crucifix. A signed and dated panel of this type from 1534 was on the Vienna art market during the twenties but disappeared after it was sold by the Sanct Lukas Galerie in 1929. A photograph made available by the gallery reveals a grim representation of an elderly, leonine saint surrounded by emblems of devotion and death (figure 36). A particularly macabre note is struck by the cavernous skull placed upside-down at the base of the crucifix—a reference both to the skull of Adam at the foot of the cross and to the pitilessly eroding force of time, symbolized by the hourglass nearby. The panel is one of numerous instances of artistic homage by Antwerp painters to Dürer's touching depiction of the elderly saint done in 1521 on his trip to the Lowlands (Lisbon).[24] Dürer's work remained at Antwerp in the possession of the Portuguese chargé d'affaires, Rodrigo Fernandez d'Almada, until 1548, when it was sent southwards. Considering the large number of copies and variants produced by the Antwerp school, it can be gathered that Fernandez d'Almada encouraged this sort of traffic, and may even have profited from it.

Unlike other artists such as Joos van Cleve, who copied the pose of Dürer's saint pointing at the skull literally (Cambridge, Busch-Reisinger Museum), Hemessen changed the emphasis to a heartfelt, prayerful contemplation of the crucifix. Pressed close to the saint's head, the stark wooden cross with its emphatically modeled statuette of Christ becomes an ensign of the aged saint's devotions, a forecast of salvation in the face of imminent death. The vision of the Last Judgment appearing in the background adds thematic urgency to the saint's unsettled expression.

Though not terribly appealing, the 1534 Hemessen *St. Jerome* nevertheless found a responsive audience in these unsettled times, since at least two early copies are known. One of these, now at Prague (figure 37), can be assigned to the Brunswick Monogrammist on the basis of its atmospheric landscape background, which is similar to paintings grouped around the artist. The Monogrammist clearly lacks Hemessen's command of modelling. He smooths out masses and concavities and adds shiny highlights—in the process losing the firm definition of Hemessen's original. The face of the saint is particularly inexpressive. It can be compared with a vapid *Portrait of a Girl with a Lute* by the Monogrammist at Berlin (figure 38), sometimes misattributed to Hemessen. Generally identified with Jan van Amstel, the Brunswick Monogrammist admired Hemessen's bold figures but was unable to emulate his plastic sensibility. His small-figure works are far more successful than his attempts to work on a large scale.[25]

Another Hemessen follower, the Master of the Augsburg *Ecce Homo*, copied a second Hemessen *St. Jerome in his Study* from the mid-1530s

(figure 40). The original Hemessen panel was in the collection of Nicholas Rockox at Antwerp in 1640 and can be seen in a cabinet painting of the Rockox Collection by Frans Francken II, now at Munich. The Augsburg Master's copy contains a number of differences from the lost Hemessen, especially in the sharper features of the saint and violent contrapposto characteristic of this highly expressionist Hemessen follower.[26] The composition represents a second variation on the Dürer type, this time provided with a pronounced diagonal thrust which recalls the tensions of Hemessen's 1531 *Penitent St. Jerome.*

Hemessen's search for a fervent characterization of the saint led him to experiment with increasingly proto-Baroque devices: strong projections of form, bold diagonals, impassioned gestures. It is too bad that the original of yet a third variant of the theme of *St. Jerome in his Study* has never surfaced, since it anticipates ideas that were to become popular in the next century. Dating from the late 1530s, it is known through a stiff copy formerly in an Amsterdam private collection (figure 41) and a better but reduced version at Vienna (figure 42). In this case, Hemessen acknowledges a debt to an oblong depiction of Jerome by Quentin Massys (sometimes given to his son Jan) that possibly antedated Dürer's representation (figure 43).[27] Hemessen borrowed the placement of the hands—the left on the skull and the right pressed dramatically to his heart—but he injects a curvilinear flow into the composition and again stresses the cross rather than the book. The still-life motives on the desk in the foreground (visible in the Amsterdam copy) contain further allusions to death and temporality. The rhythmic, flowing pose of the saint looks especially modern when compared to the angular, spidery depictions of the saint by Marinus van Roymerswaele, who also specialized in painting this popular subject.

At this point, consideration should be given to another much-copied representation of *St. Jerome in his Study* from Antwerp which, while not by Hemessen's hand, reflects his dramatic concerns. The best example from this group—and possibly the original—is now at the Norton Gallery and School of Art at Palm Beach (Fig. 44). Dated 1530 in a cartouche at the top, the panel and the related variants have usually been assigned to the Antwerp workshop of Joos van Cleve.[28] There are, indeed, remarkable similarities to Joos' work in the sensitive depiction of objects and warm colorism. Yet the energetic barechested saint is painted in a powerfully chiselled style that is not at all like van Cleve, but closer to Hemessen. The figure can be compared with the *Penitent St. Jerome* of 1531 in the prominent neck and breastbone as well as the tight, wiry arms. Though not by Hemessen, it was certainly done by an artist familiar with his Romanist male nudes.

The Norton *St. Jerome* can best be understood as a collaboration

between Joos van Cleve, working on the setting, and a Hemessen follower, working on the figure of the saint. A collaboration would tend to explain the curious iconographical fusion of the penitent St. Jerome with the theme of the saint in his study. The most attractive candidate for van Cleve's collaborator would be the Brunswick Monogrammist, who has often been identified with Jan van Amstel. The distinctive treatment of the half-open mouth, flattened ear and heavy-lidded eyes can be compared with the copy of Hemessen's 1534 *St. Jerome* at Prague (figure 37), firmly attributed to the Monogrammist on the basis of the distinctive landscape. The abrupt modelling of the features and summary definition of the body also comes close to the Mainz *Lamentation* (figure 23), a copy after a lost Hemessen from ca. 1530 that is also very likely by the Monogrammist.[29] The Norton panel is of interest not simply as a pastiche of style and iconography, but also because it displays at once two contemporary trends in Antwerp painting: the refined colorism of Joos van Cleve and rugged naturalism of Hemessen and his followers. It is understandable that its copyists were unable to cope with the "split-personality" of the collaboration and gloss over the opposing manners with slick brushwork.[30]

Hemessen went on to do several other paintings of St. Jerome in the 1540s and 1550s which will be discussed in relation to his later artistic development (figures 115, 126, 151). They continue to display heartfelt identification with the church father and his penitential agonies. The most impressive of these later works is a 1548 panel in a private collection at Barcelona (figure 116), which anticipates Ribera and other Spanish Baroque interpretations of the saint in its dramatic movement, eloquent gesture and visionary lighting. It is likely that this fervent representation of the conscience-smitten saint, which has a Spanish provenance, was done for a Spanish house of the Hieronymite order, which flourished under the protection of the Emperor Charles V, who emulated the great eremite at the close of his career, abdicating his throne for reclusive penance at the Hieronymite monastery at Yuste in Extremadura.[31]

4

The Balcarres *Double-Portrait of a Husband and Wife Playing Tables*

One of Hemessen's most fascinating works from the early 1530s is a *Portrait of a Husband and Wife Playing Tables* (figure 45), now in the collection of the Earl of Crawford and Balcarres at Balcarres, Fife, Scotland. A sizable painting measuring 1.11 × 1.28m, the panel is signed and dated on the edge of the table at lower right, "IOHANNE(S) SANDERS/DE HEME(SSE)N PINGEBAT 1532."[1] A prosperous looking man and woman are seated playing a game of tables (the early form of backgammon), accompanied by their pet parrot.[2] A half-filled beaker of wine stands near the woman's raised hand. On the husband's side, there is a large platter of fruit and nuts and an apple with a quarter-segment cut out. Both players point towards the board, as if engaged in a friendly dispute over the last throw of the dice. The buxom wife has a merry twinkle in her eyes, while her equally hefty spouse appears somewhat more serious. The outcome of the game is left up to the viewer's imagination.

The gaming situation provides an occasion for psychological interaction that adds life to what might otherwise have been a rather solemn work. One need only compare the staid Memling *Double-Portrait of a Man and Wife* of ca. 1480 recently reconstructed by Lorne Campbell to appreciate the warmth and vitality of the Hemessen.[3] Jan enhances the naturalistic appeal of his presentation by making the forward edge of the table align with the bottom of the panel, so that the wooden platter of fruit and corner of the game-board project out illusionistically towards the viewer. It is possible that he knew of an earlier half-length double-portrait that was probably done at Antwerp: the fine *Portrait of the Artist and his Wife* of 1496 by the Master of Frankfurt (Antwerp, Museum), which anticipates the illusionistic still life. Hemessen's use of a genre situation develops an innovative sixteenth-century approach to portraiture that parallels Marten van Heemskerck's even more informal outdoors *Family Portrait* around a

luncheon table, from about the same date (Kassel, Staatliche Kunstsamm-lungen).[4]

Though the Balcarres panel is, as far as I know, the earliest double-portrait on panel of a man and woman playing a board game, it is ante-dated by a sizable number of manuscript illuminations of gaming figures, some of which can be identified as particular individuals. These include an amusing French illumination of ca. 1504 attributed to Robinet Testard from the *Livre des Echecs Amoureux* (Paris, B.N. Fr. 143) showing Marguerite d'Angoulême and her younger brother François (the future French king) playing chess.[5] A popular pastime among the nobility in the Middle Ages and Renaissance, board games were appropriate activities for such gilded youth, since they combined a mood of leisurely well-being with charming allusions to courtly romance. H. J. R. Murray quotes an apropos passage from *Les Enfances Vivien* (ca. 1200): "Do you know what I should do, if I were you? I would build a castle with a great hall, where I could play chess and tables all day long!"[6]

Games, to be sure, also frequently lead to quarrels, and thus could refer to amorous frictions arising in the "game of love." Lilian Randall illustrates two such disputes between men and women in vignettes from the margins of Gothic manuscripts. In a Picard (?) Psalter *bas de page* (Paris, B.N. MS Latin 10435, fol. 61) Jehan de Lens and a lady gesture demon-stratively towards a chess board, as if quarreling. Another vignette in a mid-fourteenth century *Romance of Alexander* (Oxford, Bodleian MS Bodley 264, fol. 112) depicts both players pointing with their index fingers, like the husband and wife of the Balcarres panel. Each raises the other hand argumentatively.[7] The ability to play a board game *without* getting into a fight was, in fact, deemed a sign of gracious courtly love in the pop-ular French Gothic romance, the *Roman de la Manekine* (1277).

> Des eskès savoit et des tables,
> D'assés d'autres jeus delitables,
> Dont ele se jouoit au roy
> Sans felonnie et sans desroi.[8]

Thus the Balcarres *Double-Portrait of a Husband and Wife Playing Tables* harks back to both a visual and a verbal tradition of courtly contest between the sexes. Hemessen was undoubtedly familiar with manuscript illuminations of this type. If the couple depicted in the Balcarres panel are indeed Antwerp burghers, as seems very likely, then the choice of subject can be viewed as a reflection of the social aspirations of an upwardly mobile urban middle class. The affluent man and wife were undoubtedly flattered to be portrayed in a mode of frivolous leisure behavior widely

associated with the nobility. The courtly implication of romantic strife is counterbalanced by a comfortable atmosphere of bourgeois domesticity. The wife rests her hand gently on her spouse's shoulder, expressing, as does her trusting glance, their underlying *concordia*. Whatever momentary quarrel they may have over the throw of the dice is swiftly assuaged by marital trust and fidelity. The game can, therefore, be interpreted as an emblem of *discordia concors*, a favorite Neoplatonic notion which construed harmony as an ultimate union of opposites. Here again, Hemessen was acknowledging a debt to the Italian Renaissance.[9]

It is very possible that there was a lost North Italian gaming portrait that the young Netherlander could have seen on his travels. This is suggested by two gaming pieces by Cremonese painters from the second half of the sixteenth century. One example, by an anonymous painter (Venice, Cini Collection), shows a man and woman disputing over a game of tables, similar to the Balcarres panel, though the Cremonese artist has the man argue rhetorically by counting on his fingers, like Dürer's young *Christ Among the Doctors*. The man is clearly no match for his stubborn partner, who places both hands firmly on the board and stares at him with stern amusement.[10] If the lady is a courtesan, as her extravagant costume suggests, they may be debating her price and not just the outcome of the game.

Even livelier is a picture by Sofonisba Anguissola of her sisters playing chess (Poznan), a work that attracted Vasari's praise: "such is the diligence and readiness of execution that they actually look alive and only lack speech."[11] The older girl looks triumphantly out at the viewer as she checkmates her sister, who throws her hand up in a natural expression of dismay. The youngest sister grins in mockery while their solicitous old nursemaid observes the episode. In both of the Cremonese gaming portraits love again rules the moment of discord, whether it is the amorous infatuation of an older man for his attractive sweetheart, or teasing affection among sisters.

Whatever may be the relationship of the Antwerp double-portrait to the later Cremonese works, it is obvious that Hemessen's approach to the gaming theme is restrained and somewhat severe in contrast to the informality of the Italian paintings. Considering Hemessen's religious orientation, one might wonder whether there is not a concealed moral message in this ostensibly innocuous scene. H. J. R. Murray points out that dice games were frequently associated with fraud and deceit: as games of chance, they fell under the aegis of "two-faced" Fortune.[12] Medieval town statutes generally forbade games of pure chance. Exceptions were made for board games like chess and tables in which skill was involved.[13] In ecclesiastic circles a moral stigma remained attached to tables, a game that was

often played for stakes at taverns.[14] By the close of the fifteenth century, however, most town regulations in Italy, France, Spain and the Lowlands exempted tables from censure providing the stakes were small.

There is evidence that board games were construed as a type of "psychomachia" in the late Middle Ages, demonstrating moral oppositions between Virtues and Vices confronting the players. A fourteenth-century marginal illustration in a German manuscript shows a tables player accompanied by Justice (*Recht*), Greed (*Begierde*) and Anger (*Zorn*).[15] The *Guldin Spil* by the Dominican Meister Ingold, written in 1432–33, interprets "bretspil" as an illustration of the conflict between Gluttony and Temperance. In the same work, chess was associated with Pride and Humility, and "würfelspiel" (dice-throwing) with Avarice and Charity.[16] In the Balcarres panel, the sin of Gluttony is alluded to by the fruit platter, half-emptied beaker of wine, and also by the parrot, a bird that was thought to grow more garrulous if it drank wine![17] Virtue is implied by the rosary beads attached to the wife's girdle.

In addition, the five and six rolled on the dice convey definite numerical symbolism. According to a thirteenth-century German poet who wrote about the subject, Reinmar van Zweter, five pips on the die stand for the five senses, while six symbolize the Lenten Fast.[18] Games were, of course, typical carnival pastimes, to be renounced during the austerities of Lent. The sum of the dice is eleven, a figure evoking sin and penance. Agrippa von Nettesheim, for instance, interprets eleven as the number of sinners and penitents because it "transgresses" ten, "the number of the law and of precepts," and is less than twelve, which refers to "grace and perfection."[19] The same numbers appear again on the dice held by a gambler in Hemessen's *Parable of the Prodigal Son* (figure 46, Brussels, Museum) of 1536, to be discussed in the next chapter. Rather than just a conversation piece, the Balcarres double-portrait should thus be interpreted as an imaginative example of moralized portraiture, expressing an awareness of Psychomachia and penitence, two deepfelt concerns of the artist's work. The board game ironically alerts the couple to the perils of worldly pleasures and acts as an impetus to their reform.[20] The hope of redemption is signalled by the trefoil emblem decorating the back of the wife's chair, as well as by the prominent cross braces of the window behind the man. The parrot was also frequently a symbol of the virgin birth of Christ, and fruits could refer to the "fruits of paradise."[21] Grapes were typical eucharistic symbols of the Passion.[22]

Hans Holbein the Younger was of particular importance for Hemessen's feeling for solid, dignified forms in the Balcarres panel. Jan possibly came into contact with the distinguished portrait painter when he passed through Antwerp in 1528 and 1532, on his trips between England and

Basle. Though the petite hands and anachronistic dipped perspective of the table of the *Portraits of a Young Princess* from the 1520s remain, the artist's sense of realism has matured considerably, especially in the modelling of features and depiction of still life. The Balcarres double-portrait sets the stage for the elaborate interior scenes of the later 1530s with their numerous portrait-like heads and variety of still-life details. When he returns to portraiture, as in the donor wings of the Antwerp *Last Judgment* triptych of ca. 1536–37 (figures 72–73), he incorporates a broader and less finicky brushstroke, sacrificing the tight, detailed modelling of his earlier works to a greater emphasis on atmospheric effects. Though the Flemish love of solid material remains, it is tempered with a more Italianate reliance on soft transitions of light and shade, probably reflecting a trip to Fontainebleau during the intervening years.

5

Innovative Years (1536–40): The Prodigal Son and Temptations of the Tavern

During the second half of the 1530s, Hemessen developed a type of panel painting most often associated with his name today: oblong compositions of men and women depicted carousing in a tavern. The revellers are portrayed in half length grouped around a table, with subsidiary small-figure scenes shown in the background. The realistic costumes and still-life details of these colorful works allow us a glimpse into the earthy subculture of sixteenth-century Antwerp. Filled with typical denizens of a port-of-call, Antwerp had the usual share of lowlife characters as well as an abundant supply of travelling merchants and mariners with money in their purses. Hemessen's tavern scenes represent a moral critique of the sensual, dissipated lifestyle of a cosmopolitan and tolerant Northern Renaissance urban center. Anticipating kitchen and market pieces painted by Aertsen and Beuckelaer in the 1550s and 1560s, they mark the beginning of a long tradition of festive genre scenes in Dutch and Flemish painting.[1]

The earliest work of this type by the artist is a remarkable depiction of the *Prodigal Son at the Inn*, which includes other scenes from the biblical parable in the background (figures 46–50, Brussels). Dated 1536, this is one of Hemessen's most innovative compositions and a pivotal work in his maturation. He introduces several types that are to continue to preoccupy his imagination: sultry young prostitutes, a leering old bawd (figure 49) and grimacing, balding *débauché* lost in his cups (figure 50). The basic grouping of genre figures seated around a table was inspired by gaming and feasting scenes by Lucas van Leyden, though Hemessen's work is at once more complex and more realistic than those of Lucas. He may well have known of the North Netherlander's print of the *Prodigal Son at the Inn* (figure 51), which contains a similar motif of a wily prostitute embracing the young dandy while surreptitiously snatching his purse. Like the youth in the print, Hemessen's Prodigal Son wears a fashionable jacket

with cut and slashed sleeves, an extravagant type of outfit that was frequently rebuked by sumptuary statutes in Northern European cities. His bulging striped cod-piece stands noticeably erect, attesting to his arousal, and he nervously tips his pitcher of drink so that it looks about to spill its contents into our space. This illusionistic gesture is countered by the poised bare arm of the prostitute steadily balancing a glass beaker of wine in mid-air.

There is something about the woman's gesture that is reminiscent of the marvelous motif of the glass pitcher of wine held aloft by a reveller in Titian's *Bacchanal of the Andrians* (figure 52), painted for the Studio of Alfonso d'Este at the Castle at Ferrara in 1518–19. The tilt of heads and rhythms of upraised arms of the prostitutes further recall the *Bacchanal*. The silenus greedily quaffing his drink in the Titian conceivably inspired Hemessen's drunkard, who gazes sottishly at the dregs of his pitcher of brew. That a pagan bacchanal should have inspired a moralizing Flemish tavern scene underscores the daring liberties of Hemessen's eclecticism. There are other Italianate borrowings as well. The elegant Renaissance loggia adorned with classicizing ornamentation is in line with standard Romanist taste as found in Gossaert, Orley and Coecke van Aelst.[2] The startled cat harks back to *all'antica trompe-l'oeil* such as Giulio Romano's *Madonna della Gatta* (Naples, Museo Nazionale), though there is also a Flemish antecedent in the exotic *Adoration of the Kings* commissioned for Philip de Nevers ca. 1522 from an anonymous South Netherlandish artist.[3] Perhaps the most extraordinary Romanist borrowing in the Brussels panel is the old bawd with the plunging neckline who mimics the seated posture of Michelangelo's *Erythraean Sibyl* (figure 53)!

Hemessen's 1536 panel is the first known instance in Netherlandish painting of the *Prodigal Son at the Inn,* with one minor exception.[4] As Konrad Renger has observed in his interesting study of the "Lockere Gesellschaft," the brothel scene was given increased attention in sixteenth-century plays dealing with the subject of the Parable. This development may well have contributed to realistic portrayals of the scene in painting.[5] It should be noted, however, that the representation of the wastrel's "riotous living" (Luke 15:13, "vivendo luxuriose") occurs already in Gothic stained glass windows devoted to the parable at Bourges and Sens, as well as in sculptures of the central portal of the Cathedral of Auxerre. A Brussels tapestry of ca. 1485 (J.B. Speed Museum, Louisville) presents the brothel episode as the culmination of the first half of the youth's adventures.[6] The Prodigal is shown fondling a pretty young figure of Luxuria, while behind them a man named Amor Sui (Self-Love) beckons towards a bed in an alcove. Above, the harlots converge on the foolish youth to relieve him of his patrimony.

As Philippe Verdier observes in his extensive study of Prodigal Son iconography, the injection of spicy realism in the tavern scene was initially due to the popular *Jeu* of *Courtois d'Arras*, written in the early thirteenth century in Picard dialect and often attributed to Jean Bodel.[7] Fifteenth-century moralities dealing with the theme, such as *Bien avisé, mal avisé* (ca. 1430) and *L'Homme juste et l'homme mondain* by Bougoin, tend to be highly abstract and allegorical.[8] Towards the end of the century, vulgar aspects of the brothel scene receive renewed attention in drama, a trend undoubtedly inspired by the revival of antique Latin comedies by Plautus and Terence with their numerous low-minded characters. Of particular importance for this development was the Italian *Del Figliuol Prodigo* by Castellano Castellani, printed at the beginning of the sixteenth century, but written somewhat earlier.[9] Northern playwrights enlarged upon the brothel scene in later treatments of the Parable, adding colorful secondary characters to enhance the narration.

One of the best known Netherlandish morality dramas, the popular *Acolastus, or Comedy of the Prodigal Son* by William Gnapheus, was first published at Antwerp in 1529 and subsequently used throughout the century as a primer for students of Latin.[10] In *Acolastus,* the personalities of the prostitutes are considerably developed, as are other subsidiary characters who fill in the biblical story, such as the panderers Pamphagus and Pantobalus. This evil pair flatter the wastrel's ego and act as go-betweens for the harlots.[11] In Hemessen's Brussels panel, the two men seated at the table with the Prodigal Son serve the functions of the parasites in the drama. The gambler holding the dice recalls the figure of Pamphagus, who at the beginning of Act IV declares that he will slim his victim's purse with loaded dice.[12] The name "Pamphagus" means "omnivorous" or "a famished glutton" — characteristics conveyed by the drunkard who looks longingly at the last drop of his beer. The figure of Pantolabus (meaning "catch-all") is suggested by the turbaned man who ushers in a musician at the left. The mulish old barmaid grinning lecherously at the Prodigal's seduction is probably meant to be a procuress. A similar coif is worn by the bawd in a School of Fontainebleau painting of a *Procuress* in the Collection of Count Chandon de Briailles.[13]

The distinctive worldly characters in Hemessen's *Prodigal Son* are meant to symbolize various Deadly Sins that tempt the youth and lead him to waste his patrimony in foolish dissipation. As Verdier puts it, "The pilgrimage 'abroad into a far country' of the Prodigal represents the long journey of Mankind far from God; the riotous living of the Prodigal connotes the wasting in vice and sinful conduct of the riches belonging to the human soul."[14] The tavern was a traditional haunt for the vices in medieval pilgrimage literature like the early thirteenth-century *Songe d'Enfer* of

Raoul de Houdenc.[15] It served to divert the *viator* from his journey to the City of God, often fatally. In the Louisville tapestry, Mundus and the Seven Deadly Sins dog the Prodigal Son throughout his worldly adventures.[16] Dropping the old-fashioned labels attached to the Vices in the tapestry, Hemessen employs realistic devices such as situation, gesture, facial expression and costume to help the viewer identify his personifications. The young prostitutes stand for Lust and dissipation, vices also denoted by the seedy bagpiper.[17] Gluttony—a Deadly Sin which subsumed overindulgence in drink as well as food—is characterized by the red-faced drunkard and the assortments of foodstuffs on the table. The gambler obviously stands for Avarice. Pride, the Deadly Sin that has led the Son astray from the very beginning, is denoted by the youth's extravagant attire.[18]

The old *vrouw* leering at the lovemakers symbolizes Envy, a sin that was frequently represented in illuminated manuscripts by an ugly old woman looking out of the corner of her eyes at a couple conversing or embracing, muttering to herself (figure 54).[19] In the Hemessen, her jealousy is offset by her glee at the youth's seduction, since she will undoubtedly share in the profits. The bawd is meant to evoke Luxuria and Gula as well, in degraded forms that counterpoint the attractive young prostitutes. Commingling various sins of the tavern, she definitely merits the compositional importance given her by the artist. Her repulsive, mask-like features anticipate the Ira, or Wrath, directed at the Prodigal Son when he is finally evicted from the tavern in the background.

All of the Seven Deadly Sins are present in the panel, with the sole exception of Acedia (Sloth). But is the last not expressed by the youth's groggy expression, betraying his indolent and weak nature? Hemessen's personifications of vice update the iconography of the Deadly Sins, making it relevant to a cosmopolitan Renaissance urban milieu. The development of increasingly realistic genre approaches to allegories of the Vices had been going on for some time.[20] Earthy humor was a natural device used to satirize foolish pursuits of fallen mankind. D. W. Robertson's studies of Chaucer have underscored the sense of humor implicit in late medieval attitudes towards morality.[21] Hemessen's concern with humanizing the vices follows in the footsteps of Bosch's *Table of the Seven Deadly Sins* (Madrid, Prado), in which each of the vices is characterized by a laughable genre situation, and paves the way for Bruegel's boisterous peasants.

Both facial expression and gesture play essential roles in defining character in the *Prodigal Son at the Inn*. Renaissance artistic investigations of realms of feeling and the emotions were stimulated by Pliny's description of the Theban painter Aristides, famed in antiquity for his expressive figures: "He was the first of all painters who depicted the mind (*animum*) and

expressed the feelings (*sensus*) of a human being, what the Greeks term *ethē,* and also the emotions (*perturbationes*)."[22] Moshe Barasch has noted the tendency of Italian theorists of the fifteenth and sixteenth centuries to equate transient emotions (what Alberti called "*affetti*") with underlying personal character.[23] Giotto was universally regarded as a pioneer investigator of expression in the modern era.[24] Leonardo da Vinci's explorations of gesture and movements in his *Treatise on Painting* and works such as the *Last Supper* stimulated artistic interest in what would be called today "body-language."[25] His observations of facial expression and grotesque heads also paved the way for the interest of sixteenth-century artists and art theorists in this fertile area.[26]

As Barasch has pointed out in his perceptive study of expression in Renaissance art theory, the revival of the pseudo-science of physiognomy made an important contribution to the increasing emphasis on the face as a means of transmitting emotions and character.[27] The first treatment of the subject in a Renaissance art treatise occurs in Pomponius Gauricus' *De Sculptura* of 1504, an influential work that was avidly studied by Northern Romanists.[28] Though very little research has been done so far on the impact of physiognomic theory on sixteenth-century artists, one can safely assume that Hemessen was affected by such ideas, considering the attention paid to individual characterization in his paintings. The beings gathered together with the Prodigal Son in the tavern display a striking assortment of physical types and facial expressions pregnant with associations for those initiated in physiognomic lore. The attention paid to the forehead alone reveals Hemessen's concern, for this part of the head received special emphasis in treatises on the subject.[29] The prominent round bump on the forehead of the young prostitute at the left would signify, according to Gauricus, her lack of true feeling ("Gibbosa insensatum"), while the furrowed brow of the old bawd suggests treachery and cunning ("Aspera que quasi fossas habeat, infidum, calidum").[30] The flat forehead of the wastrel accords with the dulled stupor of his expression ("plana secordiae").[31]

Of greater interest for modern psychology than these phrenological references was Hemessen's perceptive depiction of emotions distorted by drunkenness, lust and greed. The malicious glee of the madam at the rich youth's downfall is brilliantly expressed. Physiognomic writers frequently noted debased varieties of laughter that distorted the features in an unnatural comic mask.[32] According to Gauricus, those who uncover their canine teeth when they laugh are "bad-mannered, foul-mouthed, brutal, insulting and shrewish."[33] An amusing French *Treatise on Laughter* (1560) by Laurent Joubert warns the young ladies of the court to avoid "immodest" laughter, which imprints an ugly stamp upon the features:[34]

> When laughter is modest, born of a light occasion, the lips stretch back to a medium opening; when it is dissolute or of long duration the throat opens wide and the lips draw back to an extreme. . . . And because of this, laughter becomes ugly, improper, lascivious, letting go excessively and tiring the muscles, which are then unable to draw up the mouth and put it back in its right position, due to which it remains indecently open.

Indulgence in vulgar laughter over a long period of time was thought to result in the type of harsh wrinkles lining the face of Hemessen's bawd.

> This is also why dissolute and too continued a laughter causes an ugly countenance because of such opening of the mouth, from which come many wrinkles in the face.

Joubert concludes that, "From this argument we are able to understand why young girls are warned not to laugh foolishly, and threatened that they will become old sooner."[35]

In Hemessen, states of mind are not conveyed exclusively by facial expression. Gesture is also an important factor for revealing the person depicted. Hemessen's use of significant gesture and "body-language" becomes more and more important in his work. Seminal High Renaissance investigations of gesture in paintings such as Leonardo's *Last Supper* helped to shape his interest in this area, as did the increasingly sophisticated vocabulary of poses employed in the theater.[36] This is a difficult area to explicate, however, since gestural meanings varied according to regional usage and were shaped by conventions of rhetoric and legal customs that have since fallen into obscurity. Also, the significance of gesture in the visual arts is seriously conditioned by stylistic fashions. Nonetheless, it is possible to adduce meanings by paying attention to the particular narrative context involved. The prostitutes in the Hemessen cajole and tempt the wastrel: their arms encircle him in stealthy, snake-like rhythms that reflect their evil intent. The young woman at the left raises one hand in insincere blandishment while the other tensely fingers his purse in the shadows. The old madam nervously clutches the knob of her chair with obscene intensity. Her other hand covers the top of the glass in a way that implies the youth's erotic entrapment. The Prodigal's fumbling gestures superbly convey his sottish distraction.

The theme of the Parable of the Prodigal Son provided Hemessen with the opportunity to develop his moral-psychological powers of observation. The Parable was particularly suited to his pietistic concerns, since the point of the story is the recognition of the sinful nature of worldly dissipation as a prelude to penitence and eventual forgiveness. A small-figure scene in the background shows the contrite youth reduced to an impoverished swineherd, earnestly praying to God for mercy (figure 47). His redemption is forecast by the festive scene at the right (figure 48),

where he is received back into his father's house. In his *Paraphrases of the New Testament*, the Dutch humanist Erasmus sums up the moral of the Parable: "Now in the natural love of this father for his son behold the goodness of God who is far more clement to sinful man, if only he repent and despise himself, than any father toward his son, however tenderly he may love him."[37]

Thematic implications of the *Prodigal Son at the Inn* are further developed in two later depictions of brothels, one at Karlsruhe (figure 55), from ca. 1539, and another at Hartford (figure 58), dated 1543. Both portray a man seduced by prostitutes, similar to the Brussels panel, though the advanced age of the man and absence of subsidiary scenes pertaining to the biblical Parable make it clear that we are not dealing with the same incident. The man is more likely meant to be a generic representation of Everyman (Elckerlijk), a popular figure in Netherlandish drama of the sixteenth century. Everyman derives from the important late medieval *topos* of the journey of the pilgrim through life, a theme popularized by the influential *Pèlerinage de la vie humaine* by Guillaume de Deguilleville.[38] A telling section of the *Pèlerinage* deals with the encounter of the Pilgrim with the Seven Deadly Sins on his journey through life.[39] As Verdier rightly notes, the *topos* of the Pilgrim-Everyman shared a number of similarities with the Prodigal Son, and the two figures were often fused in medieval drama.[40] The Prodigal relates tropologically to Adam, and to mankind in general.[41]

It was thus perfectly legitimate that Hemessen should have used the tavern scene of the parable as a point of departure for generic treatments of the theme, especially considering the popularity of Elckerlijk in the Low Countries. Combining medieval allegory with a Renaissance emphasis on individual conscience, *Den Spiegel der Salicheyt van Elckerlijk*, attributed to Pieter van Diest, was one of the most successful morality dramas of the day. Hemessen was doubtless familiar with it, and with a Latin translation by Christianus Ischyrius, titled *Homulus*, published at Antwerp in 1536.[42] The play was performed at Antwerp by the Chamber of Rhetoric of Brabant. Another Latin version, *Hecastus*, was written by Georges Macropedius of Bois-le-Duc ('s-Hertogenbosch) and published at Antwerp in 1539.[43] Macropedius, a member of the Brethren of Common Life and head of the Hieronymite college at Utrecht, achieved considerable fame for his risqué moral comedies. His early works include a version of the Parable of the Prodigal Son, entitled *Asotus Evangelicus* (Bois-le-Duc, 1537; written ca. 1507) and the *Rebelles* (Bois-le-Duc, 1537; also written much earlier), which casts two Hieronymite students in the role of the Prodigal. Both plays include extended tavern scenes, by now the central episode in all treatments of the story. In *Hecastus,* the aging protagonist is surprised in the midst of gaming and drinking by a stabbing pain in his right side. The

pain frightens Hecastus with the sudden recognition that death could occur at any moment. This realization eventually leads him to repent.[44]

It is likely that Hemessen was portraying a similar moment of crisis in the Karlsruhe panel. While enjoying the enticements of the brothel, the aging "Everyman" wayfarer is suddenly hit by a *dolor gravis* that courses through his system, buckling his knees. Pale and trembling, he raises one hand in alarm while the other tries to steady himself by leaning on the table. His face knits in grim anxiety. A six of spades on top of the deck of cards symbolizes the sudden downturn of the traveller's fortunes, similar to Hecastus, whose bad luck at dicing signals his dire fate in the play. Faced with the fearful threat of imminent demise, the traveller is forced to confront the consequences of his dissolute life.

The subsidiary small-figure scenes—painted by Hemessen's talented collaborator—amplify the moral implications of the main scene. The vignette at the upper left shows a confrontation at the open doorway of the brothel (figure 56). A traveller (perhaps a seafarer) wearing Turkish pantaloons with a dark cloak slung around his shoulders stands hesitantly in front of the house. Two swarthy men in broad-brimmed hats approach him from behind. One holds out a coin to distract his attention, while the other picks his pocket. Two tavern maids placed strategically at the portal beckon him to enter the inn. A third woman emerges from the cellar with a jug of drink. The bird-cage and the trapdoor of the cellar refer to the trap that is being laid for the unfortunate wayfarer by the thieves and prostitutes. A bird-cage hung by the door was a typical attribute of a house of prostitution in Netherlandish art.[45] The man appears confused and gestures nervously down the street.

In the second episode, a young traveller is shown having a cozy supper in the inn by a hearth (figure 57). Here the man is distracted by a prostitute holding up an egg, while her accomplice rifles his purse at the foot of the bed. Seated on the bed, a young prostitute in a low décolletage demurely spoons soup—her action possibly meant as an erotic pun.[46] The traveller has removed his shoes and loosened his cod-piece. He grasps his staff in a way that makes a clear phallic allusion. Eggs were associated with carnal intercourse;[47] the way the woman holds the egg up to the light suggests that she is trying to convince the man that it is fresh. As Lilian Randall has noted, the gesture of candling an egg implies treachery and deception. It was proverbial in Flemish that, "Een bedorfen ei is het beld der huichelarij" (A rotten egg is the image of falsity").[48] Another example of a carnal symbol with a concealed warning for Everyman can be observed in the sausages hung above the fireplace. Traditional symbols of Gula, the sausages spell out the letters "M T U," alluding to the Old Testament handwriting on the wall: "mene, mene, tekel, upharsin" (Daniel 5:25). The same divine

warning occurs in Macropedius' *Hecastus*, along with a passage containing a similar message from Isaiah 38:1, "Set thine house in order; for thou shalt die, and not live."[49]

The triangular stool toppled over on its side may well be meant to refer to the passage in Isaiah. The motif also symbolizes Sloth (Acedia), a third carnal vice that is evoked by the sleeping dog as well.[50] A circular "wheel of chance" is attached to the hearth just below the sausages, providing an unmistakable reference to sudden shifts of Fortune. A similar device is attached to the inside of the window of the tavern in Bosch's *Peddler* (Rotterdam, Boymans-van Beuningen Museum) where it also refers to Fortune.[51] Unlike the older traveller in the foreground scene of the Karlsruhe panel, the youth displays little awareness of his plight. Foolishly allowing himself to be seduced by pleasures of the flesh, he faces the damnation presaged by the fire blazing nearby.

Demonstrating evils lurking behind the life of the tavern, the background scenes make the sudden alarm of the man in the center even more understandable. Fear was, to be sure, traditionally regarded as an impetus to reform by patristic writers. The traveller reacts similarly to figures who are accosted suddenly by Death in northern images of the *Dance of Death*. His purse decorated with three beautiful pearl buttons stands for the spiritual wealth that he is in danger of losing. As Christ remarks in Matthew 13:45: "The kingdom of Heaven is like unto a merchant man, seeking goodly pearls; who, when he had found one pearl of great price, went and sold all that he had, and bought it." Everyman's position at the proverbial "fork in the road" is denoted by the little shell that clasps together the two cords tying the purse, forming a "Y". The traditional pilgrim's symbol thus becomes a nexus for the man's choice between virtue and vice, between continuing along the sinful path leading inexorably to death and damnation, or embarking on the penitential path of reform, leading to salvation.[52] His fearful awareness will, it is hoped, accomplish a shift in mental outlook, a *metanoia* converting him from the pursuit of worldly pleasures to the austerities of the virtuous life.[53]

The Karlsruhe panel brilliantly updates the fifteenth-century Netherlandish blookbook theme of *Ars moriendi* (*The Art of Dying Well*), replacing the traditional deathbed *psychomachia* with a dramatic *spel van sinne* taking place in the colorful arena of an Antwerp brothel.[54] It is probably not coincidental that in June of 1539 (the year the painting was presumably done) there was a great Landjuweel held at Ghent devoted to the subject, "What brings the greatest consolation to a dying man?" Nineteen Chambers of Rhetoric from various parts of the Lowlands competed for prizes in what was surely one of the most bizarre theatrical festivals of all times.[55] The Violieren of Antwerp won first place with a moving performance of an

Elckerlijc spel.[56] In a precedent for a *Rederijkers* competition, all of the plays were published shortly afterwards at Ghent (31 August) and then at Antwerp (three editions alone in October).[57] It is tempting to think that Hemessen witnessed the performances at Ghent and perhaps even participated in staging the Antwerp Chamber's *spel.*[58]

While some of the plays performed at Ghent in 1539 were conservative and Catholic in orientation, the majority carefully avoided invoking the Church and the Sacraments as ultimate consolations.[59] Shortly after their publication, the Chancellor of Brabant, Adolph Van der Noort, denounced the *Sinnespelen* in a letter to Mary of Hungary as "plein de mauvaises et abusives doctrines et séductions, de tout tendant à l'opinion lutheraine."[60] In 1540 the comedies were banned by imperial decree along with numerous other books, plays and prints regarded as supportive of the Protestant movement.[61] Current scholarship feels that the Emperor's condemnation of the performances (which he had, in fact, officially authorized when they were presented) was chiefly due to persistent political problems with the city of Ghent, which seriously worsened following the event.[62] Rather than Lutheran, the *Landjuweel* was actually predominantly Erasmian in it scriptural emphasis. The theme itself was anticipated by a treatise by the Dutch humanist that appeared in 1534, the *De praeparatione ad mortem.*[63]

Nonetheless, following the Ghent competition the Netherlandish Chambers of Rhetoric came under increasing suspicion of heretical affiliations, a situation compounded by the defection of a number of prominent playwrights to the Protestant camp, including the author of *Acolastus, or Comedy of the Prodigal Son,* William Gnapheus. It was dangerous for Hemessen to continue to do paintings of the theme of Death and Everyman after 1540.[64] His only subsequent treatment of a brothel scene transforms the tense personal drama of the Karlsruhe panel into a more palatable (and pessimistic) allegory of sottish dissipation. In this panel from 1543, now at the Wadsworth Atheneum in Hartford (figure 58), the wayfarer looks befuddled and rather tipsy. Entwined in the arms of two plump temptresses, he casts a fatuous glance at the upraised glass of wine, symbolic of carnal dissipation and also of the redemption he is in danger of forfeiting. There is an obvious sexual allusion in the spout of the jug held by the old servant woman, who again looks enviously at the revellers. The way she fondles the dog's paw expresses her frustrated lust.[65] While the revellers are distracted, a wily cat creeps up to the table to snatch some food from a dish—a motif that may well refer to an erotic pun.[66] "A cat's paw" proverbially meant "to be someone's tool". The implication is that the foolish man is being manipulated by the sexy prostitutes.[67] In a room in the background, the man has given in to sloth and falls asleep by the hearth.[68]

The Hartford panel takes a more pessimistic attitude towards the pos-

sibility of reform. Rather than reacting with alarm to the temptations confronting him, like the wary Everyman of the Karlsruhe panel, the wayfarer allows his dissolute life to overwhelm his moral responsibility. His body twists tightly like a corkscrew in a remarkable Netherlandish takeoff on an Italianate contrapposto as the serpentine arms of the prostitutes writhe around him, tightening their grip like the snakes of the *Laocoön.* Dazed in an alcoholic stupor, he fails to recognize the "Y" message implicit in the shape of the goblet held up by the prostitute. There are additional "Y"'s visible in the cross-brace on the window just above his head as well as in the metal clasps at the corners of the frame. Everyman faces perhaps his last chance to reform. His haggard features betray the ravages of alcoholism. Hemessen may well have been responding to Netherlandish moral works dealing with drink, as Konrad Renger has suggested.[69] Foolishly impenitent, the man reflects a new offshoot of the Prodigal Son story that was becoming popular in the Netherlandish Rhetoric drama, about wastrels who obstinately refuse to reform and damn themselves in the end.[70] Several of Macropedius' plays from the late 1530s deal with these unregenerate types, such as *Aluta* (1535), *Andrisca* (1538) and *Lazarus the Beggar* (1541).

A particularly noteworthy aspect of Hemessen's brothel scenes involves the characterization of woman as an evil seductress in league with the Devil. The prejudicial attitude towards the female sex derives from the biblical tradition that pictured Eve as temptress—giving in first to the serpent and then leading Adam astray. The deceitful seductress became a common figure in medieval literature.[71] While a more balanced view of women begins to emerge in the Renaissance, misogynist attitudes continued to shape a great deal of art and literature and helped to encourage the witch-hunting mania of the sixteenth century.[72] According to the influential *Malleus Maleficarum* (1486), "All witchcraft comes from carnal lust, which is in women insatiable."[73]

A widely performed treatment of the theme of the demon-possessed femme fatale was published in Dutch and English versions at Antwerp ca. 1518: the story of *Mariken van Nieumeghen (Mary of Nimmegen).* Sometimes attributed to the mystical author Anna Bijns, this popular Netherlandish counterpart to the German Faust legend explores a case of female compact with the Devil.[74] Upon allying herself with Satan, the young Mariken is swept off from her native Nijmegen to 's-Hertogenbosch, and eventually to Antwerp, where the pair frequent a notorious tavern called the "Golden Tree." The lively description of the tavern by the Devil in the miracle play makes an apropos commentary on Hemessen's panels.

> Yes, faith, there shall ye see
> All the spendthrifts that thrive by mischance;
> And the wenches who know well all the old dance,

> The which on ten and four hazard all at a throw.
> Above sit the burghers, and the craft below,
> With whom 'tis more blessed to take than to give.[75]

The tavern is filled with those,

> ...who live in riot and wantonness
> And win a profit of very idleness,
> Gamblers, fighters, daughters of the game.
> Bawds and all they who use the same...[76]

After spending a couple of years in this infamous locale, where they incite confusion and even murder, Mariken and the Devil return to Nijmegen. A moving pageant held on the day of Our Lady's procession leads the young woman to repent. In an attempt to break her resolution, the Devil carries Mariken high up in the sky and casts her down, but she somehow manages to survive the fall and confess her sins to a priest. She finally seeks absolution from the Pope, who imposes a heavy penance that she performs in good faith.

Undoubtedly familiar to Hemessen, the Mariken story was first published at Antwerp ca. 1518 by Willem Vorsterman. Vorsterman, a member of the St. Luke's Guild at Antwerp from 1512, worked at the city until 1543 and was responsible for publishing a pro-Catholic translation of the Bible in 1528.[77] *Mariken van Nieumeghen* was probably composed by a member of the Antwerp Chamber of Rhetoric, De Violieren, since the group's device "Uyt ionsten versaemt" ("brought together by love") appears three times in the drama.[78] It should be noted that the tavern scene in the play is again a prelude to contrition and repentance (similar to the Prodigal Son story). The figure of the seductress manipulated by the Devil undoubtedly helped to shape the image of Hemessen's tavern prostitutes.

Hemessen investigated the realm of moralized genre further in two panels dating from ca. 1540, the *Bagpiper and Merry Wife* (figure 60, Brussels, Museum) and *Tearful Bride* (figure 59, Prague, National Museum).[79] Their similar dimensions and figure scale suggest that they may originally have been painted as a pair. The satirical Netherlandish theme of the Tearful Bride has been examined in a valuable study by Konrad Renger. Renger points out a number of pertinent examples of sixteenth-century prints and paintings showing a weeping young bride being led to the wedding bed by her mother and the bridegroom, accompanied by the music of a lusty bagpiper.[80] All of these works—which date somewhat later than Hemessen's panel—show the reluctant bride carrying two attributes: a candle to light her way and an earthenware jug for her nuptial ablutions. As Renger notes, the candle and jug also contain an obvious erotic

reference to her impending defloration, ostensibly the cause for her tears. An inscription on a print of the subject by Pieter Baltens of 1598 (figure 61) pokes fun at the maiden's trepidations, soon to be forgotten: "Maintenant plorer icy voyez l'Espousée, / Qui de rire au lict se tient bien assurée." ("Now weeps the bride, and yet I wager, / She shall laugh again, once she is in bed."[81]

Hemessen characteristically adds ambiguous dimensions to his treatment of the theme that suggest disconcerting undertones. The bride and bridegroom are both well advanced in years and also extremely unattractive. Resembling the mulish bawd of the Brussels *Prodigal Son* panel, the runny-nosed bride clutches her mannish hands together and blubbers effusively. Her elderly husband looks weary and cadaverous. An attractive young man on the opposite side of the weeping bride proffers her the nuptial pot. Instead of wearing the customary marital crown, she sports a garland of ripe red cherries. The candle is nowhere to be seen. In fact, light shining through the window suggests that it is already morning. The other revellers are also absent, though it is possible that they are represented in the *Bagpiper and Merry Wife*, which could originally have formed a pendant.[82]

Hemessen interprets the subject in a way that mocks the bride's tearful protests, for she is clearly neither young nor inexperienced. While cherries had nuptial connotations, they were also common emblems of *luxuria*, as in the work of Hieronymus Bosch.[83] The bawdy bride's pretense of virginal qualms hardly conceals her lustful attraction to the handsome youth offering the chamberpot. Her tears imply a lack of control over her carnal appetites, signalled by the low décolletage and profusion of cherries. Hemessen's interpretation of the subject invokes a medieval tradition which regarded sadness (*Tristitia*) as a sign of sinful behavior (for instance in the *Foolish Weeping Virgins* of Magdeburg Cathedral). As Bloomfield points out in his study of the Deadly Sins, *Tristitia* was closely associated with *Acedia* (Sloth) and was normally treated as an adjunct to that deleterious sin of the flesh.[84] By introducing the comely youth, Hemessen also invokes a favorite satirical theme of Northern Renaissance artists—the foolish romantic involvements of unequal lovers, either an old man and a young woman, or, as here, vice versa.[85]

Though Hemessen's painting of the *Tearful Bride* is the earliest extant dated example of the subject, there is no doubt that there must have been earlier Netherlandish representations portraying the bride in the normal manner, with candle and pot. This is confirmed by a citation of 1529 adduced by Renger, describing a painting in the collection of Francis I at the Louvre of a "Dame d'honneur à la mode de Flandres portant une chandelle en son poing et un pot en l'autre."[86] Hemessen was probably

attracted to the subject since it gave him the chance to represent more of the type of characters who people his tavern scenes along with a variety of facial expressions, from the groom's woeful grimace to the bride's crocodile tears. The bagpiper's no doubt scurrilous ditty and merry wife's lusty laughter would counterpoint the lachrymose mood of the panel.[87]

Hemessen's genre moralities opened up important new directions in Antwerp painting. They anticipate the intriguing scenes by Aertsen and his disciple Beuckelaer, with their complex layerings of condensed symbolic content.[88] His humorous investigations of behavior and physiognomy bridge the work of Quentin Massys with that of Pieter Bruegel.[89] Drawing from the "bizarreries" of pagan antiquity as well as from the realistic impulses of contemporary Flemish theater, they evoke the perils of the life of the senses with heightened immediacy, providing a unique visual document of the innuendoes of the tavern locale.

6

Christ and the Publican: The *Calling of St. Matthew*

While Hemessen's Prodigal Son and Everyman panels deal with the shady milieu of Renaissance brothels, his representations of the Calling of St. Matthew focus upon another setting ruled by worldly, materialistic values: the office of the wealthy money-broker. Matthew, or Levi as he was also called, was originally a publican, one of a class of rich capitalists who farmed taxes and customs for ancient Rome. Their Jewish ranks (*portitores*) were regarded as extremely corrupt in their native land, as apostates and tools of the oppressive Roman empire. Subject to rabbinic bans, they were execrated as the worst sort of sinners. It was from this class that Christ and John the Baptist drew some of their earliest followers, most prominently the apostle Matthew, who in the famous episode recorded in three of the Gospels, was called by Christ while he was "sitting at the receipt of custom."[1] Jesus said, "Follow me" ("*Sequere me*"). Without any hesitation, Matthew "arose and followed him." (Matthew 9:9, Mark 2:14, Luke 5:27–28). Charged by the Pharisees with associating with Matthew and other wicked publicans, Jesus eloquently defended his power to lead the sinful to repentance with the healing balm of divine mercy: "They that are well need not a physician, but they that are sick. But go and learn what that meaneth, I will have mercy, and not sacrifice; for I am not come to call the righteous, but sinners to repentance." (Matthew 9:12–13, Mark 2:17, Luke 5:31–32)

Early Christian commentators on the Gospels interpreted the episode as a demonstration of how even the most notorious sinner can find salvation through conversion and penance.[2] According to St. John Chrysostom, it attested to Christ's ability to heal "the wickedness of the soul," just as he was able to raise the dead or cure physical ailments.[3] The Calling of Matthew provided supreme verification of Christ's power to release the sinner from the thralldom of worldly affairs. Erasmus stresses the miraculous nature of the saint's release in his *Paraphrases of the New Testament*:

Jam hoc erat insignius miraculum, hominem infami quaestui deditum, et negotiis inexplicabilibus involutum, repente vertere in alium, quam paralytico suos nervos reddere.[4]

A sixteenth-century English translation of the passage reads:

Now to convert a man wholly given before to a slanderous trade of getting all his gains, and enwrapped with manifold affairs such as it is beneath possible to get out of, or to convert such a one suddenly to clean contrary trade, this was a miracle much more notable, than to restore the sinews to a man that had lain sick of palsy.[5]

According to Jerome, and later Erasmus, Christ's voice and face acted magically to pull Matthew from his office, like the mysterious force of a magnet acting upon iron.

Habebat enim Jesu vox energiam quandam admirabilem, relucebat et in vultu vis quaedam occulta, qua vos volebat, non aliter ad se trahebat quam magnes ferrum.

(For the voice of Jesus had a certain wonderful efficacy and strength, and a certain secret power and majesty shining in his countenance, whereby whom he would, he allured and drew unto him, even as the Adamant draweth iron.)[6]

Though the *Calling of St. Matthew* had been represented for some time in Books of Hours, it was only in the 1530s that the subject began to be portrayed by Northern panel painters. It first occurs in the work of Marinus van Roymerswaele, an artist originally from Zeeland who had been apprenticed to the Antwerp stained-glass master Symon van Daele in 1509.[7] One of Roymerswaele's versions of the *Calling*, now at Ghent, is dated May 14, 1536. It is likely that this is a copy or variant of a lost original by the artist, since it is hard and summary. Another version of the subject, formerly owned by the Earl of Northbrook and now in the Thyssen-Bornemisza Collection at Lugano (figure 62), is of considerably higher quality and probably antedates the Ghent panel by a few years. Showing Matthew straining out of his cluttered booth towards Christ and removing his hat, Roymerswaele suggests both the publican's entrapment in his customs' duties and the profound force of his mystical attraction to the Saviour.

A persuasive testimonial to Christ's power to heal sinners and bring them to repentance, the Calling of St. Matthew had been a source of inspiration for the *devotio moderna*, the pietistic Netherlandish reform movement whose founder, Gerard Groote (1340–84), experienced a similarly dramatic conversion from a life devoted to worldly ambition.[8] Groote and his followers insisted on the necessity of establishing a direct relationship with Christ in the quest for redemption. The Christocentric gospel of

the Brethren of the Common Life was promulgated through the numerous schools which they established in the Netherlands and Germany, as well as by the extremely popular treatise by Groote's disciple Thomas à Kempis, *The Imitation of Christ*, which opens with another New Testament passage unmistakably evoking the message of "Sequere me": "He who follows me can never walk in darkness." (John 8:12)[9]

The best-known follower of the "modern piety" in Hemessen's age was the Dutch humanist theologian Desiderius Erasmus (1466–1536), who trained as a young student in the Brethren's schools at Deventer and 's-Hertogenbosch.[10] Though Erasmus found the teaching methods of the Brethren old-fashioned, he eagerly absorbed their emphasis upon a heart-felt devotion to Jesus, based on a fervent human response to Christ's inner call. For Erasmus, the true *philosophia Christi* consisted of "a life of wisdom entirely consecrated to God."[11] This doctrine was developed in his widely-read manual for lay piety, the *Enchiridion militis Christiani,* first printed in 1503, and again in 1509 and 1515, followed by twenty-three editions in the next six years.[12] Erasmus sets forth the theme of *imitatio Christi* in the "fourth rule": "that you set Christ before you as the only goal of your whole life and direct all your efforts, all your activities, all your leisure, all your business in His direction."[13]

While the emergence of the subject of the Calling of St. Matthew in Antwerp painting undoubtedly relates to the popular Erasmian revival of Netherlandish piety in the second quarter of the century, it also expresses a concern with what many viewed as an alarming rise in "publican" activities in sixteenth-century urban life. The tax-collectors of Northern Europe were actually the great banking houses, and they were engaged in the manipulation of vast amounts of money beyond the wildest dreams of their medieval forebear.[14] The center of the money trade in Northern Europe was Antwerp, which had rapidly overtaken Bruges in the first decades of the century.[15] There was a phenomenal increase of money-brokering activities, from Lombard pawnbrokers and Flemish burgher moneychangers to the great German banking dynasties, the Fuggers, Hochstetters and Welsers, all of whom had set up large establishments in the city. The Germans had a virtual monopoly on tax-supported loans to the imperial court. The money professions at Antwerp benefited from an almost total lack of restrictions on trade in currency, bullion and bills — an exceptional degree of financial freedom that contributed to the city's amazing prosperity but also led to rampant speculation and other abuses.[16] Controversy centered especially around bills of trade or exchange (*cambium*), promissory notes used for major transactions that were easily manipulated by sharp investors. The famous Antwerp Bourse was primarily a market for these bills (*marché des*

changes).[17] Their use—and abuse—accelerated rapidly with the growth of trade in the first half of the century.[18]

Though more and more people were becoming involved in the money trades (which, to be sure, were essential for the health of an economy based on international trade), there remained lingering suspicions of these activities due to traditional medieval religious restrictions on usury and the fact that many of the individuals involved were foreigners. Ambivalent attitudes towards the money profession are expressed by an interesting group of paintings of bankers, tax-collectors and moneylenders by Massys and Roymerswaele that glamorize endless accoutrements of gold coin, scales, purses, account books, bills of exchange, etc., but also underscore the folly of a life dedicated to Mammon through the greedy, compulsive gestures, Semitic features and foppish, archaizing costumes of the participants. The visual emphasis given to the scales in these panels make appropriate allusion to the "just weights" commanded of the Israelites in the Old Testament (Lev. 19:36, Deut. 25:15, Prov. 20:10, 23) as well as to the traditional "weighing of the souls" in the iconography of the Last Judgment.[19] Roymerswaele does an effective job of suggesting the transitory, "weightless" nature of these monetary activities in contrast to the ultimate "weight of Glory" (II Cor. 4:17) they are in danger of forfeiting through his splendid depictions of dried-out parchment leaves, starched fabrics and dessicated flesh. Even the gold coins seem to float like feathers on the flimsy hand-held scales.[20]

Hemessen's first representation of the *Calling of St. Matthew,* dated 1536 (figure 63, Munich, Alte Pinakothek) is a bizarre and not fully understood work that fuses the biblical episode with the popular satirical subject of the corrupt money-broker, adding the artist's penchant for contemporary setting and a "crossroads" situation. The most noteworthy aspect of the painting is the original omission of the figure of Christ.[21] Both the vertical section with Christ and a generous strip along the top of the panel that contains a *cartellino* with the words, "SE QVERE ME/MATTHAE I CAP:IX" are seventeenth-century additions. The original composition is preserved in a studio copy in the collection of the Marquess of Lothian, Dalkeith, Scotland (figure 64). The panel thus originally depicted a money-broker in his office, confronting an unseen visitor whose identity is left ambiguous.

There is no doubt that the panel was meant to refer to the Calling of Matthew, considering the money-broker's transfixed stare, the hand of the elderly man pointing towards the visitor, and figures that recur in Hemessen's later depictions of the subject, which *do* include Christ: the accountant preoccupied with his labors, the pretty female assistant and distressed old couple (figures 66, 70). Yet it could also refer to another momentous

summoning that we have already noted concealed in Hemessen's tavern scene at Karlsruhe: the arrival of Death. This subject had a long history in Netherlandish graphic art, in the blockbook *Ars moriendi* (*Art of Dying Well*). It was more recently represented in Holbein's woodcut of *Death and the Miser* ("*Der Rych Man*") for the *Dance of Death* (published Lyons, 1538, but drawn at Basel 1523–26), and by Jan Provost in a fascinating pair of shutters showing a miserly money-broker who deals with Death, seemingly yet unaware of the true identity of his visitor (figure 65). Hemessen's ambiguous treatment may have been inspired by Bosch's version of the subject (Kress Collection, National Gallery of Art), which portrays a dying miser vacillating between money bag and crucifix.[22] In Hemessen the equivocal identity of the off-stage visitor itself suggests the alternatives of Death/damnation or Christ/salvation for Matthew/miser.

Like the Prodigal Son and Everyman panels considered in the previous chapter, the Munich *Calling* was undoubtedly influenced by contemporary Rhetoric dramas such as Macropedius' *Hecastus*, in which a wealthy man is shocked from apathy by the sudden threat of death and led to repent his worldly life. The theme of merchant/Everyman was treated in an extensive moralizing play by Thomas Naogeorgus published in 1540, entitled *Mercator*.[23] There were very likely other versions of the subject of the dying Plutus in the repertory of the Antwerp Chamber of Rhetoric that could have influenced Hemessen. His conception may well have been based on a theatrical device in which the identity of a visitor offstage is not immediately revealed. Like the alarmed wayfarer of the Karlsruhe *Brothel Scene* (figure 55), the money-broker of the Munich panel is poised on the brink of a profound change of outlook that has not yet been fully consummated. Though he rises in response to the call, he remains hesitant and seemingly perplexed, teetering on the *point d'appui* of *metanoia* like the sharp knife balanced on the parchment next to him. Hemessen again suggests that he is at the proverbial crossroads through the symbolic "Y" formed by the vertical support and crossbar of the scale held by his female assistant.

Hemessen's densely packed interior — even more claustrophobic originally — helps to generate the sense of "negotiis inexplicabilibus involutum" described by Erasmus in his commentary on Matthew. The participants are crammed so tightly around the table that there is virtually no space left open. The dense clutter of coins, slips of paper, leather pouches and account books creates a superb atmosphere of worldly fixation and disorder. Their gestures convey the obsessive nature of their occupation: witness the contorted hand of the elderly man covering a mound of coins, and the single-minded determination of the female assistant and the accountant, both oblivious to the drama taking place. To the rear an elderly man and woman — usually identified as Matthew's parents — bemoan

the tax-collector's strange behavior with effusive gestures of mourning. Hemessen's concern with gesture as a means of conveying psychological values harks back to Leonardo da Vinci. The hand of the old man pointing towards the visitor is, of course, a direct quote from the *Last Supper*. The publican's halting spiritual awakening is announced by his raised hand, which opens gropingly towards his calling, while the fingers of his left hand slowly slip from the binding of an account book.

Equally remarkable are the panel's contemporary references. Rather than picturing the tax-collector in archaizing costume like Marinus van Roymerswaele, Hemessen dresses him in fashionable sixteenth-century garb and provides him with a squarish beard similar to the style adopted by the German bankers.[24] The young woman's dress is perfectly à la mode, and the coins current imperial mintage. Considering the realism of the presentation, it is very likely that Hemessen was making allusion to contemporary events. He was undoubtedly familiar with the world of wealthy money-brokers at Antwerp. A few years later (1539) he purchased a house on the Lombaardevest, where the North Italian pawnbrokers were located, and then another on the Hochstetterstraat, a new street that was formed on a large piece of land owned by the Hochstetters following the financial collapse of the German banking house in 1529–30.[25] The Hochstetters had been widely disliked for their unfair trading practices. As Richard Ehrenberg remarks in his excellent study of the Fuggers and their age, "The Hochstetter were the most hated monopolists of their time."[26] Notorious speculators, they lost considerable sums of money on wildcat schemes to control mining of quicksilver in Spain and Hungary. Several younger members of the family were reputed to be gamblers and wastrels.[27] Their downfall followed a scandalous deal with the Court of Brussels in 1528, when the hard-pressed Government agreed to accept overvalued cinnabar and quicksilver owned by the firm for the value of a loan. When sold by the Hochstetter's agent at Antwerp, Lazarus Tucher, the goods brought much less than the 200,000 carolus gulden agreed upon for the loan. The Emperor was severely embarrassed, and the Hochstetters quickly slid into bankruptcy.[28]

The Munich panel can be viewed as a call for reform of the money-brokering profession at Antwerp following the collapse of the great German banking dynasty.[29] The confused jumble on the *wisselbank* (or *table de change* in French) suggests financial affairs gone awry. The contemporary imperial coins on the table could make direct reference to the loan scandal. Our banker has the demeanor of a deeply troubled man, with furrowed brow and heavily circled eyes. Clearly what is required to cure the desperate publican is the intervention of Christ to lead him to contrition, just as he had done with his disciple Matthew. Hemessen thus invokes the

biblical subject obliquely, as a promise of merciful aid from the divine healer for the penitent sinner, to signify, as Erasmus phrased it, that "He despiseth bitterly no kind of men, as long as they repent and turn to the better."[30] The conversion of Matthew was perfectly appropriate to the reform of the money trades since he was patron saint of the profession.[31] At Florence, he was protector of the Medici's influential guild of bankers and changers, the Arte del Cambio, who had commissioned the eloquent classicizing bronze sculpture of the saint at Or San Michele from Ghiberti in 1419.

Hemessen's next depiction of the *Calling of St. Matthew* is also not without contemporary reference, though of a different sort. Dating stylistically ca. 1539–40, this handsome revised version (figure 66, Vienna) now includes the figure of Christ calling his new apostle in the upper right-hand corner, as well as a background scene of the feast of publicans and sinners with Christ and his followers in the grand house of Matthew (figure 69). There is a noteworthy change in style from the 1536 panel, whose stiff grouping and claustrophobic interior are replaced by an open, flowing composition of active figures in a palatial courtyard. The Savior turns in energetic contrapposto to point the way for Matthew, who strains upwards towards the call, his nose raised like a hunting dog sniffing out a scent. Fluttering gestures build up a lively diagonal crescendo towards Christ. The composition demonstrates renewed appreciation of North Italian pictorial formulae such as Moretto da Brescia's *Madonna and Child with St. Elizabeth* (Varese, Coll. Carantini-Scavini).[32]

Hemessen reduces the subsidiary figures to three: an alluring female assistant and effusive elderly man and woman, presumably the tax-collector's parents. The young woman raises both arms in alarm, aiming her open palms at Christ as if trying to ward off the intruder. Matthew's father grimaces and holds his head in pain while the tearful mother, who wears a bizarre crimped bonnet, lifts both hands in anguish. Her tears signify her spiritual blindness. She foolishly mourns Matthew's death to the world in a way that harks back to the figure of Synagogue saddened over the victory of the New Law over the Old.[33] Their dramatic gestures recall mourners in Medieval and Renaissance art, a tradition of expressive sorrowing that has been examined in a valuable study by Moshe Barasch.[34] Hemessen could have observed similar emotional rhetoric in Jan Vermeyen's etching, *Extreme Unction.* A more likely source, however—and one closer to the meaning of the *Calling*—was Rosso's fresco *L'Ignorance Chassée,* which he may have seen *in situ* at Fontainebleau (figure 67).[35] Like Rosso's assortment of blindfolded gesticulating figures, their hysteria indicates a failure to comprehend the true significance of the event.

The appurtenances of Matthew's profession are now handled dis-

creetly, even elegantly. Coins and jewels are confined to a sturdy iron strongbox positioned emblematically just below Christ. A traditional symbol of Avarice, the strongbox is linked to the Devil by the miniature dragons decorating its hinged clasps.[36] Matthew's conversion thus becomes a victory over the Adversary. The long sash appended to the tax-collector's ostentatious headgear snakes around him, a further reminder of the malevolent forces confounded by his calling. The incredibly intricate clipped felt of the hat and sash à la Marinus evokes the wasteful involution of Matthew's temporal affairs that have entangled his existence.

Rather than commenting upon the Antwerp money-brokers, the Vienna panel contains a message for their powerful suzerain, the Emperor Charles V. It is odd that the obvious resemblance of the tax-collector's beaklike nose and thrusting jaw to Charles' famous profile (figure 68) has so far escaped notice. Though the Emperor was somewhat younger than Hemessen's figure at the time of the completion of the painting (ca. 1539–40), there is little doubt that anyone would have missed that pronounced Hapsburg jaw. Characterizing him as Matthew was not inappropriate, since Charles was born on the Saint's day, February 24, 1500.[37] It was on the day of St. Matthew in 1530 that he had been crowned Holy Roman Emperor by Pope Clement VII at Bologna.

The concealed portrait of the Emperor explains the shift of locale to a palatial, courtly setting as well as the ultrarefined costumes of the participants. By portraying Charles as the biblical publican, Hemessen makes a persuasive plea for the modification of the Emperor's role from that of imperial tax-collector to a Christlike, merciful path. The Netherlandish cities had long resented the harsh taxes imposed upon them to finance the imperial war effort. The issue had recently come to a head with the open defiance of Ghent, which obstinately refused to support the campaigns against the French in the Artois in 1537–38. The Emperor responded by bringing an army to the gates of the city in 1539 and instituting severe punitive measures, stripping Ghent of all rights and privileges, confiscating its treasury and armory, and even hauling off the city's legendary bell and rallying call, the Roland.[38]

Hemessen's painting may well reflect *tableaux vivants* which were staged during the Emperor's trip to the Lowlands to quell the riots at Ghent. I would imagine that the panel was done in connection with his Triumphal Entry into Antwerp in 1540, a date that accords with its place in Hemessen's chronology. These occasions had often been used by the Netherlandish cities to comment upon imperial policies.[39] Many at Antwerp must have sympathized with Ghent and resented increasingly outrageous imperial tax demands. What more effective *admonitio princeps* than cast-

ing Charles in the biblical role of his natal saint responding to the Savior's call?

Hemessen's fascinating *roman à clef* also comments upon imperial attitudes towards the religio-political crisis posed by the spread of Protestantism among the German states, another very pressing problem confronting him at this time. There were ominous signs that Charles was contemplating war against the recalcitrant Germans. In 1538 and 1539 he channelled large amounts of money through the Fuggers at Antwerp from Spain and the Netherlands to Germany and Italy. The German banking house had been intimately involved with raising huge amounts of money necessary to finance the imperial wars for some years. As Richard Ehrenberg remarks on this particular build up of funds, "People puzzled over what this money was meant for. Was it for a new expedition against the Barbary pirates, against the Turks, or against the German Protestants? The last named began to regard the Fugger, who were once again largely interested in these affairs, with special distrust."[40]

The only serious alternative to war with the Germans was a religious council between Protestants and Catholics that would, happily, resolve doctrinal disputes between the two sides. The spirit of reconciliation was still very much in the air.[41] Erasmus had argued persuasively for religious concord in his treatise, *De sarcienda Ecclesiae Concordia*, first published in 1533.[42] Following Erasmus' demise in 1536, this course was championed by northern humanists as well as by the influential reformist movement within the church led by Gasparo Contarini and Reginald Pole. The conciliatory movement gained momentum in the late 1530s and eventually succeeded in winning the Emperor over to support negotiations between Catholics and Protestants at Regensburg in 1541.[43]

Hemessen's Vienna *Calling* contains a forceful plea for imperial support for reconciliation. A merciful Christ calls the Emperor/publican from imperial tax-collector to a pacificatory, apostolic role. Military designs are symbolized by the imposing war chest and the hilt of the dagger prominently jutting from Matthew's side. In the background, Christ and the apostles welcome sinners to a feast of concord at the publican's palace. At the summit of the staircase there is an apt allusion to Charles' famous device, the pillars of Hercules, in the pair of Corinthian columns that flank the arched doorway leading to a brilliantly lit hall. Worldly imperial aspirations alluded to by his motto, "Plus Ultra," are here transferred to the prospect of glorious unity of the faithful leading to the New Jerusalem.[44]

Recent studies have underscored the willingness of high-ranking clerics like Cardinals Contarini and Pole to incorporate what could be accepted as orthodox elements of Lutheranism within the ecclesiastic order as a means

of accomplishing an end to religious schism.[45] A conciliatory approach dominated the 1541 meetings at Regensburg and resulted in the adoption of a "two-fold" formula devised by Contarini that included *both* justification by faith and works. This accomodative doctrine failed to gain the approval of either Luther or the papacy, however, and hopes for concord between Protestents and Catholics soon crumbled. Dermot Fenlon perceptively comments on the finality of the historical moment:

> The failure of Regensburg reflected the ineradicable character of the opposition between the religious parties. It led to the resumption of the papal plan for a General Council, and it explains why that Council could never have been a Council of reunion. Historically, Regensburg was more significant as a failure than as a success. What it revealed was the tragic reality of the division between Protestantism and Catholicism.... It signified the reality of the Reformation and the necessity of the Counter Reformation.[46]

Hemessen's temperament bound him to the tragic realities of the religious crisis of his times. When, about a decade later (ca. 1548), he painted his ultimate version of the *Calling of St. Matthew* (figure 70), there is a distinct shift from the lyrical, conciliatory mood of the pre-Tridentine panel to pronounced Counter-Reform militancy and emotionalism. No less than five early copies are known of Hemessen's third *Calling*, attesting to its importance as an expression of fervent mid-century Catholicism.[47] Matthew rises abruptly from his worktable to pursue the call, while his frightened female companion tries vainly to restrain him. The electric gestures recall the bizarre frenzy of Rosso Fiorentino's *Scene of Magic* (Paris, Ecole des Beaux-Arts) or his print of *Fury*. An anxious Christ looks back at his new disciple, pointing the way emphatically with his raised arm while clutching the drapery at his groin in a strangely compulsive manner. Matthew's assistants continue their tasks of counting and recording with feverish intensity, perversely unaware of the furor of his vocation. Behind, the tax-collector's hysterical father breaks down in tears, while his sibylline mother points enigmatically towards Christ. Complex angular formal rhythms, murky lighting and a compressed spatial format accentuate the compelling, otherworldly effect.

One of the most powerful artistic declarations of the deterministic mood of the Tridentine period, the *Calling* conveys the dilemma of a time that witnessed both the waxing of fervent Spanish mysticism and the fearsome onslaught of oppressive forces of the Inquisition. The extreme devotionalism underlying Hemessen's late *Calling of St. Matthew* reflects a revised Counter-Reform view of the Erasmian fourth rule of the *Enchiridion*. The militant Jesuit doctrine of *"sequere me"* was formally announced

by Ignatius Loyola in the *Spiritual Exercises,* published in an official edition in 1548, *ad majorem Dei gloriam*:

> *First point*: If we heed such a call of an earthly king to his subjects, how much more worthy of consideration is it to see Christ our Lord, the Eternal King, and before Him, all of mankind, to whom, and to each man in particular, He calls and says: "It is My will to conquer the whole world and all my enemies, and thus to enter into the glory of My Father. Whoever wishes to come with Me must labor with Me, so that following Me in suffering, he may also follow Me in glory."[48]

7

The Rockox *Last Judgment Triptych*

Not long after the completion of the 1536 *Parable of the Prodigal Son* and *Calling of St. Matthew*, Hemessen undertook a large *Last Judgment* triptych for the Rockox chapel in the Sint Jacobskerk, Antwerp's second church. A major commission for one of the premier families of the city, the *Last Judgment* (figures 71–74, 80) declares the maturation of Hemessen's Romanism, combining monumental figures, flamboyant displays of illusionism and an impressive group of donor portraits which announce the severe style to dominate Netherlandish portraiture for the remainder of the century. Adrien Rockox was a wealthy burgomaster whose grandson, Nicholas, is remembered as the enlightened patron of Pieter Paul Rubens in the seventeenth century.[1]

The triptych gave the artist the chance to work out the lessons of Michelangelo and Raphael on a grand scale. Employing a striking relief of interlocking nudes for the central panel, Hemessen imported an innovative *Maniera* composition based on thorough study of Roman reproductive prints as well as fresh insights gained from a presumed recent trip to Fontainebleau. Forcefully avant-garde in style, the triptych takes an even more radical approach towards iconographic traditions of the Last Judgment. Its disturbing emotionalism conveys, perhaps more than any other visual document of the day, the bitter pessimism and anxiety prevalent during the fourth decade of the century, when the conflict between emergent Protestant sects and the conservative Catholic order reached extreme conditions.

The Rockox triptych must have involved considerable time in planning and execution. No documents have yet been uncovered concerning its commission, but one can date it ca. 1536–37 by approximating the ages of various members of the donor family, who are represented on the inside wings (figures. 71–73).[2] One of the Rockox daughters (at the far right in the second row) is depicted in profile, while two of her sisters cast glances of tender concern in her direction. This is certainly a memorial of Anna, who died in 1535 at the age of twenty-five, not long before work on the altarpiece began.[3]

Still strong though well into his seventies, the elder Rockox kneels in prayer along with his three handsome sons, a militant defender of the faith garbed in dark burnished armor (figure 72). His jousting helmet and gauntlet lie ceremonially at his feet. Just behind stands his patron St. Adrian, brandishing a large sword and anvil. The latter device symbolizes Adrian's gruesome martyrdom, which can be seen acted out off in the distance.[4] The harsh glint of steel and turbulent sky reinforce the determined attitudes of the donors. They stare impassively at the chilling scene before them.

Across the way, tiers of female donors form an equally impressive group led by the matronly Catharina van Overhoff, whose dignified features are sensitively rendered by the artist (figure 73). Her starched white headdress and magisterial robe filled out with ample fur sleeves contrast with her daughters' modish jewelled coifs, fancy chokers and sheer décolletage. The numerous Rockox daughters were, to say the least, distinct familial assets. Their well-chosen marital affiliations helped to affirm the power and wealth of the Antwerp burgher dynasty. Serving as protectress to this resplendent ensemble, a somber St. Catherine solemnly views the Dies Irae, flanked by a sword fixed with a stunning crystal hilt and her traditional spiked wheel. An admonitory finger points down towards the damned in the throes of despair.

The central panel of the *Last Judgment* (figure 74) gave Hemessen the chance to develop a large-scale composition of nudes, utilizing highly advanced concepts of anatomy, chiaroscuro and figure types. Like his monumental *St. Jerome Penitent* of 1531, the panel challenged established definitions of Romanism and redefined standards of Italianate assimilation in the Netherlands in the fourth decade of the century. This extraordinary work has never been adequately explored by historians of Northern Renaissance painting, in spite of the fact that the triptych had already in the eighteenth century attracted the attention of J. B. Descamps and Sir Joshua Reynolds on their trips through the Low Countries.[5] While both observers correctly assigned it to Hemessen — probably following local word of mouth — the triptych was subsequently misattributed to Orley by Passavant, Kugler and others.[6] Max Friedländer rightly recognized the *Last Judgment* as Hemessen's chef d'oeuvre. He commented upon the striking composition of nudes in *Early Netherlandish Painting*:

> The *Last Judgment* that occupies the centrepiece is quite characteristic of Jan Sanders, in that relatively few nude figures in vehement action, large in proportion to the picture area, are disposed about the scene in such a way as to draw all attention. The painter's aspirations seem to have been directed exclusively towards the human body, the 'life study', inspired by the academic fervour which Gossaert had unleashed in the North.[7]

Hemessen's triptych should be examined in relation to the tradition of representation of the Day of Wrath in northern art, a rich heritage that has

recently been catalogued in an exhaustive doctoral dissertation by Craig Harbison.[8] In contrast to the balanced and ordered presentation by Roger van der Weyden in the great Beaune altarpiece (ca. 1445–50) and his numerous fifteenth-century followers, artists of the new century developed a broad array of visualizations of the Last Judgment in response to changing stylistic preoccupations and eschatological leanings. Netherlandish painters evidenced increasing concern with the nude figures of the Resurrected Dead and their human responses to the finality of the judgment. Moving away from the outworn device of symbolic weighing of the souls on the scales held by the Archangel Michael, they emphasized a broad range of emotional reactions of the naked and defenseless men and women, who suddenly face the terrible moment of decision. The subject became, especially in Antwerp painting, a fertile means for depicting excited figure poses and expressive gestures.

The best-known examples of this new trend in the years prior to Hemessen's *Last Judgment* are Bernard van Orley's altarpiece for the Brotherhood of Almoners at Antwerp, completed 1525 (figure 75), and Lucas van Leyden's equally impressive presentation for the church of St. Peter at Leiden dating ca. 1526. Both depict a variety of standing, kneeling, seated and prostrate nudes influenced by a plethora of classicizing precendents. Similar tendencies are displayed by another painting of the subject now at the Metropolitan Museum of Art from around 1530, attributed to Joos van Cleve.[9]

Hemessen took pains to distinguish his treatment from these earlier Romanizing examples. As Friedländer points out, he dramatically enlarged the size of the Resurrected Dead in relation to the overall field, bringing ten nudes (plus a devil) up extremely close to the picture plane. Illusionism is heightened by strongly foreshortened heads and limbs that appear to thrust out into real space. Extreme contrasts of shiny highlight and deep shadows (which grow progressively darker towards the right) accentuate plasticity and realism. Numerous overlappings and interweavings draw the figures together into a tightly meshed tangle of clumsy limbs that takes considerable effort to puzzle out. Hysterical faces dotted throughout the frieze scream their fear of everlasting perdition; at the far right a goggle-eyed demon hefts a buxom sinner on his hip and hurries her off to the mouth of hell. He sticks out the length of his pointed tongue in a truly horrific manner. An unfortunate man standing at the center tears his hair in anguish, his arms forming a triangle reflective of the scale, now entirely absent along with St. Michael.

The *Last Judgment* owes a formidable debt to High Renaissance relief compositions transmitted northwards through reproductive drawings and engravings, such as Michelangelo's *Cascina* cartoon or Raphael's *Massacre*

of the Innocents. Some of the anatomical peculiarities of Hemessen's nudes can be attributed to the relentless study of Marcantonio's printed "reproductions" that had to suffice Netherlandish artists for renewed visual contact with the originals themselves.[10] Earlier Florentine printed sources were also utilized. Pollaiuolo's engraved *Battle of the Naked Men* was a likely model for the strained facial expressions as well as the tense modelling of arms and clavicles. It is possible that the Antwerp painter had made a drawing of Michelangelo's early relief sculpture of the *Battle of the Centaurs* (figure 76) when he visited Florence and remembered its complicated fusion of powerful nudes in his composition.

The highly sculptural effect of the *Last Judgment* nudes indicate that Hemessen was involved in the debate over the Paragone and, like so many admirers of Michelangelo, regarded painting as a means of transmitting plastic values. He was aided in this effort by a perceptive analysis of the use of *oscurità* in Leonardo and Raphael. There is no doubt that he had looked hard at Raphael's *Transfiguration* (figure 77).[11] The powerful light and shade are there, and also specific elements such as the features of the possessed boy, which he adapted for the faces of the frenzied women. In yet another instance of outlandish Romanist borrowing, the repulsive male sinner who falls backwards towards the fiery pit mimics the exalted pose of St. John on Mount Tabor!

It may not be simply coincidental that Michelangelo was also occupied with the theme of the *Last Judgment* during these years. Commissioned by Clement VII in March of 1534, the Sistine Chapel fresco was already begun by November, 1535. Work continued throughout the remainder of the decade, and it was finally unveiled on October 31, 1541. Word of Michelangelo's new project had undoubtedly travelled north by the time Hemessen began the Rockox altarpiece.[12] Possibly his choice of subject was inspired by the news. Though there is no evidence in the Antwerp triptych of direct influence from the Sistine work-in-progress, the emphatic posturing of Hemessen's large-scale, sculptural nudes can be viewed as an act of homage to his longstanding idol, and, as already noted, his relief composition harks back to Michelangelo's early relief ideas in the *Centauromachy* and the *Battle of Cascina.*

Hemessen also drew ideas from a source that was not without impact on Michelangelo, himself: Signorelli's frescoes of the *Last Judgment* at Orvieto (figure 78). Those eye-boggling orchestrations of full-bodied nudes had been admired by northern artists since their unveiling in 1500. For years they were standard reference for Romanist *Last Judgments.* In addition to contributing to the panels by Orley, Lucas and Joos van Cleve noted above, the Orvieto frescoes had influenced a less well-known Italianate representation of the theme which was installed at Brussels in 1528,

a magnificent stained-glass window commissioned by Erard de la Marck for the Cathedral of St. Michael.[13] Possibly executed after a design by Orley, the window contains a massed phalanx of nudes that anticipates Hemessen's concept.

If the Rockox *Last Judgment* demonstrates a heightened awareness of Romanist pictorial and sculptural sources, it also affirms Hemessen's understanding of the latest directions taken by Mannerist painters in the development of complex flattened relief compositions. Post-Raphael fresco style was made available to northern artists in the magnificent decorative campaigns undertaken at Fontainebleau under Rosso Fiorentino in the 1530s.[14] Though no documents have yet been uncovered to prove that Hemessen visited the French court, there is ample evidence in his *oeuvre* from ca. 1536 onwards that he must have done so. The collection formed by Francis I was a lodestone for the Netherlandish Romanists. It brimmed with High Renaissance masterpieces including Leonardo's *Madonna and St. Anne,* the *Mona Lisa*, the *Madonna of the Rocks*, del Sarto's *Charity* and Raphael's sublime *St. Michael*.[15] A partial copy at Bruges (figure 81) of one of the pearls of the French king's collection, Raphael's *Holy Family of Francis I* (figure 82), has been firmly identified as a Hemessen by Henri Pauwels.[16] Bulking out the drapery and flesh of the Madonna and child, Jan transposes Raphael's figures into an unmistakably Romanist setting replete with sturdy Flemish rocker and typically northern landscape. Like Hemessen's student copy after Andrea del Sarto's fresco at Florence (figure 21), the Bruges panel was a means of analyzing mechanisms underlying High Renaissance style, especially the interlocking poses and contours of the forms. A precedent for Hemessen's plagiarism can be found in Quentin Massy's *Madonna and Child with the Lamb* (figure 14), now at Poznan, a somewhat more appealing extraction from Leonardo's *Madonna and Child with St. Anne*. The features of a Hemessen *Nursing Madonna* (figure 83) formerly on the Munich art market, are also closely modelled on Raphael, recalling *La Belle Jardinière,* another work thought to have been at Fontainebleau.[17]

Improved relations between France and the Empire which followed the signing of *La Paix des Dames*—the celebrated Ladies Peace of 1529 negotiated by Louise of Savoy and Margaret of Austria—led to renewed artistic exchange with the Low Countries. Joos van Cleve was at the French court sometime between 1530 and 1535, where he painted his well-known portraits of the king and queen.[18] Hoogewerff has suggested that Jan Massys also travelled to France around this time.[19] Flemings were undoubtedly welcomed by Francis I's court painter Jean Clouet, originally from the Lowlands, and his talented son François, born ca. 1505–10. As Charles Sterling and others have pointed out, the younger Clouet's later

work contains a liberal dose of Flemish realism in addition to its Italianate sophistication.[20] One can assume that he assimilated illusionistic devices from visiting Flemish masters like Hemessen and van Cleve.[21]

Hemessen's growing preference for energetic relief compositions compounded from overlapping diagonals and sharp formal reversals derives directly from the *Grand Maniera* of Rosso's decorations from the *Galerie François Ier*.[22] The *Contest between Athena and Poseidon* (figure 79) contains a tight intermeshing of angular forms and a suspended animation comparable to the *Last Judgment*. The prostrate victim at the lower right, whose agonized arm stretches out along the panel's bottom, was borrowed from the *Battle of Lapiths and Centaurs*. The kicking female nude with one arm raised recalls the contorted dying Adonis from the same cycle.[23] Even the oddly abrupt shift in scale from tiny, distant figures in the heavenly realm to large-size nudes in the ground finds precedent in Rosso's portrayal of the Olympian deities peering down on Athena and Poseidon.[24]

Almost a parody of the marvelous dual structure of Raphael's *Transfiguration*, this flagrant violation of classic principles of composition was a result of Hemessen's collaboration with the "small-figure" master he also employed for the background scenes of the *Parable of the Prodigal Son* (figure 46) and the Karlsruhe *Temptation* (figure 55). In this instance, the associate's intervention probably marks a departure from Hemessen's original plans for the upper register. There is a noticeable difference in height between the center panel and the wings (approximately 30cm.), suggesting that the compositional scope of the *Last Judgment* was reduced during the execution of the project, perhaps to accommodate the background master's diminutive style. Hemessen must have originally intended to paint a large figure of Christ the Judge comparable to Jan Provost's panel of 1524–26, at Bruges. That he should have utilized a collaborator for such an important element of the triptych indicates that he was overwhelmed by work at this flourishing stage in his career.

On the exterior wings of the Rockox Triptych Hemessen introduced a spectacular depiction of the *Double Intercession* (figure 80) a subject that traces back to the influential medieval doctrinal treatise, the *Speculum Humanae Salvationis*.[25] Both Christ and the Virgin Mary intercede for mercy for humankind. The Savior, kneeling on the column of his flagellation and holding the cross, exhibits his gaping wounds to God the Father, while across the way the Virgin bares her bosom in Christ's direction.[26] The supreme being blesses Christ as he swoops down from Heaven, proferring the crystal orb of salvation. The dove of the Holy Spirit hovers gracefully above the Virgin, completing the Trinitarian presentation. At the left stands St. Peter, pensive and withdrawn, clutching the keys to the gates of Heaven, and St. Paul, sword in hand, his eyes raised excitedly upwards. A

tall, mannish St. Margaret looms on the right astride a chained demon, solemnly displaying her sword. The Virgin flings her left arm back in the direction of the muffled demon. Margaret's index finger also conspicuously points towards the lurking presence of evil.

Ambitious formal devices heighten emotionalism. A criss-cross of bold diagonals of column, cross, keys and swords interacts with empyrean swirls to create spatial disorientation and flux. Christ calmly balances on his precarious perch, but his fingers are tense and contorted, conveying Grünewald-like vibrations of agony. The Virgin is wrenched in violent contrapposto, her fingers and toes similarly disrupted by uncontrolled energies. Taking a cue from Rosso, the Rockox shutters display an increasingly liberal and flamboyant use of Michelangelo that anticipates the late sixteenth-century Mannerism of Pellegrino Tibaldi. The broad, elongated proportions of Christ and masculine St. Margaret correspond to the taste of Daniele da Volterra and Sebastiano del Piombo, but their exuberant plasticity sets Hemessen apart from Michelangelo's immediate followers and closer to the camp of Salviati and Giulio. Hemessen quotes freely from the Sistine Ceiling for the Virgin's exaggerated sibylline pose and radically foreshortened Deity, the latter borrowed from Michelangelo's awesome God of Creation. The device of bridging two shutters by a flying figure was a daring innovation, to be picked up at Antwerp in the middle of the next decade by Pieter Coecke for the *grisaille* wings of his *Descent from the Cross* (Lisbon, Museu Nacional).

The Rockox wings mark an important stage in the development of Counter-Reformation iconography at Antwerp.[27] Hemessen's stirring orchestration of the Double Intercession affirms traditional Catholic dogma of the Trinity and places renewed emphasis on redemptive images of the suffering Christ and passionate Virgin Mary, who exposes both breasts to Christ in her fervor. The presence of the imposing, highly physical figure of the Savior just above the chapel altar serves to reinforce the sacred ceremony of the Eucharist acted out below. The large circular base of the column jutting out at the bottom of the panel makes an unmistakable reference to the host.

Hemessen's interpretation should be understood as a response to Protestant heterodoxy, which posed a growing threat to basic elements of church doctrine. Radical reformers in the Lowlands had launched direct challenges to both the Eucharist and the Trinity. An Anti-Trinitarian campaign was sparked off by Erasmus' elimination of traditional Biblical justification for the doctrine from his text of the New Testament (I John 5:7), on the grounds that it did not occur in Greek manuscripts or in patristic writings prior to the Vulgate: "There are three that bear record in heaven: the Father, the Word, and the Holy Spirit, and these three are one."[28] Even

more widespread was the so-called Sacramentarian heresy, a grassroots movement that denied the objective presence of Christ in the Eucharist. Enunciated by Wessel Gansfort and fellow Dutch radical reformers, rejection of the doctrine of transubstantiation became a mainstay of Anabaptism, the revolutionary sect that spread rapidly in Germany and the Lowlands in the late 1520s and early 1530s, to the dismay of both Lutherans and Catholics. Sacramentarians gave a symbolic interpretation to the mystery of the Eucharist, insisting that the word "est" in Matthew 26:26, "Hoc est corpus meum," actually meant "signifies."[29] Their denial of the actual presence of the Lord in the bread and wine met with great resistance among conservative elements, who regarded it as a dangerous heretical attack on Christ and His Church.

The Sacramentarian heresy spread to Antwerp as it did to all of the major centers of the Lowlands. One chronicler of 1525 reported that "in some cities the holy sacrament, the holy ointment and the ceremonies of the holy church were very dishonestly neglected."[30] In 1519, the wife of an Antwerp innkeeper was charged with outrageous blasphemy of the host and forced to make a pilgrimage to Rome.[31] A Jan Berkmans was accused in 1525 by the city magistrate of distributing books of Sacramentist orientation.[32] The growth of radical Anabaptism gave the heresy newfound force and direction. Antwerp, affiliated with the Hanseatic League of port cities along the North Sea and Baltic coast, was especially vulnerable to the rapid dissemination of radical notions by merchants and travellers. George H. Williams has noted that substantial numbers of Anabaptists filtered into the city during 1534 and 1535, many from Liège and Maastricht.[33] They easily became lost among the large underground population of the city.

While imperial edicts had been issued against Anabaptists as early as 1528–29, it was their astonishing takeover of the city of Münster under the fiery John of Leiden and installation of a communist regime in 1534–35 that made the sect anathema to Flemish burghers.[34] In 1535 Cornelis Grapheus published at Antwerp a scornful condemnation of the group, the *Monstrum Anabaptisticum rei Christianae pernicies*, which dramatized the Münsterite "tragedy."[35] Following the fall of Anabaptist rule of the city, the sect continued to be regarded as a major threat to established order, as expressed by an edict issued at Antwerp on February 19, 1536: "Images, pictures, prints or engravings of Jan van Leiden, . . . books containing the biographies of such heretics and delinquents are not to be sold."[36]

Hemessen's patron Adrien Rockox was surely sensitive to the menace posed by the Anabaptists, whose activities and opinions he had to confront in his position as burgomaster. He undoubtedly welcomed the iconographic assault on their Sacramentarian views in the Trinitarian Double

Intercession. Hemessen's Counter-Radical-Reform outlook stimulated the artist's powers of illusionism and utilization of dramatic *Maniera* devices. His emphatically physical presentation of Christ and the Virgin Mary (who bares her full bosom towards the viewer) was not only meant to counter doctrinal heresies of radical reformers, but also their fundamental iconphobic bias. Iconoclasm was increasingly turned to by the extremists as a public means of expressing their views, guaranteed to bring notoriety and swift reprisals.[37]

Hemessen's interpretation of the Last Judgment in the central panel may take aim at yet another popular manifestation of religious extremism, the bizarre antinomian sect called the Loists, after their leader Eligius (Loy) Pruystinck, a slater of Antwerp.[38] Basing their views on a total separation of man's carnal and spiritual natures, the Loists regarded sins of the flesh as extraneous to the salvation of the spirit, which they felt to be essentially sinless. Termed Libertines by their opponents—due to their implicit sanction of loose behavior—the Loists came to stand for wanton excesses of the flesh and contempt for Christ's eventual judgment of mankind's sins. Loy and nine of his followers were examined by the Inquisition at Antwerp in 1526 and forced to recant, followed by public display of penance and burning of their books. Their appealing doctrine continued to find believers among both poorer classes and wealthy Antwerp burghers, however. During the 1530s the Libertine movement spread to other areas of Flanders, Brabant and around Cologne. It was only in the mid-1540s that severe repression spelled an end to the movement, culminating in the execution of Pruystinck and several of his followers, who included the Parisian watchmaker Christopher Hérault. The heresy seems to have been popular among Antwerp artists. Among the individuals who fled the city to escape persecution at this time were four prominent members of the St. Luke's Guild: Cornelis Bos, Jacob Cocx, and Quentin Massy's two sons, Jan and Cornelis.[39]

Just as the exterior of the Rockox altarpiece counteracts Sacramentist and anti-Trinitarian heresies, the central panel, with its blatantly carnal depictions of the Resurrected Dead pressed earth and hell-wards by the heavy weight of their flesh, provides a fearsome reminder of the consequences of concupiscense. The sweaty tangle of writhing limbs suggests sensual indulgence run rampant, turned into an orgiastic nightmare. Libertinism here receives its just deserts according to traditional Christian doctrine of sin and judgment.

The overall pessimism of Hemessen's scene was undoubtedly colored by the general explosion of heterodox sects at Antwerp. The repressive arm of the Inquisition, with its sensationalist displays of torture, execution and public penance, tended to create an atmosphere of alarm about the threat

posed by the radical Reformation. Imperial placards warned of the impending wrath of God should the growth of heresy go on unchecked.[40] General hysteria was aggravated by famine, outbreaks of the plague, and the renewal of millenarianism encouraged by the chiliastic oratory of Reformation preachers, many of whom were certain they were living in the last days of the world.[41] Hemessen's *Last Judgment* is as much an expression of the fears of his age as it is a record of his own insecurity about the means to achieve salvation—the central issue which was prying Christendom apart at the seams.

8

Hemessen's "Small-figure" Callaborator: Jan Swart van Groningen

Much of the literature on Hemessen has been devoted to the annoying problem of the small-figure background scenes found in a number of his works. Already in the nineteenth century, their style was regarded as identical to a painting of the *Parable of the Great Feast* (figures 85–86) at the Herzog-Anton-Ulrich Museum at Brunswick, which pictures a multitude of little figures gathered in a yard in front of a castle. Several atmospheric landscapes equipped with similar staffage were attributed to this painter, who was called the Brunswick Monogrammist after a cryptic signature on the *Great Feast*.[1] Added to this fairly well-established *oeuvre,* the Hemessen background scenes placed the Monogrammist firmly at Antwerp and linked him to the atelier of a prominent painter specializing in large figures.

Complications were rapidly introduced into the study of the problem that tended to deflect scholarly concern from the central issues. Rather than continuing to scrutinize the attribution of the background scenes to the Monogrammist in terms of the visual evidence, German art historians dealing with the field became involved in a long drawn out scholarly controversy revolving around the monogrammatic signature on the Brunswick panel. In a review of Bode's *Dutch Painters* published in 1884, Eisenmann proposed that the Brunswick Monogrammist and Hemessen were actually one and the same artist. He based this assumption on the following reading of the initials of the monogram: I S A(?) V H(?) M.[2] This identification proved to be extraordinarily appealing, in spite of the fact that it would make Hemessen an artist who commanded two very different styles of painting—one monumental and boldly realistic, the second miniature, colloquial and intrinsically landscapist and atmospheric.

Eisenmann's thesis was supported by Bode in 1887, although he had some reservations about the reading of the monogram.[3] A few years later a

rising star of Netherlandish painting connoisseurship, Max Friedländer, expressed qualified approval of the Hemessen/Brunswick Monogrammist identification in a review of the Bruges exhibition of 1902.[4] Finally, this tenuous thesis became the subject of an amateurish University of Heidelberg dissertation by a Thode student, Felix Graefe, entitled *Jan Sanders van Hemessen und seine Identification mit dem Braunschweiger Monogrammisten*, published at Leipzig in 1909. Friedländer continued to voice favor of the proposal, swayed by the apparent similarity of the Monogrammist's small figures to those of the background scenes of the Karlsruhe bordello panel (figures 56–57).[5] Like Graefe, he felt that the Monogrammist's *oeuvre* may have been the youthful work of Jan Sanders.

As Dietrich Schubert pointed out in his study of the Monogrammist published in 1970, there was considerable opposition to the idea from the very beginning.[6] Both Riegel and Weizsäcker came out against Eisenmann's hypothesis in 1900.[7] Wurzbach also dismissed it in his *Niederländisches Künstlerlexikon*, which appeared in 1906.[8] Reviewers of Graefe's 1909 monograph joined the ranks of nonbelievers, criticizing the author's generally faulty methodology.[9] A convincing argument against Eisenmann's proposal was advanced by Diez in 1909. He perceptively noted that Hemessen always signs his name in Latin form, "De Hemessen," never "van Hemessen." Since a "v" clearly appears in the monogram, there is no doubt that the initials cannot be his.[10]

It is not necessary to discuss subsequent bibliography on the subject of the Brunswick Monogrammist, since this has been dealt with adequately by Schubert. Suffice it to say that it is now generally accepted that the Monogrammist was not Hemessen. Among the various candidates for the painter, Jan van Amstel would seem the best choice, if the initials are deciphered J v A M S (L) — certainly a very logical reading.[11] Praised by van Mander for his fine landscapes, Amstel became master in the Guild of St. Luke at Antwerp in 1528. He continued to work there and died at a fairly young age, ca. 1542–43.

The question remains whether the original attribution of the small-figure background scenes to the Monogrammist can still be accepted. There is good reason for also rejecting this thesis. Comparison of photographic details of the Monogrammist's little beings with those in Hemessen's work demonstrates similarities in rhythmic grouping and facial expression, but also marked disparities in proportions, chiaroscuro, modelling and hue. The small figures of the Karlsruhe *Tavern Scene* (figures 56–57), Brussels *Prodigal Son* (figures 47–48), Vienna *Calling of St. Matthew* (figure 69) and Antwerp *Last Judgment* (figures 88–89) are much slenderer and more energetic than those of the Monogrammist, who favors squat figures with short necks and broad, lumpish faces (figures 39,

85–87). Those in Hemessen, on the other hand, have long necks and sharp, often emphatically aquiline profiles. Drapery is deftly articulated with fluid, calligraphic brushstrokes, and there are expressive dark shadows and dappled highlights. These qualities can also be noted in the two small figures (Cain and Abel?) in the roundel on the wall behind the Worcester clavichord player (figure 19), though inpainting makes their attribution difficult. The large standing figures of St. Peter and St. Stephen on the exterior shutters (figure 26) of the O'Campo *St. Sebastian Triptych* are definitely by the background master. They demonstrate his characteristic mannerisms and miniaturist touch in spite of their grander scale. They are particularly significant since they provide an instance of his work in full size.

Rather than the Brunswick Monogrammist, the true identity of the Master of the Hemessen Backgrounds is Jan Swart van Groningen, a fascinating specialist in woodcuts and stained-glass designs who, according to van Mander, also did paintings.[12] Swart's distinctive graphic manner agrees in many respects with elements we have noted in the small-figure scenes. A fairly large corpus of prints and drawings have been attributed to him on the basis of woodcuts of *Turkish Cavaliers* and *Christ Preaching by the Sea* mentioned in van Mander's essay on the artist.[13] They display the sharp profiles, expressive gestures and tendency to elaborate upon narrative potentials of the subject that can be seen in the backgrounds of Hemessen's panels (figure 90). Swart's exploration of unusual chiaroscuro effects in drawings such as *Lot and his Daughter* (figure 91, Amsterdam, Rijksmuseum) can be compared with the Karlsruhe episodes (figure 56–57).[14] His love of oriental turbans and other exotic headgear also crops up in the Hemessen scenes.

According to van Mander, Swart, or "Black Jan" as he was called, worked for a while at Gouda ca. 1522–23, where he became familiar with the painting of Jan van Scorel after his return from Italy. Though Scorel was never recorded at Gouda, the influence of his beautiful Romanist idiom can easily be detected in Swart's drawings and prints. Van Mander adds that Swart, like Scorel, spent a length of time at Venice and should be regarded as one of the foremost artists who introduced the "new manner" of Italy in the North. It has been recognized for some time that Swart must have moved to Antwerp after his trip to Italy, since his hand appears in the woodcut illustrations for the Liesveldt Bible of 1526 and the Vorsterman Bible of 1528, both of which were published at Antwerp.[15] Swart's woodcuts reveal him to be an inventive, if often rather hasty, illustrator familiar with the tradition of German Bible woodcuts and cognizant of the graphic achievements of Dürer, Lucas van Leyden, Holbein, Pieter Coecke and Dirk Vellert.[16] He was undoubtedly in contact with Lucas, who lived for a

while at Antwerp and contributed several cuts to the Vorsterman Bible. Delen assigns Swart the frontispiece for Martin Lempereur's edition of Erasmus' *Enchiridion*, published at Antwerp in 1529, and later reused for Thomas Wolsey's *Rudimenta grammatices et docendi methodus* (Antwerp, 1537). Swart contributed to other devotional works published at Antwerp as well.

Swart would thus have had numerous interests in common with Jan Sanders. Both had travelled and studied in Italy, and both were responsive to Dürer's example in the North. Perhaps they first met each other at Venice in the mid–1520s. They were about the same age and shared an avid Romanist outlook. It is understandable that Hemessen would have sought an artist who had similarly "modern" preoccupations to help in his atelier. Swart's graphic talents and expansive repertory of narrative subjects offered attractive additions to Hemessen's work, and at the same time did not pose a threat to his intrinsically bolder, monumental style. As noted in earlier chapters, his subsidiary scenes add important dimensions to Hemessen's genre-moralities and New Testament subjects. Spread out over a decade from 1530–40, the instances of collaboration were periodic and undoubtedly interspersed with Swart's print and stained-glass commissions.[17] In all likelihood Swart and Hemessen also collaborated on *tableaux* for Chamber of Rhetoric productions and other temporary festival decorations that occurred during these years.

Considering his involvement with Biblical illustration, Swart may well have swayed Hemessen to explore scriptural subjects in his panel paintings. Two drawings at Berlin survive from a suite devoted to the *Parable of the Prodigal Son* that probably predated his collaboration on the 1536 Brussels panel. The rhythmic poses, oriental headgear and foppish underpants of the *Departure of the Prodigal* (figure 92) reveal close parallels to the *Expulsion from the Inn* in the background of the Hemessen (figure 47). And, like the swineherd episode, Swart's drawing of the same subject harks back to Dürer's print, though with more of an emphasis upon the naturalistic treatment of landscape and animals.[18] Other drawings by Swart anticipate biblical themes painted by Hemessen in later years, including *Susanna and the Elders* and the *Parable of the Unmerciful Servant*.[19]

The identification of Jan Swart van Groningen as Hemessen's small-figure collaborator enables us to form a more accurate idea of this interesting artist's painting style than was possible heretofore. A mixed bag of attributions published by Hoogewerff, Friedländer and others has never proved satisfactory.[20] What now appears certain is that the competently Italianate *St. Paul and Barnabas at Lystra* (figure 93) at the Budapest Museum, formerly often attributed to Hemessen, should be firmly

assigned to Swart.[21] Its moody lighting effects can be compared with the group of chiaroscuro drawings as well as the backgrounds of the Karlsruhe panel. Another first-rate painting, *The Fall of Man* (figure 94), was acquired by the Minneapolis Institute of Arts in 1976 and perceptively attributed to Swart by Colin Eisler.[22] The small-figure *Expulsion from Eden* in the background (figure 95) is clearly by the same hand as the Hemessen scenes, and the distinctive modelling of Adam's features with slanted eyes corresponds to the saints of the O'Campo wings (figure 26). One may also note the peculiar treatment of kneecaps, ankles and toes. The nudes display a somewhat naive fusion of ideas drawn from the Raphael *Logge* depictions of the Fall with the bulky anatomical types of Hemessen's *Last Judgment*.[23] The appealing studies of a monkey, swan, doe, unicorn and other animals anticipate the delightful menageries of late sixteenth-century Netherlandish paintings of The Fall.

Background scenes with small figures in architectural or landscape settings are absent from Hemessen's work for about a decade after the Vienna *Calling* of ca. 1538–39. They re-emerge in another version of the subject of ca. 1548 (figure 70), also at Vienna, and crop up in panels from the 1550s such as the *Cure of Folly* (figure 137). Remarkably, their style resembles those of the 1530s, indicating that Hemessen's new assistant was a follower of Jan Swart. The late collaborator utilizes a variety of ancient ruins resembling the architecture of Swart's Budapest panel (figure 93), with foliage drooping from ruined entablatures and broken columns. A similar approach can be seen in two paintings that are entirely by his hand, though possibly they copy lost works by Jan Swart: the *Parable of the Unworthy Guest* (figure 96, Paris, Private Collection) and an *Adoration of the Magi* (figure 97, Liège, Hôtel de Bocholtz) based on a tapestry design by Raphael and his school.[24] The emphatic aquiline profiles and sharp oriental eyes clearly derive from Swart. They can also be observed in a *Crucifixion Triptych* at the Hermitage, probably an earlier work by this artist.[25]

At the Douai Museum there is a remarkable *Ecce Homo* (figure 98) with the characteristic small figures and antique ruins of Hemessen's late assistant.[26] The foreground figures of Christ and his tormentors place the artist in a Franco-Flemish milieu, with ties to the exaggerations of Marinus van Roymerswaele and his follower Corneille van der Capelle.[27] The formal arrangement of elongated, heavily-draped figures suggests relations to French Mannerism, while the anxious, introspective features of Christ and the man behind holding the drapery indicates influence of the ambivalent psychology of Hemessen's late panels. The same artist probably painted a tormented rendering of *Charles the Bold Wearing the Order of the Golden Fleece* (Vienna, Kunsthistorisches Museum), which has sometimes been assigned to Hemessen. Not attempting a historical portrait

of the fated Burgundian Duke, he adapted the features and pose from Dosso Dossi's *St. William*. Perhaps the painter may be identical with Adrien Pietersz Crabeth, who according to van Mander was a talented pupil of Jan Swart who travelled to France and died in Autun.[28]

As for the Brunswick Monogrammist, there is no evidence that he ever collaborated on any of Hemessen's panels. His role was limited to that of a copyist of Hemessen's work from ca. 1530–35 who attempted to assimilate the innovative figure style of the Antwerp painter, with mixed results. A copy at Prague (figure 37) after Hemessen's lost *St. Jerome in his Study* (figure 36) of 1534 contains a lovely atmospheric landscape that is undoubtedly by the hand of the Monogrammist. Obviously he was much more competent in this area than in his rendering of the features of the saint. Two other panels ascribed to the Monogrammist by Schubert are very likely copies after lost Hemessens as well: the Mainz *Lamentation* (figure 23) and a *Madonna and Child* (figure 84) that was last seen at auction in Cologne in 1962.[29] In both cases the Monogrammist fails to capture the anatomical realism and dynamic interplay of plastic forms which the originals surely possessed.

An instructive example of the Monogrammist's "large-figure" manner is found in a *Portrait of a Girl with a Lute* (figure 38) that was at one time mistakenly attributed to Hemessen by Vitale Bloch.[30] It was observed that a small-figure group of *Christ with Martha and Mary* (figure 39) by the Monogrammist formerly in Max Friedländer's private collection was in fact a fragment cut from the upper left corner of the portrait. One can understand why this appealing little scene was removed since it is considerably more competent than the lute-player with her lifeless stare and stubby fingers. (Though both panels are now at the Berlin Museum, there are no plans to fit them back together.) Again, the Monogrammist seems to have been attempting to emulate Hemessen models like the *Portraits of a Young Princess (Margaret of Parma?)* (figures 18–19) or the *Man and Wife Playing Tables* (figure 45).

In an earlier chapter, I suggested that the *St. Jerome Penitent in his Study* (figure 44), an iconographic curiosity now at the Norton Gallery in Palm Beach, could well represent a collaboration between the Monogrammist (responsible for the saint) and Joos van Cleve (the setting).[31] If so, we have a somewhat more successful instance of the Monogrammist's study of Hemessen's monumental figures, though again the foreshortening of arms and hands is not fully understood, and the expression is heavy-lidded and cadaverous. If the Monogrammist was actually Jan van Amstel, as many are now inclined to believe, the deficiencies of these "large figure" works may explain Lampsonius' comment (quoted by van Mander) that Amstel

wisely "made landscapes rather than making the mistake of painting heads, divine or human, poorly."[32]

This brief analysis of Hemessen's relations with Jan Swart and the Brunswick Monogrammist calls attention to the complexities of sixteenth-century Antwerp workshop practice, a field that demands further scholarly attention to achieve a more accurate understanding of the roles assigned by the head master to his assistants, and also the growing phenomenon of collaboration between painter-specialists of equal rank. Hemessen's extensive utilization of Jan Swart's talents expands upon the well-known precedent of collaboration between Quentin Massys and Joachim Patinir on the *Temptations of St. Anthony* (Madrid, Prado). Van Mander cites another instance in which Patinir did a landscape background to a Madonna by Joos van Cleve.[33] Like the Massys and Cleve ateliers, Hemessen also undoubtedly employed landscape specialists on his panels, especially in his later years, though no one hand stands out distinctly like that of his "small-figure" collaborator of the 1530s.[34]

Hemessen, High *Maniera* and Counter-*Maniera*

The development of Hemessen's style of painting in the decade of the 1540s demonstrates more complex and sophisticated responses to the burgeoning sphere of International Mannerism. Unfortunately, a comprehensive study of this important decade of art history in Italy and Fontainebleau is still lacking.[1] Amid a multiplicity of local movements and individual statements, two major trends in Italian art have been distinguished by Sidney Freedburg that might be useful as artistic barometers to assess Hemessen's work towards mid-century. The first is an extension of *Maniera* style in Florence and Rome, visible especially in Bronzino and Vasari, towards greater sculptural refinement of form and color, stylization of gesture and ornamental rendering of details. Normally called High *Maniera*, this evolved style is now viewed in opposition to a spiritually-oriented perspective that can be associated with Michelangelo's *Last Judgment* (completed 1541) and with his pupils like Daniele da Volterra who gave expression to reform movements within the church and to what was soon to become official Counter-Reform doctrine. Freedberg labels this other movement Counter-*Maniera*, an acceptable term though one that presumes, not always with justice, a stylistic revolt against High *Maniera*.[2]

Counter-*Maniera* signalled a growing austerity in its somber concentration on the Christian image, its iconic clarity and concern with effecting immediate communication of religious emotion. If we consider Hemessen's artistic production during the 1540s in relation to what was taking place in the South, we find him alternately mirroring both trends, shifting his point of view almost willfully from Counter-*Maniera* pietism to the stylized refinements of *Maniera*. At the outset of the decade, there is a marked intensification of the spiritual, otherworldly quality of his work, implying a deliberate effort to reform outmoded types of religious imagery to meet the requirements of spreading Counter-Reformation sentiment. He prefers an austere, monumental image, very often concentrating on a single, iso-

lated figure portrayed with an expressive naturalism. While continuing this nominally Counter-*Maniera* approach throughout the decade, Hemessen nonetheless undergoes intermittent spells of stylistic elaboration and preciosity, and at one point becomes almost exclusively interested in the elegant idiom of International Mannerism.

The first statement of new trends of Counter-*Maniera* piety can be noted in a *Salvator Mundi* that emerged briefly on the Leipzig art market in 1933 and is known only from a poor photograph taken at that time (figure 99). Though it is hard to tell for sure, the panel probably dates from the late 1530s. Christ assumes a majestic pose, the crystal orb of the world balanced on his knee and his right hand raised in a gesture of benediction. His head is framed by a circular aura, adding iconic intensity to his severe gaze. A sober and disquieting image, the *Salvator Mundi* reflects the grim mood of the Antwerp *Last Judgment* and looks forward to the monumental imagery of the 1540s.

The decade begins with a full-fledged expression of heroic piety, a three-quarter length cross-bearing *Man of Sorrows* (figure 100) now at the Linz Museum, signed and dated 1540. A robust, sinewy Christ stands holding the cross and displaying the open wound in his side, his head crowned by a thicket of thorns. The figure is illuminated by a flash of unearthly light, leaving much of the form in dark shadow. He looks off to one side with a heavy gaze and half-open mouth. Stress is placed upon harsh surface effects like the rough wood of the cross, the brittle, metallic drapery, heavily veined forearm and tiara of needle-sharp spines. The tense, aging hands and rigid posture express a mood of suffering long-endured.

The iconography of the cross-bearing *Man of Sorrows* follows a Netherlandish artistic tradition associated with the monastic orders.[3] Hemessen was undoubtedly familiar with northern antecedents like the *Man of Sorrows with an Angel and Donor* formerly in the Renders collection, which also combines an elevated cross with the gesture of *ostentatio vulnerum*.[4] The Linz panel breaks with its Netherlandish precedents in the close-range, tight presentation of the monumental nude. The format recalls Bronzino's impressive *Portrait of Andrea Doria* as a three-quarter length nude Neptune (Milan, Brera), though Hemessen introduces an otherworldly tenebrism that differs radically from the classicizing treatment of the nude. He harks back to Michelangelo's *Risen Christ* at Santa Maria Sopra Minerva with similar freedom, replacing the dignified rhythms of the sculpture with the flamboyant pose of a Titianesque standard-bearer.[5] The triumphal pose evokes the theme of the cross as military standard, an analogy dating from the beginning of Christian apologetics that was dramatically revived in the Counter-Reformation era by Ignatius Loyola in his "Meditation on Two Standards" for the *Spiritual Exercises*. Hemessen's interpretation of

the cross-bearing Man of Sorrows suggests that he was redefining traditional Netherlandish iconography to reflect Jesuit emphasis on militance and self-abasement.

A similarly bold iconographical departure occurs in a panel of *Susanna and the Elders* from 1543 in a private collection in Barcelona (figure 101).[6] The maiden is portrayed in violent contrapposto, twisting away from the clutches of the fiendish elders. One of her attackers thrusts an arm brazenly around and under her thigh, while she instinctively draws her legs together and tries to ward him off with her left hand. The other elder makes a pretense of sincere affection, his sanctimonious attitude mocking the heartfelt gesture of Hemessen's earlier *St. Jerome* (figure 42). The pose of the struggling woman again recalls the *Laocoön.* (The arm snaking over her thigh directly recalls the serpent coiled around the leg of the Trojan priest.)

Hemessen's daringly erotic presentation may have been encouraged by the relief sculpture of the theme in the *Cheminée du Franc* at Bruges, executed in 1530 by Guyot de Beaugrant, one of the best of the Italianate sculptors working for the court of Margaret of Austria.[7] Its blatant sexuality also relates to German Renaissance paintings and prints dealing with moral corruption, like Altdorfer's *Lot and his Daughters* of 1537 (Vienna, Kunsthistorisches Museum).[8] The posture of the maiden—her thighs squeezed together and head tossed back—is oddly reminiscent of Rosso's *Dead Christ with Angels* (Boston, Museum of Fine Arts), though direct derivation need not be implied. It is more likely that Hemessen knew of Boyvin's print of *Susanna* after Rosso, a dramatic presentation with a similar contrast between a sensual female nude and the grotesque, frantic elders. Another print was used for the head of the maiden: the memorable *Bust of a Bereaved Woman* formerly attributed to Jacopo de'Barbari and now regarded as the work of Jacopo Francia (figure 102).

Reproductive prints from the South had become widely available in the ateliers of Flemish painters by the 1540s, and they were employed with greater frequency by Hemessen and other Romanist masters. The latest developments at Fontainebleau were transmitted abroad by the large school of engravers (many of them Flemish) headed by Boyvin and Fantuzzi.[9] Later in the decade, northern printmakers in Rome began making their own copies after famous High Renaissance paintings. Moving to Antwerp in 1551, the Mantuan graphic artist Giorgio Ghisi worked with Hieronymus Cock to develop the art of reproductive engraving, which rapidly became a specialty of the local workshops.[10]

Hemessen's production from the early 1540s also includes two innovative versions of the *Holy Family in a Landscape,* both unfortunately known only through copies. One of these, the *Holy Family with the young*

St. John (figure 103, Munich, Alte Pinakothek), bears a false Hemessen signature and date of 1541 copying the lost original. Drawing heavily on recent *Maniera* statements in Italian art, the Munich panel creates a rustic transalpine formula for the theme of the Holy Family. The smooth, sculptural modelling of the Madonna and children and the broad, vertical structure filled out with St. Elizabeth and the brooding Joseph at left and right derive from compositions popularized by Bronzino and his followers. The tender golden highlights and fine, ornamental strands of hair can be compared with Italian paintings like Raffaello del Colle's *Madonna and Child with the young St. John,* at the Walters Art Gallery.[11] In contrast to the Italian examples, Hemessen's figures possess an earthy, countrified demeanor relevant to his own notions of reforming religious imagery.

Similar directions were taken in another *Holy Family* (figure 104) from these years, preserved in copies formerly in private collections at Berlin and Magdeburg. The copyists have clearly had trouble with the complex pose of the Christ Child, who is based on sophisticated classicizing sources such as Gossaert's *Hermaphroditus.* The child's erratic struggle contrasts with the calm, rustic setting replete with thatched cottage. Ever-solicitous, St. Joseph offers a spoonful of porridge to the hyperactive infant.[12]

We can get a better idea of the quality of the lost originals from a fine Hemessen *Madonna of Humility* (figure 105) from 1543, at the Prado. Recorded in the Spanish Royal collections as early as the eighteenth century, the panel bears a monogram "AOD" ("Anno Domini") patterned after Dürer's cipher and the date 1543. Hemessen captures a serene, soulful mood akin to Leonardo's *Madonna and Child with St. Anne,* at that time one of the treasures of the collection of Francis I.[13] The monumental presentation of figures is subdued by a roseate *sfumato* and dusky Giorgionesque landscape. The antique pose of a struggling infant Hercules modulates into a graceful dance to suit the tender mood.

A second panel of 1543, now at the Hermitage, updates the image of the *Penitent St. Jerome* (figure 106) from Hemessen's early version of 1531 (figure 27). No longer a youthful athlete, the saint has become a brawny Atlas with the overwrought muscularity of one of Giulio Romano's *Giganti.* His attitude suggests a groping, earthbound Polyphemus, a living extension of the rock he bestrides. Hunched over crucifix and open book, Jerome resembles one of the fishermen who draw in nets in Raphael's tapestry of the *Miraculous Draught of the Fishes,* the cartoon for which had been located in the Lowlands for some time.[14] As suggested in chapter 3, Hemessen also drew inspiration from a favorite Romanist source: the *Torso Belvedere* (figure 107).

The 1543 *Penitent St. Jerome* represents an evolved Mannerist state-

ment of the Flemish tradition of expressing spiritual austerity through solid, concrete reality. The muscular build of the saint is of definite iconographical significance, alluding to his heroic fortitude as he undergoes the rigors of penance. Dispensing with the device of the table formed from rock, Hemessen has the saint deposit his devotional objects directly on the ground to emphasize his humbleness, propping the crucifix and Bible against the skull in a seemingly makeshift manner. Jerome is positioned close to an angular, gnarled stump of a thorn tree—a traditional symbol of the sufferings of Christ. A vision of the Last Judgment can be seen through a gap in the rocky precipice. In effect, the saint becomes a living extension of his mountainous fortress. One wonders whether Giovanni Bologna drew inspiration from the panel for his marvelous giant sculpture of the Apennines, which he chiselled out of stone in the gardens at Pratolino in the 1570s.

The image of the strongman humbling himself in devotion again reflects the impact of Loyola's teachings. The meditation on the Three Modes of Humility in the *Spiritual Exercises* stresses the necessity of self-abasement on the path to salvation, even to the extreme of being "considered as worthless and a fool for Christ who suffered such treatment before me."[15] Hemessen must have had the Christ-like association in mind, for Jerome's pose makes an obvious allusion to Christ collapsed under the weight of the cross on the *Road to Calvary*, as seen in Schongauer's engraving of the subject or Raphael's "*Lo Spasimo di Sicilia*", which was widely known in the North through the 1517 engraving by Agostino Veneziano (figure 108). An extremely important work for developing modes of Counter-Reformation imagery, the Raphael had no doubt been known to Hemessen for some time. The murky inking of the reproductive print may have contributed to his developing preference for somber chiaroscuro.

Hemessen's growing interest in the *Spiritual Exercises* stemmed from his own penitential concerns as well as his desire to reform religious iconography. In an earlier chapter we have discussed the likelihood that he came in contact with the Jesuit leader during Loyola's early visits to Antwerp and even painted a concealed portrait of him in the Lisbon *Penitent St. Jerome* of 1531.[16] By the date of his second version of the subject, the movement had made official headway in the Lowlands. Though the *Exercises* were not officially promulgated by the church until 1548, when a Latin translation was authorized for publication at Rome by Pope Paul II, they had been widely disseminated by Loyola's corps of dedicated followers prior to this time.[17] Major efforts began in the Lowlands in 1542, when a group of founding members of the Society of Jesus fled Paris for Louvain after the outbreak of war between the Emperor and the French

King.[18] Chief among them was Loyola's confidant Pierre Favre (Peter Faber), who preached the *Exercises* at Louvain for the next two years and made a number of influential converts.

The Hermitage *St. Jerome Penitent* also suggests the impact of another important book that was published the same year as the painting, Andreas Vesalius' great *De Humani Corporis Fabrica* (Basel, 1543). This monumental anatomical treatise stimulated Hemessen's more pronounced musculature. The complex interaction of bulging muscles, tendons and ligaments of the Herculean kneeling saint corresponds closely to the flayed nude males of the second book of the treatise, who twist and turn in different directions to demonstrate, in Vesalius' words, how the muscles "affect the movements that depend on our will."[19] The figures of the *Fabrica* make a dramatic advance in anatomical illustration from the lifeless studies that were formerly available. The woodcuts take a significant place in the Northern Romanist tradition, since they were executed by the Rhenish artist Jan Stephan van Calcar, who worked at Venice under Titian from ca. 1537, absorbing the fundamentals of the new Italian manner so that, according to Vasari, "his works were not always perceived to be those of a Fleming."[20] Vasalius, son of an apothecary at the court of Margaret of Austria and Charles V, had studied at the Collegium Trilingue at Louvain and the University of Paris during the early 1530s. By the date the *Fabrica* was published he had attained an illustrious reputation as Professor of Surgery at the University of Padua. Hemessen may well have known Vesalius personally through his contacts with the imperial court. The treatise, dedicated to the Emperor Charles V in the preface dated 1 August 1542, was a massive undertaking that must have received imperial financing.

In other works from these years Hemessen pushes his technical capabilities to the limits, attaining Mannerist fluency in panels that challenge accepted iconographical notions. The scene of foolish venery of the Hartford *Brothel* panel 1543 (figure 58), is painted with a controlled brush rivalling anything being done at the time in slick sophistication. His *Madonna of Humility* of the next year (figure 109, Stockholm, Nationalmuseum) carries drapery elaboration and tactile flesh to new extremes of stylistic extravagance. Hemessen revives Gossaertian virtuosity, while at the same time he challenges Dürer's naturalism in the brilliant detailing of grapevines climbing the trellis with their lush bunches of black and white fruit.

The Stockholm Madonna, based on High Renaissance sources like *Ezekiel* from the Sistine Ceiling or Fra Bartolommeo's *St. Mark* (Florence, Pitti), bares her breast with compelling urgency, as if trying to stave off the Christ child's tragic destiny with the food of life.[21] The sense of restlessness is compounded by the pronounced contrapposto of the Child—a direct adaptation of the fluid pose of Raphael's *Galatea* (figure 110), earlier used

as a source for the Christ child in Joos van Cleve's *Madonna of the Cherries* (formerly Richmond, Cook Coll.)[22] Grasping a tuft of drapery as if trying to stabilize himself, the plump nursling writhes uncomfortably in his mother's lap. The nervous play of light and shade adds further undertones of anxiety to Hemessen's moody presentation.

In a second signed and dated panel from 1544, the *Mocking of Christ* (figure 111, Munich, Alte Pinakothek), Hemessen marshalls his ability to manipulate surface effects and lighting for chilling visual impact. Basing his composition on the vertical format developed by Bosch in his presentation of the subject (London, National Gallery), he carries the savage portrayal of tormentors to mannered extremes of bestial fury, packing in nine mocking figures to Bosch's four and adding derisive gestures borrowed from the repertory of German art. The man baring his teeth by pulling at the corners of his mouth with his fingers ("ein Gähnmaul machen") occurs in Hans Leinberger's *Crucifixion* relief (figure 4) and pictures by Jerg Ratgeb, while the crude tongue insult is found in the *Derision of Christ* from Ratgeb's *Herrenberger Altar* at Stuttgart (1518-19).[23] Christ looks down sorrowfully at two little children who join in the mockery with blatantly obscene gestures including the scabrous *"mano in fica,"* in which the thumb is stuck out between index and middle fingers.[24] The extraordinary look of choleric frenzy of the tormentor at lower left was based on expressive German sculpture like Adam Kraft's statuette of a *Man Breaking a Branch* (Munich, Bayerisches Nationalmuseum). One of the most bitter investigations of psychological abuse in the history of art, Hemessen's *Mocking of Christ* evokes the threat of evil gone rampant that obsessed Counter-Reformation Europe, contributing to such phenomena as the witchcraft scare.

Also at Munich is a striking depiction of *Isaac Blessing Jacob* (figure 112) dating from the mid-1540s. Isaac, blind and bedridden, mistakenly bestows his benediction on his younger son Jacob rather than the first-born Esau, who is out hunting and may be observed off in the distance. An allegory of the mysterious workings of divine providence, the subject was especially appropriate to a period of religious crisis.[25] The subtheme of deception provided fuel for Hemessen's growing Manichaean outlook.

The panel is dominated by a *Maniera* hommage to classic sources. Hemessen observes High Renaissance principles of symmetry in the pyramidal disposition of three figures and carefully balanced recession. Isaac, energetic and muscular in spite of his infirmity, sits up from bed to bless the young Jacob, an ephebe with comely features and flamelike locks of hair similar to Adam in Dürer's famous engraving of the *Fall of Man* (1504). Rebecca sprawls knowingly at the foot of the bed, her languorous pose reminiscent of Michelangelo's *Leda* or its antique prototype, the

Sleeping *Ariadne,* a bronze copy of which had been made for Fontaine-
bleau by Primaticcio and Vignola.[26] The classicizing composition was pat-
terned on Raphael's *Isaac and Jacob* fresco at the Vatican Logge. Agostino
Veneziano's engraving after the fresco contains similar figures of father
and son, as well as the columns and expanses of drapery over the bed
(figure 113). Hemessen adopts the strong contrast of light and shade of the
print, including the dramatic highlighting of Isaac's outstretched arm and
the dark shadow cloaking the face of the youth. He replaces the classical
lions leg table with a little Flemish server, however, its hinged leaves
opened up for the meal. The table is positioned at the center of the panel as
a focal point for the three figures. Isaac's gesture of blessing quotes the
God of Creation of the Sistine Ceiling, similar to the Christ Child in
Hemessen's early *Madonna* (figure 13) at Lisbon.

In addition to studious classicism, the *Isaac Blessing Jacob* contains a
liberal dose of mannered ornamentation in the drapery folds and writhing
locks of hair comparable to the Stockholm *Madonna of Humility* and
Munich *Mocking of Christ.* The laced ties of the pillowslip and elegant
flatwork pattern of the rumpled bedspread are outstanding passages of
Mannerist virtuosity. Alternating with these areas of patterned elaboration
we find naturalistic motives harking back to the genre-moralities of the
prior decade — the playful lapdog, platter of roast kid and dinner-roll. The
graphic portrayal of Isaac's ravaged features is almost shocking in the
midst of the stylized elements of the composition.

Such shifts between abstraction and realism within the same work
were, to be sure, nothing new in northern art, which for centuries revelled
in the intermixture of observed nature and abstract decoration. Realism in
Hemessen also normally serves a symbolic function, though in this case it is
not immediately clear to what end. The harsh portrayal of Isaac is a far cry
from conventional representations of the benevolent blind patriarch found,
for instance, in Orley's grand tapestry suite of the *Story of Jacob,* woven at
Brussels in the 1530s.[27] His degenerate appearance suggests that Hemessen
may be alluding to moral corruption in his interpretation of the Old Testa-
ment story, something also implied by Rebecca's indolent posture and her
lapdog, a symbol of Sloth.[28] As we shall see, a later version of the subject
(figure 124, Österby Chapel, Sweden) conveys in even stronger language a
sense of sinful infirmity hidden within the biblical drama.

In a signed portrait from 1543 that came to light a few years ago in an
English private collection, Hemessen adopts a severe style soon to become
the prevailing mode for international court portraits (figure 114).[29]
Wearing a flat-brimmed hat with ear-flaps associated with the legal
profession, the subject is portrayed standing in three-quarter length against
a quiet green background, holding a pair of gloves.[30] His stiff carriage,

bony hands and sharply chiselled features reflect the type of German court portraits that became *de rigueur* for the Fuggers as well.[31] The rigid demeanor and transfixed stare looks forward to the style of Antonio Moro (Anthonis Mor), the highly successful Hapsburg portraitist who worked at Antwerp in 1547–48, when Hemessen was Dean of the St. Luke's Guild.

During the second half of the 1540s, Hemessen jumps from High *Maniera* to Counter-*Maniera* approaches depending on his subject matter. Two depictions of St. Jerome from these years are done in an emotive, fundamentally naturalistic mode remarkably free from High *Maniera* refinements. A *St. Jerome Writing* is known through a studio copy at Hampton Court (figure 115) that reproduces the signature and date (1545) of the lost original. Devoid of the hyper-muscularity of the Leningrad panel of 1543, the sturdy nude saint assumes a relaxed, casual pose drawn from north Italian models like Savoldo's *Writing Evangelists*. The *facture* is broader than what we have seen before. These anti-formal tendencies are developed further in an important work from 1548, in a private collection at Barcelona (figure 116). A remarkable expression of ascetic spirituality, the hermit saint supplicates the crucifix in a moving gesture of atonement. Lightning flashes through the chasm in the background, illuminating the aged penitent, who appears carried beyond the limits of his endurance. Borrowing the expressive pose from sources like Savoldo's *Portrait of a Man with an Open Book* (Brescia, Salvadego Collection), Hemessen employs increasingly fluid brushwork and other-worldly play of chiaroscuro reminiscent of Tintoretto or, later, El Greco.[32] The Stockholm panel looks forward to Baroque depictions of the saint as an impassioned visionary pictured in similarly turbulent and moody settings. Considering its Spanish provenance, it may well have influenced the dramatic conceptions of Ribera.

Hemessen's revised interpretation of St. Jerome expresses the growing emotional fervor of the Counter-Reformation. The hermit fathers were regarded with heartfelt sympathy by Loyola and other militant forces within the Church for their penitential austerities and personal identification with the sufferings of Christ. Jerome's position of importance is underscored by the Council of Trent's action in its inaugural session of April, 1546, to accept his translation of the Bible (the Vulgate) as the Authorized Version.[33]

The emotional piety of the Barcelona *St. Jerome* is evident in another Hemessen from these years located in Spain, a *Christ Bearing the Cross* (figure 117, Toledo, Museo de Santa Cruz), which is inscribed with the name of the artist and the date 1549.[34] The Savior is depicted in three-quarter length with the crown of thorns and rope of His labors, leaning under the heavy weight of the cross. His tearful expression and the

profusion of watery blood flowing from the wounds inflicted by the thorns evoke the agonies of His betrayal in a moving way (figure 118). Christ's head is framed by a large golden nimbus in the form of a star with numerous linear rays, like those found in some of Dürer's prints.[35] The trefoil extensions at the horizontal extremes provide symbolic reminders of the Trinity. Basing his presentation again on North Italian prototypes (figure 119), Hemessen was also responding to *"Lo Spasimo di Sicilia."* The archaizing nimbus and extreme pietism indicate that, like Sebastiano del Piombo's late *Pietà* of Ubeda, the Toledo *Christ Bearing the Cross* was conceived for export to Spain.[36] Like the tearful *Penitent St. Jerome*, the weeping Savior anticipates the pronounced emotionalism of El Greco's work later in the century.[37]

The moody effects of these images can be compared with Hemessen's *Calling of St. Matthew* (figure 70) from the late 1540s, already considered in the chapter treating the subject. In contrast to the austere style of the Spanish panels, however, the *Calling* demonstrates insistent High *Maniera* qualities in its complex, interlocking figure composition and finicky detailing. While Hemessen could have come into contact with new trends at Antwerp, with its active art trade, the lack of any dated paintings or documents from 1546–47 makes it possible that he was again abroad during these years, perhaps visiting North Italy and France.

The impact of High *Maniera* is noticeable in three other works done towards the end of the decade. A polished *Portrait of a Young Man* (figure 120, Coll. of the Earl of Warwick) was first assigned to Hemessen at the Brussels exhibition of sixteenth-century Flemish painting held in 1963.[38] While the attribution is perfectly all right, the date of ca. 1540 proposed by Philippot is much too early, considering the characteristics similar to the Toledo *Christ Carrying the Cross* of 1549, notably the large, bovine eyes and half-open mouth with moustache combed down over the upper lip. The subject's aloof, sullen look recalls Bronzino's portraiture: comparably scrupulous rendering of the nubby silhouette of the garment can be noted in the Florentine's *Portrait of a Youth* (Milan, Castello Sforzesco), which also displays a preference for high-arched eyebrows and bulging eyes.

Hemessen combines Bronzino's *Maniera* influence with the nervous play of hands of Gossaert's portraits. He adds a lofty peak in the background that enhances the young man's stature and helps to establish a solitary, reflective mood. The mountain harks back to German portraits such as Cranach's famous depiction of the humanist *Johannes Cuspinian* (Winterthur, Oskar Reinhart Collection) or the so-called *Paracelsus* by Quentin Massys, which is thought to copy a lost German original.[39] The nervous outline and claw-like hands convey marked vibrations of anxiety, while the extreme refinement of surface detail evident in the glossy, almost brittle

complexion and spun-cotton beard contributes to the peculiar intensity of this work, which forecasts the frigid *morbidità* of much of northern portraiture of the second half of the century. The motto inscribed on the slip of paper held by the subject, "Fortune Le Veult" ("As Fortune Determines"), expresses a stoical acceptance of fate in accord with the growing resignation of the times.[40]

Similar emphasis on smooth modelling and *Maniera* finesse is found in a three-quarter length nude *Judith with the Head of Holofernes* (figure 121), now at the Art Institute of Chicago, probably identical with a Hemessen cited in the Antwerp collection of Steven Wils the Younger in 1628.[41] The Old Testament heroine is portrayed as a sinuous, powerful nude, her sword raised in triumph following the completion of her gruesome task. For the first time, Hemessen makes use of the *figura serpentinata,* a favorite device of International Mannerism that was to find supreme expression in the sculpture of his fellow Fleming Giovanni Bologna. Bologna could have already been experimenting with the *serpentinata* during his early years as assistant in the workshop of Jacques Du Broeucq at Mons ca. 1544–50. Her protruberant abdomen and heavy hips conform, however, to a northern standard of feminine proportions found in Dürer and Cranach, or the boxwood statuettes of the German master Conrat Meit, who settled at Antwerp after working at the court of Margaret of Austria at Malines.

The bold display of a maiden's buttocks gives the nude a provocative flavor that would undoubtedly have delighted Rubens, who may well have known of Hemessen's *Judith* at Antwerp in the seventeenth century. Wescher has suggested that the device derives from the memorable *ostensio pygal* of the antique *Venus Kallipygos.*[42] It is more likely that Hemessen was recalling the Cupid in Bronzino's intriguing *Allegory of Venus and Cupid*, now at the National Gallery, London, which was on view at the French court from ca. 1545 onwards.[43]

The idealized features of Judith—her V-shaped chin, large round eyes, elongated ears and broad forehead—follow the fashionable Mannerist standard of facial beauty established by Michelangelo's *Victory*, which became a cult work for mid-century artists. The new aesthetic had recently been promulgated at Fontainebleau by Cellini in sculptures like his elegant wax *modello* of Juno done in the early 1540s as part of a projected series of silver candelabra of pagan gods and goddesses the sculptor writes about in his *Autobiography.* Though the project was aborted, the *Juno* is recorded in a fine drawing by Cellini's hand (figure 122), now at the Louvre.[44] The drawing reveals a similar stylized abstraction of features harking back to the *Victory* and stylish classicizing coiffure parted in the middle. The graceful serpentine movement of the torso, with one arm drawn down

around the front and the other raised rigidly at shoulder level, is also very close to the *Judith*. The clear influence of the Cellini makes it almost certain that Hemessen visited Fontainebleau in the mid-1540s after its completion.

A pronounced concern with *artifizioso* effects is also noticeable in an accomplished *Holy Family* (figure 123) in the Schönborn Collection at Pommersfelden. The Christ Child looks up longingly at the bunch of grapes tendered by Joseph, his raised hand gently grazing the Virgin's cheek. The slender, doll-like proportions, porcelain flesh and tender play of curvilinear forms harks back to the exquisite mannerisms of Gossaert, for Hemessen a persistent point of reference for courtly taste.

The ambivalent nature of Hemessen's work from the 1540s, shifting back and forth from abstract stylization to spates of naturalism and strong emotion, reflects a lack of cohesion in developing modes of European art, just as it indicates a duality in his own temperament. Continuing to search out new alternatives in the painting and sculpture of the South, he discards them promptly once they have fulfilled their immediate purpose. The forced elegance of the end of the decade allowed him to work out his obsession with *Maniera* refinements, however, for he will shortly plunge into an anguished *Spätstil* that shuns intricate detailing and polished effects. As we shall see, the work of the 1550s embarks upon thematic directions that provide a unifying force missing from the erractic movements of the prior decade.

10

Hemessen and the Crisis of the Counter-Reformation

The last phase of Hemessen's career is represented by a fascinating group of signed panels dating from 1551 to 1556.[1] Shunning the Mannerist preciosity that had absorbed much of his interests in the preceding decade, they are marked by a frank, often brutal realism and jarring stylistic deformations. Hemessen's anguished *Spätstil* captures the mood of crisis pervading the Lowlands at mid-century, when hopes for religious tolerance and sensible reform were stifled by the hardened stance of the Tridentine church. Anxieties were further generated by the serious lessening of the aging Emperor's powers and the prospect—alarming to many Netherlanders—of imminent rule by the Spanish-speaking Prince Philip, an unapproachable and enigmatic figure. If the work from Hemessen's last years is frequently mired in widespread pessimism, it redeems itself by an energetic commentary on the critical issues of the Counter-Reformation that extends the revolutionary iconographical explorations of the 1530s and '40s in remarkable ways.

The first dated work surviving from the decade is an *Isaac Blessing Jacob* (figure 124), formerly in the collection of the Hapsburg Emperor Rudolph II and now at Österby Chapel in Sweden. Signed and dated 1551, the panel makes an abrupt departure from the classicizing version at Munich from only six or seven years before (figure 112). The carefully disposed symmetry of the Munich panel is replaced by an anti-classic, off-key composition consisting of a series of elongated diagonals which overlap and intersect without apparent system. Doing away with any vestiges of mannered artistry, Hemessen paints the entire scene with a loose, unflattering brush.

Isaac and Jacob are squeezed into the left half of the panel while Rebecca, a tall, ungainly *Hausfrau*, looms towards them from the right. The blind Isaac looks out at the viewer with an anguished, strangely

observant gaze. The cold lighting emphasizes the patriarch's obvious infirmity: his face ravaged by fever and body twisted by ague or palsy. Rebecca's sallow, drooping features and lethargic stare also imply some sort of degenerative condition. The young Jacob, no longer a comely ephebe, kneels unsteadily to receive the blessing. His mentally deficient look and swollen, bandaged leg suggest that he is the victim of epilepsy, or, as it was called at the time, the "falling gout."² The mood of sickness and corruption is completed by the scruffy, emaciated cat poking at an unappetizing roast hare while a little dog waits patiently under the table for a morsel.

Disease was commonly associated with moral decay in Biblical commentary, and it can be assumed that the deteriorated physical condition of Hemessen's figures is meant to symbolize the vitiating effects of the Deadly Sins. Slothful negligence is suggested by Rebecca's poorly-fitting skirt and cloak, bare feet and dishevelled headdress. Jacob's squat, gruesome appearance implies a lack of honor and decency in his greedy desire to usurp his brother's birthright. Isaac's feverish look indicates overindulgence in food and drink as well as the "burning" effects of strong passions such as Anger. The lean cat snatching food from the table denotes Envy, as well as a sense of trickery and manipulation by Evil implicit in the "cat's paw."³

Hemessen's interpretation of the theme of Isaac and Jacob as a parable of sinful deception is without parallel in northern painting. The deception underlying the biblical incident was usually glossed over by medieval exegetes, who preferred to regard Isaac's misplaced blessing as an inscrutable manifestation of divine will. The choice of Isaac in place of Jacob was viewed in positive terms, as a prefiguration of the replacement of the Old Alliance by the New, or the blessing of Christ by the apostles who knew him not.⁴ Isaac was even compared with Christ by scholastic theologians.⁵

There was, however, an alternate tradition of mockery of the immoralities of Old Testament patriarchs transmitted by German anti-Semitic folksongs.⁶ Sinful behavior was associated with the Jewish forefathers in the apocryphal *Testament of the Twelve Patriarchs* (first century A.D.), in which the dying testator confesses a specific vice and warns posterity against it.⁷ Esau's conduct was frequently questioned in typological sources. His sale of birthright to his brother for a pottage of lentils was singled out in the *Biblia Pauperum* as an exemplum of *Gula* that forecast Satan's temptation of Christ in the wilderness and harked back to the temptation of Adam and Eve.⁸ And in at least one important Biblical commentary, the *Moralis reductorium super totam Bibliam* of Pierre Bersuire

(Petrus Berchorius, ca. 1290–1362), first published in 1474, Isaac was compared to a wicked priest and Jacob to a hypocrite.[9]

Notwithstanding this exegetical sub-tradition, the unusual presentation of the Österby panel demands to be understood in terms of the widespread despondency over the deepening religious crisis at mid-century. Efforts to check the spread of Protestant heresy had so far shown few results. There was a marked tendency to speak in terms of an affliction or "disease" of the church caused by long-term corruption.[10] This was especially true of the rhetoric of the imperial camp. As early as 1543, the Bishop of Arras, Antoine Perrenot de Granvelle, had pressed the dignitaries gathered at Trent for the long-awaited opening of the Council to effect the drastic measures urged upon them by Charles V to "cure the ills that had weakened the church":

> Il (Charles V) ne souhaite pas avec moins d'empressement que le concile mette fin aux discordes religieuses, et qu'il soit utile à toute la chrétienté, persuadé qu'il n'y a point d'autre remède pour guérir les maux dont l'église est accablée. Sa Majesté sait qu'il est indispensable de travailler à une réforme... Cette réforme est nécessaire pour réparer les malheurs que nous avons éprouvés et pour en empêcher le retour.[11]

From the close of the first sessions of the Council in 1547 to its reopening in May of 1551, there was a serious growth of religious strife across northern Europe that threatened to topple the Empire. The Interim of Augsburg, a stopgap measure designed to appease both sides that was signed on May 15, 1548, failed to restore peace and, in fact, led to increased dissension between Catholics and Protestants. On June 14, 1548, a new plan for reform was presented to the Diet of Augsburg by Granvelle. Published at Louvain the same year, the *Formula reformationis* chastened the church fathers for not having corrected abuses and scandals, "propter quae Deus iratus severiter adeo ecclesiam suas castigat."[12] The Emperor urged the immediate adoption of reform measures outlined in the *Formula* and wrote personal appeals to the powerful bishops of Germany and the Lowlands. His most eloquent letter was addressed to Robert de Croy, Bishop of Cambrai, in a letter dated May 7, 1550. Read aloud in a synod convened by de Croy at Cambrai in October of 1550, the Emperor's words deserve to be quoted at length since they were widely disseminated in the Lowlands and lay behind the moody iconography of Hemessen's *Isaac and Jacob*:

> Certes le grand mal qui est venu en l'Église de Dieu, et qui journellement s'espand plus avant, ne nous peult poinct estre incogneu....
>
> Ayant doncques ceulz du Saint Empire et notre authorité approuvé la forme de la réformation conceupte par les theologiens et aultres personnages scavans, affin que icelle

fust mise en effect, avons admonesté tous les évêques des Allemagnes, qu'ils ensuyvent la susdite forme de doctrine; et considerant que pas seulement les membres de l'Empire sont infectez de ce mal, mais aussi nos pays patrimoniaux en sont fort tentez, avons grandement labouré de y remedier.

Par quoy par beaucoup de decret nous sommes efforcez de expurger nosdits pays des abominables et reprouvées opinions: et par experience avons cogneus contre ledit mal rien tant pouver aider, que si les pasteurs et ceulx qui ont charge d'âme exercent vigilantement leur office....

En quoy nous a grandement pleust, que affin que la plus grande cure fust mise pour eslire et examiner les pasteurs, ils ont commis personnages litterez et saiges, pour explorer et cognoistre les vertus de ceulx qui en nos pays veuillent administrer les paroisses.

Car en la corruption de doctrine et discipline, gist tant de mal, que toute la confusion de l'état ecclésiastique semble à beaucoup de gens de cette racine estre née, creuste et apres confirmée.[13]

It is evident that Hemessen's bitter version of *Isaac Blessing Jacob* from the following year was devised as a metaphor for the "grand mal" brought upon the church, and in effect all of Christendom by what the Emperor calls the "corruption de doctrine et discipline." As already observed, the Old Testament subject was traditionally associated with the "New Alliance" and the "proclamation of Christ among all nations," and as such would have been related to the current state of Catholicism. Bersuire's identification of Isaac as a corrupt priest and the moral disapprobation of Jacob and Esau provided fuel for an allegory of clerical decay and a call for reform.

Through the public admission of wrongdoing and the firm resolve to make amends, it was hoped that the Counter-Reformation church might obtain divine forgiveness and subsequent relief from its trials. The vision of a collective church doing penance had been preached to the Council of Trent by Reginald Pole as the essential passe-partout for its restoration.[14] Challenged by Protestant reformers, Catholic belief in the outward display of penance for the expiation of sin was wholeheartedly affirmed by the Counter-Reform movement, which formally proclaimed penance as a true Sacrament of the New Law in the Fourteenth Session of the Council of Trent on November 15, 1551. It should be noted that the articles on the sacrament were presented by a group of eminent doctors from the University of Louvain, led by Charles V's trusted adviser on canonical matters, Ruard Tapper.[15] A veteran adversary of Luther and Melanchthon, Tapper had refuted Protestant views on penance at length in his propositions of 1544, published in the *Explicationis articulorum* of 1544–57.[16] Tapper had long been an advocate of the reform of the clergy to check the progress of

heresy and he sanctioned the confessional stance of the "Church Penitent" as it was officially promulgated by the Emperor. Considering Hemessen's long preoccupation with the theme of penance in his work, it is likely that he played a role in helping to fashion this basic Counter-Reformation policy.

The soul-searching mood of the times is vividly reflected in Loyola's *Spiritual Exercises,* which must have deeply affected the artist's outlook. The entire first week of meditation was to be devoted to the examination of personal sin as well as the original transgressions of the fallen angels and Adam and Eve. The aspirant was encouraged to dwell upon the contemptible nature of his fallen state in vivid mental images. "In meditation on sins, the mental image will consist of imagining, and considering my soul imprisoned in its curruptible body, and my entire being in this vale of tears as an exile among brute beasts."[17] When dressing for the day, it was proper to contemplate the chains that might one day bind one as a sinner before the Lord of Judgment.

> In like manner, in the second Exercise, I will see myself as a great sinner, bound in chains, who is about to appear before the supreme, eternal Judge; and I will take as an example how prisoners in chains and worthy of death appear before their earthly judge. As I dress I will think over these thoughts, or others, according to the subject matter.[18]

Such penitential imaginings on corruption and sinfulness undoubtedly helped to generate the morbid iconography of the Österby *Isaac.*

The penitential fixation on man's sinful nature, as preached by the Jesuits, led to such morose visual programs as the extraordinary Grande Salle at Binche, that splendid but shortlived palace erected for Mary of Hungary by Jacques Dubroeucq of Mons in 1545–49. The main features of decoration of the hall were four large paintings by Titian illustrating punishments inflicted on great sinners from antiquity: Tityus, Ixion, Tantalus and, of course, Sisyphus. The pictures were commissioned when the Venetian painter was at Augsburg in 1548 and were in place at Binche the following year for the fêtes held in honor of the Emperor and Prince Philip.[19] The Spanish chronicler Calvete de Estrella mentions that there were also tapestries of each of the Seven Deadly Sins placed around the Grande Salle, six on the wall opposite the Titians and the seventh, depicting *Pride*, fittingly placed behind the throne.[20] Such lessons of sin and punishment provided effective backdrops for Netherlandish court ceremonies, which became increasingly somber during the last years of Charles V's reign. When the Emperor retired to the Hieronymite monastery of Yuste in 1556, Titian's four mythologies followed along, grim reminders of damnation during his last years of penitence.

The harsh style of Titian's paintings for Binche—which can be seen in

the two remaining examples, *Tityus* and *Sisyphus*, both today at the Prado, may well have affected the directions of Hemessen's anxious late style. Similarly loose, unflattering brushwork, massive diagonal slashes of form and towering figures can be noted in the *Isaac Blessing Jacob* of 1551. Hemessen moves even further away from formal clarity and balance in other works from these years. A *Christ Carrying the Cross* (figure 125), now at Esztergom, Hungary, signed and dated 1553, conveys emotional desperation expressing the spiritual anguish of the times. Christ is hemmed in by a jostling mob of tormentors, their spiky halberds silhouetted ominously against a cloudy sky. A frail, doddering *St. Jerome Praying before a Crucifix* (figure 126, Genoa, Palazzo Rosso) contrasts with the forceful representations of the saint from the 1530s and '40s. In a *Holy Family with St. Elizabeth and the Young John The Baptist* (figure 127, Cracow, Wawel Castle), there is pervasive disintegration of formal values, evident in the nervous, angular composition and thin, haggard facial types.[21] The distinctive "rabbit-like" features of the Virgin are shared by other Hemessen Madonnas from the 1550s, who are similarly chinless with high, flairing ears (figures 128–29). Hemessen depicts the Christ Child in unstable, convulsive postures, as if at the mercy of forces beyond his control. A copy of a lost panel of the *Infants Jesus and John Playing with the Lamb* (figure 130) uses a chaotic grouping that emphasizes the awkwardness and lack of coordination of the playful children, who almost parody Leonardo's original idea.[22]

A more graceful note is struck by the *A Musician and his Muse* (Allegorical Portrait of Caterina van Hemessen and Chrétien?) (figure 131, Toronto, T. Heinrich Collection), which we have identified as an allegorical marriage portrait of the artist's daughter, the painter Caterina van Hemessen, and the musician Chrétien de Morien.[23] The 1554 wedding must have been a cheering occasion for the artist in these troubled years. Hemessen pictures the young painter wearing a crown of laurel and shedding fecund inspiration upon her partner's viol, as he in turn gazes lovingly at her. The couple are pictured in a serene pastoral setting seated near one of Hemessen's characteristic vine-covered trees. The musician and muse are patterned on the youthful lovers of Titan's *Three Ages of Man* (figure 132), sold to a collector at Augsburg a few years before the painting. Hemessen probably also had in mind the elegant saltcellar created by Cellini for Francis I (figure 133), in which Terra conveys her fertile blessings to Neptune in a similar manner. Completed in 1543, the saltcellar could have been seen by Hemessen if we are right in assuming he visited Fontainebleau again in the mid-1540s.[24]

The evocative mood of the *A Musician and his Muse* is shared by a second emblematic painting from about the same time, a *Dying Putto* (fig-

ure 135) formerly in the Boer Collection at the Hague and sold at Amsterdam in 1961. The stricken babe reclines languidly in an exotic, dreamlike landscape, his elbow propped against a skull. He holds a little staff bearing a *cartellino* inscribed in neat classicizing letters, "NASSE(ntes) MORIMVR" (As we are born, we die").[25] The inscription makes it clear that the putto is not just nodding off to sleep, but dying, his pudgy fist slowly slipping down the staff and his head tumbling inexorably to the ground. Close to the Toronto panel in the soft tenebrism of modelling of flesh and atmospheric landscape, the *Dying Putto* shares idiosyncratic mannerisms of Hemessen's late years, such as splayed toes and wrinkles of flesh at the bend of the knee, the latter perhaps adopted from Savoldo.[26]

The image of a dying babe allegorizes the brevity of life in succinct dramatic terms. As Janson pointed out in his study of the theme, Hemessen harks back to German prints that picture a dead or dying infant with a skull.[27] The earliest dated example is an engraving by Barthel Beham of 1525. These northern graphics in turn derive from an earlier Italian tradition associating a live putto with a skull and hour glass, first represented in Giovanni Boldù's humanist medal of 1458.[28] The inscription from the obscure ancient Manilius appears earlier in northern art in a woodcut *"Nascendo Morimur"* of 1537 by Cornelis Antonisz and a panel painting by Dürer's pupil Georg Pencz sold a few years ago at Sotheby's in London.[29] By the date of Hemessen's panel the iconography of the dying putto had re-emerged in the South. It is found in a delicate drawing by the Veronese painter Domenico Brusasorci (Florence, Uffizi), perhaps a study for a lost painting, and in the margins of one of the illuminations of Giulio Clovio's sumptuous Farnese Hours, now at the Morgan Library.[30] By the close of the century the theme had become a cliché of International Mannerism depicted in stylized versions by Marten de Vos and Bartholomeus Spraenger.[31]

The hazy landscape of the *Dying Putto* reinforces the mood of sad reverie established by the figure. The infant reclines upon a plateau of parched earth rent by fissures. Behind rises a stark rocky outcropping topped by a few trees. At the left there is a tiny figure walking off alone in the distance. Two more soulful wayfarers can be glimpsed at far right wending their way towards a fortress perched high above a lake. The landscape setting is reminiscent of antique Roman wall painting, just as the putto's listless pose is meant to recall an ancient Narcissus. An eloquent *memento mori,* Hemessen's panel is one of the most successful representations of this rather cloying allegorical theme.

Hemessen returns to the Old Testament in a large panel from 1555 now at the Louvre depicting *Tobias Curing his Father's Blindness* (figure 136). He interprets the biblical subject in a more hopeful way than the

Isaac Blessing Jacob done a few years earlier. The youth tenderly applies the healing gall of a fish to his father's eyes. As Genaille has observed, Tobias' right hand quotes the gesture of God the Father conveying the spark of life to Adam on the Sistine Ceiling.[32] The archangel's rhythmic pose also derives from Italy, probably not from Tintoretto, as Genaille proposes, but from the beguiling angel holding the staff in Moretto da Brescia's *Crowning of the Virgin* (Brescia, SS. Nazzaro e Celso, ca. 1526–30). The strict parallelism of legs of Tobias and the angel was a classicizing device favored by the School of Fontainebleau and by the archeologically-minded Lambert Lombard of Liège. Similar antique ideas affected Vermeyen's handsome tapestry suite of *Vertumnus and Pomona*, a masterpiece of mid-century Netherlandish art. Entering the collection of Mary of Hungary in 1548, the tapestries attracted considerable attention for their poetic evocation of the charm of the Golden Age.[33]

In spite of the attempt to develop a flowing composition, the Louvre *Tobias* contains a strong measure of excitement and turbulence in handling of drapery and lighting. The miracle takes place on an overclouded day high up on a rugged hillside, a setting similar to those of Frans Floris' lost suite of paintings of the *Labors of Hercules*, known today through engravings by Cornelis Cort.[34] Large figures are similarly viewed at close range on plunging slopes. Returning to Antwerp in 1547 after an extended stay in Italy, Floris found an enthusiastic audience for his inventive, rapid brushwork and Venetian colorism.[35]

Like practically all of Hemessen's religious works from his last years, the Louvre *Tobias* can be interpreted as a comment on the religious crisis of the day. If blindness is taken for the "spiritual blindness" of disbelief, then the panel can be read to symbolize the longings of the church for a miraculous dispensation that would enable it to "cure" heresy.[36] For the Counter-Reformation fathers, this was the ultimate answer to the problems confronting the Christian world. As Reginald Pole warns in his *Appeal to the Council of Trent* (1546), "wishing to heal these ills by our own power and prudence" will be futile "without the breathing of the divine spirit."

> And this may warn us that there is only one way left for curing these ills. First, we must acknowledge that all of our remedies are useless, and indeed are more powerful to strengthen than to destroy these evils. Secondly, we who have the office of Fathers must act in everything by faith and hope and place our trust in the power of Christ, whom God the Father calls His Right Hand, and in the Wisdom of Christ, who is the Wisdom of the Father, whose ministers in all things we acknowledge ourselves to be. . . . [37]

The gentle Tobias, augur of Christ "the good shepherd" and "fisher of men," is here imaged as the harbinger of the Divine Healer, without whose intervention the labors of the Council would be in vain.[38]

Another form of miraculous cure is investigated in one of Hemessen's most expressionist works, *The Stone Operation* or *Cure of Folly* (figure 137), dating from ca. 1556. Listed in the Spanish Royal Collection as early as 1614, the panel may well have been commissioned for Philip II, whose taste for the eccentric is well-known. Hemessen depicts in graphic detail the surgical extraction of the "stone of folly" from the patient's forehead.[39] According to an old superstition, madness was thought to stem from stones beneath the skull. Unscrupulous barber-surgeons took advantage of the naive by making a superficial incision in the scalp and pretending to extract small stones. A similar type of operation had been portrayed ca. 1480 by Bosch in a small panel satirizing quackery and gullibility (Madrid, Prado).[40] It can safely be assumed that the Bosch was known to Hemessen since he depicts his patient in much the same position, looking directly out at the viewer with an agonized expression.

Like Bosch, Hemessen suggests that the greedy surgeon is extracting money from the foolish patient. This is expressed by the golden color of the nugget embedded in the man's forehead, and also by the elaborate jewelled headdress of the surgeon's pretty young assistant. Lucas van Leyden's print of a *Dental Operation* (figure 138, 1523) makes the point in a more obvious manner, as the female confederate picks the patient's purse. Similar to Lucas' dentist, the outlandish garb of Hemessen's barber-surgeon—the archaic hat, foppish sash and comic pince-nez—lets us know that he is a quack. His lack of true learning is demonstrated by the confused jumble of surgical implements on the table. The furtive preparations of the female assistant at the left provide another clue to the deception, as do the bicorn headdresses of both women, traditionally associated with indecency and avarice.[41] Archaizing Burgundian costumes can be found in Quentin Massys and Marinus van Roymerswaele, also not without moralizing connotations.

The surgery takes place out in the open in a town square. The itinerant charlatan has set up a sign on top of a tall pole from which dangle a number of stones attesting to the success of his prior operations.[42] There is a lengthy document unrolled on the table: presumably a testimonial to the surgeon's qualifications. Among the flasks and bandages we can spot a pair of sturdy pincers for extracting stones and a strange rectangular metal instrument open at one end. The latter can perhaps be identified as a trephine, an instrument used for boring through the skull.[43]

The other end of the square is occupied by a mill with workmen and some women carrying sacks of grain or flour. The river powering the wheel flows underneath the arch behind the workmen, while in the center rises a massive granary tower. Like the stone operation, the mill was traditionally associated with the foolish pursuit of gain. Both images appear in Antwerp

ommegangs and *landjuweels* of the 1560s.[44] The mill and storage tower also provide appropriate allusions to Prudence, the cardinal Virtue being neglected by the foolish man undergoing the operation. The separation of wheat from chaff symbolizes the ability to distinguish good from evil. Bruegel's personification of *Prudentia* (V.B. 136) carries a sieve prominently atop her head, with similar implications. The sacks of wheat and the storage tower illustrate another important aspect of the Virtue: foresight, or the prudent provision for the future. By placing himself in the hands of the quack surgeon, the patient has exhibited a lack of caution and foresight. The "blind" grief of the figure at the right (his mother or father?) with head raised upwards and eyes tightly shut, also suggests a failure to see into the nature of the fraud.

In the *Stone Operation* Hemessen once again makes an oblique comment on the course of the Counter-Reformation, this time aiming his critique at the growing reliance upon radical, coercive attempts to cure the "folly" of heresy, and the gullibility of those who would give into such violent methods. Netherlanders were rightly worried about the directions the Inquisition would take now that Charles V was no longer in power. Though the Emperor had issued repressive placards in the early 1550s, he was reluctant to launch a full-scale purge of heretical elements in the land of his birth. The last years of his reign were marked by official silence on religious matters.[45] The Spanish-speaking Philip II was less sensitive to the concerns of his Flemish subjects. His views rapidly hardened around the use of force to solve the religious problems of the Lowlands, and resulted in widespread atrocities committed by Spanish troops in the Low Countries in the next decade.

The worsening situation is satirized in Pieter Bruegel's two prints of the subject of the *Cure of Folly* from the following years. The first, dated 1557 (V. B. 192) shows several stone operations performed by a motley group of quacksters. In the *Witch of Malleghem* (figure 139, V. B. 193, dated 1559), Bruegel depicts a mass gathering of demented beings converging upon a lady barber-surgeon who, along with her male accomplices, rapidly performs the stone operation on all-comers. The Flemish verses beneath the image translate as follows:

> Folk of Foolsville, be of good cheer;
> I, Lady Witch, wish to be well-loved here
> As I am elsewhere....
> I have come here to cure you
> With my proud aide; I assure you
> We're at your service: draw near.
> So let them come on, come one and come all,
> Hurry on, every one,

If you've a wasp in your dome
Or are plagued by a stone.[46]

The Lady Witch who wants to be "well-loved here" surely refers to Margaret of Parma, appointed by Philip II as regent in the Netherlands in 1559 to carry out his repressive policies. Her "proud aide" would, of course, be Granvelle, soon to be installed by the King as President of the Netherlands Council of State and chief of the Council's Executive Committee.

The reliance of the new regime on military force is suggested by the profusion of small stones streaming like gunshot from the head of the man being operated upon in the egg at lower right. Larger, cannonball size stones pour from the conical tower in the background on top of a hapless passerby. The threat of imprisonment for those who do not submit to the operation is suggested by the grinning fool behind bars at the lower left. Two hooded executioners joke together on a parapet above the cell, while a stone tied to a cord hangs menacingly above the prisoner's head. At the upper left, we again find a mill, separated from Malleghem by an estuary bridged by a single wooden plank. The men carrying sacks of grain across to the mill perhaps represent the last resort of prudent Flemings — flight to the northern Provinces.

Comparable in dramatic power to the *Cure of Folly* is Hemessen's large panel from 1556 now at Nancy, the *Expulsion of Merchants and Moneylenders from the Temple* (figure 140). The painter scrupulously follows the biblical text in his depiction of Christ driving the sellers of "oxen, sheep and doves" from the temple and overturning the "changers' money,": "And (He) said unto them that sold doves, Take these things hence: make not my Father's house a house of merchandise." (John 2:14–16) The subject lends itself well to the artist's abundant powers of visual expression. The desperate efforts of the merchants and moneylenders to salvage their valuables results in a confused turmoil of flailing limbs and agonized faces that hark back to the Antwerp *Last Judgment* (figure 74). Hemessen has evidently drawn some of his ideas from Dürer. The man carrying the lamb and the prostrate usurer terrified at the prospect of losing his bag of money can be noted in his woodcut of the subject (B. VII. 119. 23). The commotion of the Nancy panel can also be related to Frans Floris' *Fall of the Rebel Angels* (Antwerp, Museum), completed two years earlier for the Michaelsaltar of the Antwerp Cathedral, a key work in transmitting painterly developments of Venetian art to the Lowlands. Hemessen's increasingly broad orchestration of moving forms and shifting, Tintorettesque *chiaroscuro* undoubtedly benefited from the example of the younger Romanist.

The choice of the *Expulsion from the Temple* was directly relevant to the issue that, after heresy, dominated the thoughts of the church fathers at the Council of Trent: ecclesiastical reform. One of the commendable aspects of the Counter-Reformation was the decision to face squarely the need to root out abuses within the church, especially the corruption of the bishops, many of whom were de facto laymen who had acquired great personal wealth by siphoning funds from the church. For Reginald Pole, the internal and external struggles afflicting the church were nothing but the "scourges of God" brought down upon them for allowing such corrupt practices to flourish. "We are of the opinion that God sends these scourges to punish our sinning and to turn our gaze towards these very sins by which we greatly offend His Majesty."[47] Pole goes on to amplify his comment in one of the most effective passages of the *Appeal*:

> In a word, all that is to be said of every kind of war, whether men have taken up arms against us, have driven the shepherds from their churches, have thrown the Orders into confusion, have set laymen in the place of bishops, have robbed Church property, have hindered the preaching of God's word, we may sum up in this: if they are willing to read the Book of Abuses of Shepherds, the greater number of those who claim this name will find it stated in the clearest terms that there is none of these things which has not been done by themselves. It will be found that our ambition, our avarice, our cupidity, have wrought all these evils on the people of God; and that, on account of this, shepherds are being driven from their churches, and the churches starved of the Word of God...If, then, the Turks and the heretics do the same to us, what else are we witnessing than our crimes and at the same time the just judgment of God—a judgment, indeed, full of mercy? If He punished us as we deserved, we should have been long since as Sodom and Gomorrah.[48]

Hemessen's rendering of the *Expulsion* expresses the reformist guilt of the Counter-Reform church in vivid terms. Not insignificantly, Christ directs his fury chiefly at the greedy moneylenders, whom we can take to refer to mercenary prelates. The sullen merchants who gather up their lambs and doves and make for the portal stand for what Pole describes as the "shepherds driven from the churches" for their abuses. The inclusion of Turks wearing oriental turbans within the ranks of usurers and tradespeople suggests that moral decay within the church serves the purposes of external enemies of Christendom as well, a point that Pole emphasizes throughout his discourse. To the left the Apostles ponder the meaning of their master's violent outburst—evoking anxieties of the Counter-Reform church over what was regarded as God's "just judgment" for its corruption. John solemnly imposes silence upon St. Peter, who claws nervously at his throat, his eyes fixed upward on Christ's scourge. Just below a disciple (James?) clutches his beard in a gesture symbolizing fear, while his comrade tries to rally his courage.[49]

The Nancy *Expulsion of Merchants and Moneylenders from the Temple* can thus be read as an exhortatory statement parallelling Pole's *Appeal to the Council of Trent*, which Hemessen must have regarded with admiration.[50] Perhaps, like the *Cure of Folly*, the work was painted with the young Philip II in mind. The Spanish king held the power to dictate ecclesiastic reform in the Netherlands through his control over matters relating to property and land use. For much of 1556—the year the Nancy panel was done—the king was considering a decision that would be of special importance in this regard: whether or not to allow the Company of Jesus to establish itself officially in the Lowlands. The Jesuits stood for a drastic reform of the entire structure of religious indoctrination as a means of rehabilitating the church. While Philip was highly sympathetic to Loyola's cause, he was reluctant to make a hasty decision that would offend the Flemish bishops, including the powerful Granvelle.[51] The sudden rise to prominence of the new Order at Rome was looked upon with suspicion by established factions within the church. Yet in spite of considerable opposition, there were many Netherlanders, Hemessen surely among them, who regarded Loyola's militant asceticism as the best way to re-establish the moral integrity of the clergy.

The request was formally made by Loyola's agent Ribadeneira on the 14th of February, 1556, at a royal audience held at the Abbey of St. Michael at Antwerp, where the king had been residing during the ceremonies for the 22nd Chapter of the Order of the Golden Fleece. For months Philip gave no indication of his reaction to the proposal. During this time the Company received the valuable support of Princess Jeanne of Portugal, regent of Spain during Philip's lengthy absence (1554–59). She continually urged him to accept the Order in the Netherlands. The historian Poncelet attributes Philip's ultimate decision in favor of the Jesuits to the direct appeals of his sister, Queen Marie of Bohemia, who visited him at the Castle of Tervueren in Brussels in July of 1556. Marie granted a special audience to Ribadeneira, who was successful in winning her support. The king finally approved the establishment of Jesuit colleges in the Lowlands on the 15th of August.[52]

One aspect of the Nancy panel confirms that Hemessen meant the *Expulsion* as a parable of the need for decisive action to reform the Flemish church: the close resemblance of the interior of the temple to the Antwerp Cathedral (figure 141). In January of 1556, the Cathedral of Notre-Dame was the setting for the 22nd Chapter of the Golden Fleece, presided over by the new king. The strategy that Philip II would elect to deal with the religious crisis was no doubt a major subject of discussion among the princes of the Order, many of whom were closely involved with the machinations of the bishops. The wooly lamb carried on the shoulder

of the chastened merchant in Hemessen's panel may, in fact, be a concealed barb at nobility that had abrogated their sacred trust, symbolized by the transmuted, Golden Fleece.[53] Both Charles V and his son hoped that the Order would help to unify the nobility in the struggle against Protestantism. Philip II eventually became discouraged with its efficacy and obtained powers from Pope Gregory XIII that enabled him to suppress the Order. The last Chapter of the Golden Fleece was held at Ghent in 1559.[54]

Hemessen investigates the theme of just judgment further in a panel illustrating the *Parable of the Unmerciful Servant* (figure 142, Ann Arbor, University of Michigan Art Museum), which dates stylistically to his last years.[55] As related in Matthew 18:23–25, a king forgives one of his lords a large debt, only to learn that the same lord refused to display similar mercy to his own servant. The lord is recalled and punished severly for his misdoing, "So likewise shall my heavenly Father do also unto you, if ye from your hearts forgive not everyone their trespasses."

The Ann Arbor panel pictures the crucial moment of judgment. A stern king points decisively at his unforgiving steward, who is led off to be buried alive in the background. Hemessen borrows the assistant deliberately counting coins from his earlier portrayals of the *Calling of St. Matthew*. His preoccupation with his temporal task again symbolizes the blind materialism of Avarice. The startled reaction of the accountant, on the other hand, indicates a lack of true understanding of the righteous nature of the punishment. Hemessen employs an extremely elongated format for the drama while at the same time compressing the participants into rigidly confined areas of space. The oblong composition and emphatic angular shifts of form hark back to Hugo van der Goes' Berlin *Adoration of the Shepherds*, from ca. 1480. The yawning gulf that separates the condemned lord from his master powerfully articulates the awesome finality of judgment. The severity of punishment is conveyed symbolically by scissors and thread on the table and the hourglass placed on a shelf just above the daggerlike spikes of the king's crown, which is fashioned like some cruel instrument of torture.

In the *Parable of the Unmerciful Servant* Hemessen updates the tradition of portraying scenes of just judgment in Netherlandish painting.[56] The panel embodies a lesson of profound import for the artist's times: the responsibility of those in power to emulate the forgiving nature of Christ in judging the transgressions of their subjects, or face an even sterner judgment from above for denying the mercy that God has shown them to others. As noted above, Reginald Pole stressed the importance of charity to the Council of Trent, characterizing the crisis facing the church as a deserved "just judgment of God" that should prompt an immediate repentance.

Why do we recall these things? To shame you? Far from it; but rather, my beloved Fathers and brethren, to admonish you—and our own selves first of all—how to avoid these scourges which now rain on us, and even greater evils which wait us unless we repent; so that we may escape God's fearful judgment—fearful indeed to those who will not repent and especially to those who hold authority. "For a most severe judgment shall be for them that bear rule." (Wisdom of Solomon 6:5)[57]

Created during a time when censorship and repression were acting to stifle artistic expression, Hemessen's late panels represent a courageous expansion of the didactic role of religious imagery to confront the critical issues of the Counter-Reformation. Though he did not live to witness the ensuing debacle of the next decade—which sadly confirmed his most pessimistic insights—his work set the stage for the satirical commentary of Pieter Bruegel, in many ways the true heir to Hemessen's moral parables. Like Bruegel, Hemessen must have enjoyed a special position among his contemporaries at Antwerp to enable him to express such strong criticism without rebuke. His close connections with court circles, probably developed very early in his career and maintained throughout, would have provided a certain measure of impunity. In addition, the tolerant attitude towards creative expression at Antwerp provided a very special situation for theatrical and visual arts.

How and where Hemessen spent his last years remains a mystery. As mentioned in our discussion of his biography, there is no evidence that he emigrated to Haarlem at the close of his career beyond van Mander's questionable remark that the painter was a citizen of that North Netherlandish city. It is certain that he was still at Antwerp as late as 1555, one year prior to his last firmly dated work, the *Expulsion of Merchants and Money-lenders from the Temple* (figure 140).[58] Perhaps he had already died before his daughter Caterina and her husband Chrétien left for Spain in the entourage of Mary of Hungary in September of 1556.

An elaborate religious work by a close Hemessen follower serves to connect his workshop with Spain in the ensuing years. Now at the Cincinnati Art Museum, the *Tendilla Retable* was commissioned some time after the death of Ignatius Loyola in 1556 by Iñigo Lopez de Mendoza, Count Tendilla, to commemorate Loyola as well as the later mother of the Emperor Charles V, Juana the Mad (d. 1555). Both coats of arms are prominently displayed. The retable consists of two large *grisaille* panels of the *Annunciation* and eleven smaller ones depicting various scenes from the Bible (figures 143–44). Though not of sufficient quality to attribute to Hemessen's hand, it is possible that the artist began the work shortly before his death and that it was later completed—perhaps in Spain—by two or more artists who had studied under him.[59] One of the hands may well be

that of his daughter Caterina, though further work is necessary to identify her style of painting religious subjects.[60]

Several other works can be associated stylistically with the artist's last years, among them a large panel of the *Agony in the Garden* (figure 145), formerly in the Esterhazy Collection, and two wings of *St. Mary Magdalen* and *St. John the Baptist* (figure 147), unfortunately destroyed by fire in the bombing of Orléans in World War II. Judging from the photograph, the *Agony* is a dramatic masterpiece of major proportions. Christ kneels supplicatingly before a vision of the chalice and an angel bearing the cross. To the right, the apostles John, Peter and James huddle together in uneasy sleep, their limbs tangled liked the damned in the central panel of Hemessen's *Last Judgment*. The inclusion of the chalice suggests renewed emphasis on the iconography of the Eucharist. Sensationalist lighting and flamboyant gestures hark back to Rosso's great *Pietà* for Ecouen (figure 146) and perhaps also imply contact with Tintoretto. The Orléans wings present the Magdalen and John similarly distraught in the radically abridged space of the narrow panels. An *Old Peasant Woman* from the time (figure 148, Dublin, National Gallery of Ireland) grimaces demoniacally in her coarse song.[61] Hemessen's late portraits are sober and roughhewn (figure 149), a far cry from the studied elegance of the 1540s. A compelling *Portrait of a Man* at Vienna (figure 150), sometimes regarded as a representation of Gossaert, possibly records Hemessen's own features.[62]

Considering the extreme nature of much of Hemessen's work, it is understandable that he did not form a school of artists to carry on his style. While his investigations of still life and genre-moralities were carried on by Pieter Aertsen and his talented pupil Joachim Beuckelaer, the only artist who continued to probe the emotional depths of his art was the fascinating Master of the Augsburg *Ecce Homo*, whose work has been assembled perceptively by Dietrich Schubert.[63] The name-piece is a sizeable panel now on deposit at Munich containing a horde of wildly gesticulating small figures and background replete with lurid Boschian architecture. A descendant of Jan Swart, the Brunswick Monogrammist and Dirk Vellert, the Augsburg Master drew inspiration from the expressionist distortions of Hemessen's late work. He was responsible for an equally frenzied *Sacrifice of Isaac* and two wings of the *Story of Jonah* at Nuremberg, and two versions of the *Great Flood*, one formerly on the Munich art market and the other now in a private collection at Brussels.[64] The close derivation of his caricatural *Christ Bearing the Cross* (Soestdijk; another at Vienna) from Hemessen's panel of 1553 (figure 125) makes it clear that he was in contact with Jan late in his career. To the Master of the Augsburg *Ecce Homo* rightly belongs a drawing of a sneering tormentor in the Frits Lugt Collection at the Institut Néerlandais in Paris, where it is wrongly attributed to

Hemessen.[65] As Schubert notes, the artist was also responsible for a copy of a lost Hemessen *St. Jerome at Prayer* from the 1530s which is now at the Rockoxhuis in Antwerp (figure 40).[66]

Responding to critical issues facing the Counter-Reformation, Jan Sanders van Hemessen's innovative exploration of symbolic potentials of Flemish realism expressed the spiritual impulses of Jesuit teachings as well as the eloquent reformist humanism of Erasmus and Pole. His involvement in theatrical investigations of the Netherlandish Chambers of Rhetoric marks a new chapter in the productive Northern Renaissance dialogue between dramatic and visual arts. Hemessen's work anticipates key iconographical directions of the late sixteenth and seventeenth centuries. The repentant sinner, as Mâle has pointed out, was to become an important religious image for the era following the close of the Council of Trent. It was figured by El Greco, Guido Reni, Lanfranco, Guercino and others in the expiatory St. Peter, his tears evoking the penitential anguish of the Counter-Reform church. Baroque painters were to develop new images of humble devotion and expand upon the meditation upon death and decay in imaginative ways.[67]

Many of the symbolic forms of realism developed by Hemessen and other Flemish Romanists were retained by seventeenth-century masters of genre, though the moralized approach of the earlier school was gradually replaced by a more positive affirmation of life. The process of transformation that took place from Mannerist to Baroque genre has not yet been clarified, and, indeed, the implications posed by predominantly negative attitudes towards secular figures in Hemessen and other Antwerp Romanists like Aertsen and Beuckelaer remain largely unexplored. Does Hemessen's emphasis on corrupt aspects of everyday life reflect a general feeling of alarm over the rise of secularism and the growth of irreligion, the latter perhaps considerably more extensive than generally thought?[68] Or is it indicative of even more serious fears that growing numbers of people were in league with the Devil, a widespread threat that contributed to the hysterical persecution of witchcraft that reached a peak of frenzy during the years 1550 to 1660?[69] Provided with new powers of expressive realism, the mirror of art reflected an image of man tarnished by a profound distrust of worldly values and dimmed by the specter of spiritual desolation that hung menacingly above these troubled times.

To be sure, the sacred purpose of art itself was challenged by Protestant reformers who totally denied the value of religious images. Reviving traditional arguments connecting Christian icons with pagan idolatry, anti-image polemicists channelled popular resentments towards the tangible wealth of art contained in Northern cathedrals and abbeys. Radical oratory resulted in waves of iconoclasm in the Netherlands in 1566 and again in

1581.[70] The church in turn defended religious art and hastily instituted increased ecclesiastical control over images. Restrictions were placed on nudity, anything that could be interpreted as indecent or lascivious, and spurious aspects of Christian iconography.[71] The effect of both iconoclasm and Counter-Reformation restraints on Netherlandish artists in the years following the close of the Council of Trent in 1563 is only beginning to be explored by art historians.[72]

While Hemessen's career had come to a close a decade before the savage outbreaks of image destruction, his work, as we have tried to demonstrate, involved an ongoing struggle to regenerate religious art in light of the critical issues affecting the spiritual life of his day. An artist caught between Reform and Counter-Reform, he takes a unique position in the history of Northern Renaissance painting.

Illustrations

Figure 1. Jan Sanders van Hemessen, *Christ and the Adulteress,*
1525, New York, Art Market. (Cat. No. 2)

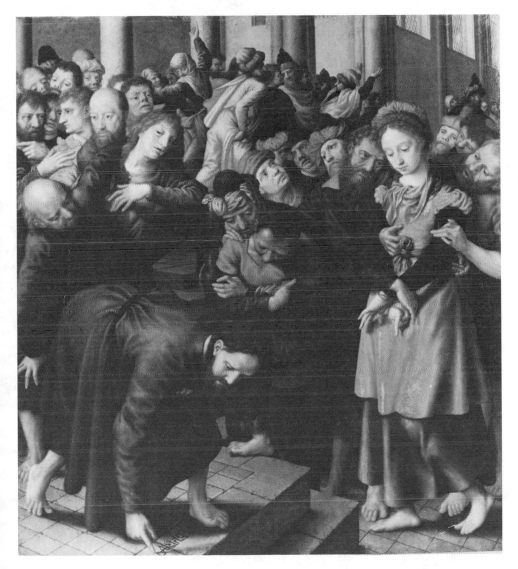

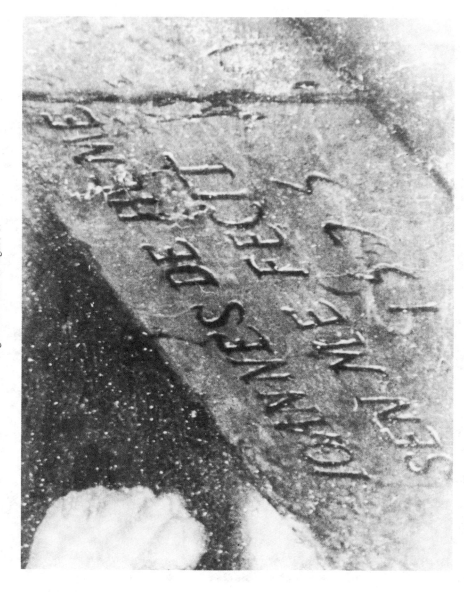

Figure 2. Detail of figure 1.

Figure 3. Ludovico Mazzolino, *Christ and the Adulteress,* London, National Gallery.

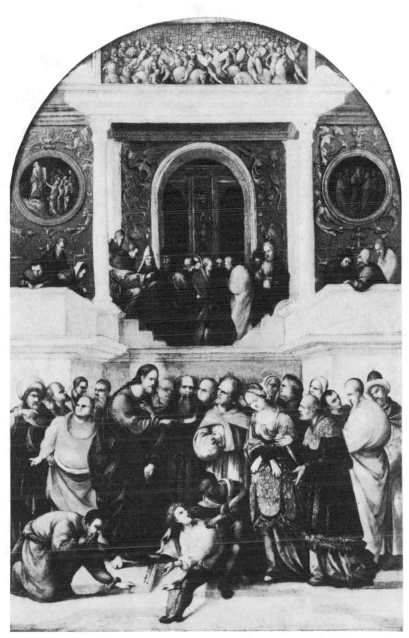

Figure 4. Hans Leinberger, *Crucifixion,* 1516, Munich, Bayerisches Nationalmuseum.

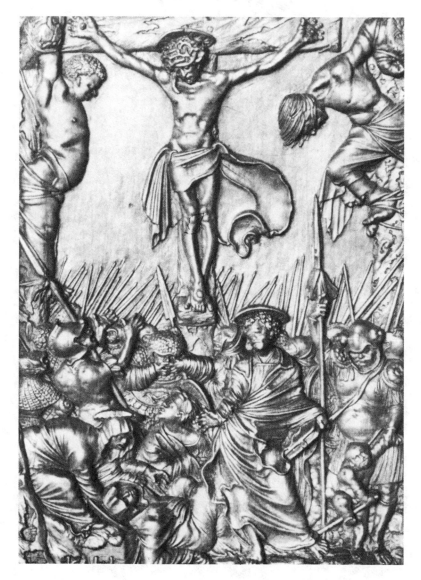

Figure 5. Hemessen, *Descent from the Cross,* ca. 1526–27, Brussels, Musées Royaux des Beaux-Arts. (Cat. No. 4)

Figure 6. Marcantonio Raimondi, after Raphael, *The Deposition,*
ca. 1520–21, engraving (B.XIV. 37–9, 32).

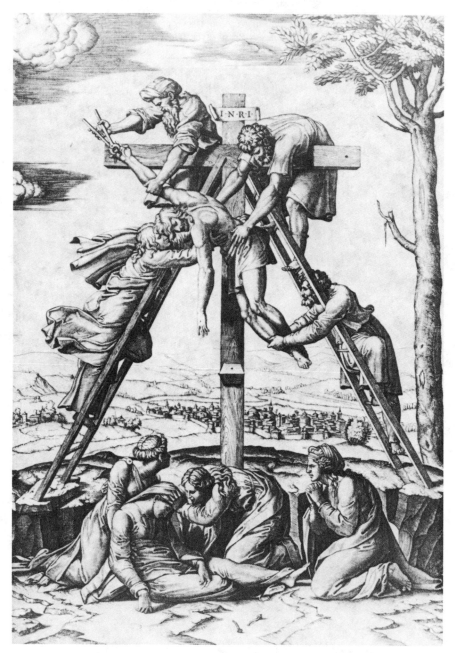

Figure 7. Ugo da Carpi, after Raphael, *The Deposition*. chiaroscuro
woodcut (B.XII.43.22).

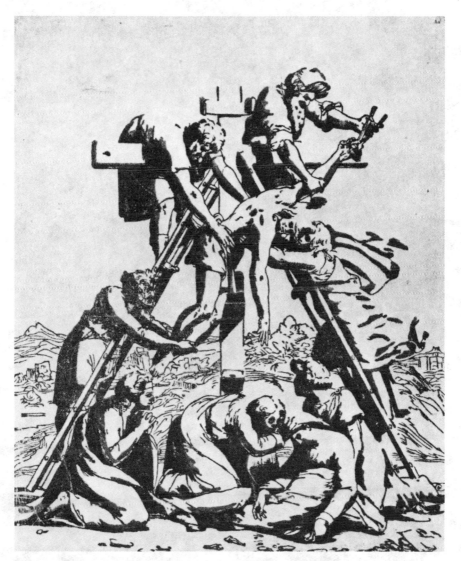

Figure 8. Detail of figure 5.

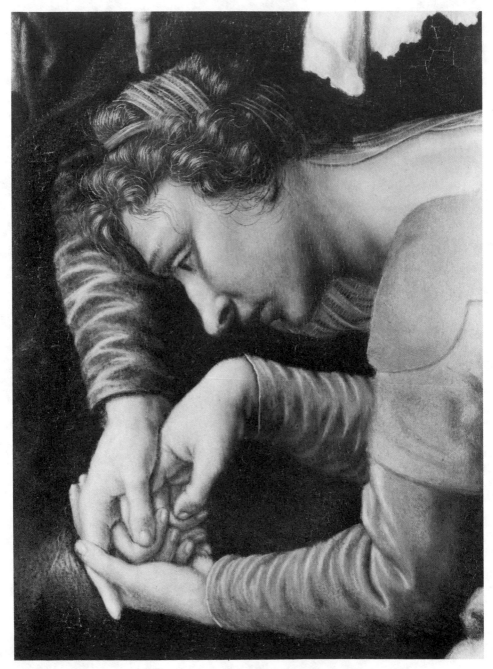

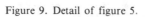
Figure 9. Detail of figure 5.

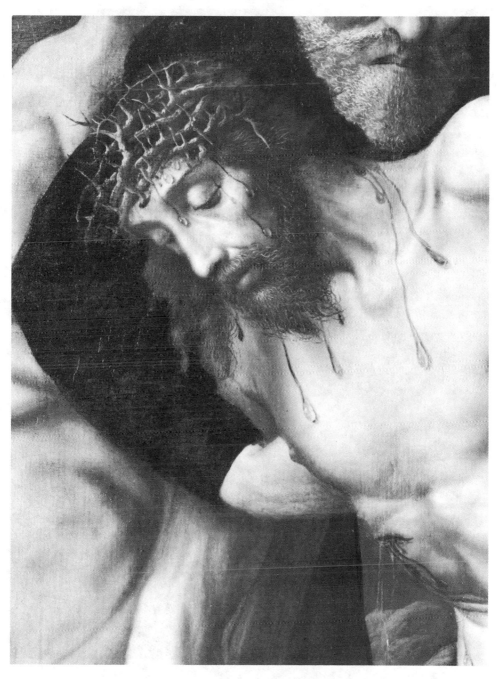

Figure 10. Detail of figure 5.

Figure 11. Detail of figure 5.

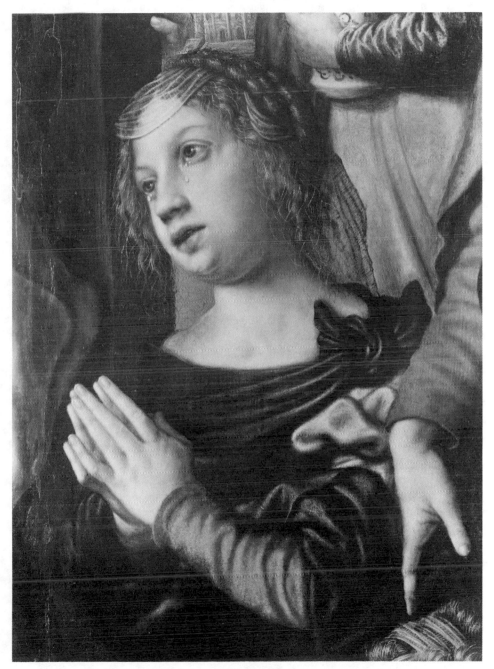

Figure 12. Conrad Meit, *Virgin and Child,* Brussels, Sainte-Gudule.

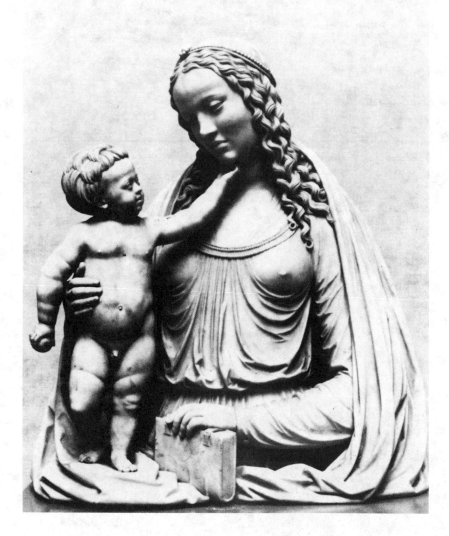

Figure 13. Hemessen, *Madonna and Child Seated in an Interior, with St. Joseph in the Background,* ca. 1525, Lisbon, Museu Nacional de Arte Antiga. (Cat. No. 3)

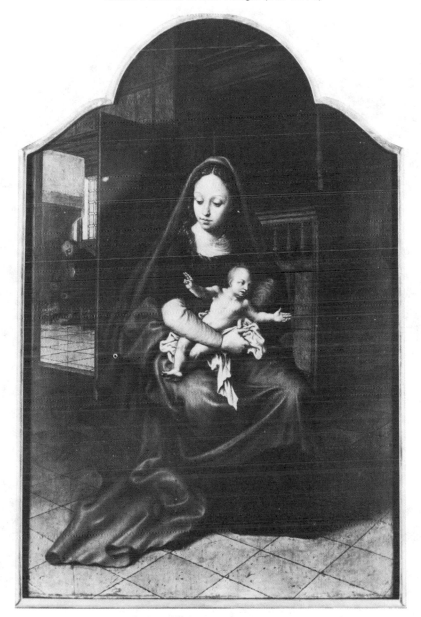

Figure 14. Quentin Massys, *Madonna and Child,* Poznan, Museum.

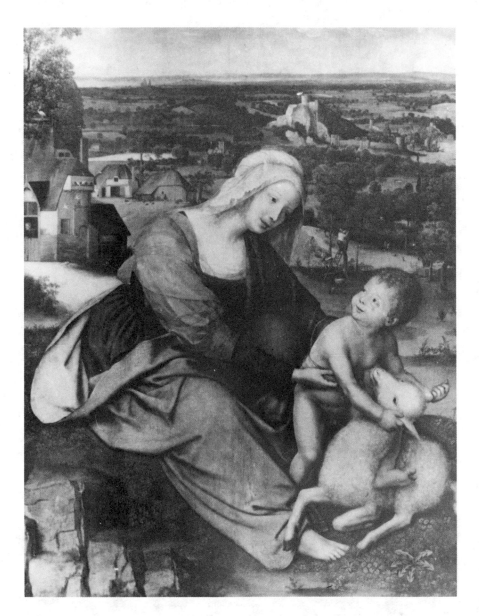

Figure 15. Hemessen, *Madonna of Humility (Rest on the Flight to Egypt),* ca. 1527–28, location unknown. (Cat. No. 5)

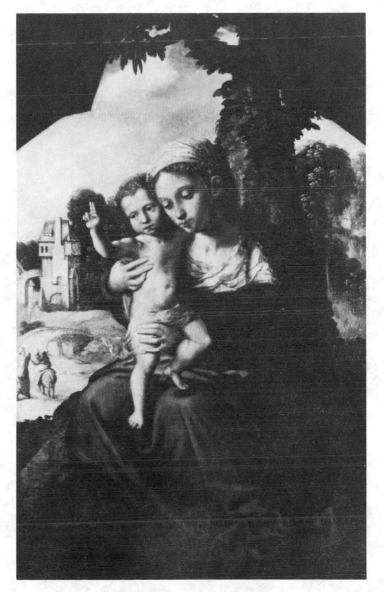

Figure 16. Hemessen, *Madonna of Humility (Rest on the Flight to Egypt),* ca. 1522–23, location unknown. (Cat. No. 1)

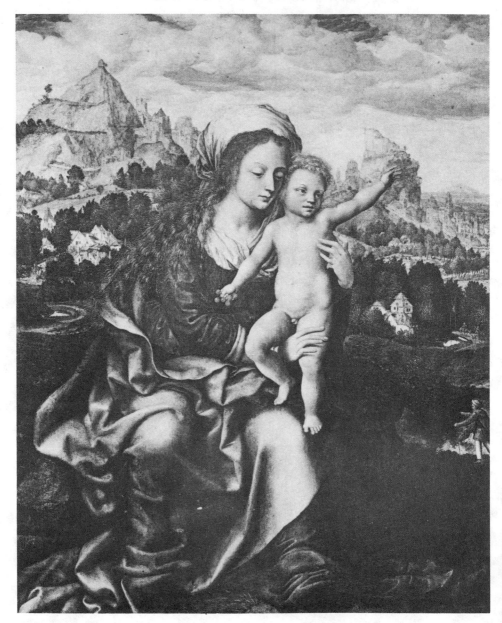

Figure 17. Master of the Magdalen Legend, *Two Female Donors and Saints Mary Magdalen and Margaret,* Schwerin, Museum.

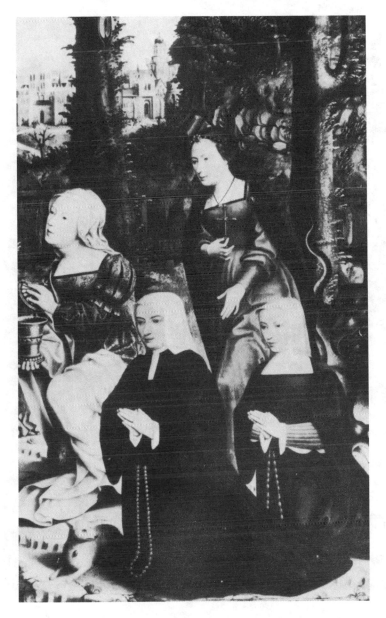

Figure 18. Hemessen, *Portrait of a Young Girl (Margaret of Parma?) Weighing Gold,* ca. 1528–29, Berlin, Dahlem Museum. (Cat. No. 6)

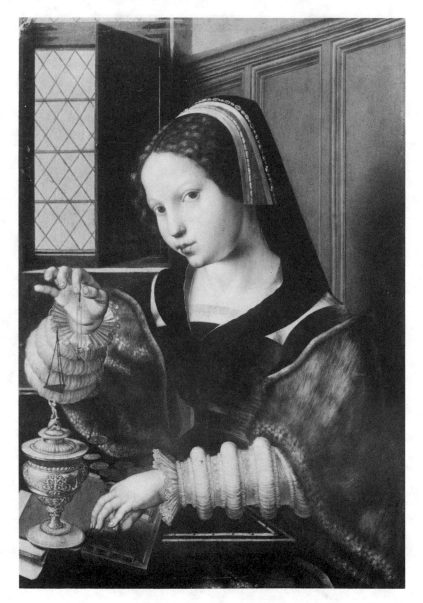

Figure 19. Hemessen, *Portrait of a Young Girl (Margaret of Parma?) Playing a Clavichord,* ca. 1528-29, Worcester, Mass., Worcester Art Museum. (Cat. No. 7)

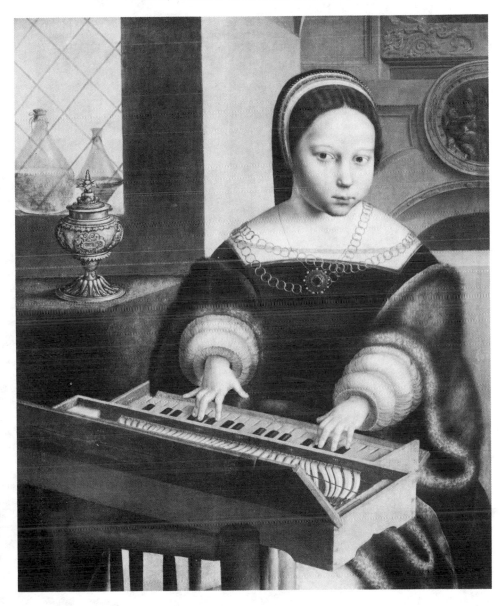

Figure 20. Hemessen, copy after, *Portrait of a Young Girl (Margaret of Parma?) Writing,* ca. 1530, London, National Gallery. (Cat. No. 56)

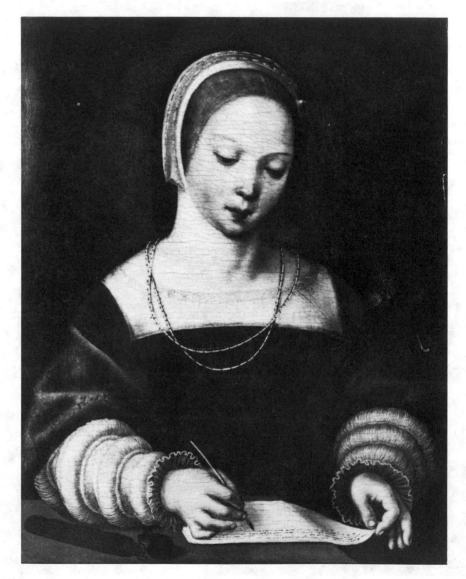

Figure 21. Hemessen, after Andrea del Sarto, *Charity,* ca. 1528-30, location unknown. (Cat. No. 8)

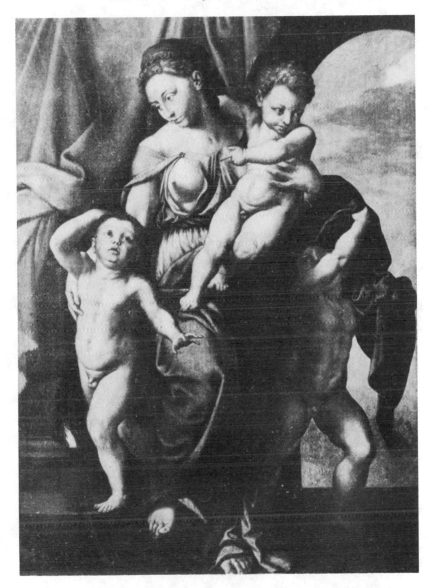

Figure 22. Andrea del Sarto, *Charity,* Florence, Chiostro dello Scalzo.

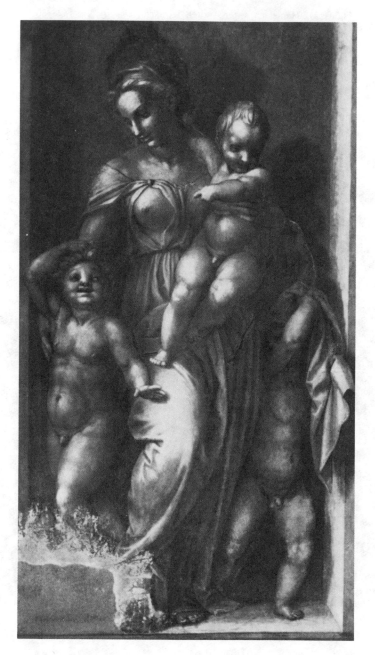

Figure 23. Hemessen, copy after (by the Brunswick Monogrammist),
Lamentation, ca. 1529–30, Mainz, Gemäldegalerie. (Cat.
No. 55)

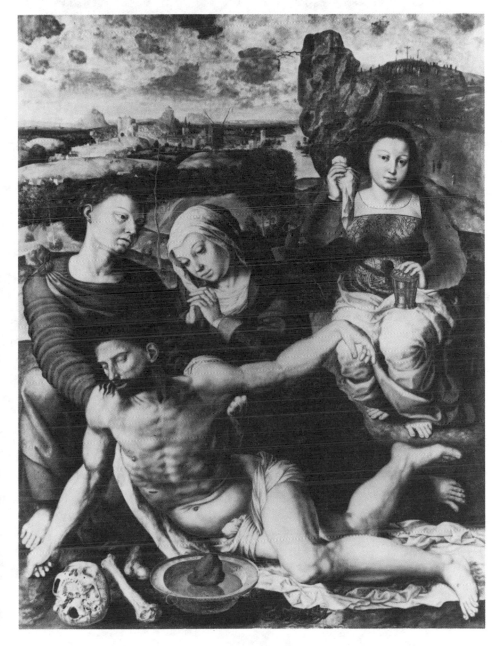

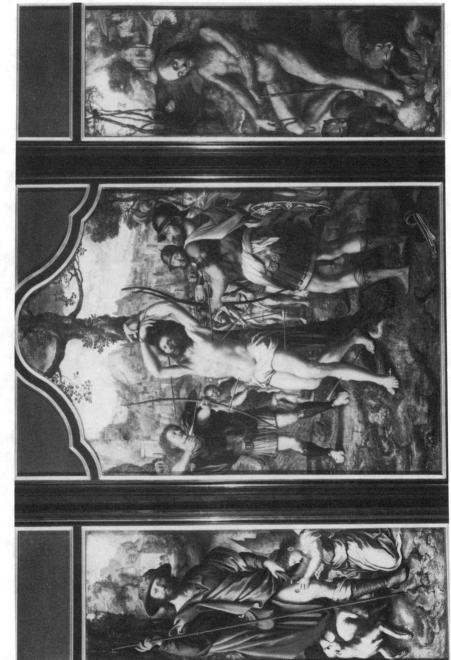

Figure 24. Hemessen, *St. Sebastian Triptych* (open), ca. 1530, Paris, Petit Palais, Coll. O'Campo. (Cat. No. 9)

Figure 25. Jacopo de'Barbari, *St. Sebastian,* engraving.

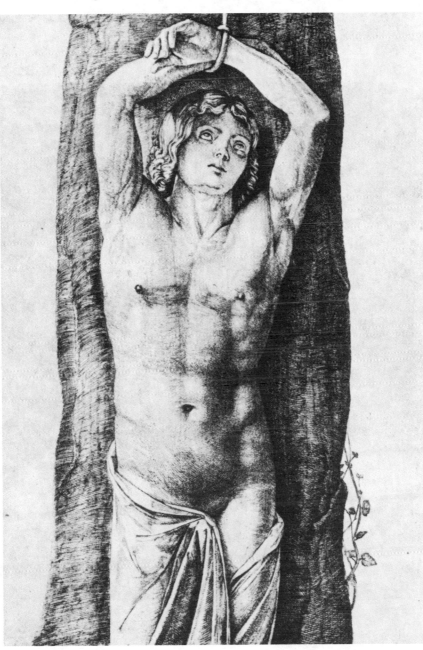

Figure 26. Jan Swart van Groningen, *Saints Peter and Stephen* (closed wings of *St. Sebastian Triptych*), ca. 1530, Paris, Petit Palais, Coll. O'Campo. (Cat. No. 9)

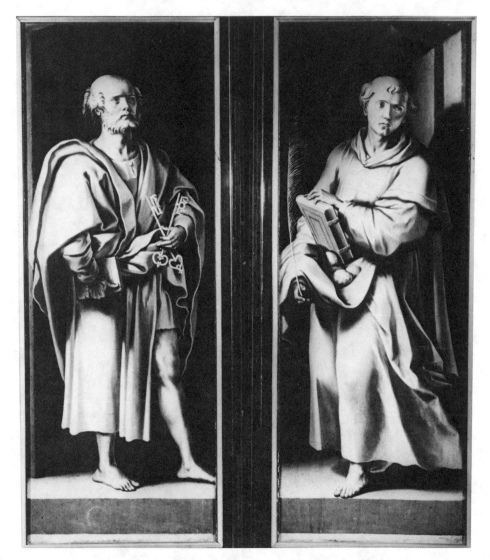

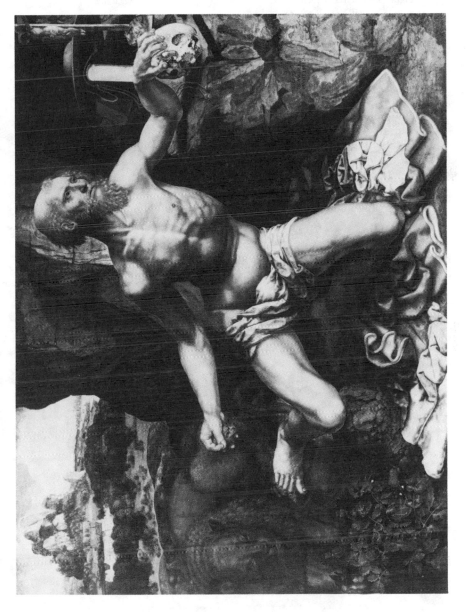

Figure 27. Hemessen, *St. Jerome Penitent*, 1531, Lisbon, Museu Nacional de Arte Antiga. (Cat. No. 10)

Figure 28. Marco Dente, *Laocoön,* ca. 1520–25, engraving (B.XIV.268.353).

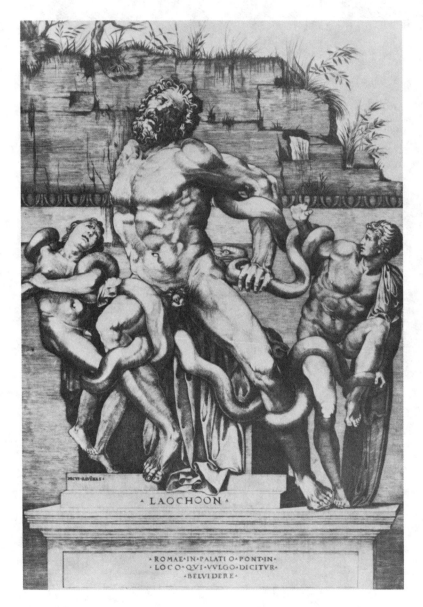

Figure 29. Marcantonio Raimondi, after Michelangelo, *The Climbers*, 1510, engraving (B.XIV.361.487).

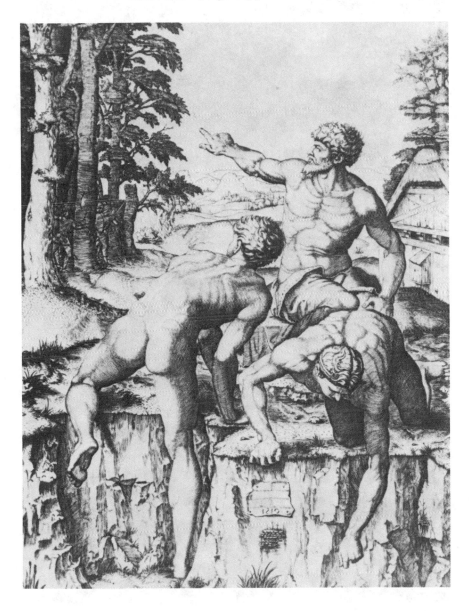

Figure 30. Hans Memling, *St. Jerome Penitent,* Basle, Kunstmuseum.

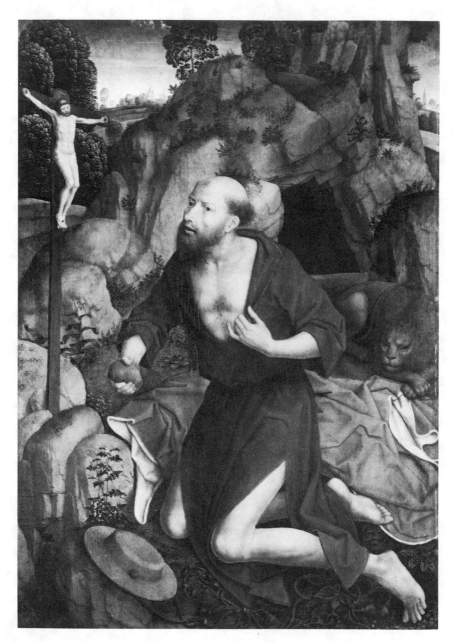

Figure 31. Giovan Gerolamo Savoldo, *Penitent St. Jerome*, London, National Gallery.

Figure 32. Detail of figure 27.

Figure 33. *Portrait of Ignatius Loyola,* after Coello, engraving.

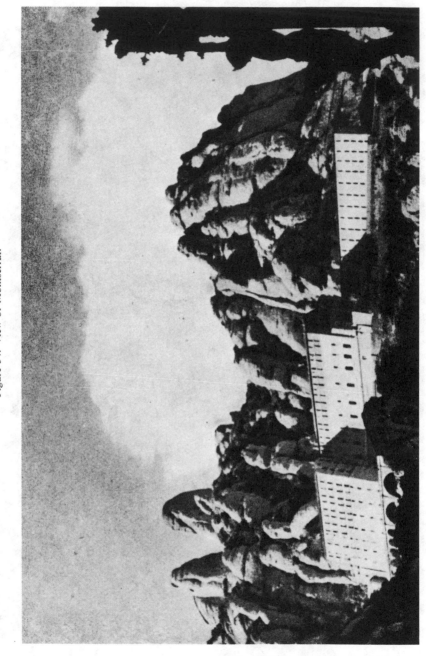

Figure 34. View of Montserrat.

Figure 35. *Monk Prays before Our Lady of Montserrat,* 16th Century, anonymous Spanish woodcut.

Figure 36. Hemessen, *St. Jerome in his Study,* 1534, location unknown. (Cat. No. 12)

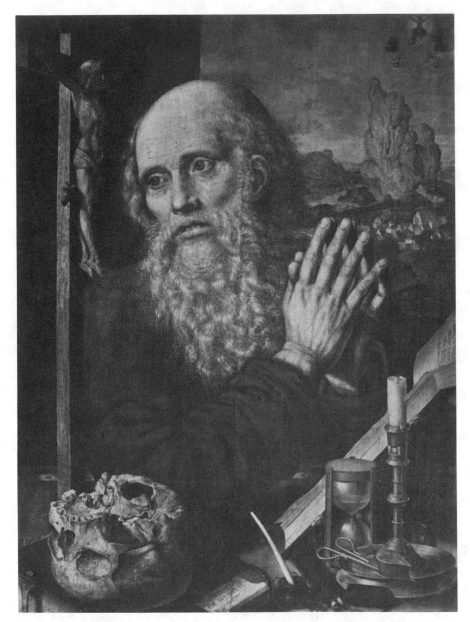

Figure 37. Hemessen, copy after (by the Brunswick Monogrammist), *St. Jerome in his Study,* Prague, National Gallery. (Cat. No. 12a)

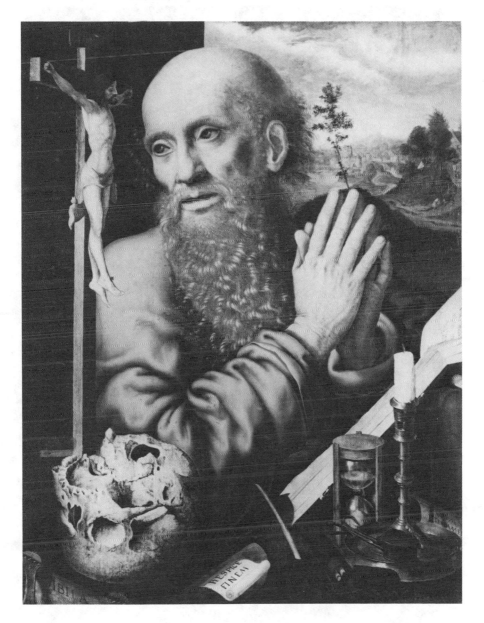

Figure 38. Brunswick Monogrammist (Jan van Amstel?), *Portrait of a Girl with a Lute,* Berlin, Dahlem Museum.

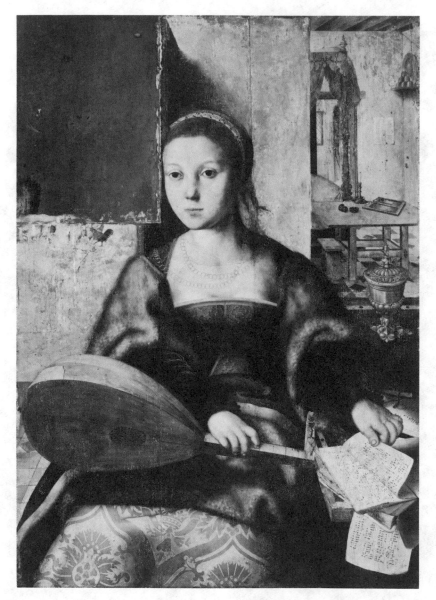

Figure 39. Brunswick Monogrammist (Jan van Amstel?), *Christ with
Martha and Mary* (section removed from figure 38), Ber-
lin, Dahlem Museum.

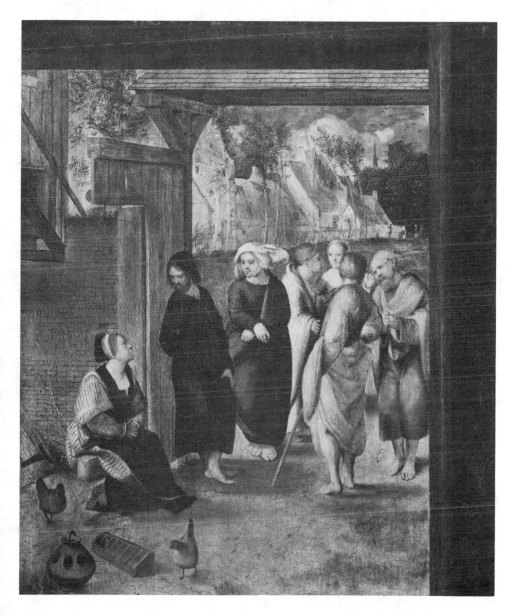

Figure 40. Hemessen, copy after (by the Master of the Augsburg
Ecce Homo), *St. Jerome in his Study,* ca. 1530–35, Ant-
werp, Rockoxhuis. (Cat. No. 57)

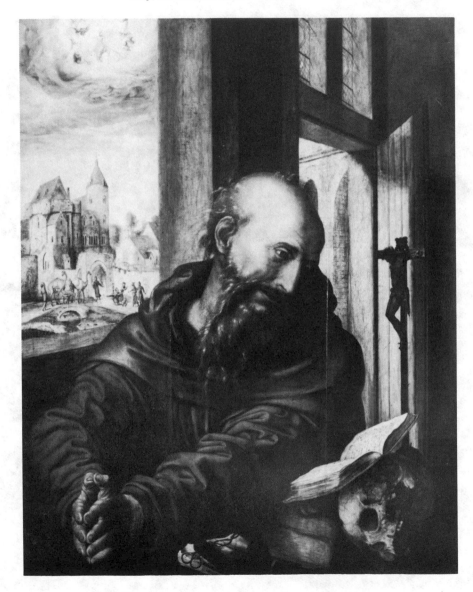

Figure 41. Hemessen, copy after, *St. Jerome in his Study,* ca. 1538–40, formerly Amsterdam, private collection. (Cat. No. 60b)

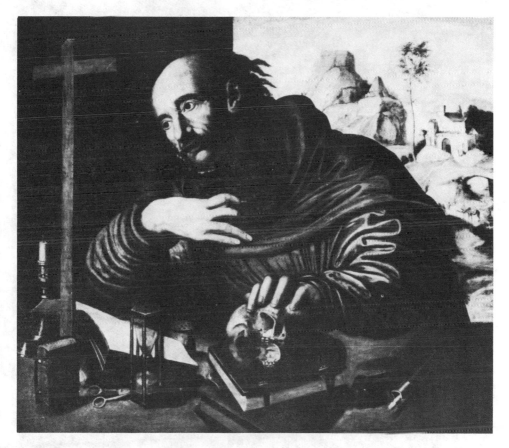

Figure 42. Hemessen, copy after, *St. Jerome in his Study*, ca. 1538–40, Vienna, Kunsthistorisches Museum. (Cat. No. 60a)

Figure 43. Quentin Massys (or Jan?), *St. Jerome in his Study*, Vienna, Kuns-historisches Museum.

Figure 44. Brunswick Monogrammist (Jan van Amstel?) and Joos van Cleve, *St. Jerome Penitent, in his Study,* 1530, West Palm Beach, Norton Gallery and School of Art.

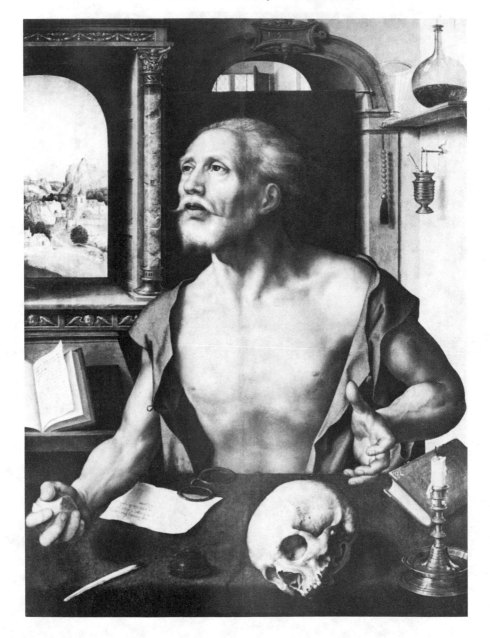

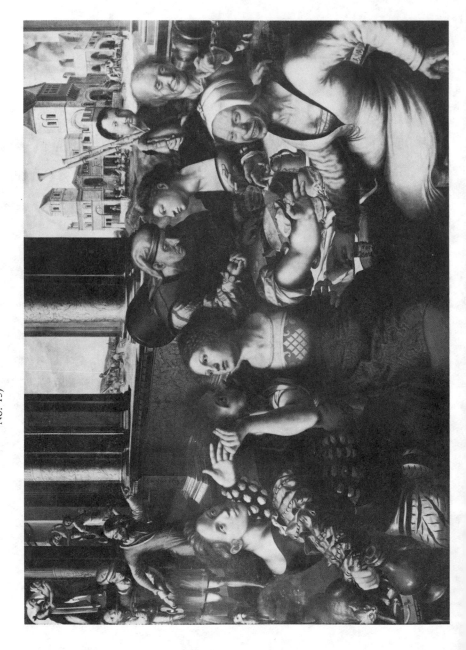

Figure 46. Hemessen, with Jan Swart, *Parable of the Prodigal Son*, 1536, Brussels, Musées Royaux des Beaux-Arts. (Cat. No. 15)

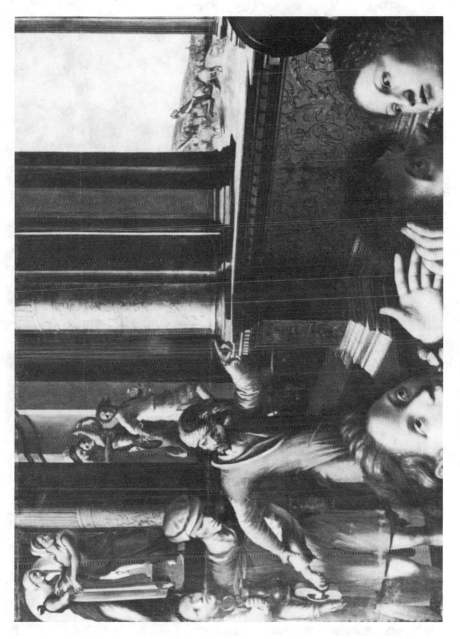

Figure 47. Detail of figure 46 (background scene by Jan Swart).

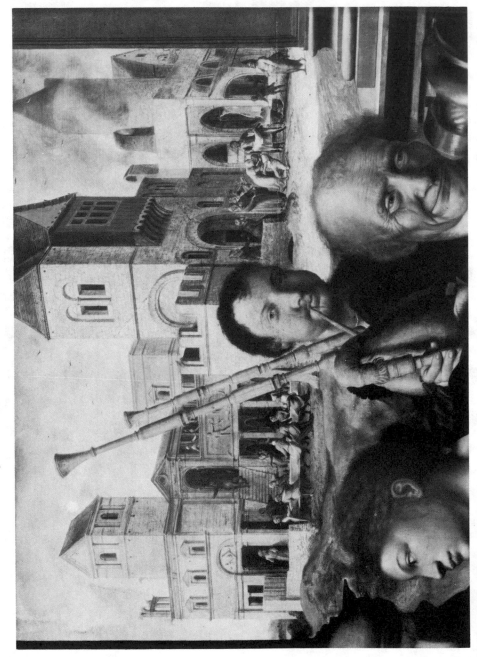

Figure 48. Detail of figure 46 (background scene by Jan Swart).

Figure 49. Detail of figure 46.

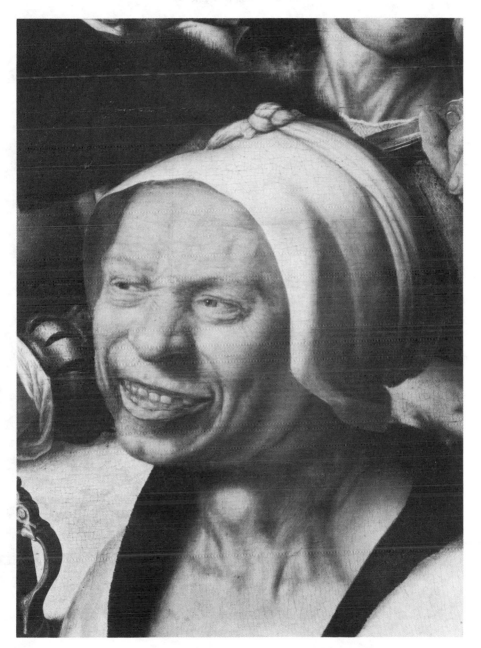

Figure 50. Detail of figure 46.

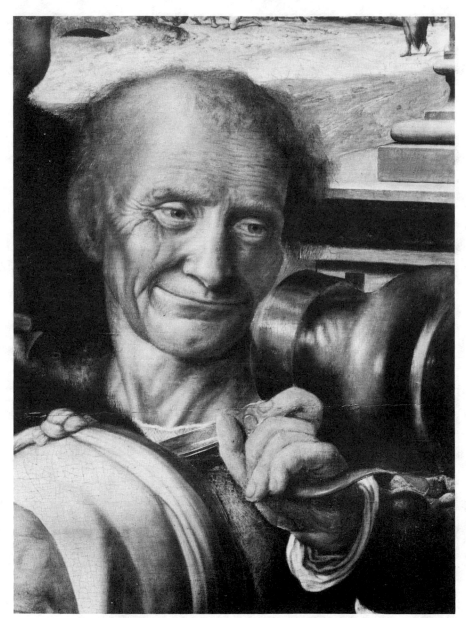

Figure 51. Lucas van Leyden, *Prodigal Son at the Inn,* 1519, woodcut.

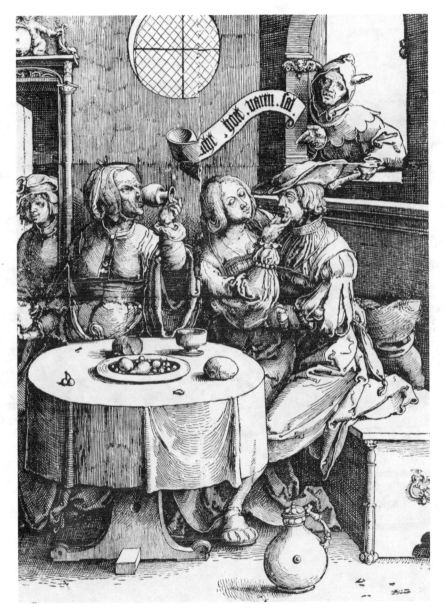

Figure 52. Titian, *Bacchanal of the Andrians,* Madrid, Museo del Prado.

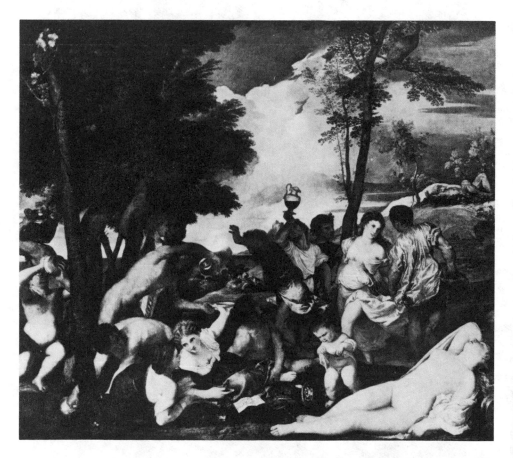

Figure 53. Michelangelo, *Erythraean Sibyl,* Sistine Ceiling.

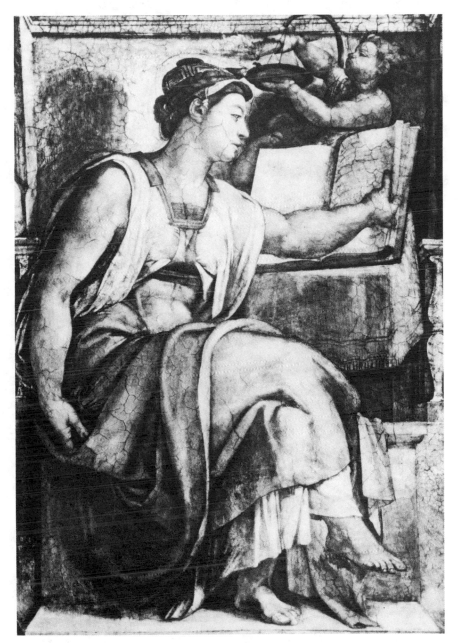

Figure 54. *Envy,* from *Roman de la Rose,* French, 15th Century, Oxford, Bodleian Library, MS Douce 364, fol. 3ᵛ.

Figure 55. Hemessen, with Jan Swart, *Wayfarer in a Brothel,* ca. 1539, Karlsruhe, Staatliche Kunsthalle. (Cat. No. 19)

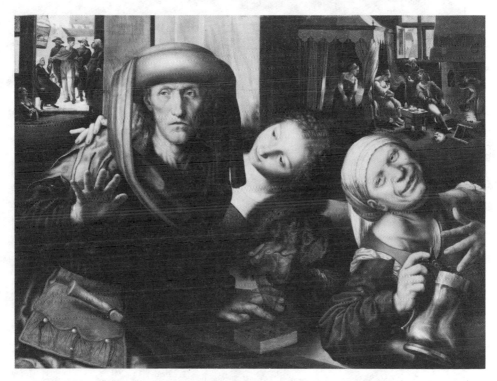

Figure 56. Detail of figure 55 (background scene by Jan Swart).

Figure 57. Detail of figure 55 (background scene by Jan Swart).

Figure 58. Hemessen, *Wayfarer in a Brothel*, 1543, Hartford, Wadsworth Atheneum. (Cat. No. 27)

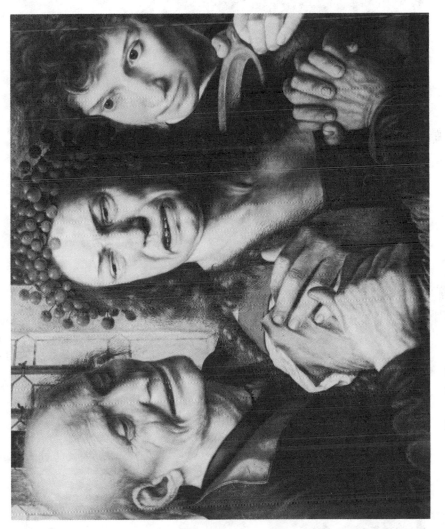

Figure 59. Hemessen, *Tearful Bride*, ca. 1540, Prague, National
Gallery. (Cat. No. 22)

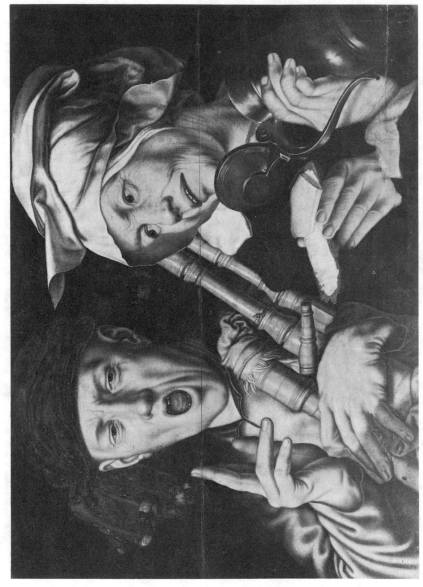

Figure 60. Hemessen, *Bagpiper and Merry Wife*, ca. 1540, Brussels, Musées Royaux des Beaux-Arts. (Cat. No. 21)

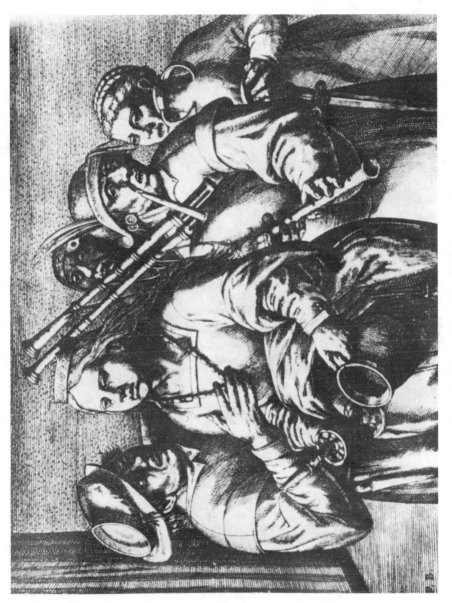

Figure 61. Pierre Baltens, *Tearful Bride*, engraving.

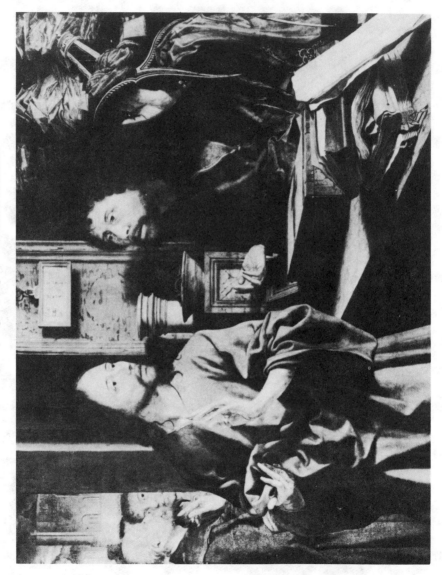

Figure 62. Marinus van Roymerswaele, *Calling of St. Matthew*, Castagnola, Lugano, Thyssen-Bornemisza Collection.

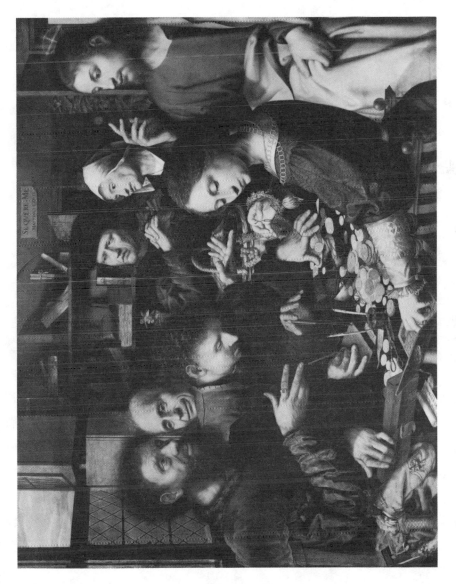

Figure 63. Hemessen. *Calling of St. Matthew (Money-Broker Greets Unseen Visitor)*, 1536, Munich, Alte Pinakothek. (Cat. No. 16)

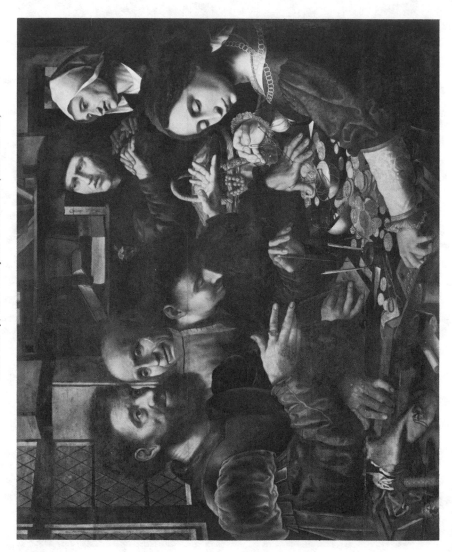

Figure 64. Hemessen, copy after, *Calling of St. Matthew (Money-Broker Greets Unseen Visitor)*, Dalkeith (Scotland), New-battle Abbey, Coll. Marquess of Lothian. (Cat. No. 16a)

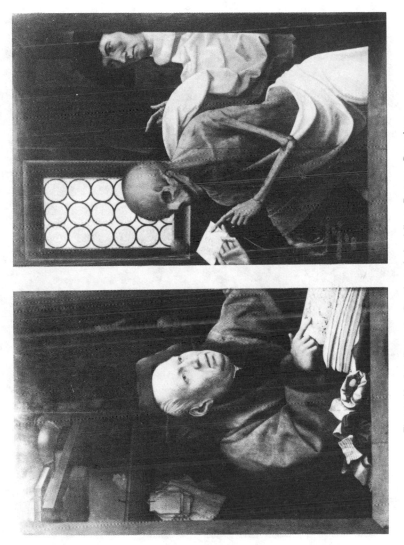

Figure 65. Jan Provost, *Death and the Miser*, Bruges, Groeninge-museum.

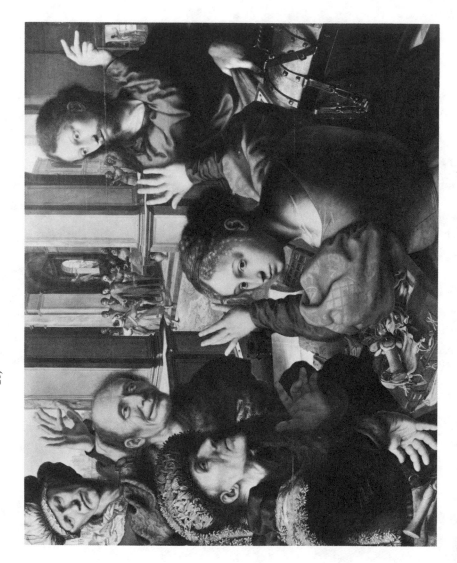

Figure 66. Hemessen, with Jan Swart, *Calling of St. Matthew*, ca. 1539–40, Vienna, Kunsthistorisches Museum. (Cat. No. 20)

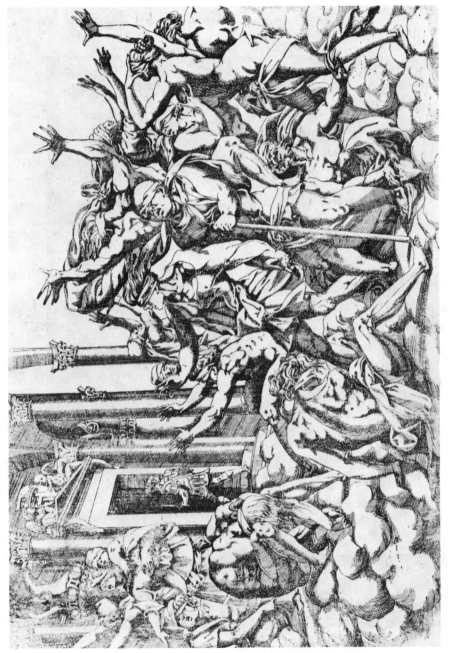

Figure 67. Antonio Fantuzzi, after Rosso Fiorentino, *L'Ignorance Chassée*, etching.

Figure 68. Bernard van Orley, copy after, *Portrait of Charles V*, Paris, Musée du Louvre.

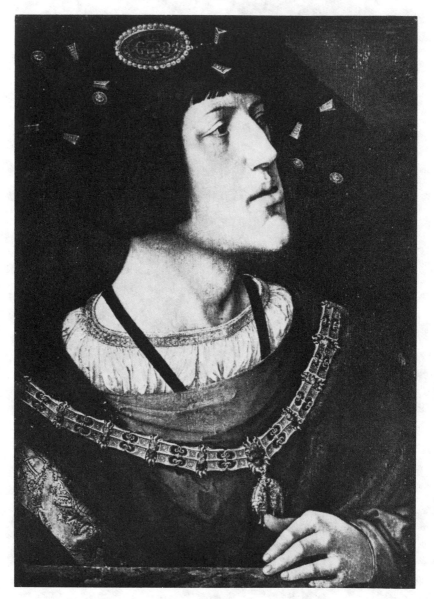

Figure 69. Detail of figure 66 (background scene by Jan Swart).

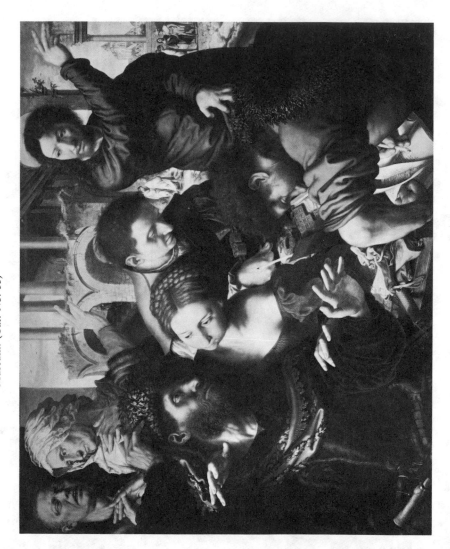

Figure 70. Hemessen, with Master of the Douai *Ecce Homo, Calling of St. Matthew,* ca. 1548, Vienna, Kunsthistorisches Museum. (Cat. No. 33)

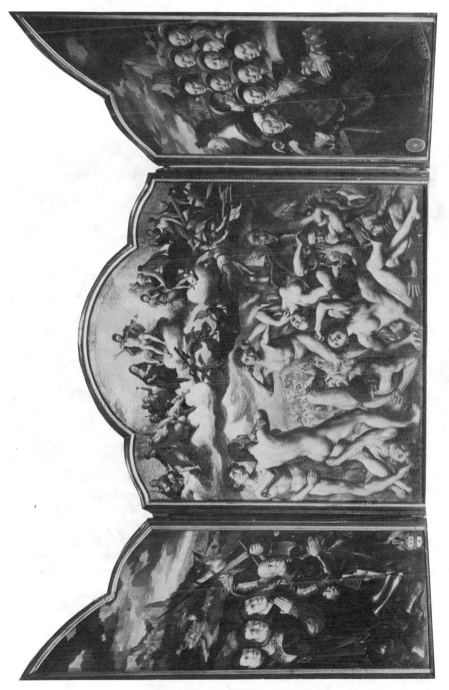

Figure 71. Hemessen, with Jan Jan Swart, *Last Judgment Triptych* (open), ca. 1536–37, Antwerp, Sint Jacobskerk. (Cat. No. 17)

Figure 72. Detail of figure 71 (left wing: *Male Donors*).

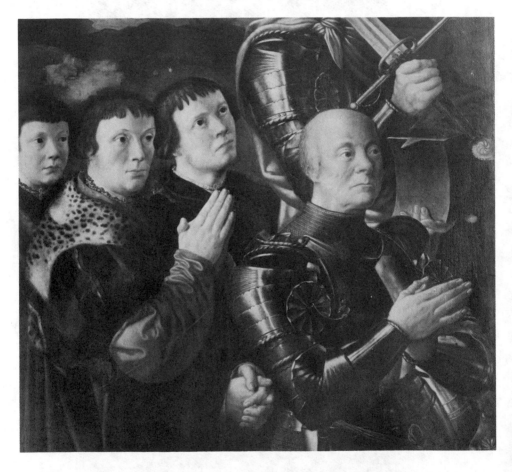

Figure 73. Detail of figure 71 (right wing: *Female Donors*).

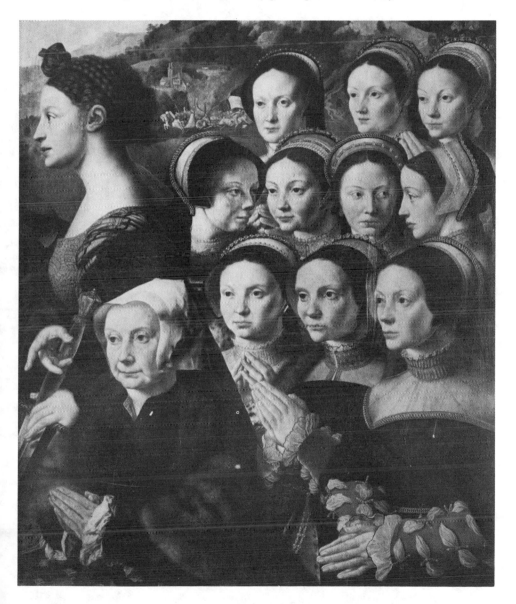

Figure 74. Detail of figure 71 (center panel: *Last Judgment*).

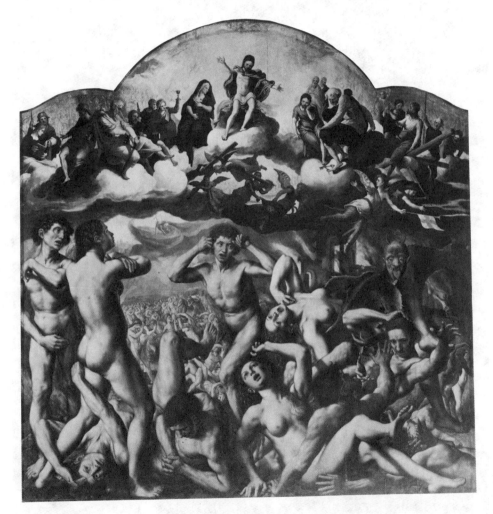

Figure 75. Bernard van Orley, *Last Judgment,* Antwerp, Koninklijk Museum voor Schone Kunsten.

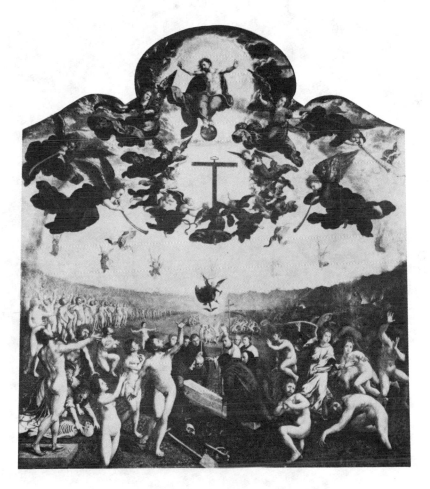

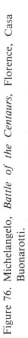

Figure 76. Michelangelo, *Battle of the Centaurs*, Florence, Casa Buonarotti.

Figure 77. Raphael, *Transfiguration,* Rome, Pinacoteca Vaticana.

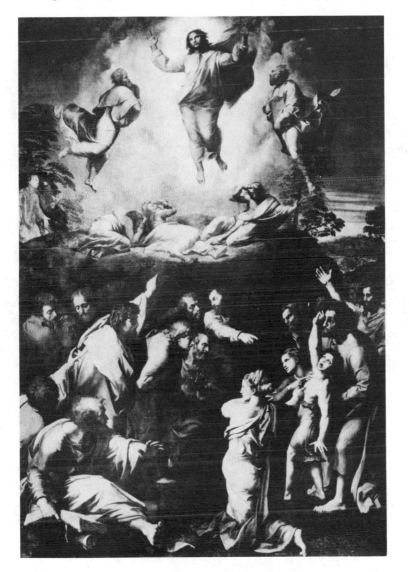

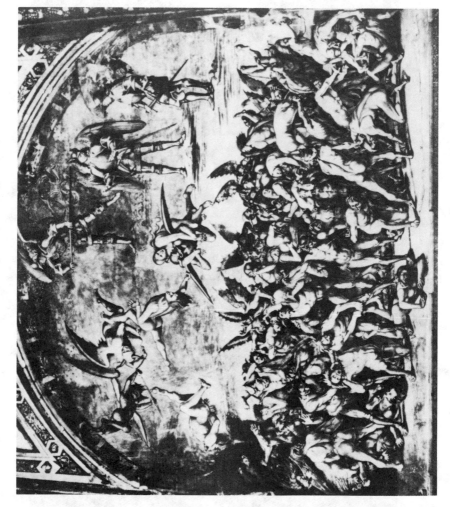

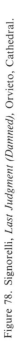

Figure 78. Signorelli, *Last Judgment (Damned)*, Orvieto, Cathedral.

Figure 79. Antonio Fantuzzi, after Rosso Fiorentino, *Contest Between Athena and Poseidon*, etching.

Figure 80. Hemessen, *Double Intercession* (closed wings of *Last Judgment Triptych,* figure 71).

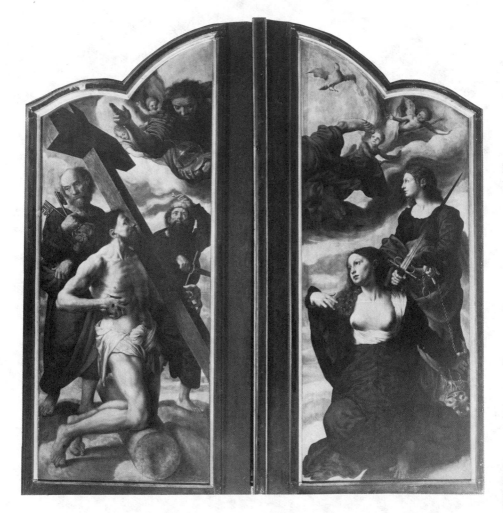

Figure 81. Hemessen, after Raphael, *Madonna and Child,* ca. 1535-36, Bruges, Groeningemuseum. (Cat. No. 14)

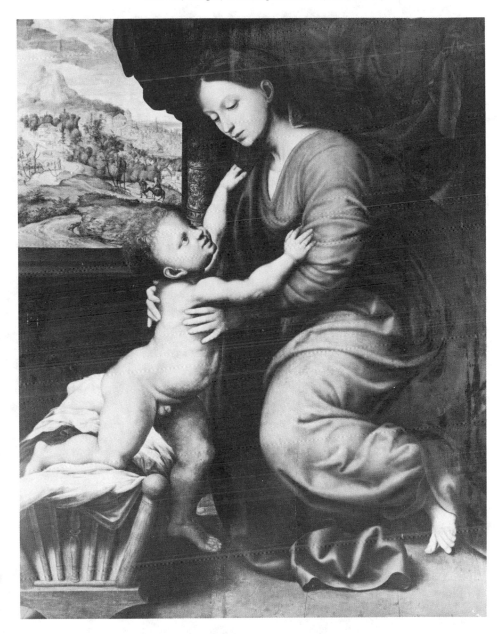

Figure 82. Raphael, *Holy Family of Francis I,* Paris, Musée du Louvre.

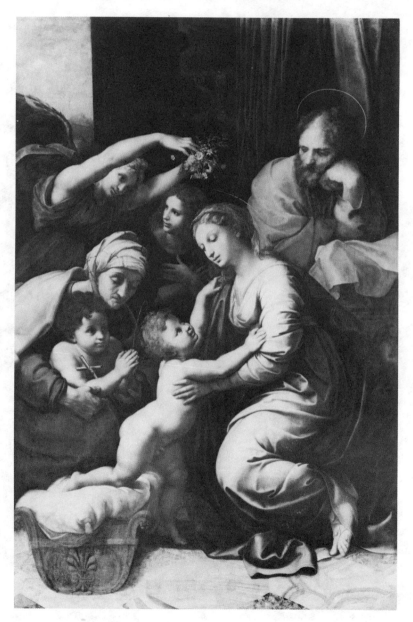

Figure 83. Hemessen, *Madonna and Child,* ca. 1535, location unknown. (Cat. No. 13)

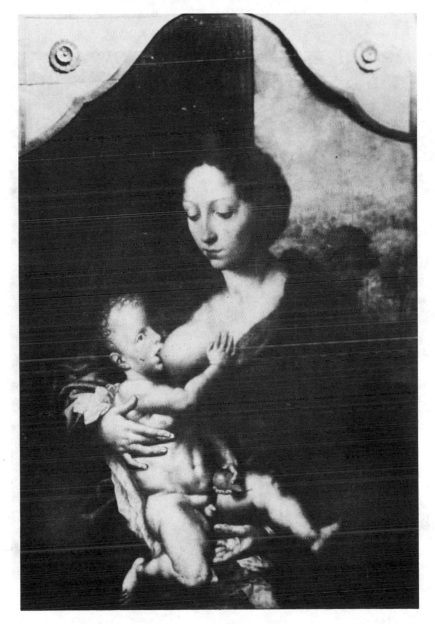

Figure 84. Hemessen, copy after (by the Brunswick Monogrammist),
Madonna and Child, ca. 1535, location unknown. (Cat.
No. 58)

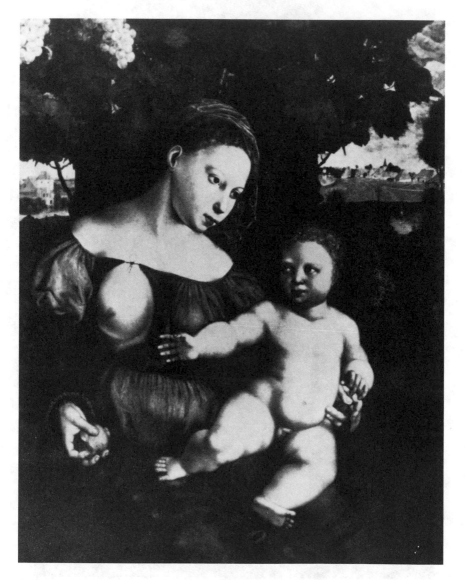

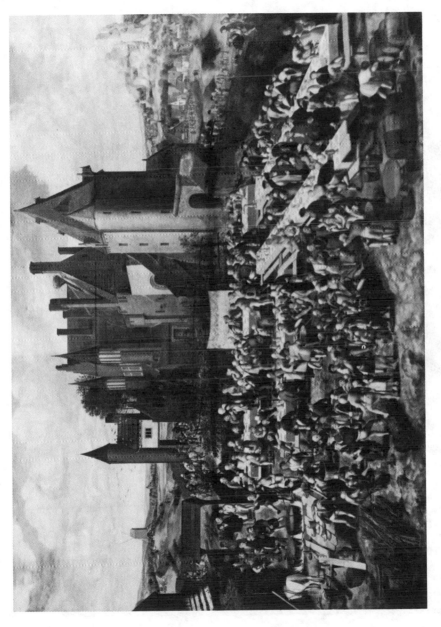

Figure 85. Brunswick Monogrammist (Jan van Amstel?), *Parable of the Great Feast*, Brunswick, Herzog-Anton-Ulrich Museum.

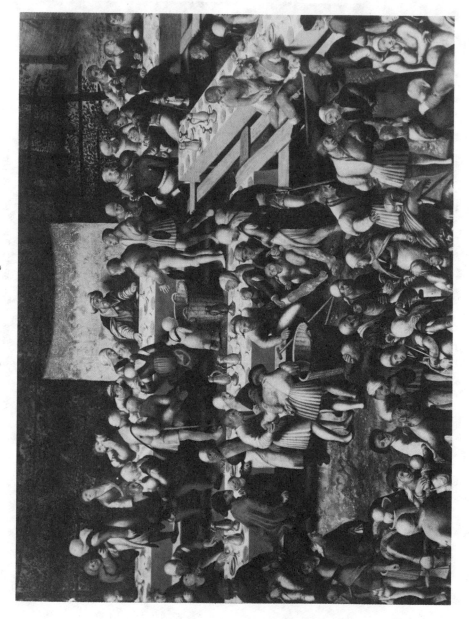

Figure 86. Detail of figure 85.

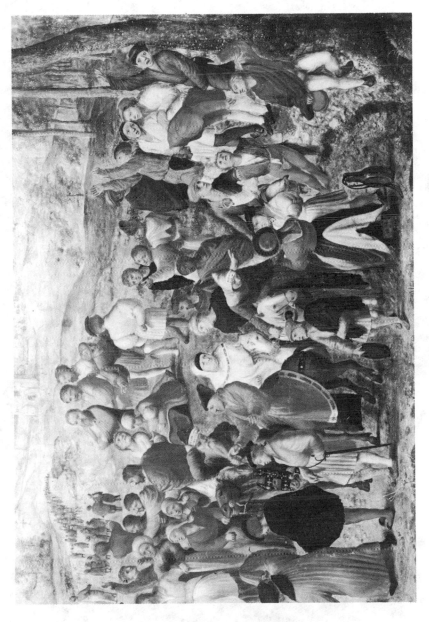

Figure 87. Brunswick Mcnogrammist (Jan van Amstel?), *Entry of Christ into Jerusalem* (detail), Stuttgart, Staatsgalerie.

Figure 88. Detail of figure 74 (upper register of *Last Judgment*, by Jan Swart).

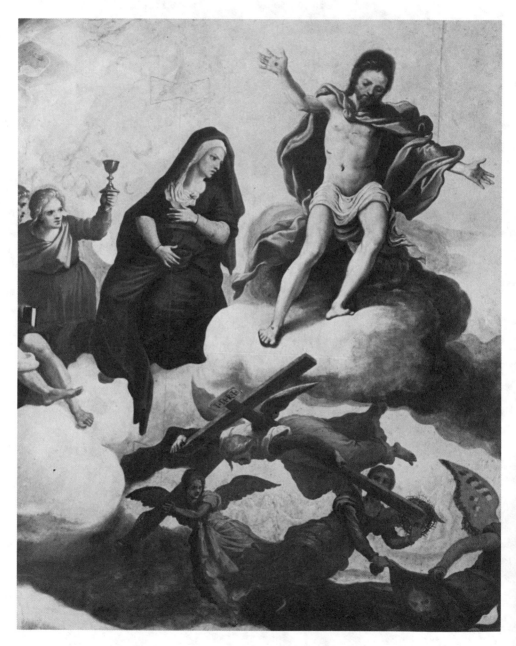

Figure 89. Detail of figure 74 (upper register of *Last Judgment*, by Jan Swart).

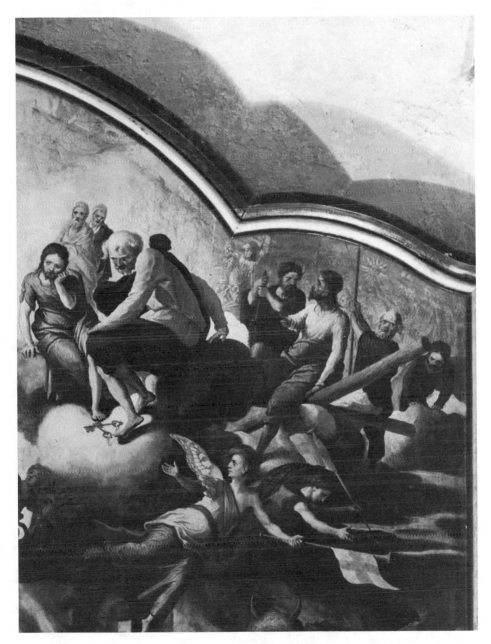

Figure 90. Jan Swart, *Preaching of St. John the Baptist,* woodcut, Berlin, Kupferstichkabinett.

Figure 91. Jan Swart. *Lot and his Daughter,* Amsterdam, Rijks-
museum.

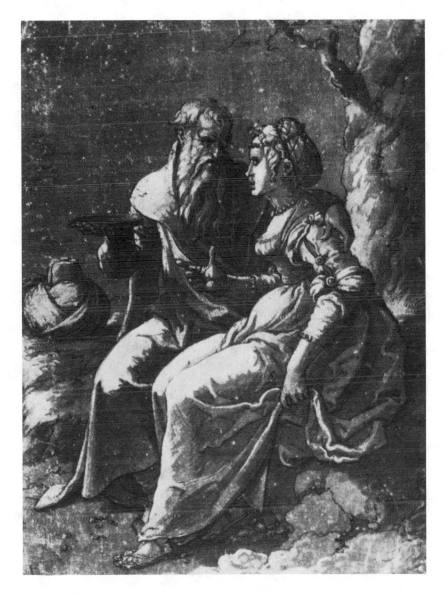

Figure 92. Jan Swart, *Departure of the Prodigal Son,* Berlin, Kupferstichkabinett.

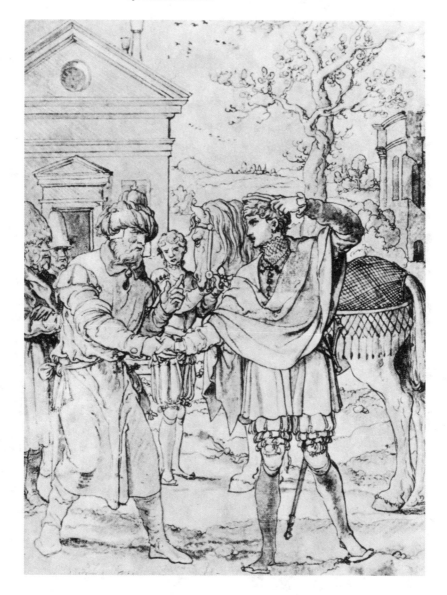

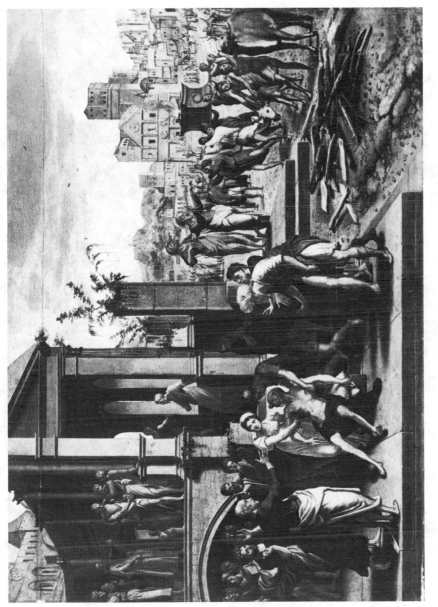

Figure 93. Jan Swart, *St. Paul and Barnabas at Lystra*, Budapest, Museum of Fine Arts.

Figure 94. Jan Swart, *Fall of Man,* Minneapolis Institute of Arts.

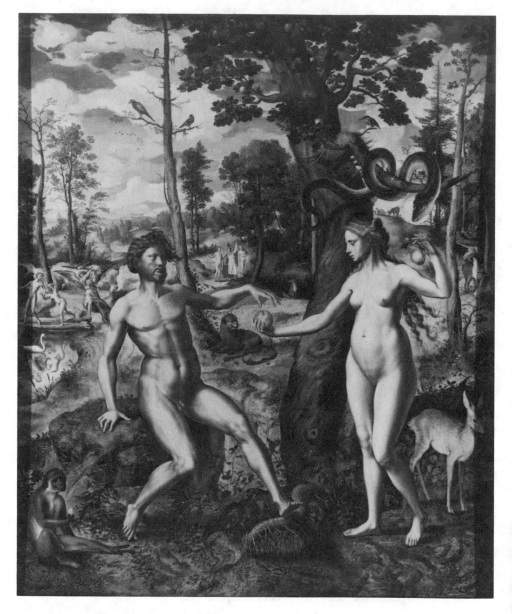

Figure 95. Detail of figure 94.

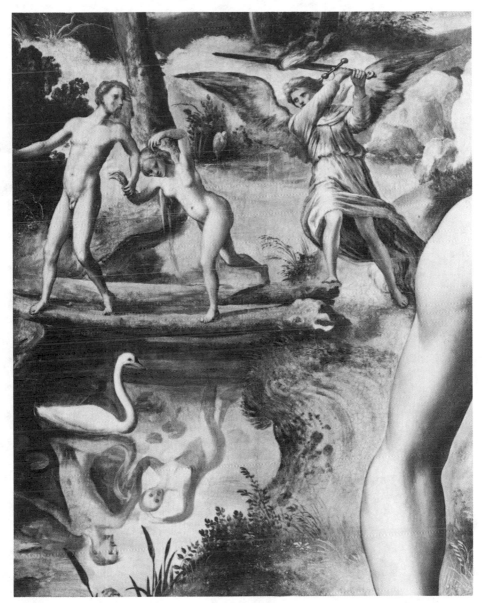

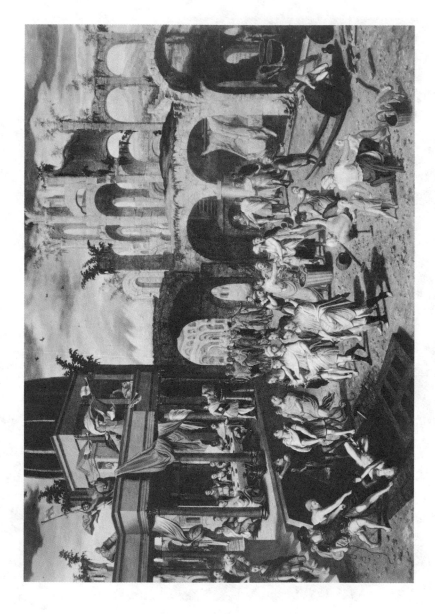

Figure 96. Master of the Douai *Ecce Homo, Parable of the Unworthy Guest*, Paris, private collection.

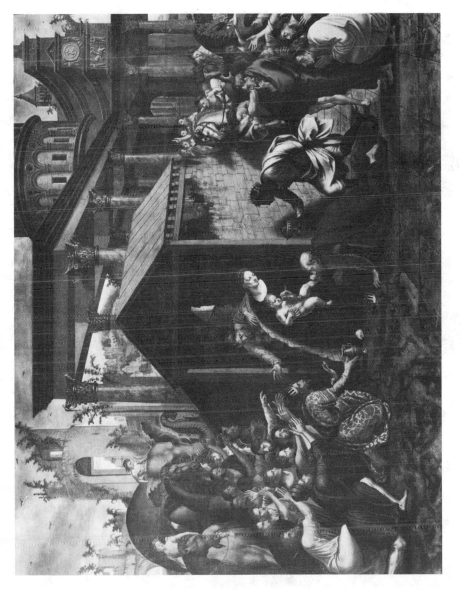

Figure 97. Master of the Douai *Ecce Homo, Adoration of the Magi,* Liège, Hôtel de Bocholtz, Banque de Paris et des Pays-Bas.

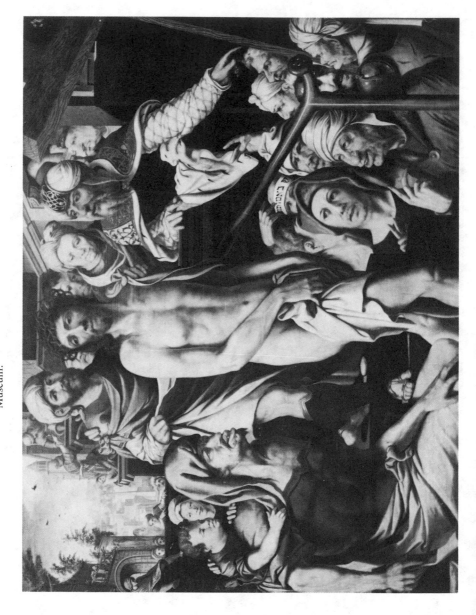

Figure 98. Master of the Douai *Ecce Homo*, *Ecce Homo*, Douai, Museum.

Figure 99. Hemessen, *Salvator Mundi,* ca. 1538-40, location unknown. (Cat. No. 18)

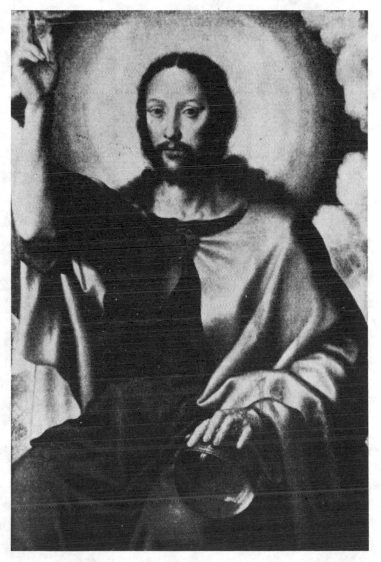

Figure 100. Hemessen, *Man of Sorrows,* 1540, Linz, Landesmuseum
(Cat. No. 23)

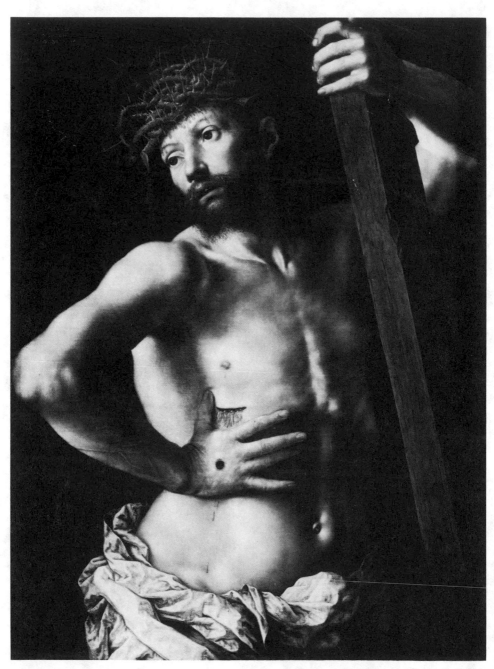

Figure 101. Hemessen, *Susanna and the Elders,* 1543, Barcelona, Coll. Dr. Franco de Cesare. (Cat. No. 24)

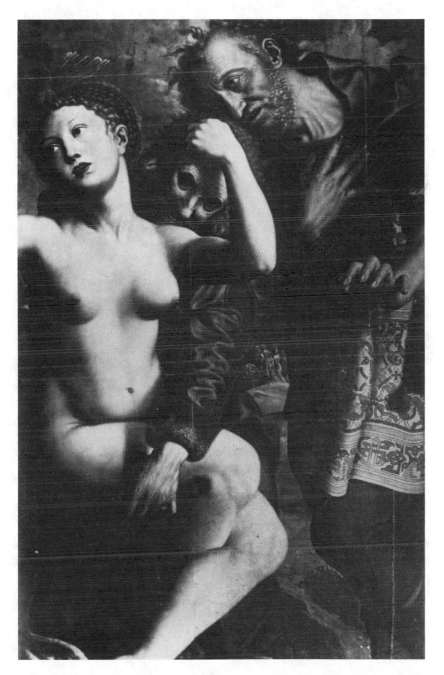

Figure 102. Jacopo Francia, *Bust of a Bereaved Woman,* engraving.

Figure 103. Hemessen, copy after, *Holy Family*, 1541, Munich, Alte Pinakothek. (Cat. No. 62a)

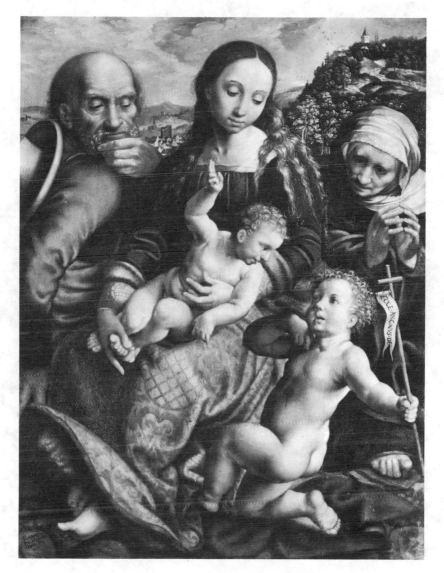

Figure 104. Hemessen, copy after, *Holy Family in a Rustic Setting,*
ca. 1541, location unknown. (Cat. No. 63a)

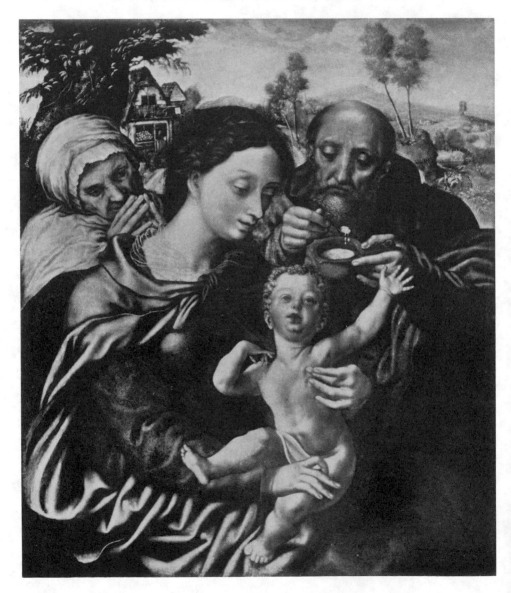

Figure 105. Hemessen, *Madonna of Humility,* 1543, Madrid, Museo del Prado, (Cat. No. 25)

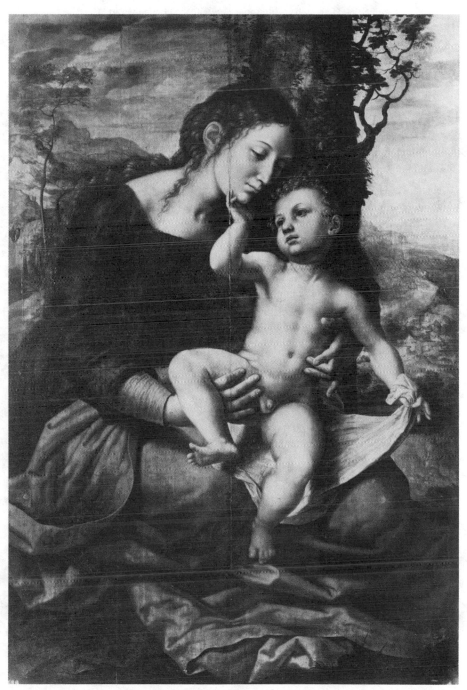

Figure 106. Hemessen, *St. Jerome Penitent,* 1543, Leningrad, Hermitage. (Cat. No. 26)

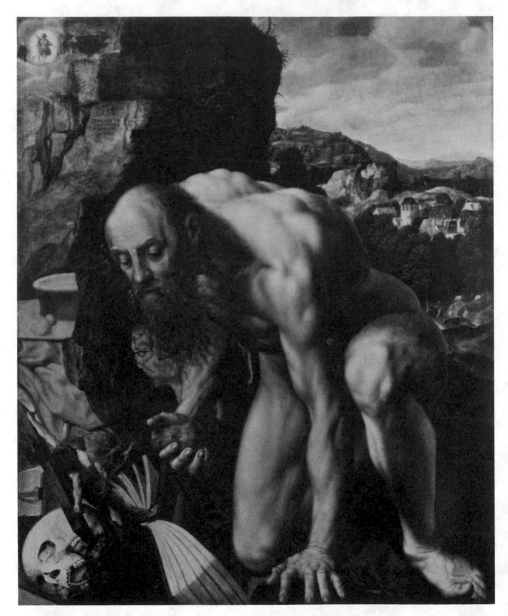

Figure 107. Maerten van Heemskerck, *Torso Belvedere*, from *Roman Sketchbook*, I fol. 63ʳ, Berlin, Kupferstichkabinett.

Figure 108. Agostino Veneziano, after Raphael, *Christ Bearing the Cross ("Lo Spasimo di Sicilia"),* 1517, engraving (B.XIV.34.28).

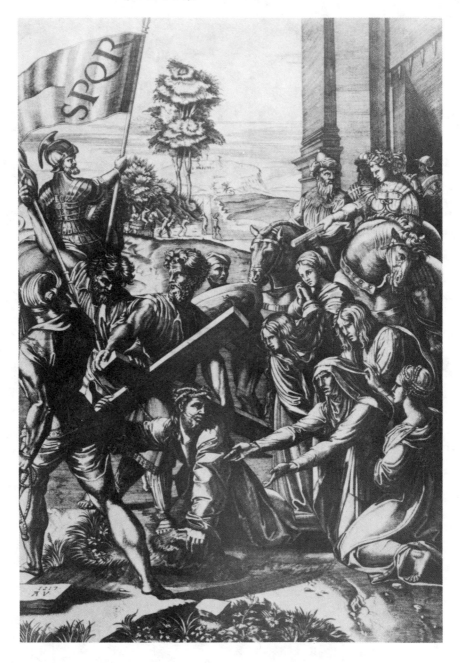

Figure 109. Hemessen, *Madonna of Humility,* 1544, Stockholm, Nationalmuseum. (Cat. No. 29)

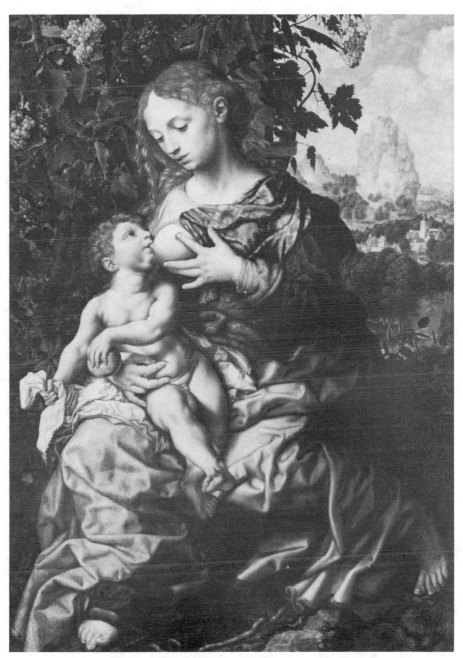

Figure 110. Marcantonio Raimondi, after Raphael, *Galatea,* ca. 1515–16, engraving (B.XIV.262–64, 350).

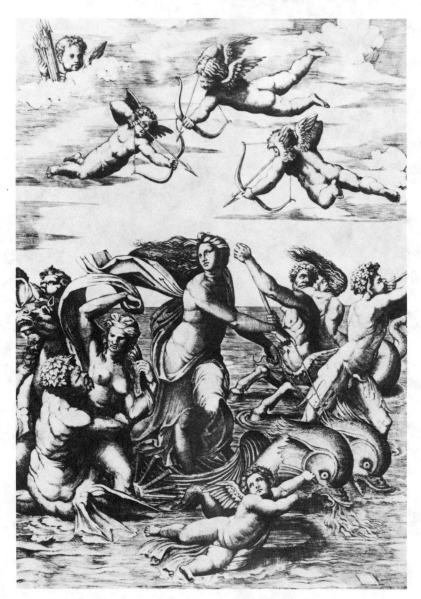

Figure 111. Hemessen, *Mocking of Christ,* 1544, Munich, Alte Pinakothek. (Cat. No. 30)

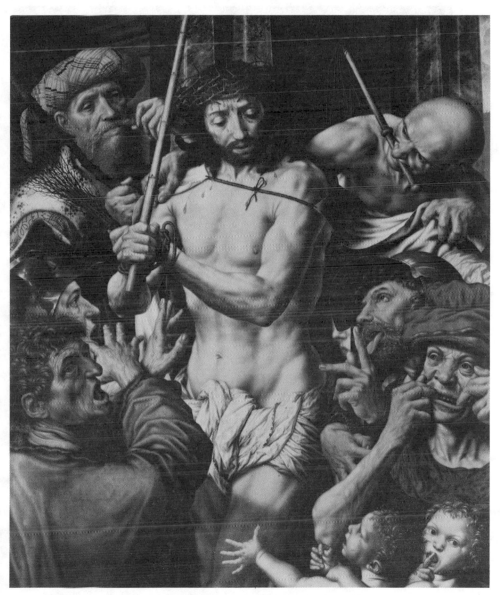

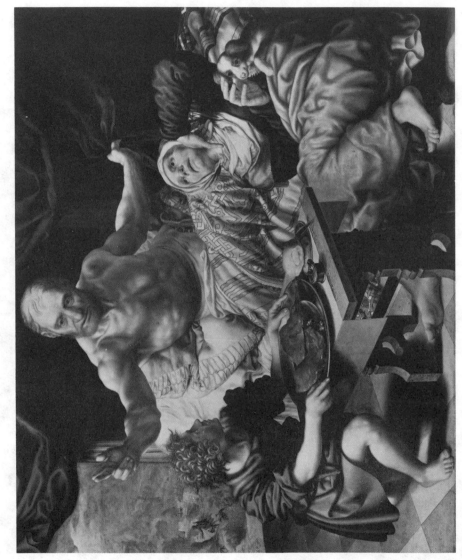

Figure 112. Hemessen, *Isaac Blessing Jacob*, ca. 1544–45, Munich, Alte Pinakothek. (Cat. No. 31)

Figure 113. Agostino Veneziano, after Raphael, *Isaac Blessing Jacob*, 1522, engraving (B.XIV.6).

Figure 114. Hemessen, *Portrait of a Magistrate,* 1543, London, private collection. (Cat. No. 28)

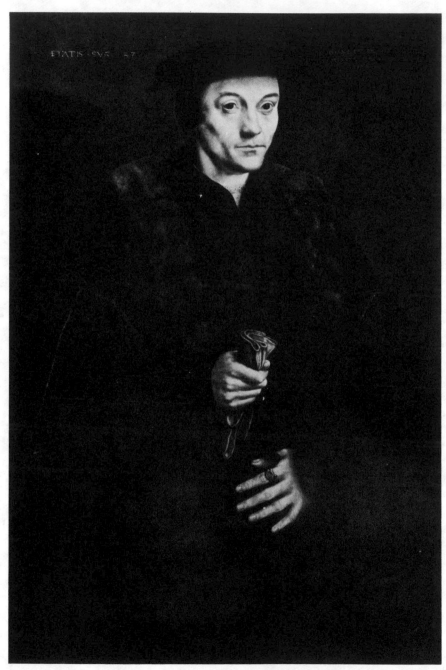

Figure 115. Hemessen, copy after, *St. Jerome Writing,* 1545, Hampton Court, Coll. Queen Elizabeth II of England. (Cat. No. 64)

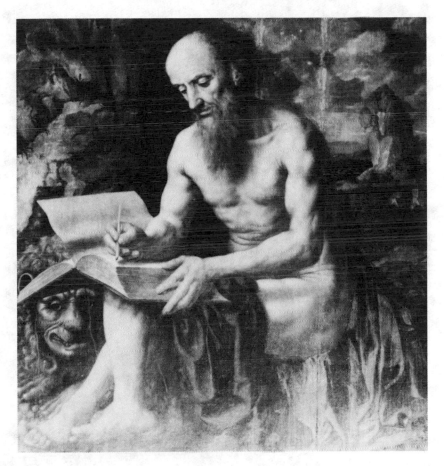

Figure 116. Hemessen, *St. Jerome in the Wilderness,* 1548, Barcelona, private collection. (Cat. No. 32)

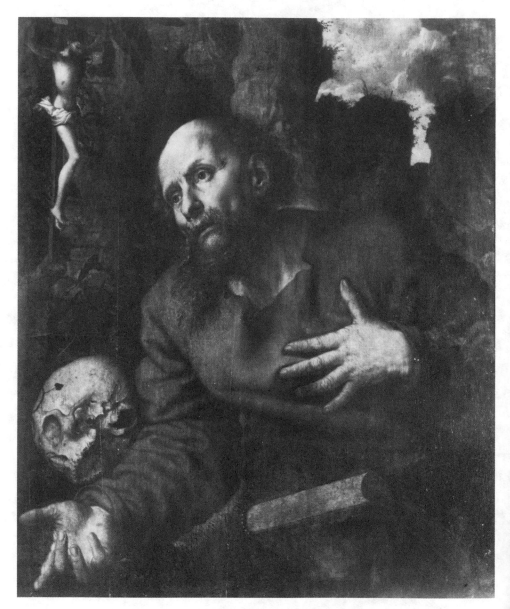

Figure 117. Hemessen, *Christ Bearing the Cross,* 1549, Toledo, Museo de Santa Cruz. (Cat. No. 34)

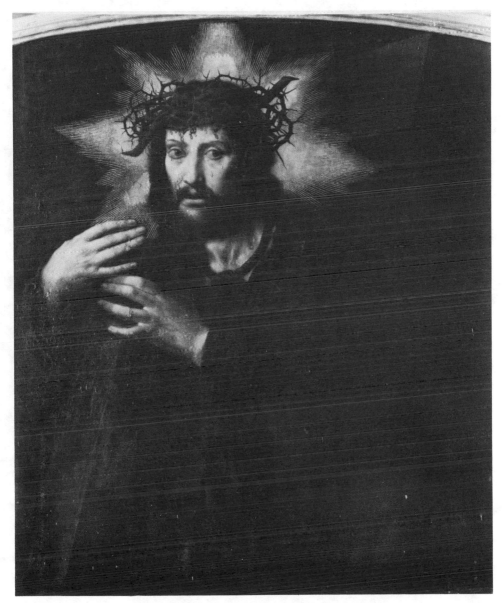

Figure 118. Detail of figure 117.

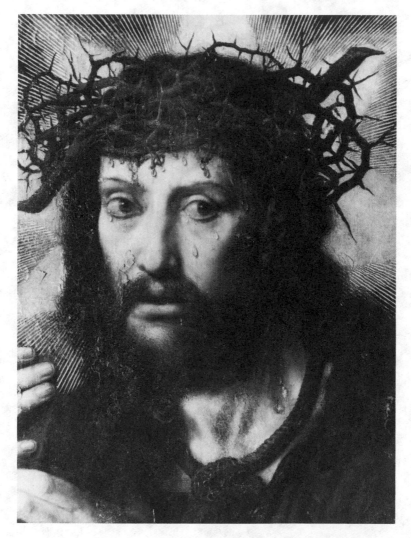

Figure 119. Romanino, *Christ Carrying the Cross,* Milan, private collection.

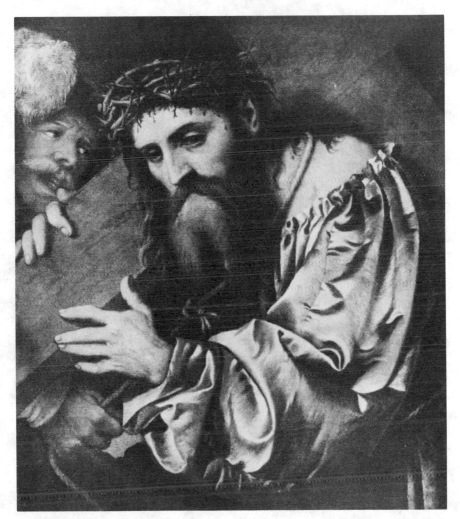

Figure 120. Hemessen, *Portrait of a Man,* ca. 1549–50, Warwick
Castle, Coll. Earl of Warwick. (Cat. No. 35)

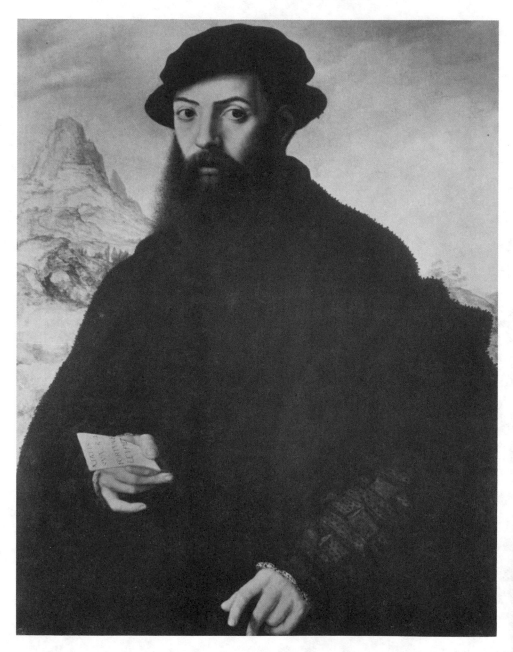

Figure 121. Hemessen, *Judith with the Head of Holofernes,* ca. 1549–50, The Art Institute of Chicago. (Cat. No. 36)

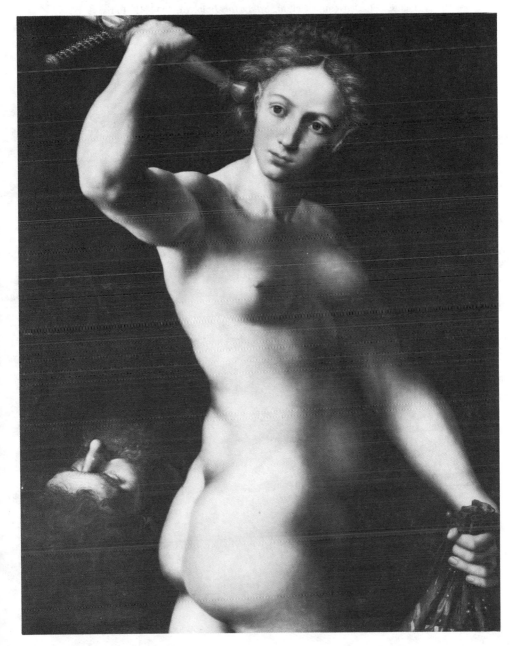

Figure 122. Benvenuto Cellini, *Study for Juno,* ca. 1540–41, Paris, Musée du Louvre.

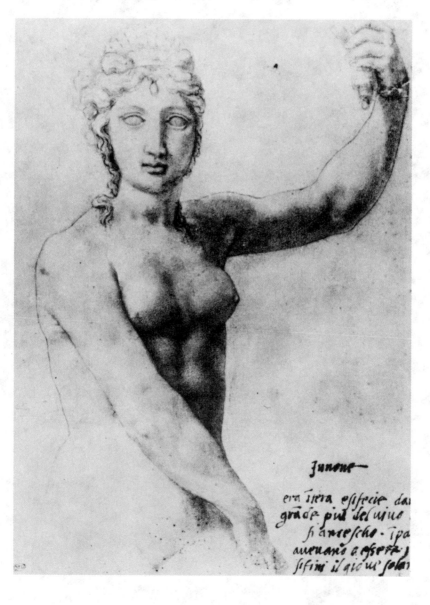

Figure 123. Hemessen, *Holy Family,* ca. 1549–50, Pommersfelden, Schönborn Coll. (Cat. No. 37)

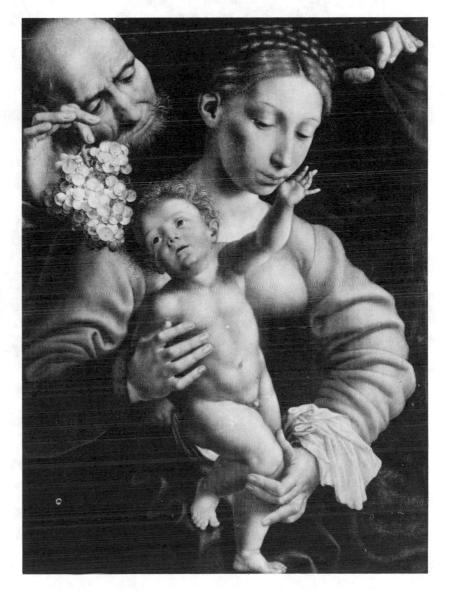

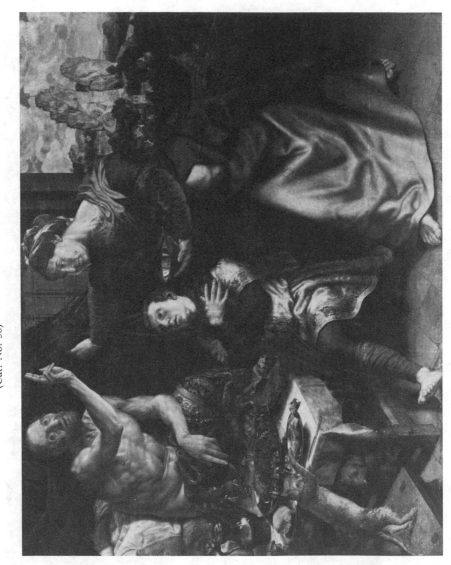

Figure 124. Hemessen, *Isaac Blessing Jacob*, 1551, Fagersta Bruk AB, Dannemora-Verken (Sweden), Österby Church. (Cat. No. 38)

Figure 125. Hemessen, *Christ Bearing the Cross,* 1553, Esztergom, Gran (Hungary), Diocesan Museum. (Cat. No. 42)

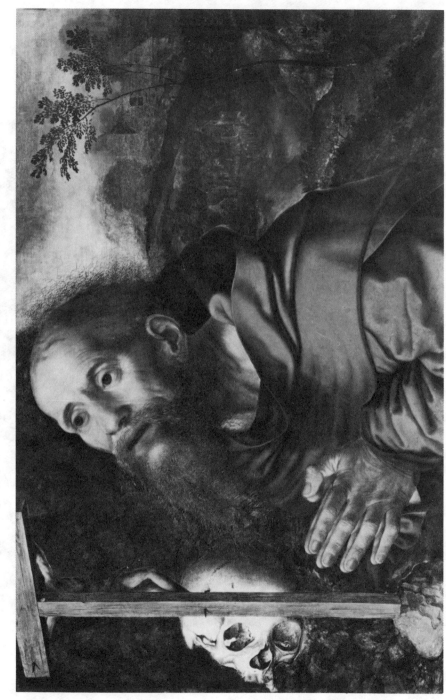

Figure 126. Hemessen, *St. Jerome in the Wilderness*, ca. 1551–52, Genoa, Palazzo Rosso. (Cat. No. 39)

Figure 127. Hemessen, *Holy Family,* ca. 1552, Cracow, State Collection of Art at Wawel Castle. (Cat. No. 40)

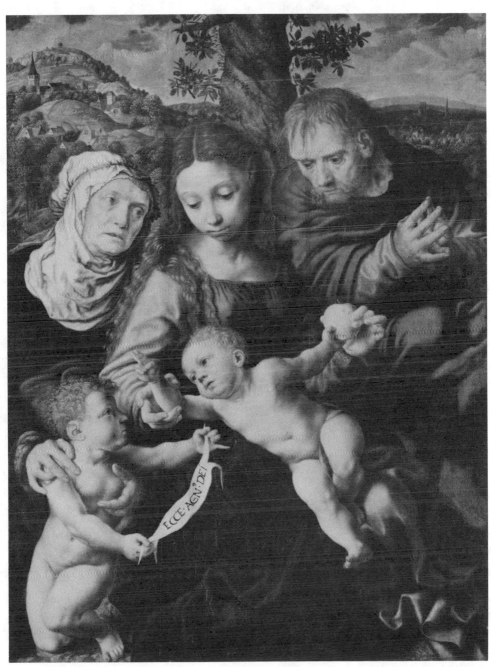

Figure 128. Hemessen, *Madonna and Child,* ca. 1552, location unknown. (Cat. No. 41)

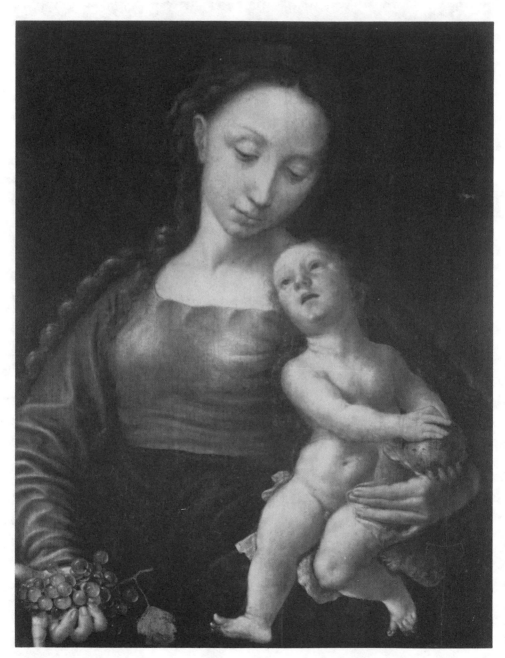

Figure 129. Hemessen, copy after, *Madonna of Humility,* ca. 1553, Wassenaar (The Netherlands), W. J. Geertsema Coll. (Cat. No. 66a)

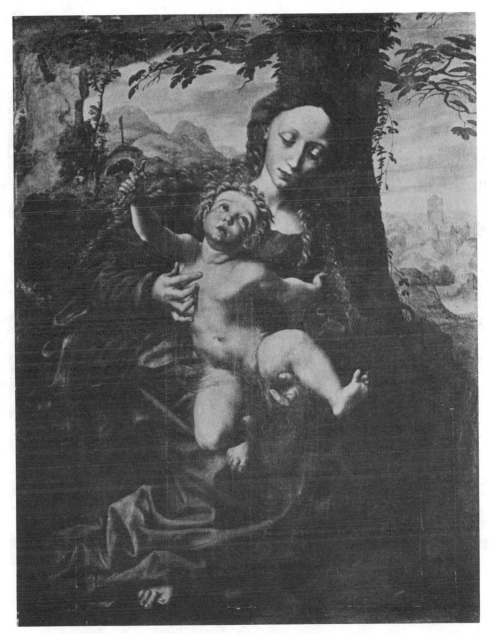

Figure 130. Hemessen, copy after, *Christ Child and the Young St. John the Baptist at Play, with Lamb and Angel,* ca. 1547–50, location unknown. (Cat. No. 65)

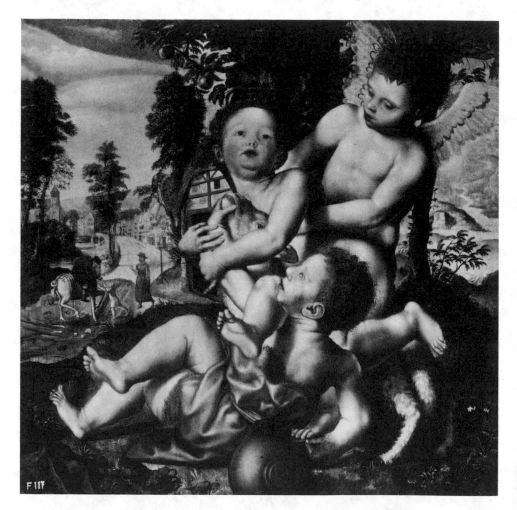

Figure 131. Hemessen, *A Musician and his Muse* (*Allegorical Marriage Portrait of Caterina van Hemessen and Chrétien de Morien?*), ca. 1554, Toronto, Coll. Theodore A. Heinrich. (Cat. No. 43)

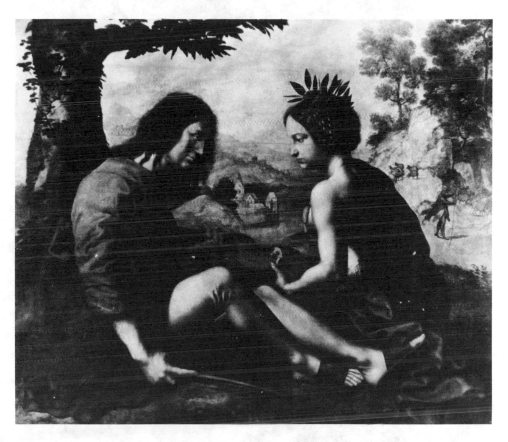

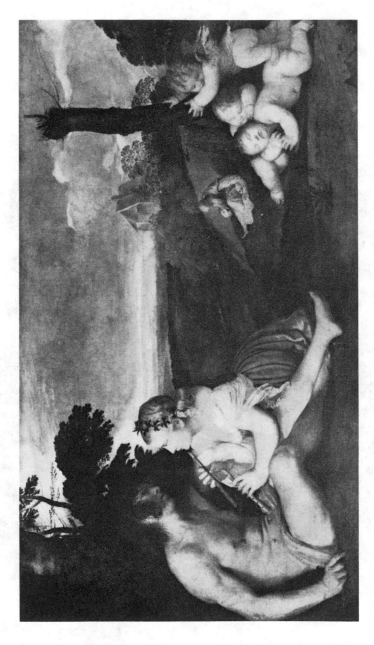

Figure 132. Titian, *Three Ages of Man*, Edinburgh, National Gallery of Scotland (on loan from the Duke of Sutherland Coll.).

Figure 133. Benvenuto Cellini, *Salt-Cellar of Francis I,* ca. 1540–43, Vienna, Kunsthistorisches Museum.

Figure 134. Caterina van Hemessen, *Self-Portrait*, 1548, Basle, Museum.

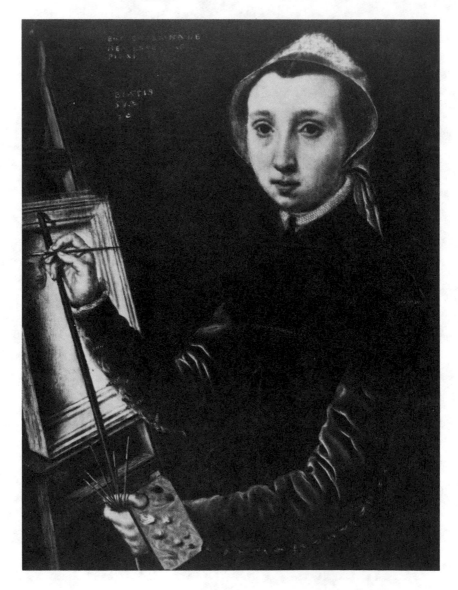

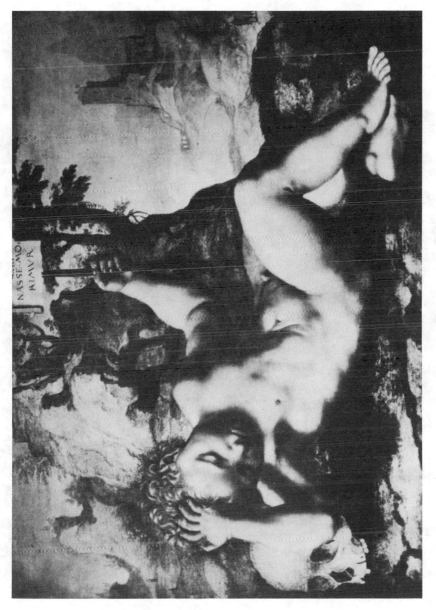

Figure 135. Hemessen, *Putto with a Death's Head*, ca. 1554, location unknown. (Cat. No. 44)

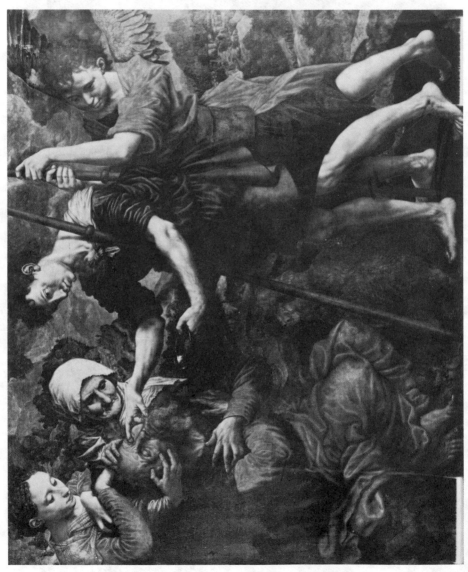

Figure 136. Hemessen, *Tobias Cures His Father's Blindness*, 1555, Paris, Musée du Louvre. (Cat. No. 47)

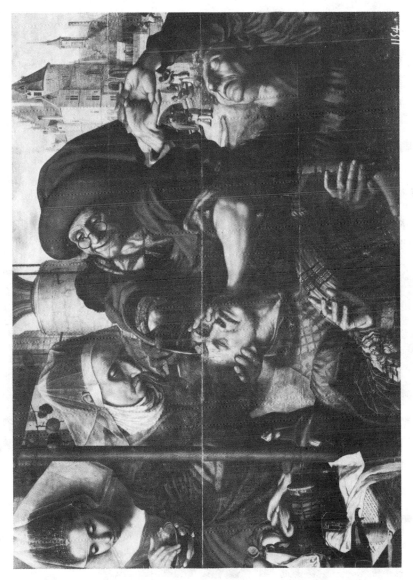

Figure 137. Hemessen, *The Cure of Folly*, ca. 1556, Madrid, Museo del Prado. (Cat. No. 49)

Figure 138. Lucas van Leyden, *Dental Operation,* 1523, engraving.

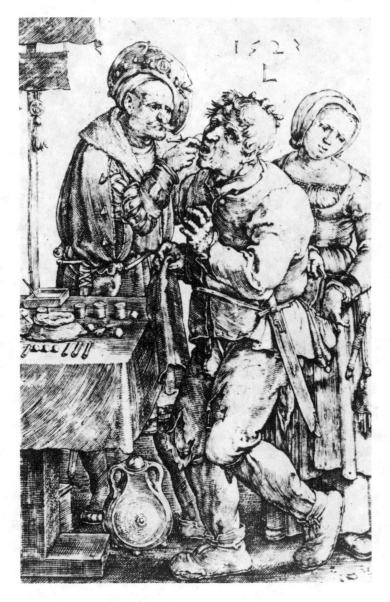

Figure 139. Pieter van der Heyden, after Pieter Bruegel the Elder, *The Witch of Malleghem*, 1559, engraving (V.B. 193).

Figure 140. Hemessen, *Expulsion of Merchants and Moneylenders from the Temple*, 1556, Nancy, Musée des Beaux-Arts. (Cat. No. 48)

Figure 141. Antwerp Cathedral, Interior.

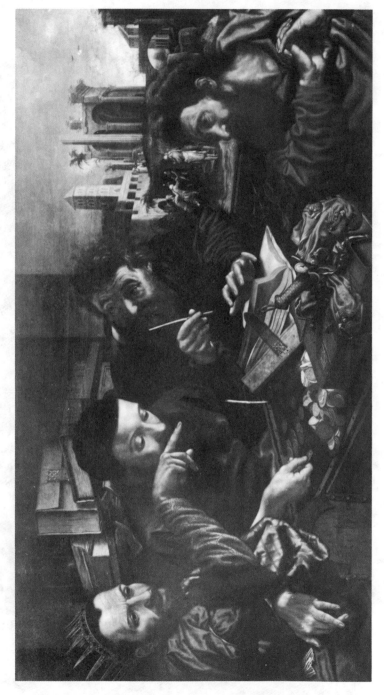

Figure 142. Hemessen, *The Parable of the Unmerciful Servant*, ca. 1556, Ann Arbor, Michigan, University of Michigan Art Museum. (Cat. No. 50)

Figure 143. Hemessen follower, *St. Jerome Penitent,* from *Tendilla Retable,* ca. 1556–57, Cincinnati Art Museum.

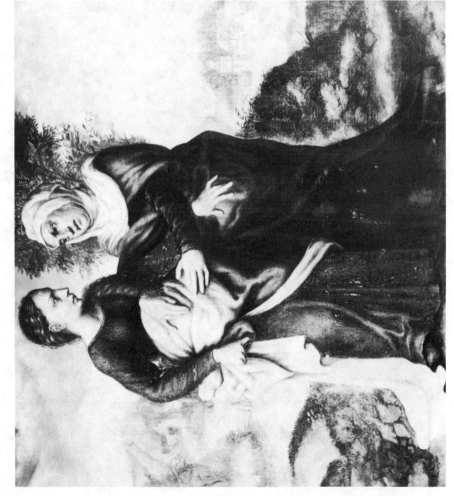

Figure 144. Hemessen follower, *Visitation*, from *Tendilla Retable*, ca. 1556–57, Cincinnati Art Museum.

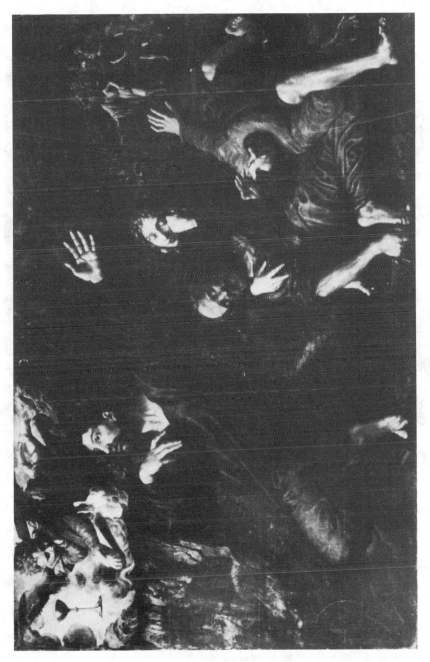

Figure 145. Hemessen, *Agony in the Garden*, ca. 1556, location
unknown. (Cat. No. 52)

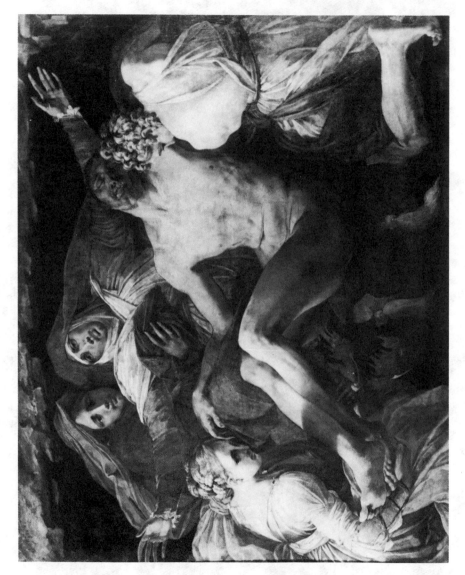

Figure 146. Rosso Fiorentino, *Pietà*, Paris, Musée du Louvre.

Figure 147. Hemessen, *Saints Mary Magdalen and John the Baptist,* ca. 1556, formerly Orléans, Musée des Beaux-Arts. (Cat. Nos. 51a–b)

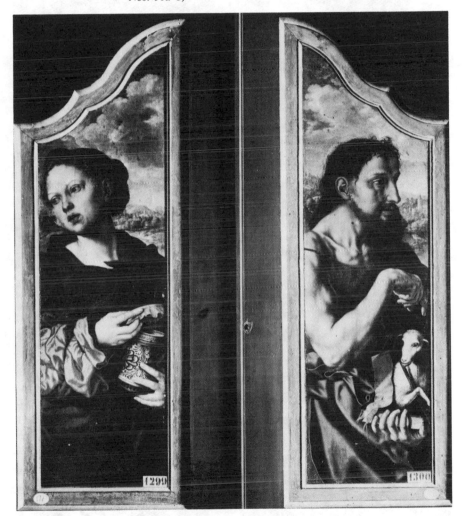

Figure 148. Hemessen, *Peasant Woman with a Jug,* ca. 1556, Dublin, National Gallery of Ireland. (Cat. No. 53)

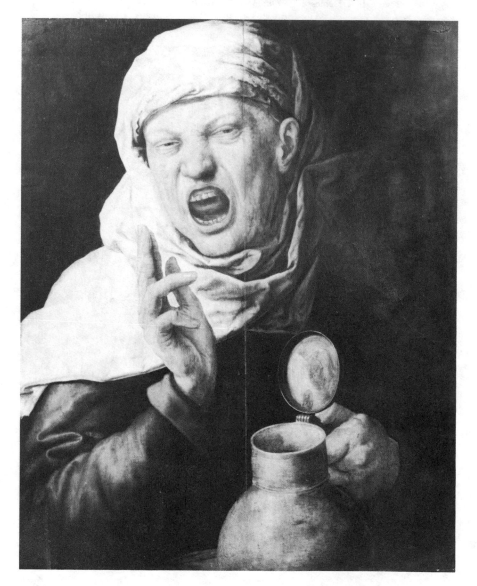

Figure 149. Hemessen, *Portrait of a Man,* ca. 1554–56, Vienna, Kunsthistorisches Museum. (Cat. No. 45)

Figure 150. Hemessen, *Portrait of a Man (Gossaert?)*, ca. 1554–56, Vienna, Kunsthistorisches Museum. (Cat. No. 46)

Figure 151. Hemessen, *St. Jerome, Reading,* 1557?, London, F.
Stimpson Coll. (Cat. No. 54)

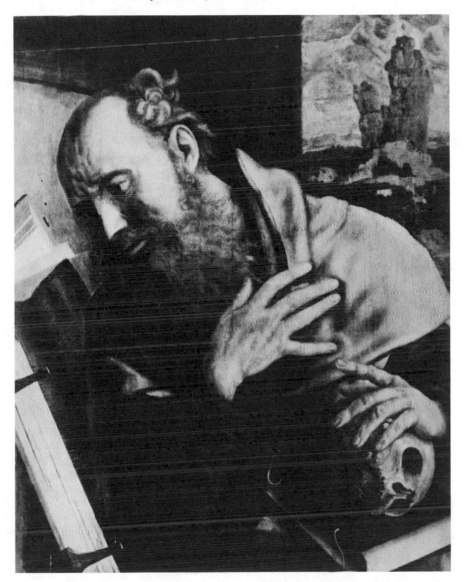

Catalogue

I. Paintings by Hemessen, including Copies and Variants

1. *Madonna of Humility* (*Rest on the Flight to Egypt*), ca.
 1522–23. (Fig. 16)
 Present location unknown.
 0.72 × 56m
 Provenance
 Coll. Ledru-Rollin (Sale 25 May 1889, No. 79, as Orley).
 Coll. Jean Dollfuss, Paris (Sale Galerie Georges Petit,
 1 April 1912 p. 124, No. 112, as Scorel).
 Bibliography
 Winkler, *Altniederländische Malerei,* p. 297 (early Hemessen).
 Friedländer, *Early Netherlandish Painting,* XII, p. 110, No.
 201 (Hemessen, early?).
 Genaille, "Hemessen et le Romanisme," p. 31, n. 5 (early
 Hemessen).
 Schubert, *Monogrammisten,* p. 136, n. 4 (early Hemessen).
 P. Wescher, "Jan van Hemessen," p. 38 (Hemessen).

2. *Christ and the Adulteress,* 1525. (Figs. 1–2)
 New York, Art Market.
 0.885 × 0.795m
 Signed and dated, on the step at bottom: "JOANNES DE
 HEME/SSEN ME FECIT/1525."
 Remarks
 Probably cut down somewhat at the sides. The disputed third
 digit of the date must be a "2" rather than a "3" or "7", as
 formerly thought.
 Provenance
 Coll. Steen de Jehay, Brussels (Sale, Brussels, Salle Gudule,
 April 1904, No. 85).

Coll. M. Binder, Berlin (Exhib. Utrecht, 1913, No. 37).
Coll. Rudolf Busch, Mainz, 1918 (No. 473).
Art Dealer Goldmann, Munich, 1921.
Coll. Coray-Stoop, Zürich (Exhib. Coray-Stoop, Zürich,
 1923, No. 107).
Coll. Han Coray, Berlin (Coray Sale, Wertheim, Berlin,
 October 1930, No. 56).
Coll. "ABT" (Sale, Fischer, Lucerne, 2–5 September 1942,
 No. 1255).
Exhib. Zürich, Kunsthaus, 1942–1958.
Bibliography
H. Hymans, in C. van Mander, *Le livre des Peintres,* Paris,
 1885, II, p. 354 (1575).
Friedländer, *Early Netherlandish Painting,* XII, p. 109, No.
 189, and Pl. 106 ("1575?, more likely 1535?").
O. Fischel, *Sammlung Han Coray,* Berlin, 1930, No. 56 (1535).
Zürich, Kunsthaus, *Sammlung, Inventarkatalog der Gemälde
 und Skulpturen,* Zürich, 1958, p. 29, No. 2603.
Wescher, "Jan van Hemessen," p. 48 (1557).
Wallen, "Portraits," n. 36.

3. *Madonna and Child Seated in an Interior, with St. Joseph in
 the Background,* ca. 1525. (Fig. 13)
 Lisbon, Museu Nacional de Arte Antiga (Inv. No. 1798).
 0.88 × 0.56m
 Provenance
 Coll. first Condes de Burnay (Burnay Sale, Lisbon, 1934,
 p. 113, No. I.155).
 Entered museum in 1936.
 Bibliography
 I. Reis-Santos, *Masterpieces of Flemish Painting of the
 Fifteenth and Sixteenth Centuries in Portugal,* Lisbon,
 1962, pp. 111–12, No. 67 (Hemessen).

4. *Descent From the Cross,* ca. 1526–27. (Figs. 5, 8–11)
 Brussels, Musées Royaux des Beaux-Arts (Inv. No. 6909).
 1.23 × 0.945m
 Provenance
 Coll. F. Stuyck, Brussels (Sale, Palais des Beaux-Arts, Brussels,
 12 July 1960, No. 117).
 Bibliography

Friedländer, *Early Netherlandish Painting,* XII, p. 131, Supp. 407 (Hemessen).

Catalogue, Antwerpens Gouden Eeuw, Antwerp, 1955, p. 75, No. 104 (Aertsen).

Catalogue, Sale F. Stuyck, Brussels, Palais des Beaux-Arts, 7 December 1960, No. 117.

Siècle de Bruegel, p. 111, No. 129 (Hemessen).

D. Kreidl, "Die religiöse Malerei Pieter Aertsens als Grundlage seiner künstlerischen Entwicklung," *Jahrbuch der Kunsthistorischen Sammlungen in Wien,* LXVIII (n.s. XXXII), 1972, p. 58 (Hemessen).

Possible Inventory Reference

Denucé, *Forchoudt,* p. 108: "Voor Alexander en Gillian Forchoudt te Weenen. No. 6 L'Afdoeningh van den Cruyse met ebbenhout lyst van Jan Hemmisen originael curieus en fraey gemaeckt. 250 guilders 1668."

Ibid., p. 84: "1670 Rekening van Morlet (Lamorlet) 'Een Afdoeningh van't Cruys van Hemessens geaccomodeert?'"

Ibid., p. 115: "1670 3 January. Brief van vader Forchoudt, aan zijn zonen te Weenen. 'een Afdoeningh van den Cruyse van Jan Hemsen.'"

5. *Madonna of Humility (Rest on the Flight to Egypt),* ca. 1527-28. (Fig. 15)
 Present location unknown.
 0.865 × 0.535m
 Provenance
 Coll. Steiner, Carlsbad (Sale, Vienna, 11 November 1901, No. 60a).
 Coll. Gustav Ritter von Hoscheck, Prague (Mss. Cat. Hofstede de Groote, December, 1903, No. 116; Cat. Martin, 1907, No. 56).
 Coll. Gaston von Mallmann, Berlin (Sale Berlin, Lepke, 12 June 1918, No. 150).
 Coll. L. S. (Sale Gall. Charpentier, Paris, 22 June 1934, No. 7, as Gossaert).
 Anon. Coll. (Sale Parke Bernet, 9 January 1947, No. 16).
 Coll. Jean Hahn, Paris, 1948.
 Bibliography
 T. von Frimmel, *Lexikon der Wiener Gemäldesammlungen,* Munich, 1914 II, pp. 221-22 (Hemessen).

Graefe, *Hemessen,* p. 45, p. 57 (Hemessen, ca. 1530).

H. Voss, "Die Galerie Gaston von Mallmann in Berlin," *Der Cicerone,* I, 1909, p. 45 (Hemessen, early).

M. J. Binder, "Rezension: F. Graefe. Jan van Hemessen," *Monatschefte für Kunstwissenschaft,* III, 1910, p. 392.

Friedländer, *Early Netherlandish Painting,* XII, p. 110, No. 198 (Hemessen).

6. *Portrait of a Young Girl (Margaret of Parma?) Weighing Gold,* ca. 1528–29. (Fig. 18)
Berlin, Dahlem Museum (No. 656–a).
0.44 × 0.31m
Provenance
Acquired by the museum in 1847.
Bibliography
G. Γ. Waagen, *Verzeichnis der Gemälde-Sammlung,* Berlin, 1857, p. 225, No. 656a (Gossaert).

A. Michiels, *Histoire de la Peinture Flamande,* Paris, 1868, V, p. 55 (Gossaert).

Königliche Museen zu Berlin, *Beschreibendes Verzeichnis der Gemälde,* Berlin, 1891, p. 117, No. 656a (anon. follower of Gossaert).

M. J. Friedländer, *Die Gemälde-Galerie der Königlichen Museen zu Berlin,* Berlin, 1888–1919, III, p. 34.

F. Heidrich, *Altniederländische Malerei,* Jena, 1910, p. 58, (anon. Netherlandish master, ca. 1530).

F. Weisz, *Jan Gossaert gan. Mabuse,* Parchim, 1913, p. 107 (Hemessen, influenced by Gossaert).

Graefe, *Hemessen,* p. 41 (Hemessen).

G. Ring, *Beiträge zur Geschichte niederländischen Bildnis-malerei im 15. und 16. Jahrhundert,* Leipzig, 1913, p. 18, p. 144 (Hemessen).

L. Baldass, "Sittenbild und Stilleben im Rahmen des Niederländischen Romanismus," *Jahrbuch des Kunsthistorischen Sammlungen in Wien,* XXXVI, 1923, p. 20.

O. Benesch, "Jan Vermeyen als Bildnismaler," *Munchner Jahrbuch,* VI, 1929, pp. 211–12 (Vermeyen).

Friedländer, *Early Netherlandish Painting,* XII, p. 47, p. 112, No. 221 (Hemessen, early).

G. Glück, "Bildnisse aus dem Hause Habsbourg," *Jahrbuch der Kunsthistorischen Sammlungen in Wien,* VII, 1933, p. 192 (Vermeyen).

Puyvelde, *Peinture Flamande,* 1962, p. 190 (Hemessen).

Osten and Vey, *Painting and Sculpture,* p. 197 (Hemessen, early).

Wescher, "Jan van Hemessen," pp. 37–38 (Hemessen, early).

Wallen, "Portraits," pp. 77–79 (Hemessen, early).

Schubert, *Monogrammisten,* pp. 139–44, No. 12, pp. 189–90 (Brunswick Monogrammist, ca. 1530–35).

Katalog, Gemäldegalerie, Berlin, Berlin-Dahlem, 1975, p. 200, No. 656 A (Hemessen?).

7. *Portrait of a Young Girl (Margaret of Parma?) Playing a Clavichord,* ca. 1528–29. (Fig. 19)

Worcester, Mass., Worcester Art Museum (No. 1920.88).

0.67 × 0.55

Remarks

The panel has evidently been cut down on all sides. A narrow strip about an inch wide has been added to the right side.

Provenance

Coll. Molinari, Milan (Molinari Sale, Milan, 1885).

Coll. Charles Léon Cardon, Brussels.

Coll. Max Rothschild (The Sackville Gallery), London.

Acquired by the Museum in 1920.

Bibliography

F. Weisz, *Jan Gossaert gen. Mabuse,* Parchim, 1913, p. 107 (Hemessen, influenced by Gossaert).

L'Exposition de la Toison d'Or, Brussels, 1908, No. XXIV, Pl. 22 (as *Eleanor of Portugal,* by imitator of Jan Gossaert, influenced by the Master of the Female Half-Lengths).

L. Maeterlinck, "Les Peintres Rhétoriciens Flamands et le 'Maitre des Femmes a Mi-Corps'," *Gazette des Beaux-Arts,* XXXIX, 1908, p. 227 (Master of the Female Half-Lengths).

I. Dumont-Wilden, "Collection de M. Ch.-L. Cardon," *Les Arts,* No. 94, October, 1909, p. 4. (Master of the Female Half-Lengths).

Fierens-Gevaert, *Les Primitifs Flamands,* Brussels, 1910, II, (Master of the Female Half-Lengths).

M. J. Friedländer, *Die Gemälde-Galerie der Königlichen Museen zu Berlin,* Berlin, 1888–1909, III, p. 34 (Hemessen).

G. Ring, *Beiträge,* p. 18, p. 144 (Hemessen).

E. I. B., "Eleanor of Portugal (?)," *Bulletin of the Worcester Art Museum,* XI, 1921, pp. 70–72 (Flemish, sixteenth century).

G. Glück, "Bildnisse aus dem Hause Habsbourg," *Jahrbuch der Kunsthistorischen Sammlungen in Wien,* VII, 1933, p. 192 (Vermeyen).

Friedländer, *Early Netherlandish Painting,* XII, p. 47, p. 112, No. 220 (Hemessen, early).

Catalogue, The Worcester-Philadelphia Exhibition of Flemish Painting, Philadelphia, 1939, p. 46, No. 75.

Puyvelde, *Peinture Flamande,* p. 190 (Hemessen).

R. Wangermée, *Flemish Music and Society in the Fifteenth and Sixteenth Centuries,* New York, 1968, p. 208.

Osten and Vey, *Painting and Sculpture,* p. 197 (Hemessen, early).

Wescher, "Jan van Hemessen," pp. 37–38 (Hemessen).

Schubert, *Monogrammisten,* pp. 139–44, No. 11, p. 189 (Brunswick Monogrammist).

Wallen, "Portraits," pp. 77–79 (Hemessen, early).

E. Haverkamp-Begemann, in *European Paintings in the Collection of the Worcester Art Museum,* Worcester, Mass., 1974, pp. 174–79 (Hemessen).

8. *Charity,* ca. 1528–30. (Fig. 21)
 Present location unknown.
 1.11 × 0.81m
 Remarks
 A copy of Andrea del Sarto's *Charity* fresco (Fig. 22) at the Chiostro dello Scalzo, Florence.
 Provenance
 Coll. G. Bossi (Sale, Vienna, 10 May 1886, No. 76).
 Bibliography
 Winkler, *Altniederländische Malerei,* p. 297 (Hemessen).
 Antal, "Manierismus," p. 242, No. 5 (Hemessen).
 Wescher, "Einige neue Bilder," p. 39 (Hemessen).
 Wescher, "Jan van Hemessen," p. 36 (Hemessen).

9. *St. Sebastian Triptych,* ca. 1530. (Figs. 24, 26)
 Paris, Petit Palais, Coll. O'Campo (Inv. No. 2568).
 Center: *Martyrdom of St. Sebastian* - 1.38 × 0.94m.
 Rt., open: *St. Onuphrius* - 1.17 × 0.44m.
 L., open: *St. Roch* - 1.17 × 0.44m.
 Rt., closed: *St. Stephen* - 1.17 × 0.44m.
 L., closed: *St. Peter* - 1.17 × 0.44m.

Remarks
The figures of Peter and Stephen on the outside are by Jan
 Swart van Groningen.
Provenance
Coll. J. de Coen, Brussels.
Exhibition, *Art Ancien,* Ghent, October, 1924, No. 63.
Galerie Georges Giroux, Brussels, Sale, 15 March 1926, No.
 43.
Sale, Dijon, 8 July 1927, No. 35.
Coll. O'Campo, Paris.
Bibliography
L. van Puyvelde, "Art ancien à Gand," *La Revue d'Art,*
 March-April, 1925, pp. 128-29.
E. Michel, "Un triptyque de Van Hemessen dans la collection
 O'Campo," *Beaux-Arts, Revue d'Information,* VI, 1928,
 pp. 67-69 (Hemessen).
Wescher, "Einige neue Bilder," p. 39 (Hemessen, early).
Friedländer, *Early Netherlandish Painting,* XII, p. 108, No.
 176 (Hemessen).
J. Foucart, "Peintures des Ecoles du Nord du XVIe Siècle,"
 La Revue du Louvre et des Musées de France, XVIII, 1968,
 p. 180, n. 4 (Hemessen).
Wescher, "Jan van Hemessen," pp. 39-40 (Hemessen, early).

10. *St. Jerome Penitent,* 1531. (Fig. 27)
 Lisbon, Museu Nacional de Arte Antiga (Inv. No. 1651).
 1.10 × 1.49m
 Signed and dated at the right: "IOES DE/HEMESSEN/
 PINXIT 1531."
 Provenance
 Coll. Silva Télès, Master of the Verderers to King John V of
 Portugal.
 Coll. Conde de Ameal.
 Entered Lisbon National Museum in 1921.
 Bibliography
 P. A. Orlandi and P. Guarienti, *Abecedario Pittorico,* Venice,
 1753, p. 248.
 A. Raczynski, *Les Arts en Portugal,* Paris, 1846, p. 324.
 Idem, Dictionnaire Historico-Artistique du Portugal, Paris
 1847, p. 130.
 *Catalogue descriptif, Vente d'Objects d'Art, Collections,
 "Comte de Ameal",* 1921, No. 118, p. 20.

Friedländer, *Early Netherlandish Painting,* XII, p. 111, No.
215a (ill. reversed).
*Exposicão Temporária de Algunas Obras de Arte do Museu
das Janelas Verdes, Roteiro,* Lisbon, 1942, p. 15.
Roteiro das Pinturas, Museu nacional de Arte Antiga, Lisbon,
1951, p. 81, No. 211.
Marlier, *Erasme,* 1954, pp. 207–08.
L. Reis-Santos, *Masterpieces of Flemish Painting of the
Fifteenth and Sixteenth Centuries in Portugal,* Lisbon, 1962,
pp. 113–14, No. 68.
Puyvelde, *Peinture Flamande,* p. 282.
Siècle de Bruegel, p. 112, No. 132.
Wescher, "Jan van Hemessen," p. 40.
Schubert, *Monogrammisten,* p. 127, p. 154.

11. *Portrait of a Man and Wife Playing Tables,* 1532. (Fig. 45)
Balcarres, Fife (Scotland), Coll. Earl of Crawford and Bal-
carres.
1.11 × 1.28m
Signed and dated, on edge of table at lower right:
"IOHANNE(S). SANDERS./DE.HEME(SSE)N. PINGEBAT
1532."
Provenance
Presumably at Balcarres for centuries.
Bibliography
Wescher, "Jan van Hemessen," p. 40.
Wallen, "Portraits," pp. 75–76.

12. *St. Jerome in his Study,* 1534. (Fig. 36)
Present location unknown.
0.715 × 0.525
Signed and dated, on slip of paper at bottom: "IOHANNES
ˋ (NDERS)/DE . HEMESSĒ(N) PINXIT 1534."
Prov. ɪance
Coll. Max Mandl, Vienna.
Coll. Kropf-Strache, Dombocle.
Coll. Dr. Hugo Strache, Vienna, 1896.
Coll. K. Weniger, Vienna (Sale, Vienna, 7 May 1906, No. 34).
Galerie Sanct Lucas, Vienna, ca. 1929.
Bibliography
Catalogue, Weniger Sale, Dorotheum, Vienna, 7 May 1906,

No. 34. (Inscription read as: "IOHANNES SADERS DE HEMESSEN PINGEBAT 1534").

Winkler, *Altniederländische Malerei,* p. 299.

Friedländer, *Early Netherlandish Painting,* XII, p. 111, No. 210, and pp. 45–46.

Marlier, *Erasme,* pp. 206–07.

Copies and Variants

a) Prague, National Gallery (No. DO - 4963). (Fig. 37)

 Remarks

 A studio copy by the Brunswick Monogrammist (Jan van Amstel?).

b) Present location unknown

 0.66 × 0.51m

 Provenance

 Sale, Vienna, Kende, 15 May 1918, No. 197, as Quentin Massys.

 Coll. Prof. Hoffman, Vienna, October, 1938

 Remarks

 A variant on the copy at Prague.

13. *Madonna and Child,* ca. 1535. (Fig. 83)

 Location unknown.

 Dimensions unknown.

 Provenance

 Art Dealer C. L. Maier, Munich.

 Bibliography

 Friedländer, *Early Netherlandish Painting,* XII, p. 110, No. 204.

14. *Madonna and Child,* ca. 1535–36. (Fig. 81)

 Bruges, Groeningemuseum (Inv. No. 232).

 1.50 × 1.165m

 Remarks

 A copy of the Madonna and Child from Raphael's *Holy Family of Francis I* (Fig. 82, Paris, Louvre), which Hemessen could have seen at Fontainebleau.

 Provenance

 Coll. Abbey at Duinen, Bruges.

 Museum of the "Ecole Centrale," Bruges, 1797.

 Stadhuis, Bruges, ca. 1804.

 Academic, Bruges.

Entered the Groeningemuseum in 1828.

Bibliography

Van de Putte, *Cabinet de Tableaux de l'Abbaye des Dunes, Hand. Soc. d'Emul.*, 1848, p. 174.

W. H. James Weale, "Mélanges et Nouvelles, Vandalisme à Bruges," *Le Beffroi*, II, 1864–65, p. 238.

H. Pauwels, *Catalogus, Groeningemuseum*, Bruges, 1960, p. 79, No. 49 (Hemessen, after Raphael).

Copies

a) Antwerp, Sint Jacobskerk.

15. *Parable of the Prodigal Son,* 1536. (Figs. 46–50)

Brussels, Musées Royaux des Beaux-Arts (No. 217).

1.40 × 1.98m

Signed and dated, on the edge of the table at the lower left: "IOĒS DE HEMESSEN/PINGEBAT . 1536."

Remarks

The small-figure scenes in the background are by Jan Swart van Groningen.

Provenance

Coll. Count G. de Nécanda, Paris.

Acquired by the Brussels Museum in 1881.

Bibliography

O. Eisenmann, (Review of Bode, *Studien*), *Repertorium für Kunstwissenschaft*, VII, 1844, p. 209.

W. Bode, "Die Austellungen alter Gemälde aus Privatbesitz in Düsseldorf und Brüssel im Herbst 1886," *Repertorium für Kunstwissenschaft*, X, 1887, p. 45.

A. J. Wauters, *Musée de Bruxelles, Tableaux Anciens,* Brussels, 1900, p. 71, No. 217.

Fierens-Gevaert, *La Peinture en Belgique, Les Primitifs Flamands,* Brussels, 1912, IV, p. 290.

Graefe, *Hemessen,* p. 40, p. 55.

F. M. Haberditzl, (Review of Graefe, *Hemessen*), *Kunstgeschichtliche Anzeigen*, 1909, pp. 90–94.

L. Baldass, "Sittenbild," pp. 18–19.

Catalogue de la Peinture Ancienne, Musées Royaux des Beaux-Arts de Belgique, Brussels, 1927, p. 119, No. 217.

Friedländer, *Early Netherlandish Painting,* XII, pp. 44–45, p. 109, No. 184.

E. Lotthé, *La Pensée Chrétienne dans la Peinture Flamande et Hollandaise,* Lille, 1947, II, p. 170.

Puyvelde, *Peinture Flamande,* pp. 182–83.
Catalogue de la Peinture Ancienne, Musées Royaux des Beaux-Arts de Belgique, Brussels, 1957, p. 53, No. 217.
Marlier, *Erasme,* pp. 280–81.
Siècle de Bruegel, pp. 112–13, No. 133.
G. T. Faggin, *La pittura ad Anversa nel Cinquecento,* Florence, 1968, p. 46.
Schubert, *Monogrammisten,* p. 94, p. 102, p. 153.
Renger, *Gesellschaft,* pp. 51ff.
Vlam, "Calling," pp. 566–68.

16. *Calling of St. Matthew (Money-Broker Greets Unseen Visitor),* 1536. (Fig. 63)
 Munich, Alte Pinakothek (Inv. No. 11).
 1.15 × 1.55m (Original section: 1.08 × 1.283m)
 Signed and dated, on slip of paper at bottom: "1536/ IOHANNES . DE . HE/MESSEN . PIN(X)IT."
 Remarks
 The panel was enlarged in the seventeenth century, with the addition of the figure of Christ at the right and a strip at the top with an open window and a scroll bearing the words, "SE QVERE ME./MATTHAEI CAP:IX." The original composition of a money-broker greeting an unseen visitor is preserved in studio copies, *infra.* Left to the viewer's imagination, the visitor could be either Christ or Death for this contemporary Matthew/Levi.
 Provenance
 Coll. Elector Maximilian I of Bavaria.
 Inventory Reference
 Inventory of the collection of the Elector Maximilian I of Bavaria (1628): "Ain wexl Panckh mit etlichen Personnen, die Goldt zellen und wägen, auch wie andere in einem Körblin, Güertl, Paternoster und dergleichen zu versezen bringen, alles sehr vleissig gemalt, van Johann Hemessen a° 1528, auf ein Tafel 3 . schuech . 10 zoll hoch, vnd 4-½ schuech brait. No. 61." (Reber, *Maximilian I,* p. 44).
 Bibliography
 Katalog der Gemälde-Sammlung der Kgl. Alteren Pinakothek in München, Munich, 1884, p. 36, No. 169 (74).
 Graefe, *Hemessen,* p. 40, p. 56
 Friedländer, *Early Netherlandish Painting,* XII, p. 109, No. 185.

Baldass, "Sittenbild," p. 23, p. 25.

Winkler, *Altniederländische Malerei,* p. 297.

Marlier, *Erasme,* pp. 282ff.

Puyvelde, *Peinture Flamande,* p. 183.

Katalog I, Alte Pinakothek, München, Deutsche und Nieder-
ländische Malerei zwischen Renaissance und Barock,
Munich, 1961, No. 11, pp. 28–29.

Schubert, *Monogrammisten,* p. 151, no. 17, and p. 153.

J. P. Filedt Kok, *et al.,* "Das Diptychon des Lucas van
Leyden von 1522, Versuch einer Rekonstruction," *Neder-*
lands Kunsthistorisch Jaarboek, XXVI, 1975, pp. 248–49.

Vlam, "Calling," pp. 566–68.

Copies

a) Coll. of the Marquess of Lothian, Newbattle Abbey,
Dalkeith, Scotland. (Fig. 64)

107.9 × 130.8m

Remarks

A studio copy done prior to the enlargement of the orig-
inal panel in the seventeenth century.

Provenance

Exhibited Edinburgh, 1883, No. 239 (as Massys).

Bibliography

Catalogue, Between Renaissance and Baroque, European
Art, 1520–1600, Manchester, 1965, p. 44, No. 135.

Filedt Kok, *et al.,* "Diptychon," pp. 248–49.

b) Galerie Finck, Brussels, 1968.

1.09 × 131.5m

Remarks

A less successful early copy, showing a partially open
door behind the head of the old woman.

Provenance

Sale, Sotheby's, 21 June 1967.

Bibliography

Catalogue, Exhibition Galerie Finck, Brussels, 22 Novem-
ber-15 December 1968, No. 6.

17. *Last Judgment Triptych,* ca. 1536–37. (Figs. 71–74, 80, 88–89)
Antwerp, Sint Jacobskerk.

0.975 × 0.985m (dimensions of central panel)

Remarks

The small figures at the top of the central panel were executed
by Jan Swart van Groningen.

Provenance

Chapel of the donor, Adrien Rockox.

Bibliography

J. B. Descamps, *Voyage pittoresque de la Flandre et du Brabant,* Paris, 1769, p. 176 (Hemessen).

Sir Joshua Reynolds, *A Journey to Flanders and Holland in the Year 1791,* in Reynolds, *The Works,* ed. E. Malone, London, 1809, II, p. 332 (Hemessen).

K. Schnaase, *Niederländische Briefe,* Stuttgart, 1834, pp. 228–29 (Hemessen).

G. K. Nagler, *Künstler-Lexikon,* Munich, 1838, VI, p. 35 (Hemessen).

G. Rathgeber, *Annalen der Niederländischen Malerei, Formschneide und Kupferstecherkunst,* Gotha, 1842–44, p. 141.

J. D. Passavant, *Kunstreise durch England und Belgien,* Frankfurt, 1833, p. 382 (Orley).

F. Kugler, *Handbuch der Geschichte der Malerei in Deutschland, den Niederländen, Spanien, Frankreich und England,* Stuttgart 1848, II, pp. 149–50 (Orley).

T. Van Lerius, *Notice des Oeuvres d'art de l'église Saint-Jacques à Anvers,* Borgerhout, 1855, p. 159 (Orley).

G. Lafenestre, *La Peinture en Europe, La Belgique,* Paris, 1895, pp. 297–98 (Orley).

A. J. Wauters, "Les deux Josse van Cleve," *L'Art Flamand et Hollandais,* VII, 1907, pp. 64–66 (Joos van Cleve, the younger).

J. de Bosschere, *De Kerken van Antwerpen,* Antwerp, 1910, p. 43 (Hemessen, ca. 1537–40).

Graefe, *Hemessen,* p. 58 (after Hemessen).

Baldass, "Bildnisse," p. 88 (1537).

Friedländer, *Early Netherlandish Painting,* XII, p. 46 and p. 108, No. 175 (Hemessen, ca. 1535; illustrations reversed).

J. de Coo, "Een oud en merkwaardig Familieportret," *Album van de Bond der Kroostrijke Gezinnen,* Brussels, 1954, n. p.

Catalogue, Antwerpens Gouden Eeuw, Antwerp, 1955, No. 115 (Hemessen, ca. 1530–40).

Puyvelde, *Peinture Flamande,* p. 189 (Hemessen, 1530).

S. Bergmans, "Le problème du Monogrammiste de Brunswick," *Bulletin, Musées Royaux des Beaux-Arts de Belgique,* XIV, 1965, p. 148 (Hemessen, prior to 1530).

Faggin, *Pittura ad Anversa,* p. 46.

Schubert, *Monogrammisten,* p. 31 and p. 41, n. 65 (Hemessen).

Wescher, "Jan van Hemessen," p. 43 (Hemessen).
Wallen, "Portraits," pp. 80–82 (Hemessen).

18. *Salvator Mundi,* ca. 1538–40. (Fig. 99)
 Location unknown.
 1.15 × 0.75m
 Provenance
 Franke, Leipzig, 1933.
 Bibliography
 Friedländer, *Early Netherlandish Painting,* XII, p. 110,
 No. 195 (Hemessen).

19. *Wayfarer in a Brothel,* ca. 1539. (Figs. 55–57)
 Karlsruhe, Staatliche Kunsthalle (Inv. No. 152).
 0.83 × 1.115m
 Remarks
 The small-figure background scenes were painted by Jan Swart
 van Groningen.
 Provenance
 Coll. Markgrafen von Baden-Durlach.
 Coll. Markgrafen Ludwig Wilhelm von Baden-Baden.
 Bibliography
 Inventory of the Markgräfler Hof at Basel, 1688, No. 162.
 Inventory of the Markgräfler Hof at Basel, 1773, No. 69.
 G. Parthey, *Deutscher Bildersaal,* Berlin, 1864, II, p. 111
 (Quentin Massys).
 Karlsruhe, Kunsthalle, *Katalog,* 1867, No. 419 (Quentin
 Massys).
 W. Bode, *Studien zur Geschichten der Holländischen Malerei,*
 Brunswick, 1883, p. 10.
 O. Eisenmann, (Review of Bode, *Studien*), *Repertorium für
 Kunstwissenschaft,* VII, 1884, pp. 209–10 (Hemessen; small
 figures also by Hemessen, alias the Brunswick Monogram-
 mist).
 W. Bode, "Die Austellungen alter Gemälde aus Privat-Besitz
 in Düsseldorf und Brüssel im Herbst 1886," *Repertorium
 für Kunstwissenschaft,* X, 1887, p. 46 (Hemessen).
 Graefe, *Hemessen,* p. 39 (Hemessen).
 Baldass, "Sittenbild," pp. 20–21 (Hemessen).
 Winkler, *Altniederländische Malerei,* p. 297 (Hemessen).
 E. Heidrich, *Alt-Niederländische Malerei,* Jena, 1924, p. 59
 (Hemessen; small figures by Dutch follower).

G. Glück, *Aus drei Jahrhunderten Europäischer Malerei,*
Vienna, 1933, p. 145 (Hemessen; small figures by Bruns-
wick Monogrammist, alias van Amstel).

Friedländer, *Early Netherlandish Painting,* XII, p. 46, p. 112,
No. 218 (Hemessen).

Marlier, *Erasme,* p. 287 (Hemessen; small figures by the
Brunswick Monogrammist).

Siècle de Bruegel, p. 113, No. 135 (Hemessen).

J. Lauts, *Staatliche Kunsthalle, Karlsruhe, Katalog Alte
Meister,* 1966, pp. 141–42, No. 152 (Hemessen).

Faggin, *Pittura ad Anversa,* p. 46 (Hemessen).

Osten and Vey, *Painting and Sculpture,* p. 198 (Hemessen).

Schubert, *Monogrammisten,* p. 92, pp. 94–96, No. 10, pp.
187–88 (Hemessen; small figures by the Brunswick Mono-
grammist).

Renger, *Gesellschaft,* pp. 120–28.

Vlam, "Calling," p. 568.

Copies and Variants

a) Dartmouth Sale, Christie's 13 July 1928.
 Bought by Hartveld.
 0.825 × 114.3m

b) Fievez Sale, Brussels, 8 June 1931, No. 50.
 0.85 × 1.14m
 Coll. Lt. Gen. Pitt Rivers, London.
 Coll. Capt. Pitt Rivers, Dorset.
 Art Dealer D. Katz, Dieren, 1938.

20. *Calling of St. Matthew,* ca. 1539–40. (Figs. 66, 69)
 Vienna, Kunsthistorisches Museum (Inv. No. 985).
 0.85 × 1.07m
 Remarks
 The small-figure scene is by Jan Swart van Groningen.
 Provenance
 Coll. Archduke Leopold Wilhelm.
 Stallburg, 1720.
 Imperial Gallery, Vienna.
 Inventory Reference
 Inventory of the collection of Archduke Leopold Wilhelm,
 1659: "Ein Stukh von Öhlfarb auf Holcz, warin Christus
 der Herr den Matthaem bey dem Zohl abfordert, vmb ihm
 nachzufolgen. In einer schwartzen Ramen, die innere Leisten
 auszgeschnitten vnndt verguldt, hoch 5 Spann 4 Finger

vnndt 6 Spann 4 Finger Braith. Original von Hembszen."
(Berger, "Inventar," p. cxxxiii, No. 343.)

Bibliography

Storffer, *Gemaltes Inventarium der Aufstellung der Gemälde-galerie in der Stallburg,* 1720, III, No. 95 ("Johann Hembsen").

A. Joseph de Prenner, *Theatrum artis pictoriae,* Vienna, 1728–1732, Pl. 23 (publ. in Zimmermann, "Theatrum Artis Pictoriae").

C. de Mechel, *Catalogue des Tableaux de la Galerie Impériale et Royale de Vienne,* Basle, 1784, p. 164, No. 62 ("Johann van Hemessen").

E. von Engerth, *Kunsthistorische Sammlungen des Allerhöchsten Kaiserhauses, Gemälde,* Vienna, 1884, II, p. 183, No. 890 (Hemessen).

Frimmel, *Wiener Gemäldesammlungen,* I, p. 137, II, p. 471, No. 699 (Hemessen).

Katalog der Gemäldegalerie des Allerhöchsten Kaiserhauses, Alte Meister, Vienna, 1907, pp. 162–63, No. 699 (E. 890).

Graefe, *Hemessen,* p. 53 (Hemessen).

Friedländer, *Early Netherlandish Painting,* XII, p. 109, No. 186 (Hemessen).

Katalog der Gemäldegalerie, Kunsthistorisches Museum, Vienna, 1958, II, p. 68, No. 200 (Hemessen, ca. 1540).

Vlam, "Calling," pp. 568–69.

Katalog der Gemäldegalerie, Flämische Malerei von Jan Van Eyck bis Pieter Bruegel, Kunsthistorisches Museum, Vienna, 1981, pp. 200–01 (Hemessen, ca. 1540).

21. *Bagpiper and Merry Wife,* ca. 1540. (Fig. 60)
Brussels, Musées Royaux des Beaux-Arts (No. 676).
0.45 × 0.655m

Remarks

The panel has been cut down at top and bottom, and extensively rubbed.

Provenance

Coll. Emperor Rudolph II, Prague.
Coll. Queen Christina of Sweden.
Coll. M. P. Buéso, Brussels, 1901.
Acquired by the Museum in 1901.

Inventory References

Zimmermann, "Inventar," p. xxxix, No. 888: "Ein man und

weib mit offenem mund vom Johann de Hems. (Orig.)".

Granberg, *Galerie,* p. xli, No. 336 (Inv. of coll. of Queen Christina of 1652): "Dito, un vieillard avec une cornemuse, et une vieille, sur dito (du bois)."

Ibid., p. ix, No. 228 (Brief inv. of paintings confiscated by Christina from the coll. of Rudolph II, 1648): "Ein Sackpfeiffer mit ein Weib."

Bibliography

Fierens-Gevaert, *La Peinture en Belgique, Les Primitifs Flamands,* Brussels, 1912, IV, pp. 287–88 (Huys).

Baldass, "Sittenbild," p. 20 (Hemessen).

Friedländer, *Early Netherlandish Painting,* XII, p. 112, No. 219 (Hemessen; "A bit divergent in style").

Catalogue de la Peinture Ancienne, Musées Royaux des Beaux-Arts, Brussels, 1927, p. 119, No. 676 (Hemessen or Huys).

Catalogue de la Peinture Ancienne, Musées Royaux des Beaux-Arts de Belgique, Brussels, 1953, p. 65, No. 676 (Hemessen).

Copies and Variants

a) Detroit, Institute of Arts (No. 37.158).

 0.55 × 0.787m

 Bibliography

 E. A. Richardson, "Pieter Huys," *Bulletin, Detroit Institute of Arts,* XVII, 1937–38, pp. 53–54 (Huys).

b) Thos. Agnew and Sons, London, 1957.

 0.53 × 0.60m

 Remarks

 A better copy than the one at Detroit, probably a workshop replica. The panel is roughly the width of the Brussels original, with a bit more of the bagpipe and sleeve of the woman at the bottom, and several inches of dark background at the top.

 Bibliography

 Burlington Magazine, IC, December, 1957, Advertising Supplement, Pl. V.

c) London, Art Market, 1950–60.

 0.46 × 0.64m

 Provenance

 Coll. Prof. Ludwig von Löfftz.

 Sold Lempertz, Cologne, 6 May 1953.

 Coll. Paul Ackerman.

Sale, Sotheby, London, 24 March 1965.

d) Berlin, Dahlem Gallery (No. 693).

0.86 × 0.84m

Remarks

A replica with extensive variations, signed by Pieter Huys
and dated 1571.

Bibliography

M. Rooses, *Flandre,* Paris, 1913, p. 132.

22. *Tearful Bride,* ca. 1540. (Fig. 59)

Prague, National Gallery (No. 320).

0.52 × 0.62m

Provenance

Mallet Sale (anon. collection), Sotheby's, 19 June 1935, No.
79 (Pieter Aertsen).

Galerie Sanct Lucas, Vienna, 1936.

Private collection, Prague.

Bibliography

Friedländer, *Early Netherlandish Painting,* XII, p. 131, Supp.
409 (Hemessen).

St. Poglayen-Neuwall, article in *Die Weltkunst,* X, 31 May
1936, No. 21 and No. 22, p. 4.

J. Held, "Dr. Friedländer's scholarly study of early Flemish
and Dutch painting," *Art in America,* XXVII, 1939,
pp. 86–87.

Marlier, *Erasme,* pp. 236–37.

Catalogue, Prague National Gallery, 1955, No. 300.

G. Schiff, "Lachen, Weinen und Lächeln in der Kunst," in
*Sachlichkeit, Festschrift zum achtzigsten Geburtstag von
Helmuth Plessner,* Opladen, 1974, pp. 145–46.

K. Renger, "Tränen in der Hochzeitznacht," in *Festscrift für
Otto von Simson zum 65. Geburtstag,* Berlin, 1977,
pp. 317–18.

Copies and Variants

a) Present location unknown.

0.483 × 0.597m

Remarks

A copy with the inscription, "JOHANNES DE HEM/
ESSEN/PINGEB(AT)/1540."

Provenance

Stanhope Sale (anonymous collector), Christie's, 31 May
1935, No. 120, bought by Brandon.

Sale Christie's, 28 February 1936, No. 46, bought by
 Hartvelt.
b) Present location unknown.
 0.67 × 0.78m
 Provenance
 Coll. Lichtenham (Art Dealer, Basle), 1950–51.
 Remarks
 A later version, extensively reworked, with a crown of
 flowers substituted for the cherries.

23. *Man of Sorrows,* 1540. (Fig. 100)
 Linz, Landesmuseum (Inv. No. G695).
 0.98 × 0.72m
 Signed and dated, "IOANNES . DE/HEMESSEN/PINGBAT.
 1540."
 Provenance
 Coll. Archduke Leopold Wilhelm, Vienna (1659).
 Purchased by Museum from Vienna art dealer in 1892.
 Inventory Reference
 Inventory of coll. of Archduke Leopold Wilhelm, Vienna,
 1659: "Ein stuckh von Öhlfarb auf Holcs, warin ein nack-
 hendter Christus mit der Cron auf dem Haubt, halt die
 rechte Handt bey der Wundten in der Seithen vnndt in der
 lincken das Creütz. In einer schwartz glatten Ramen, hoch
 5 Span 5 Finger vndt 4 Span 1 Finger braidt. Original von
 Johan Hembszen." (Berger, "Inventar," p. CXXXI,
 No. 308).
 Bibliography
 Frimmel, *Wiener Gemäldesammlungen,* I, p. 150.
 Graefe, *Hemessen,* p. 46.
 Friedländer, *Early Netherlandish Painting,* XII, p. 110,
 No. 196.
 Puyvelde, "Nouvelles Oeuvres," p. 65
 Copies and Variants
 a) Kiel, Kunsthalle (Inv. No. Cau. 40).
 0.96 × 0.67m
 Remarks
 An early copy, but dry and hard.
 Bibliography
 Katalog der Gemäldegalerie, Kiel, Kunsthalle, Kiel, 1958,
 p. 67.

24. *Susanna and the Elders,* 1543. (Fig. 101)
 Barcelona, Coll. Dr. Franco de Cesare.
 1.40 × 0.75m
 Signed and dated, "JO VAN HEMMSEN 1543" (Puyvelde's
 reading).
 Provenance
 Coll. Luis Navas (Sale, 1926).
 Private collection, Madrid.
 Bibliography
 Wescher, "Einige neue Bilder," p. 39.
 Friedländer, *Early Netherlandish Painting,* XII, p. 108,
 No. 181.
 Puyvelde, "Nouvelles Oeuvres," p. 58.
 Copies and Variants
 a) Present location unknown.
 1.80 × 1.30m
 Signed and dated, "JOANNES VAN HEMESSEN A°
 1540" (?).
 Remarks
 Possibly an original by the artist.
 Provenance
 Sale, Hôtel Drouot, Paris, 8 July 1925.
 Bibliography
 L. Dimier, "Tableaux qui Passent," *Gazette des Beaux-*
 Arts, XIII, 1926, p. 120.
 L. Dimier, "Over een Suzanna en de grijsaards, gemerkt:
 Joannes van Hemessen a° 1540," *Onze Kunst,* XLII,
 1925, p. 31.
 Puyvelde, *Peinture Flamande,* p. 183.

25. *Madonna of Humility,* 1543. (Fig. 105)
 Madrid, Museo del Prado (No. 1542).
 1.345 × 0.895m
 Inscribed with monogram, "AOD 1543."
 Provenance
 Spanish Royal Collections, 1746 (La Granja); 1794 (Aranjuez).
 Bibliography
 Graefe, *Hemessen,* p. 59 (copy after Hemessen).
 Friedländer, *Early Netherlandish Painting,* XII, p. 110, No. 199
 (Hemessen).
 Don Pedro de Madrazo, *Catálogo de los Cuadros de Museo*

Nacional de Pintura y Escultura, Madrid, 1903, p. 234,
No. 1397.

Museo del Prado, *Catálogo de los Cuadros,* Madrid, 1942,
pp. 290–91, No. 1542.

Museo del Prado, *Catálogo de los Cuadros,* Madrid, 1949,
p. 293, No. 1542 (Hemessen).

J. Lavalleye, *Les Primitifs Flamands, Collections d'Espagne,
Antwerp, 1953, p. 25, No. 27 (Hemessen).*

26. *St. Jerome Penitent,* 1543. (Fig. 106)
Leningrad, Hermitage (Inv. N451, No. 911).
1.02 × 0.835m
Signed and dated, on the rock at the upper left: "IOANNES
DE/HEMESSEN/PINGEBAT/1543."
Provenance
Coll. W. W. Prédtćtchensky, St. Petersburg.
Acquired by the Museum in 1895.
Bibliography
A. Somof, *Catalogue de la Galerie des Tableaux, Ermitage
Impérial,* St. Petersburg, 1901, II, p. 155, No. 1833.
Friedländer, *Early Netherlandish Painting,* XII, p. 111,
No. 212.
Graefe, *Hemessen,* p. 47.
Marlier, *Ermasme,* p. 208.
Catalogue, Hermitage, 1958, No. 451.

27. *Wayfarer in a Brothel,* 1543. (Fig. 58)
Hartford, Wadsworth Atheneum (No. 1941.233).
0.84 × 1.18m
Signed and dated at upper right, on wall "IOANNES . DE/
HEMESSEN/PINGEBAT/1543."
Provenance
Coll. Thibaut-Sisson, Paris.
Acquired by the Atheneum in 1941 from Arnold Seligmann,
Rey and Co., New York.
Bibliography
Glück, "The Feeding of the Five Thousand in the Paintings
of the Netherlands," *Art Quarterly,* V, 1942, p. 51.
*Catalogue, Pictures of Everyday Life: Genre Painting in
Europe, 1500–1900,* Carnegie Institute, Pittsburg, 1954,
No. 5.

P. Grigaut, "An Exhibition of Genre Painting at the Carnegie Institute," *Art Quarterly,* XVII, 1954, p. 400.

Handbook, Wadsworth Atheneum, Hartford, 1958, p. 47.

Osten and Vey, *Painting and Sculpture,* p. 198.

Schubert, *Monogrammisten,* p. 48.

Renger, *Gesellschaft,* pp. 129–34.

Wescher, "Jan van Hemessen," p. 59.

Catalogue I, Wadsworth Atheneum Paintings, The Netherlands and the German-Speaking Countries, Fifteenth-Nineteenth Centuries, Hartford, 1978, pp. 151–52, No. 71.

Copies and Variants

a) *Old Peasant Woman with a Jug*
 Vienna, Kunsthistorisches Museum (No. 1974).
 0.49 × 0.415m
 Remarks
 A partial copy of the Hartford panel, showing the old woman at the right with two small figures.
 Bibliography
 Baldass, "Sittenbild," p. 20.
 Katalog der Gemäldegalerie, Vienna, 1981, pp. 209–10.

28. *Portrait of a Magistrate,* 1543. (Fig. 114)
 London, Private Collection.
 1.054 × 0.698m
 Signed and dated, to the left and right of the head of the subject, respectively: "AETATIS SUAE 37" and "IOANNES DE HE/MESSEN PINGEBAT 1543."
 Provenance
 Benyon Collection, Englefield, Berkshire.
 Eustace Hoare Collection.
 Bibliography
 Wallen, "Portraits," pp. 83–84.

29. *Madonna of Humility,* 1544. (Fig. 109)
 Stockholm, Nationalmuseum (No. 2140).
 1.45 × 1.01m
 Signed and dated, on rock at lower right: "IOES . DE . HE/MESSEN . PIN/GEBAT . 1544."
 Provenance
 Coll. Emperor Rudolph II, Prague.
 Coll. Queen Christina of Sweden.
 Coll. Aspelin, Sweden, ca. 1830.

Entered museum in 1919.

Inventory References

Prague, Inventory of Collection of Rudolph II, 1621, No.
 886: "Ein Marienbild mit dem Kindel vom Johann de
 Hems. (Orig.)" (Zimmermann, "Inventar," p. XXXIX.).

Königsmarck Inventory of Prague pictures confiscated by
 Christina, 1648, No. 153 (?). (Granberg, *Galerie*, p. vii).

Inv. of Collection of Queen Christina, 1652, Nos. 68 or 209.
 (Ibid., pp. xxxvi, xxxviii.)

Bibliography

O. Granberg, *Catalogue raisonné de tableaux anciens inconnus
 jusqu'ici dans les collections privées de la Suède*, Stock-
 holm, 1886, I, p. 278, No. 475.

Graefe, *Hemessen*, p. 57 (mistakenly referred to as an *Ecce
 Homo*).

*Catalogue Descriptif, Maîtres étrangers, Collection de Peintures
 du Musée National*, Stockholm, 1928, p. 80.

Friedländer, *Early Netherlandish Painting*, pp. 46–47, p. 110,
 No. 205.

Lotthé, *Pensée Chrétienne*, I, p. 133.

F. Horb, *Zu Vincent Sellaers Eklektizismus*, Stockholm, 1956,
 p. 58.

Å. Berrgtsson, *50år - 50 masterverk, En konstbok från
 Nationalmuseum*, Stockholm, 1961, pp. 28–30, p. 152.

Puyvelde, *Peinture Flamande*, 1962, p. 184.

Catalogue, Christina, pp. 517–18, No. 1–302.

30. *Mocking of Christ*, 1544. (Fig. 111)
 Munich, Alte Pinakothek (No. 1408).
 1.23 × 1.025m
 Signed and dated, "IOANNES DE HE/MESSEN PINGEBAT/
 A° 1544."

Provenance

Kurfürstlichen Galerie, Düsseldorf.

Coll. Wittelsbach.

Brought to Munich in 1805.

Schleissheim, Galerie, No. 3042.

Bibliography

N. de Pigage, *La Galerie Électorale de Duesseldorf, ou
 Catalogue raisonné*, Brussels, 1781, pp. 317–18, No. 313.

Sir Joshua Reynolds, *A Journey to Flanders and Holland in
 the Year 1781,* in Reynolds, *The Works,* ed. E. Malone,
 London, 1809, II, pp. 402–03.

G. K. Nagler, *Künster-Lexikon,* VI, Munich, 1838, p. 34.

Graefe, *Hemessen,* p. 46, p. 56.

E. Bassermann-Jordan, *Unveröffentlichte Gemälde alter Meister aus dem Besitz des Bayerischen Staates,* Leipzig, 1910, III, p. 2, No. 4.

Friedländer, *Early Netherlandish Painting,* XII, p. 109, No. 191.

Puyvelde, "Nouvelles Oeuvres," p. 57.

H. Voss, (Review of *Deutsche und Niederländische Malerei zwischen Renaissance und Barock*), *Kunstchronik,* XIV, 1961, p. 239, p. 249.

Catalogue, Deutsche und Niederländische Malerei Zwischen Renaissance und Barock, Alte Pinakothek, Munich, 1963, p. 35, p. 70.

Faggin, *Pittura ad anversa,* p. 46.

Osten and Vey, *Painting and Sculpture,* p. 198.

Copies and Variants

a) Liverpool, Walker Art Gallery (No. 1179).
 1.276 × 1.038m
 Remarks
 A good but badly rubbed studio copy. A mark near the center top may be the copyist's monogram.
 Provenance
 Coll. William II of Holland, 1815.
 Coll. Malcolm Guthrie.
 Presented to the Walker Art Gallery in 1884.
 Bibliography
 Catalogue, Liverpool, 1927.
 Foreign Schools Catalogue, Walker Art Gallery, Liverpool, 1963, I, p. 88, No. 1179, II, 96.

b) Present location unknown.
 1.28 × 1.04m
 Signed "Chr. Amberger" and dated 1574 on the frame.
 Remarks
 Possibly a copy by Christopher Amberger, though the date of 1574 is erroneous, since Amberger died ca. 1561/62.
 Provenance
 Coll. Albert Grossman, Brombach.
 Grossman Sale, Hugo Helbing, Munich, 30 October 1902.
 Sold at Auction in Munich, Weinmüller, 14 March 1962, No. 840.

31. *Isaac Blessing Jacob,* ca. 1544–45. (Fig. 112)
Munich, Alte Pinakothek (No. 10).
1.10 × 1.50m
Provenance
Coll. of Elector Maximilian I of Bavaria.
Inventory Reference
Inventory of the collection of the Elector Maximilian I of
Bavaria, 1628: "Ein Tafel 4 schuech 2 Zol hoch und 5
schuech 4 Zoll brait, darauf die Historia Isaac, wie er seinen
Sohn Jacob benediciert von Johann Hemessen, mit No. 7."
(Reber, *Maximilian I,* p. 40).
Bibliography
G. K. Nagler, *Künstler-Lexicon,* Munich, 1838, VI, pp. 34–35.
*Katalog der Gemälde-Sammlung der Kgl. Alteren Pinakothek
in Munchen,* Munich, 1884, pp. 36–37, No. 170 (64).
Graefe, *Hemessen,* pp. 47–48, p. 56 (Hemessen).
Friedländer, *Early Netherlandish Painting,* XII, p. 108, No. 178
(Hemessen).
Puyvelde, "Nouvelles Oeuvres," pp. 57–58.
Marlier, *Erasme,* p. 287, Fig. 57.
*Catalogue, Deutsche und Niederländische Malerei Zwischen
Renaissance und Barock, Alte Pinakothek,* Munich, 1961,
p. 29, No. 10.
Copies and Variants
a) Budapest, Museum of Fine Arts (Inv. No. 1049).
1.19 × 1.63m
Remarks
An exacting but dry early copy.
Provenance
Coll. François Kleinberger, Paris.
Donated to the Museum in 1896.
Bibliography
*Catalogue des Tableaux Anciens et Modernes, Musée des
Beaux-Arts,* Budapest, 1910, No. 676 (1049).
Friedländer, *Early Netherlandish Painting,* XII, p. 108,
No. 179 (Hemessen).
A. Pigler, *Katalog der Galerie Alter Meister, Budapest,*
1968, I, p. 308, No. 1049 (676).
Possible Inventory References
1) Inventory of the collection of Herman de Neyt, Ant-
werp, 15–21 October, 1642, No. 355: "Een stuck
naer Hemssen, daer Jacob aen synen zoon de bene-

dictie geeft." (Denucé, *Inventare,* p. 103).

2) Catalogue of the collection of Pierre Stevens, Antwerp, 1668, No. 63: "De Jean de Hemessen: La Benediction d'Isaac donnée à son Fils Jacob." (Speth-Holterhoff, *Cabinets d'Amateurs,* p. 199.)

32. *St. Jerome in the Wilderness,* 1548. (Fig. 116)
Private Collection, Barcelona.
0.84 × 0.69m
Signed and dated, "1548/IOANNES/DE HEMES/SEN PINGE/BAT."
Provenance
Coll. Lafora, Madrid
Bibliography
Friedländer, *Early Netherlandish Painting,* XII, p. 131, Supp. 410.
Catálogo, Pintura Antigua, Siglos XV al XVII, Colecciones Barcelonesas, Barcelona, 1946, II, p. 33.

33. *Calling of St. Matthew,* ca. 1548. (Fig. 70)
Vienna, Kunsthistorisches Museum (Inv. No. 961).
1.14 × 1.37m
Remarks
Cut down slightly at top and right side. The background scene is attributed to the Master of the Douai *Ecce Homo.*
Provenance
Coll. George Villiers, Duke of Buckingham.
Prague, 1718.
Stallburg, 1720.
Imperial Gallery, Vienna.
Paris, 1809.
Returned to Vienna, 1815.
Inventory References
Inventory of the collection of George Villiers, Duke of Buckingham (sold Antwerp, 1648): "No. 2. The Calling of St. Matthew by our Saviour, wherein seven large figures and other small ones are represented 3F6 × 4F6." (B. Fairfax, *A Catalogue of the...Collection of Pictures of Georges Villiers, Duke of Buckingham,* London, 1758, p. 20).
Bibliography
Storffer, *Gemaltes Inventarium der Aufstellung der Gemäldegalerie in der Stallburg,* 1720, I, No. 92 ("Quintino Masais").

A. Joseph de Prenner, *Theatrum artis pictoriae,* Vienna,
1728–32, Pl. 5 (in Zimmermann, "Theatrum Artis Pic-
toriae").

C. de Mechel, *Catalogue des Tableaux de la Galerie Impériale
et Royale de Vienne,* Basle, 1784, p. 166, No. 68 (Hemessen).

E. von Engerth, *Kunsthistorische Sammlungen des Allerhöch-
sten Kaiserhauses, Gemälde,* Vienna, 1884, II, p. 182, No.
888 (Hemessen).

Frimmel, *Wiener Gemäldesammlungen,* II, p. 471, No. 701
(Hemessen).

*Katalog der Gemäldegalerie des Allerhöchsten Kaiserhauses,
Alte Meister,* Vienna, 1907, p. 163, No. 701 (E. 888).

Graefe, *Hemessen,* p. 57 (referred to erroneously as replica of
No. 988).

Friedländer, *Early Netherlandish Painting,* XII, p. 109, No. 187
(Hemessen).

Marlier, *Erasme,* pp. 282–83.

Katalog der Gemäldegalerie, Kunsthistorisches Museum,
Vienna, 1958, II, p. 68, No. 201 (the reference to the ill.
is misplaced next to No. 200).

Faggin, *Pittura ad Anversa,* p. 46.

Katalog der Gemäldegalerie, Vienna, 1981, p. 202 (Hemessen,
shortly before 1550).

Copies and Variants
a) Vienna, Kunsthistorisches Museum (No. 988), on loan to
 Linz, Landesmuseum.
 1.14 × 1.45m
 Remarks
 A fairly accurate early copy, a bit wider on the sides.
 Provenance
 Stallburg (?).
 Imperial Gallery, Vienna.
 Linz, Landesmuseum.
 Bibliography
 Mechel, *Catalogue,* p. 166, No. 69 ("Johann v.
 Hemessen").
 E. von Engerth, *Kunsthistorischen Sammlungen des Aller-
 höchsten Kaiserhauses, Gemalde,* Vienna, 1884, II,
 p. 183, No. 889 (Hemessen).
 Frimmel, *Wiener Gemäldesammlungen,* II, p. 471, No.
 700 (Hemessen).
 Graefe, *Hemessen,* p. 57 (Hemessen, 1548, No. 700).

Friedländer, *Early Netherlandish Painting,* XII, p. 109,
No. 187a (replica).
Katalog der Gemäldegalerie, Vienna, 1981, p. 209 (after
Hemessen).

b) Bucharest, Museum of the Roemeense Volksrepubliek.
1.11 × 1.40m
Remarks
A fine early copy of Vienna 961.
Provenance
Coll. of King Charles I of Rumania.
Peles Castle, Sinaia.
Bibliography
Graefe, *Hemessen,* p. 58 (after Hemessen).
L. Bachelin, *Tableaux Anciens de la Galerie Charles Ier,
Roi de Roumanie,* Paris, 1898, pp. 147–48, No. 107.
Friedländer, *Early Netherlandish Painting,* XII, p. 109,
No. 187b (replica).
G. Oprescu, *Great Masters of Painting in the Museums
of Rumania,* Bucharest, 1961, No. 6 (Hemessen).

c) Madrid, Coll. Peñalver.
Remarks
A fair copy, with more architecture at top and right side.

d) New York, Metropolitan Museum of Art (Access. No.
71.155).
1.11 × 1.51m
Provenance
Purchased 1871.
Bibliography
*Catalogue, The Taste of the Seventies, Metropolitan
Museum of Art,* New York, 1946, No. 25.
K. Baetjer, *European Paintings in the Metropolitan
Museum of Art, A Summary Catalogue,* I, New York,
1980, p. 85 (Hemessen).

e) Present location unknown.
1.12 × 1.42m
Provenance
Sale Fievez, Brussels, 16 December 1933, No. 130.

34. *Christ Bearing the Cross,* 1549. (Figs. 117–18)
Toledo, Museo de Santa Cruz (No. 472).
1.10 × 0.94m
Signed and dated, at bottom left: "I(OA)NNES (D)E
H(E)MES(SEN)/(P)INGEBA(T)/(15)49."

Remarks

The panel has suffered a great deal of damage, especially in the drapery, and it has probably been cut down at the top. Close examination of the nimbus reveals it to be original.

Provenance

Convent of San Isidro, Toledo.

Cloister of San Juan de los Reyes, Toledo, 1846.

Bibliography

Amador de los Ríos, *Toledo pintoresca,* Toledo, 1845 (Morales).

Comisión de Monumentos Históricos y Artisticos de la Provincia de Toledo, Catálogo razonado por orden numérico de las pinturas, esculturas y arqueológicos, Toledo, 1865, fol. 1123.

Parro, *Toledo en la mano,* Toledo, 1857, p. 54 (Morales).

Conde de Palazuelos, *Toledo, guía artíistico-práctica,* Toledo, 1890, p. 632, No. 243 (Morales).

Elías Tormo, *Toledo, Los Museos,* II, pp. 15–16 (anon. sixteenth century Spanish master)

M. Díaz Padrón, "Una tabla de Jan de Hemessen en el Museo Provincial de Toledo," *Arte Espanol,* XXV, 1963–66, pp. 69–71.

35. *Portrait of a Man,* ca. 1549–50. (Fig. 120)

Warwick Castle, Coll. of the Earl of Warwick (Inv. No. 48).

0.92 × 0.735m

Inscribed, on a slip of paper held by the sitter, "AETATIS/ SVAE 24/FORTVNE/LE VEVLT."

Bibliography

Siècle de Bruegel, p. 113, No. 134 (Hemessen, ca. 1540).

Wallen, "Portraits," pp. 70–71, p. 84.

36. *Judith with the Head of Holofernes,* ca. 1549–50. (Fig. 121)

The Art Institute of Chicago (56.1109).

0.998 × 0.772m

Provenance

Coll. Marquis de la Pallu, Paris.

Acquired by the Institute in 1956.

Inventory Reference

Inventory of the Collection of the painter Steven Wils, the younger, Antwerp, 6 July 1628, No. 5: "Item, een stuck

van Hemssen, wesende een Judith, op panneel." (Denucé, *Inventare,* p. 47).

Bibliography
H. Huth, "Mannerist Judith for the Art Institute," *Chicago Art Institute Quarterly,* LI, 1957, pp. 2–3 (Hemessen).
H. Comstock, "A Flemish mannerist Judith," *Connoisseur,* CXXXX, 1957, p. 139 (Hemessen).
Faggin, *Pittura ad anversa,* Fig. 111 (Hemessen).
Osten and Vey, *Painting and Sculpture,* p. 198, Pl. 183 (Hemessen, ca. 1540–50).
Wescher, "Jan van Hemessen," p. 42 (Hemessen).

37. *Holy Family,* ca. 1549–50. (Fig. 123)
Pommersfelden, Schönborn Collection (Inv. No. 238).
0.72 × 0.527m
Bibliography
Wiesentheid Inventory, 1754–56, No. 274.
Th. von Frimmel, *Kleine Galeriestudien,* Bamberg, 1891, I, pp. 22–23, No. 267 (Hemessen).
Idem, Verzeichnis der Gemälde im Graflich Schönborn-Wiesentheid'schen Besitze, Pommersfelden, 1894, p. 89.
Friedländer, *Early Netherlandish Painting,* XII, p. 111, No. 206a (Hemessen, "an original").
Wescher, "Einige neue Bilder," p. 40 (Hemessen).
Copies and Variants
a) Cologne, Wallraf-Richartz Museum (No. 481).
0.765 × 0.56m
Remarks
A fairly good early copy of the picture at Pommersfelden.
Provenance
Coll. Ferdinand Franz Wallraf.
Bibliography
Inventory, Coll. Ferdinand Franz Wallraf, 1824–25, fol. 80, No. 22 (Italian School).
Graefe, *Hemessen,* 1909, pp. 45–46, p. 55 (Hemessen).
Friedländer, *Early Netherlandish Painting,* XII, p. 110, No. 206 (Hemessen).
Katalog der Deutschen und Niederländischen Gemälde bis 1550 im Wallraf-Richartz Museum, Cologne, 1969, pp. 126–27, No. 481 (Hemessen, copy after).

38. *Isaac Blessing Jacob,* 1551. (Fig. 124)

Fagersta Bruk AB, Dannemora-Verken (in Österby Church), Sweden.
1.50 × 1.89m
Signed and dated, "IOANNES DE HEMESSEN/PINGEBAT 1551."
Provenance
Coll. Emperor Rudolph II, Prague.
Coll. Queen Christina, Sweden.
Inventory References
1) Inventory of the Collection of Emperor Rudolph II at Prague, 6 December 1621: "No. 1004: Ein fürnembes stuck, wie Isaac dem Jacob den seegen gibt, vom Johann de Hems. (Orig.)." (Zimmermann, "Inventar," p. xli).
2) Königsmarck Inventory of Prague pictures confiscated by Christina, 1648, No. 179: "Ein Vornembes stük, Wie Isak seinem Sohn den Seegen gibt." (Granberg, *Galerie,* p. IX).

Bibliography
O. Granberg, *Inventaire général des trésors d'art. Peintures et sculptures principalement des maîtres étrangers en Suède,* Stockholm, 1911, I, No. 139.
Idem, Svenska Konstsamlingarnas historia från Gustav Vasas tid till våra dagar, Stockholm, 1929, I, p. 48, No. 22.
Friedländer, *Early Netherlandish Painting,* XII, p. 108, No. 180.
Puyvelde, *Peinture Flamande,* p. 184.
Catalogue, Christina, p. 518, No. 1–303.

39. *St. Jerome in the Wilderness,* ca. 1551–52. (Fig. 126)
Genoa, Palazzo Rosso (No. 69).
0.51 × 0.80m
Remarks
The panel has evidently been cut down several centimeters at the top.
Bibliography
E. Jacobsen, "Le Gallerie Brignole-Sale Deferrari in Genoa," *Archivio Storico dell'Arte,* II, 1896, p. 14 (follower of Quentin Massys).
Catalogue, Palazzo Rosso, Genoa, 1909, p. 72, No. 10 (Lucas van Leyden).
E. Jacobsen, "Gemälde und Zeichnungen in Genua," *Reper-

torium für Kunstwissenschaft, XXXIV, 1911, p. 193.

Grosso, *Catalogo della Galleria di Palazzo Rosso,* Genoa, 1912, Pl. 4 (Flemish School).

Graefe, *Hemessen,* p. 46, p. 56 (Hemessen).

Friedländer, *Early Netherlandish Painting,* XII, p. 111, No. 214 (Hemessen).

Catalogue, Palazzo Rosso, Genoa, 1931, p. 52, No. 69 (Marinus van Roymerswaele).

G. J. Hoogewerff, "Zes onbekende oud-nederlandsche schilderijn," *Onze Kunst,* XLV, 1929, pp. 65–66 (Hemessen).

Catalogo provisorio della galleria di Palazzo Rosso, Genoa, 1961, p. 26, No. 69 (Roymerswaele).

Copies and Variants

a) Present location unknown.

0.66 × 0.515m

Remarks

A studio copy in a vertical format, with the landscape reduced.

Provenance

Coll. Marquis de Victoire de Heredia, Paris (Sale Hôtel Drouot, 15 June 1912).

Satinover Galleries, New York, 1917.

Coll. John R. van Derlip, Minneapolis, Minn.

Deposited at the Minneapolis Institute of Arts, 1935.

Withdrawn from the Institute in 1955.

Bibliography

Friedländer, *Early Netherlandish Painting,* XII, p. 111, No. 211 (Hemessen).

b) Göttingen, Kunstsammlung der Universität.

0.56 × 0.63m

Remarks

A precise copy that reproduces areas at the top and details of rocks now missing from the original. The landscape to the right is reduced.

Bibliography

Catalogue, Kunstsammlung der Universität Göttingen, 1926, No. 80.

c) Madrid, Prado, No. 2185.

40. *Holy Family,* ca. 1552. (Fig. 127)

Cracow, State Collection of Art at Wawel Castle (Inv. No. 117).

0.965 × 0.70m
Provenance
Imperial Gallery, Vienna (eighteenth century).
Art Dealer, J. Böhler, Munich.
Coll. Baron I. Pininski.
Donated to Wawel Castle in 1934.
Bibliography
Engraved by A. J. de Prenner in *Theatrum artis pictoriae,*
 Vienna, 1728–32 (Cf. Zimmermann, "Theatrum Artis
 Pictoriae").
Friedländer, *Early Netherlandish Painting,* XII, p. 111,
 No. 209a (Hemessen).
St. Swierz-Zaleski, *Zbiory Zamku Królewskiego na Wawelu w
 Krakowi,* Cracow, 1935, p. 19.
J. Bialostocki and M. Walicki, *Europäische Malerei in Pol-
 nischen Sammlungen,* Warsaw, 1957, p. 498, Nos. 131–33
 (Hemessen, ca. 1545).
Siècle de Bruegel, pp. 111–12, No. 130 (Hemessen).
Puyvelde, *Peinture Flamande,* p. 189.
*Catalogue, La Peinture Néerlandaise dans les Collections
 Polonaises, 1450–1550,* Warsaw, National Museum, 1963,
 No. 27.
Schubert, *Monogrammisten,* No. 5, pp. 178–79, and pp.
 133–36 (Brunswick Monogrammist, ca. 1530–35).
Copies and Variants
a) Donaueschingen, Fürstlich Fürstenbergische Sammlungen
 (No. 112).
 1.07 × 0.76m
 Remarks
 A late sixteenth century copy, with an architectural setting
 added.
 Bibliography
 A. Woltmann, *Verzeichnis der Gemälde, Fürstlich Für-
 stenbergische Sammlungen zu Donaueschingen,* Karls-
 ruhe, 1870, p. 50, No. 112 (Orley).
 Friedländer, *Early Netherlandish Painting,* XII, p. 111,
 No. 209 (Hemessen).
b) Present location unknown.
 1.01 × 0.71m
 Provenance
 Coll. Mme. Charles Kreglinger, Brussels, 1 April 1936
 (Coxcie).

c) Present location unknown.
 1.06 × 0.755m
 Provenance
 Art Dealer J. Denijs, Amsterdam, 1942 (W. Key).

41. *Madonna and Child,* ca. 1552. (Fig. 128)
 Present location unknown.
 0.584 × 0.438m
 Provenance
 Coll. Lord Rothermere.
 Art Dealer Wengraf, London, November, 1946.
 Coll. John Scott-Taggart, Sale, Sotheby's, 2 July 1958.
 Art Dealer Dr. Singer, London.
 Art Dealer P. de Boer, Amsterdam, 1959.
 Sale, Fischer, Lucerne, 21 November 1961, No. 2170.
 Bibliography
 Royal Academy, Exhibition of Flemish Art, 1300–1700,
 1953–54, No. 78.

42. *Christ Bearing the Cross,* 1553. (Fig. 125)
 Esztergom, Gran, Hungary. Diocesan Museum.
 1.11 × 0.975m
 Signed and dated in lower left-hand corner: "1553 IOHANNES
 DE HEMESSEN PINGEBAT."
 Provenance
 Coll. Art Dealer Gustav Bayer, Vienna.
 Purchased by Cardinal Simor in 1874.
 Bibliography
 Wescher, "Einige neue Bilder," ill. opp. p. 39.
 Friedländer, *Early Netherlandish Painting,* XII, p. 109,
 No. 192.
 Puyvelde, "Nouvelles Oeuvres," p. 65.
 M. Boskovits, M. Mojszer and A. Mucsi, *Das Christliche
 Museum von Estergom (Gran),* Budapest, 1965, No. 75.

43. *A Musician and His Muse* (*Allegorical Marriage Portrait of
 Caterina van Hemessen and Chrétien de Morien?*), ca. 1554.
 (Fig. 131)
 Toronto, Coll. Theodore A. Heinrich.
 158.7 × 190.5m
 Provenance
 Coll. Lord Northbrook, Wilton House.

Arcade Gallery, London, 1950.
Bibliography
E. Winternitz, "The Inspired Musician, A Sixteenth-Century
Musical Pastiche," *Burlington Magazine,* C, 1958, pp. 48–55.
G. Bandmann, *Melancholie und Musik,* Cologne, 1960,
pp. 111ff.
P. Wescher, "Jan van Hemessen," p. 43 (Hemessen).

44. *Putto with a Death's Head,* ca. 1554. (Fig. 135)
Present location unknown.
0.65 × 0.90m
The putto holds a rod with a scroll bearing the inscription:
NASSE(NTES) . MO . /RIMVR."
Provenance
Coll. de Lafitte du Treihl (Sale, Roos, Amsterdam, 16–19
April 1912, No. 1269, as Goltzius).
Coll. J. B. van Stolk, Haarlem.
Coll. Art Dealer Dr. N. Beets, Amsterdam, 1933–38.
Coll. A. E. Boer, The Hague, 1938.
Sale Amsterdam, P. Brandt, 28 November 1961, No. 1.
Bibliography
Friedländer, *Early Netherlandish Painting,* XII, p. 111,
No. 216 (Hemessen).
H. W. Janson, "The Putto with the Death's Head," *Art Bulletin,* XIX, 1937, pp. 438–39.
Faggin, *Pittura ad Anversa,* p. 46 (Hemessen).
Copies and Variants
a) Coll. Marquess of Salisbury, Hatfield House.
0.57 × 0.76m
Remarks
An early variant, with the putto inside a room and a
window opening on a yard.

45. *Portrait of a Man,* ca. 1554–56. (Fig. 149)
Vienna, Kunsthistorisches Museum (Inv. No. 915).
0.365 × 0.28m
Provenance
Coll. Archduke Leopold Wilhelm.
Stallburg, 1720.
Imperial Gallery, Vienna.
Inventory Reference
Inventory of the collection of Archduke Leopold Wilhelm,

1659: "Original von Holbein" (Berger, "Inventar," No. 448).

Bibliography

Storffer, *Gemaltes Inventarium der Aufstellung der Gemälde-galerie in der Stallburg,* 1720, III, No. 91 (Holbein).

C. de Mechel, *Catalogue des Tableaux de la Galerie Impériale et Royale de Vienne,* Basle, 1784, p. 261, No. 96 (Holbein).

E. von Engerth, *Gemälde, Kunsthistorisches Sammlungen des Allerhöchsten Kaiser-Hauses,* Vienna, 1884, No. 1580 (Style of Holbein).

Friedländer, *Early Netherlandish Painting,* XII, p. 112, No. 223 (Hemessen).

Baldass, "Bildnisse," p. 89 (Hemessen).

Wallen, "Portraits," p. 85.

Katalog der Gemäldegalerie, Vienna, 1981, pp. 203–04 (Hemessen).

46. *Portrait of a Man (Gossaert?),* ca. 1554–56. (Fig. 150)
Vienna, Kunsthistorisches Museum (No. 1030).
0.47 × 0.39m

Remarks

The panel was formerly an oval. The traditional identification of the subject as Gossaert is supported by the similarity of features to the engraved portrait by Lampsonius (1572), though the panel dates long after Gossaert's death.

Provenance

Stallburg (?).

Belvedere Gallery, 1781.

Bibliography

C. de Mechel, *Catalogue des Tableaux de la Galerie Impériale et Royale de Vienne,* Basle, 1784, p. 171, No. 92 (Hemessen, *Portrait of Mabuse*).

C. G. Waagen, *Handbuch der niederländischen und deutschen Malerschulen,* Stuttgart, 1862, I, p. 306 (Hemessen, *Portrait of Mabuse*).

E. von Engerth, *Gemälde, Kunsthistorisches Sammlungen des Allerhöchsten Kaiser-Hauses,* Vienna, 1884, p. 185, No. 894 (Hemessen, *Gossaert*).

Frimmel, *Wiener Gemäldesammlungen,* II, p. 471, No. 695 (Hemessen, *Gossaert*).

Katalog der Gemäldegalerie des Allerhöchsten Kaiserhauses,

Alte Meister, Vienna, 1907, p. 162, No. 695 (E. 894).
Style of Hemessen, *Gossaert?*).
Graefe, *Hemessen,* p. 60 (After Hemessen, by Caterina?).
Friedländer, *Early Netherlandish Painting,* p. 112, No. 222
(Hemessen).
Baldass, "Bildnisse," pp. 88–89 (Hemessen, ca. 1540–50,
Portrait of Gossaert?).
Wallen, "Portraits," pp. 85–86.
Katalog der Gemäldegalerie, Vienna, 1981, pp. 202–03
(Hemessen).

47. *Tobias Cures His Father's Blindness,* 1555. (Fig. 136)
Paris, Musée du Louvre (Inv. No. 1335).
1.40 × 1.72m
Signed and dated, at lower left: "IOANNES/DE HE/
MESSEN/INVEN/TORET/PICTOR 1555."
Provenance
Coll. Duc de Penthièvre, Châteauneuf-sur-loire.
Confiscated in 1793.
Inventory Reference
*Notice des Tableaux des Ecoles Française et Flamande exposés
dans la grande Galerie dont l'ouverture a eu lieu le 18
germinal an VII (7 avril 1799)...,* p. 54, No. 307.
Inventaire Napoléon.
Bibliography
C. P. Landon, *Annales du Musée et de l'École moderne des
Beaux-Arts, École Flamande,* Paris, 1825, II, p. 17.
G. K. Nagler, *Künstler-Lexikon,* Munich, 1838, VI, p. 34.
Graefe, *Hemessen,* pp. 47–48, p. 56.
Friedländer, *Early Netherlandish Painting,* XII, p. 109, No.
182.
Genaille, "Hemessen et le Romanisme," pp. 32–42.
E. Michel, *Catalogue Raisonné, Peintures Flamandes...,
Musée National du Louvre,* Paris, 1953, pp. 135–37, No.
2001.
Siècle de Bruegel, p. 111, No. 128.
Puyvelde, *Peinture Flamande,* p. 184.

48. *Expulsion of the Merchants and Moneylenders from the
Temple,* 1556. (Fig. 140)
Nancy, Musée des Beaux-Arts.

1.71 × 2.24m

Signed and dated on the step at lower left: "IOANNES DE HEMES/SEN PICTOR ET/INVENTOR/1556."

Provenance

Coll. of Dukes of Bavaria, eighteenth century.

Munich, Hofgartner Gallery.

Seized by Mission Neveu in 1799–1800.

Deposited in Museum in 1803.

Bibliography

Die Bildergalerie in München, Munich, 1787, p. 36, No. 183.

Neveu (?), Inventory of April 1799, No. 34.

Mannlich, Inventory of 1 September 1800, pp. 226–27.

A. Pinchart, "Voyage artistique en France et en Suisse en 1865," *Bulletin des commissions royales d'art et d'archéologie de Belgique,* VII, 1868, pp. 226–27.

Catalogue, Musée de Nancy, 1897, No. 234.

L. Gonse, *Les chefs-d'oeuvre des Musées de France. La Peinture,* Paris, 1900, pp. 223–25.

Graefe, *Hemessen,* p. 20, p. 23, p. 48, p. 49, p. 54, p. 56.

G. Vauthier, "Une mission artistique et scientifique en Bavière sous le Consulat," *Bulletin de la Société de l'Histoire de l'art français,* 1910, pp. 223–24, p. 242.

Wurzbach, *Niederländisches Künstler-Lexikon,* I, p. 675.

L. Preibisz, *Martin van Heemskerck,* Leipzig, 1911, p. 65.

Friedländer, *Early Netherlandish Painting,* XII, p. 109 No. 183.

Puyvelde, "Nouvelles oeuvres," pp. 65–66.

Marlier, *Erasme,* pp. 284–85.

Catalogue, Le XVIe Siècle Européen, Paris, Petit Palais, 1965–66, No. 166, pp. 130–31.

49. *The Cure of Folly,* ca. 1556. (Fig. 137).
 Madrid, Museo del Prado (No. 1541).
 1.00 × 1.40m
 Provenance
 Spanish Royal Collection, Inventory El Prado, 1614.
 Bibliography
 L. Gonse, *Les chefs-d'oeuvre des Musées de France, La Peinture,* Paris, 1900, p. 29.
 Don Pedro de Madrazo, *Catálogo de los Cuadros del Museo Nacional de Pintura y Escultura,* Madrid, 1903, p. 233, No. 1396.

H. Meige, "Les Opérations sur la Tête," *Nouvelle Iconographie de la Salpêtrière*, VIII, 1895, pp. 251–56.

J. B. F. van Gils, "Het snijden van den Kei," *Nederlandsch Tijdschrift voor Geneeskunde*, II, 1940, pp. 310ff.

Graefe, *Hemessen*, p. 48, p. 56 (Hemessen).

Friedländer, *Early Netherlandish Painting*, XII, p. 111, No. 217 (Hemessen).

Catálogo de los Cuadros, Museo del Prado, Madrid, 1949, p. 243, No. 1541 (Hemessen).

Genaille, "Hemessen et le Romanisme," p. 32, n. 2 (Hemessen).

Marlier, *Erasme*, pp. 285–86 (Hemessen).

50. *The Parable of the Unmerciful Servant*, ca. 1556. (Fig. 142)
 Ann Arbor, Michigan, University of Michigan Art Museum
 0.84 × 1.54m
 Provenance
 Coll. Sir Culling Eardley, 3rd Bart., Hadley, Middlesex.
 Sale, Richard Ford, Christie's, London, 14 June 1929, No. 29.
 Coll. F. E. Fremantle, Bedwell Park, Hatfield, Hertfordshire.
 Coll. Dr. Paul Drey, New York.
 Inventory Reference (?)
 K. J. Köpl, "Urkunden, Acten, Regesten und Inventare aus dem K. K. Statthalterei-Archiv in Prag," *Jahrbuch der Kunsthistorischen Sammlungen des Allerhöchsten Kaiserhauses*, X, 1889, p. CXXXVI, No. 307 (Inventory 1718, April 8, Prague): "Hembsio. Orig.: Die parabl von dem ungerechten hausalter," and p. CXLII, No. 307 (Inv. 1723, November 5, Prague to Vienna): "Qvirinus Masseis: Die parabl von dem ungerechten hausalter."
 Bibliography
 Waagen, *Galeries and Cabinets of Art in Great Britain*, London, 1857, supplementary volume, p. 281 (Hemessen).
 Wurzbach, *Niederländisches Künstler-Lexikon*, I, p. 675.
 Friedländer, *Early Netherlandish Painting*, XII, p. 109, No. 188 (Hemessen).
 Catalogue, Holbein and his Contemporaries, John Herron Art Museum, Indianapolis, 1950, No. 31 (Hemessen).
 Puyvelde, "Nouvelles Oeuvres," pp. 62–65 (Hemessen).
 J. Snyder, "The Parable of the Unmerciful Servant Painted by Jan Sanders van Hemessen," *The University of Michigan Museum of Art Bulletin*, I, 1965–66, pp. 2–13 (Hemessen).
 Copies and Variants

a) Present location unknown.
0.93 × 1.20m
Provenance
Sale, Berlin, 17 February 1914, No. 57, as P. Aertsen.
Sale, Vienna (Dorotheum), 9 June 1959, No. 57, as
"circle of Jan van Hemessen."

51a. *St. Mary Magdalen,* ca. 1556.

51b. *St. John the Baptist,* ca. 1556. (Fig. 147)
Formerly Orléans, Musée des Beaux-Arts, destroyed by fire in
1940.
1.05 × 0.30m each
Remarks
The panels were wings from a lost triptych.
Bibliography
Catalogue, Orléans, 1908, No. 177 (Gossaert).
Wescher, "Einige neue Bilder," p. 39.
Friedländer, *Early Netherlandish Painting,* XII, p. 108,
No. 177 (Hemessen).

52. *Agony in the Garden,* ca. 1556. (Fig. 145)
Present location unknown.
1.52 × 2.32m
On the sheath of the sword of St. Peter, the inscription:
"H.../H..."
Provenance
Art Dealer Forchoudt, Antwerp, 1676 (?).
Esterhazy Gallery, Inv. of 1867, No. 651.
Coll. J.-B. Émile Gérard, Vienna, No. 59.
Sale Heberle, Cologne, 5–6 November 1901, No. 54.
Galerie Neupert, Zurich, 1934–40.
Auctioned Fischer, Lucerne, 18–19 June 1971 (No. 492).
Inventory Reference
Letter of 31 January 1676 from Forchoudt to his son at
Vienna: "Hebbe van Johan Hemsen een groet stuck alst
cleyn leven ons Heer int hoefken." (Denucé, *Forchoudt,*
p. 198. See also ibid., p. 148, bill of 19 May 1676: "No. 13.
1 groodt stuck Ons Heer int Hofken van Jan Hemsen g.
240.")
Bibliography
Friedländer, *Early Netherlandish Painting,* XII, p. 109,
No. 190.

53. *Old Peasant Woman,* ca. 1556. (Fig. 148)
 Dublin, National Gallery of Ireland (No. 619).
 0.69 × 0.53m
 Provenance
 Purchased by the Museum in Dublin, 1910 (Thornley Stoker
 Sale).
 Remarks
 Sadly mutilated, but possibly original.
 Bibliography
 *Concise Catalogue of the Oil Paintings, National Gallery of
 Ireland,* Dublin, n. d., No. 619 (Pieter Aertsz).
 Wescher, "Jan van Hemessen," p. 46 (Hemessen).

54. *St. Jerome, Reading,* 1557?. (Fig. 151)
 London, F. Stimpson Coll.
 0.71 × 0.585m
 Signed and dated, at upper left: "IOHANNES DE HEMES-
 SEN/INVENTOR ET PICTOR 1557 (?)"
 Remarks
 The head of the saint has evidently been extensively repainted.
 Provenance
 Sale Christie's, 23 April 1926, No. 71 (Houstoun-Boswall
 sale).
 Coll. Art Dealer Meakin.
 Bibliography
 Friedländer, *Early Netherlandish Painting,* p. 111, No. 213.
 Marlier, *Erasme,* p. 207.
 Puyvelde, *Peinture Flamande,* p. 184.

II. Copies after Lost Paintings by Hemessen

55. *Lamentation,* ca. 1529–30. (Fig. 23)
 Mainz, Gemäldegalerie (Inv. No. 70).
 1.105 × 0.84m
 Remarks
 A copy by the Brunswick Monogrammist (Jan van Amstel?)
 probably executed in Hemessen's workshop after a lost
 original from ca. 1529–30.
 Provenance
 Acquired by the Museum between 1880 and 1886.
 Bibliography
 M. J. Binder (review of Graefe, *Hemessen*), *Monatshefte
 für Kunstwissenschaft,* III, 1910, p. 392 (early Hemessen).

E. Weisz, *Jan Gossaert gen. Mabuse,* Parchim, 1913,
 pp. 107–08 (Hemessen).
Winkler, *Altniederländische Malerei,* p. 298 (Hemessen).
Wescher, "Einige neue Bilder," p. 39 (Hemessen).
Friedländer, *Early Netherlandish Painting,* XII, p. 110,
 No. 194 (Hemessen; "a bit divergent in style, Early?").
Catalogue, Mainz, Gemäldegalerie, 1911, No. 70 (Gossaert).
Schubert, *Monogrammisten,* pp. 76–79, No. 1, p. 176
 (Brunswick Monogrammist).
Wescher, "Jan van Hemessen," p. 41 (early Hemessen).

56. *Portrait of a Young Girl (Margaret of Parma?) Writing,*
 ca. 1530. (Fig. 20)
 London, National Gallery.
 0.27 × 0.235m
 Remarks
 The lost original was probably provided with an interior set-
 ting like the Berlin and Worcester panels (Cat. Nos. 6
 and 7).
 Provenance
 Coll. Prince Ludwig Kraft Ernst von Oettingen-Wallerstein,
 Schloss Wallerstein.
 Exhibited Kensington Palace, 1848, No. 101.
 Purchased by the Prince Consort, 1848.
 Exhibited Manchester, 1857 (lent by Prince Albert).
 Presumably presented to the National Gallery in 1863.
 Bibliography
 Wallerstein, *Catalogues,* ca. 1826 and 1827, No. 46 (artist
 unknown).
 Waagen, *Catalogue,* 1854, No. 64 (Mabuse).
 Waagen, *Treasures,* IV, 1857, p. 130.
 Martin Davies, *National Gallery Catalogues, Early Nether-
 landish School,* London, 1955, No. 622, pp. 100–01.

57. *St. Jerome in his Study,* ca. 1530–35. (Fig. 40)
 Antwerp, Rockoxhuis.
 101.5 × 0.56m
 Signed, at the lower left, "IOĒS DE/HEMESSEN/PINXIT."
 Remarks
 A copy by the Master of the Augsburg *Ecce Homo.* The
 original panel was in the collection of Nicolas Rockox at
 Antwerp in the seventeenth century and was illustrated

in a cabinet painting by Frans Francken II, now at Munich.
(Inventory of the collection of Nicolas Rockox, Antwerp,
1640: "Eene Schilderye olieverwe in syn lyste wesende
eenen Jeronimus van Hemsen." (Denucé, *Galeries d'Art*,
p. 88. Cf. also Speth-Holterhoff, *Cabinets d'Amateurs*,
Fig. 24).

Provenance

Coll. Rev. L. C. Newhouse, The Chantrey, Bournemouth,
England.

Coll. Leo van Puyvelde, Brussels.

Acquired by the Rockoxhuis in 1966.

Bibliography

H. G. Evers, *Rubens and Sein Werk*, Brussels, 1943, p. 157.

Puyvelde, "Nouvelles Oeuvres," p. 62 (Hemessen).

Marlier, *Erasme*, p. 207.

Puyvelde, *Peinture Flamande*, p. 184.

Siècle de Bruegel, p. 112, No. 131 (Hemessen).

*Katalog, Alte Pinakothek, Munich, Deutsche und Nieder-
ländische Malerei zwischen Renaissance und Barock*,
Munich, 1963, pp. 33–34.

D. Schubert, "Eine Zweite 'Sintflut' vom 'Meister des Augs-
burger Ecce Homo'," *Wallraf-Richartz-Jahrbuch*, XXXIII,
1971, p. 325. (copy after Hemessen by the Master of the
Augsburg *Ecce Homo*).

58. *Madonna and Child*, ca. 1535. (Fig. 84)
Present location unknown.
0.86 × 0.77m

Remarks

A workshop copy by the Brunswick Monogrammist.

Provenance

Art Dealer (Werner), Leipzig, 1935.

Auction, Lempertz, Cologne, 17 May 1962, No. 91

Bibliography

P. Wescher, "Einige neue Bilder," pp. 39–41 (Hemessen,
early).

Friedländer, *Early Netherlandish Painting*, XII, p. 110,
No. 202 (Hemessen, early).

Schubert, *Monogrammisten*, No. 3, p. 177, also pp. 141–43
(Brunswick Monogrammist).

Wescher, "Jan van Hemessen," p. 38 (Hemessen).

59. *Madonna and Child,* ca. 1535.
Present location unknown.
0.81 × 0.62m
Provenance
Sale, Paris, 28 January 1926, No. 207.

60a. *St. Jerome in his Study,* ca. 1538–40. (Fig. 42)
Vienna, Kunsthistorisches Museum (Inv. No. 1682).
0.66 × 0.80m
Remarks
The copy omits landscape and still-life details. Semicircular
sections at the upper right and left-hand corners have been
restored.
Provenance
Collection of Archduke Leopold Wilhelm.
Stallburg, 1720.
Imperial Gallery, Vienna.
Inventory Reference
"Ein Stuckh von Öhlfarb auff Holcz, warin der heyl. Jeron-
imus hält seine rechte Handt auf der Brusst vnd die linckhe
auff einem Todtenkopff, vor ihm ein Crucifix, ein offenes
vnndt ein geschlossenes Buech, ein Sandtuhr vnndt ein
Leichter...Von einem vnbekhandten Mahler." (Berger,
"Inventar," No. 274).
Bibliography
Storffer, *Gemaltes Inventarium der Aufstellung der Gemälde-
galerie in der Stallburg,* 1720, III, No. 2 ("Qu. Massais").
C. de Mechel, *Catalogue des Tableaux de la Galerie Impéri-
ale et Royale de Vienne,* Basle, 1784, p. 150, No. 2
(Hemessen).
E. von Engerth, *Gemälde, Kunsthistorisches Sammlungen des
Allerhöchsten Kaiserhauses,* Vienna, 1884, pp. 183–84,
No. 891 (Hemessen).
*Kunsthistorische Sammlungen des Allerhöchsten Kaiser-
hauses, Die Gemälde-Galerie,* Vienna, 1896, p. 209, No.
696 (after Hemessen).
Frimmel, *Wiener Gemäldesammlungen,* II, p. 471, No. 696
(Hemessen).
Graefe, *Hemessen,* p. 46, p. 57 (Hemessen).
Katalog der Gemäldegalerie, Vienna, 1981, pp. 204–05
(Hemessen).

60b. *St. Jerome in his Study,* ca. 1538–40. (Fig. 41)
Private collection, Amsterdam (1942).
1.00 × 1.20m
Remarks
While inferior in quality, this copy gives a better idea of
the composition of the lost original.

61. *Man of Sorrows, Supported by an Angel,* ca. 1538–40.
Present location unknown.
0.52 × 0.56m
Remarks
A partial copy of a lost Hemessen *Man of Sorrows.*
Provenance
Astor (Watney) Sale, Christie's, London, 23 June 1967,
No. 44 (as Colijn de Coter).

62a. *Holy Family,* 1541. (Fig. 103)
Munich, Alte Pinakothek, No. 171 (Neubert, Museum).
0.47 × 0.35m
Signed and dated, on rock at lower left: "IOANNES /DE
HEMES/SEM . P . 1541."
Provenance
Collection of the Elector Maximilian I of Bavaria.
Erlangen Gallery.
Inventory Reference
Inventory of the collection of the Elector Maximilian I of
Bavaria (1628): "Ein Tafel darauf unser liebe Fraw, mit
dem Khindelein, Item S. Joseph und St. Jo. Baptista auch
S. Elisabet, von Johann Hemessen, a° 1541 gemalt ist 4
schuech 8-½ Zoll hoch, 3-½ brait. No. 9." (Reber, *Maxi-
milian I,* p. 40).
Bibliography
G. F. Waagen, *Handbuch der deutschen und niederländischen
Malerschulen,* Stuttgart, 1862, I, p. 306.
*Katalog der Gemälde-Sammlung der Kgl. Älteren Pinakothek
in München,* Munich, 1884, p. 37, No. 171 (692).
Graefe, *Hemessen,* pp. 44–45, p. 56.
Friedländer, *Early Netherlandish Painting,* XII, p. 111,
No. 208 (Hemessen).
Schubert, *Monogrammisten,* pp. 134–35.

62b. *Holy Family,* 1541.
Warsaw, National Museum (Inv. No. 34690).
0.46 × 0.335m
An early copy, on copper.
Inscribed: "Hemessen pinx. 1541."
Provenance
Coll. Mitusow, St. Petersburg.
Coll. Poplawski, St. Petersburg.
Since 1935 in National Museum at Warsaw.
Bibliography
"Uprzednio w zbiorach Mitusowa w Petersburgu," *Staryje Gody,* I, 1915, p. 76.
J. Zarnowski, *Katalog wystawy obrazów ze zbiorów dr. Jana Poplawskiego, Muzeum Narodowe w Warszawie,* Warsaw, 1936, p. 8.
Katalog Galerii Malarstwa Obcego, Warsaw, 1938, No. 110.
J. Bialostocki, *Catalogue, La Peinture Néerlundaise dans les Collections Polonaises, 1450–1550, Musée National de Varsovie,* Warsaw, 1960, No. 29.

62c. *Holy Family,* 1541.
Present location unknown.
1.17 × 0.91m
Provenance
L. Fournier Sale, Muller, Amsterdam, 24 June 1924, No. 88.

63a. *Holy Family in a Rustic Setting,* ca. 1541. (Fig. 104)
Present location unknown.
0.60 × 0.51m
Provenance
Coll. Wedewer, Wiesbaden.
Wedewer Sale, Lepke, Berlin, 26 January 1909, No. 73 (Jan van Scorel).
Exhibition Utrecht, 1913, No. 35.
Binder Collection, Berlin.
Sale Graupe, Berlin, 27–29 May 1935, No. 23 (Hemessen).
Bibliography
Graefe, *Hemessen,* 1909, p. 45 (Hemessen).
Friedländer, *Early Netherlandish Painting,* XII, p. 111, No. 207 (Hemessen).
Schubert, *Monogrammisten,* p. 136, n. 4.

63b. *Holy Family in a Rustic Setting,* ca. 1541.
Present location unknown.
Provenance
Coll. Dr. Rinbelen, Magdeburg.
Bibliography
Friedländer, *Early Netherlandish Painting,* XII, p. 111,
No. 207a (Hemessen).

64. *St. Jerome Writing,* 1545. (Fig. 115)
Hampton Court, Collection of Queen Elizabeth II of England
(Inv. No. 579).
0.99 × 0.99m
Signed and dated, on rock at upper left: "IOANNES/DE .
HEMES/SEN . PINGE/BAT 1545." Old inventory number
"963" at lower left. Mark of Charles I on the reverse.
Provenance
Collection of Charles I.
Sold by Commonwealth, 28 May 1650, to a Mr. King, as
"St. Jerome, done by Quentin."
Collection of James II (No. 882: "St. Jerome sitting with a
lion by him; by Quentin Matsys.").
Exhibited London, 1946–47, No. 164.
Bibliography
Jameson, *A Handbook to the Public Galleries of Art in
and Near London,* London, 1842, II, p. 415, No. 706
(Hemessen).
E. Law, *The Royal Gallery of Hampton Court,* London,
1898, p. 209, No. 579 ("J. van Hemessen?").
L. Cust, "Notes on the pictures in the royal collection,"
Burlington Magazine, May, 1910, pp. 120–23.
Graefe, *Hemessen,* p. 59 (after Hemessen).
Winkler, *Altniederländische Malerei,* p. 297.
C. H. Collins Baker, *Catalogue of the Pictures at Hampton
Court,* Glasgow, 1929, p. 72, No. 579.
Friedländer, *Early Netherlandish Painting,* XII, p. 111,
No. 215 (Hemessen).
Puyvelde, "Nouvelles Oeuvres," p. 58.
Marlier, *Erasme,* p. 208.
Puyvelde, *Peinture Flamande,* p. 184.

65. *Christ Child and Young St. John the Baptist at Play, with
Lamb and Angel,* ca. 1547–50. (Fig. 130)

Present location unknown.

0.58 × 0.61m

Remarks

The panel may be a partial copy of a lost Hemessen *Holy
Family* from 1547 which was in the collection of the Elector
Maximilian I of Bavaria in the seventeenth century. De-
scribed as "khünstlich gemahlt," the panel represented
"unser liebe Fraw St. Elisabeth vnnd St. Joseph, das
Khindlein, mit St. Johann Baptista, vnd einem Engele,
mit einem Lemble scherzendt, von einem Niderlendischen
beruehmbtem Maister, Johann Hemessen genandt a°
1547...No. 12." (Reber, *Maximilian I,* p. 41).

Provenance

Art Dealers Neumann and Salzer, Vienna, 1934.

Art Dealer Hevesey, Vienna, 1937.

Bibliography

St. Poglayen-Neuwall, "Unbekannte Bilder am Wiener Kunst-
markt," *Die Weltkunst,* VIII, 18 November 1934, No. 46,
pp. 1–2 (Hemessen).

Friedländer, *Early Netherlandish Painting,* XII, p. 131,
Supp. 408 (Hemessen).

66a. *Madonna of Humility,* ca. 1553. (Fig. 129)

Wassenaar (The Netherlands), W. J. Geertsema Coll.

1.27 × 0.98m

Provenance

Coll. Pedro Añes, Barcelona (Sale Lepke, Berlin, 1 May
1894, No. 49, as Heemskerck).

Bibliography

Friedländer, *Early Netherlandish Painting,* XII, p. 110,
No. 200 (Hemessen).

66b. *Madonna of Humility.*

Antwerp, Museum (No. 982).

1.40 × 1.09m

Provenance

Donated to the Museum in 1932.

Bibliography

Friedländer, *Early Netherlandish Painting,* XII, p. 110,
No. 200a (copy after Hemessen).

A. J. J. Delen, *Beschrijvende Catalogus, I. Oude Meesters,*

Koninklijk Museum voor Schone Kunsten, Antwerp, 1948, p. 132, No. 982 (old copy after Hemessen).
Beschrijvende Catalogue, Oude Meesten, Koninklijk Museum voor Schone Kunsten, Antwerp, 1959, No. 982.

Notes

Introduction

1. Romanism is a somewhat misleading label, since it implies that the High Renaissance achievements at Rome were the exclusive impetus for this generation of Netherlanders. This was not entirely the case, for Northern Italy continued to exert a spell on transalpine painters, and, after the Sack of Rome in 1527, Fontainebleau became a great center of artistic interest.

2. An excellent chapter on the social and economic transformations at Antwerp can be found in H. Pirenne, *Histoire de Belgique,* Brussels, 1923, III, pp. 218–95.

3. E. Panofsky, *Early Netherlandish Painting.* Cambridge, Mass., 1960, I, pp. 350–54.

4. Panofsky, Ibid., and L. von Baldass, "Gotik und Renaissance im Werke des Quentin Metsys," *Jahrbuch der Kunsthistorischen Sammlungen in Wien,* n.s., VII, 1933, pp. 137ff.

5. K. van Mander, *Het Schilder-Boeck,* Haarlem, 1604, fol. 205r.

6. J. Denucé, *Exportation d'Oeuvres d'Art au 17e Siècle à Anvers, La firme Fouchoudt,* Antwerp, 1930, pp. 84, 108, 115.

7. H. Zimmermann, "Das Inventar der Prager Schatz- und Kunstkammer vom 6. Dezember 1621," *Jahrbuch der Kunsthistorischen Sammlungen des Allerhöchsten Kaiserhauses,* XXV, 1905, Nos. 886, 888, 889, p. xxxix, No. 916, p. xl, No. 1004, p. xli, No. 1008, p. xlii, and No. 1374, p. xlix. For the history of the Prague collections, see Th. von Frimmel, *Geschichte der Wiener Gemäldesammlungen,* Leipzig, 1898, I, pp. 100ff.

8. For the 1648 inventory of works of art pillaged from Prague by the Swedes, see B. Dudik, in *Mittheilungen der k.k. Central-Commission in Wien,* XII, 1867, pp. xxvff, and also O. Granberg, *La Galerie de Tableaux de la Reine Christine de Suède,* Stockholm, 1897, Appendix I, pp. i–xxii. A comprehensive account of Christina's collections can be found in *Christina, Queen of Sweden,* exhibition catalogue, Stockholm, 1966, pp. 416ff.

9. *Infra,* Cat. Nos. 16, 31, 62a and 65, and F. von Reber, *Kurfürst Maximilian I. von Bayern als Gemäldesammler,* Munich, 1892, Nos. 7 and 9, p. 40, No. 12, p. 41, and No. 61, p. 44.

10. *Infra,* Cat. Nos. 20 and 23, and A. Berger, "Inventar der Kunstsammlung der Erzher-

zogs Leopold Wilhelm von Osterreich," *Jahrbuch der Kunsthistorischen Sammlungen des Allerhöchsten Kaiserhauses*, I, Vienna, 1883, No. 308, p. cxxxi, and No. 343, p. cxxxiii.

11. J. Denucé, *Inventare von Kunstsammlungen zu Antwerpen im 16 und 17 Jahrhundert*, Antwerp, 1932, p. 65.

12. G. K. Nagler, *Künstler-Lexikon*, Linz, 1905, VI, pp. 380–81; F. J. Van den Branden, *Geschiedenis der Antwerpsche Schilderschool*, Antwerp, 1883, pp. 98–102; and H. Hymans, "Jan Sanders van Hemessen," *Biographie Nationale de Belgique*, Brussels, 1911–13, XXI, cols. 312–16. Earlier sources such as Sandrart rely on van Mander's brief and inaccurate remarks. (Cf. H.-W. von Löhneysen, *Die ältere niederländische malerei, Künstler und Kritiker*, Eisenach, 1956, pp. 283–85.)

13. M. Rooses, *Flandre*, Paris, 1913, p. 129.

14. G. F. Waagen, *Handbuch der Deutschen und Niederländischen Malerschulen*, Stuttgart, 1862, I, p. 306; J. A. Crowe, *The German, Flemish and Dutch Schools of Painting*, London, 1911, p. 247.

15. G. F. Waagen, *Galleries and Cabinets of Art in Great Britain*, London, 1857, suppl., p. 281. Waagen's poor opinion of Hemessen can be attributed, at least in part, to the lack of clear definition of the artist's *oeuvre* at the time. Along with Rooses and others, he accepted as an original Hemessen an inferior *Calling of St. Matthew* at the Antwerp Museum which bore a false inscription, "Jan van Hemes." (Waagen, *Handbuch*, I, p. 306; M. Rooses, *Geschichte der Malerschulen Antwerpen*, Munich, 1889, pp. 68–69; A. von Wurzbach, *Niederländisches Künstler-Lexikon*, Vienna, 1906, I, p. 675.) The panel actually copies a fine original work by Marinus van Roymerswaele, now at Schloss Rohoncz.

16. W. Friedlaender, *Caravaggio Studies*, New York, 1972, p. 106.

17. C. Blanc, *Histoire des Peintres de Toutes les Ecoles, Ecole Flamande*, Paris, 1868, Appendix, p. 6.

18. L. Gonse, *Les chefs-d'oeuvre des Musées de France, La Peinture*, Paris, 1900, p. 29.

19. A. Michel, *Histoire de l'Art*, Paris, 1912, V, i, pp. 247–48.

20. Panofsky, *Early Netherlandish Painting*, I, pp. 140–44.

21. St. Ignatius Loyola, *The Spiritual Exercises*, transl. A. Mottola, introd. R. W. Gleason, New York, 1964, pp. 67ff.

22. The impact of the early Counter-Reformation on Netherlandish Romanist painters of Hemessen's generation has been almost entirely ignored. Hemessen anticipates important directions of late sixteenth-century painters responding to codified Counter-Reform doctrine.

Chapter 1

1. P. Rombouts and T. van Lerius, eds., *De Liggeren*, Antwerp, 1872, I; A. Pinchart, "Voyage artistique en France et en Suisse en 1865," *Bulletin des Commissions Royales d'Art et d'Archéologie*, VII, Brussels, 1868, pp. 186ff; Van den Branden, *Geschiedenis*. Biographical accounts can be found in: F. Graefe, *Jan Sanders van Hemessen*, Leipzig, 1909, pp. 19–24; H. Hymans, "Jan Sanders van Hemessen," *Biographie Nationale de*

Belgique, Brussels, 1911–13, XXI, cols. 312–16; M. J. Friedländer, *Early Netherlandish Painting,* trans. H. Norden, New York, 1975, XII, pp. 44–49; and L. van Puyvelde, *La Peinture Flamande au Siècle de Bosch et Bruegel,* Paris, 1962, pp. 193–94.

2. Hemessen's earliest dated work is a *Christ and the Adulteress* (Fig. 1) of 1525 that re-emerged on the New York art market in 1970. The last panel with a firm date and signature is the *Expulsion of Merchants and Money-lenders from the Temple* (Fig. 140, Nancy), signed and dated 1556. A date of 1557 has been observed on a much damaged *St. Jerome* in the F. Stimpson Collection, London, but this has not been verified (Fig. 151).

3. G. Vasari, *Le Vite de'più eccelenti Pittori, Scultori ed Architettori,* ed. G. Milanesi, Florence, 1881, VII, p. 583.

4. Works from the collection of Francis I were exhibited at The Louvre in 1972, with an informative catalogue: J. Cox-Rearick, *La Collection de François Ier,* Paris, Musée du Louvre, 1972.

5. Van Mander, *Schilder-Boeck,* fol. 205r. L. Guicciardini, *Description de Tout le Pais Bas,* Antwerp, 1567, p. 132. Van Mander includes Hemessen in a section with artists such as Hans Memling, Gerard David and Lancelot Blondeel, about whom he frankly confesses ignorance. The passage reads as follows: "Tot Haerlem is in vroeghen tÿdt oock gheweest Ian van Hemsen, Borgher van aldaer de welcke een maniere hadde meer treckende nae d'antÿcksche en meer afgheschepden van de moderne: maeckte groote beelden en was in sommighe deelen seer net en curioos. Van hem is een stuck met veel staende Apostelen op Christus, gaende op nae Jerusalem en is te Middelborgh ten huyse van d'Heer Cornelis Monincx, köstliefhebber." ("At Haarlem in earlier times lived the renowned Jan van Hemessen, a burgher of the city, who possessed a style that followed to a great extent the old manner and diverged to a similar degree from the new: he painted large panels and was in various respects highly proficient and unusual. There is a painting by him with a number of apostles and Christ, on the road to Jerusalem, at Middelburgh in the house of the art lover Cornelis Monincx.") The painting owned by Monincx has never been identified.

6. See n. 75, *infra.*

7. Van Mander's sources are discussed by H. E. Greve, *De Bronnen van Carel van Mander voor het Leven der Doorluchtige Nederlandsche en Hoogduytsche Schilders (Quellenstudien zûr hollandischen Kunstgeschichte,* ll), The Hague, 1903.

8. Van den Branden cites a document of 1524 that refers to a Jan Sanders "geseten tot Hemishem...op eene stede met huyse, lande, enz. gestaen ende gelegen te Hemishem, daer men na de kercke gaet." (*Scabinale protocollen der stad Antwerpen,* 1524, sub Keyser & Ballinck, fol. 25) (Van den Branden, *Geschiedenis,* p. 98, n. 1.)

9. For the Brethren's schools, see A. Hyma, *The Christian Renaissance,* Hamden, Conn., 1965, pp. 122–35 and 605–10.

10. *Liggeren,* I, p. 41, p. 93.

11. M. J. Friedländer, "Die Antwerpen Manieristen von 1520," *Jahrbuch der königlichen Preussischen Kunstsammlungen,* XXXVI, 1915, pp. 65–91, and further bibliography cited by G. von der Osten and H. Vey, *Painting and Sculpture in Germany and the Netherlands, 1500 to 1600,* Baltimore, 1969, p. 194, n. 3.

12. For Joos, see Friedländer, *Early Netherlandish Painting,* IX, i, and the recent disserta-

tion by J. O. Hand, *Joos van Cleve: the Early and Mature Paintings,* Ph.D. Diss., Princeton University, 1978.

13. For Massys and Patinir, see A. de Bosque, *Quentin Metsys,* Brussels, 1975, and R. A. Koch, *Joachim Patinir,* Princeton, 1968.

14. Ibid., p. 14.

15. J. D. Farmer, *Bernard van Orley of Brussels,* Ph.D. Diss., Princeton, 1981, pp. 15–17.

16. Ibid., pp. 148–55, with further bibliography.

17. The diary and sketchbook have been published in *Albrecht Dürer, Diary of his Journey to the Netherlands, 1520–21,* introd. J.-A. Goris and G. Marlier, Greenwich, Conn., 1972.

18. Lucas was inscribed as Free Master at Antwerp in 1522. (*Liggeren,* I, p. 99)

19. J. Held, *Dürers Wirkung auf die niederländische Kunst seiner Zeit,* The Hague, 1931. See also the thorough exhibition catalogue, *Albert Dürer aux Pays-Bas,* Palais des Beaux-Arts, Brussels, 1977.

20. Van den Branden, *Geschiedenis,* p. 98, n. 2.

21. *Liggeren,* I, p. 104. He was probably identical with "Hanneken van de Kerchove" apprenticed by Jan Robbrechts in 1528. (*Liggeren,* I, p. 111.)

22. Friedländer and Puyvelde suggest Hemessen was the "Jan de Meyere, scildere" recorded Free Master in 1523. (Friedländer, *Early Netherlandish Painting,* XII, p. 44, and Puyvelde, *Peinture Flamande,* p. 193) There were, however, several other "Jan's" recorded during these years who could also qualify. (Cf. *Liggeren,* I, pp. 94, 96, 102 and 104)

23. Discussed *infra,* chapter 2.

24. Friedländer conjectured that the Master of the Magdalen Legend was Pieter van Coninxloo. (Friedländer, *Early Netherlandish Painting,* XII, p. 16) No documents have yet been found recording Hemessen at Malines. A mention of "une bien petite Nostre-dame de illuminure, de la main de Sandres" in the inventory of the collection of Margaret of Austria (cited by Hymans, *Biographie Nationale de Belgique,* XXI, cols. 314–15) surely refers to the manuscript illuminator Sanders Bening, sometimes identified with the Master of Mary of Burgundy.

25. Three portraits of Margaret painted at Malines when she was a child are documented by payments made to the court artist, Jan Cornelisz Vermeyen. One of these was sent to Pope Clement VII and the second to her father the Emperor, while the third was retained in the collection of her aunt. (J. Houdoy, "Marguerite d'Autriche," *Gazette des Beaux-Arts,* V, 1872, pp. 516–17) Since the document does not indicate that the portraits were specifically by Vermeyen (as it does beside other entries), there is a possibility that they could have been painted by Hemessen in Vermeyen's employ. Hemessen's energetic depictions of the young girl certainly owe a good deal to Vermeyen's lively portraits. For the latter, see O. Benesch, "Jan Vermeyen als Bildnismaler," *Münchner Jahrbuch,* VI, 1929, pp. 204–15.

26. Gossaert is recorded at work on the restoration of some paintings at Malines in 1523. (G. de Boom, *Marguerite d'Autriche-Savoie et la Pré-Renaissance,* Paris, 1935, pp. 144–46, and *Le Siècle de Bruegel,* Brussels, 1963, p. 100) He died in 1532, probably at

Antwerp. (J. Duverger, "Jan Gossaert te Antwerpen," *Bulletin Museum Boymans-van Beuningen,* XIX, 1968, pp. 16–24; and W. S. Gibson, "Jan Gossaert de Mabuse: Madonna and Child in a Landscape," *Bulletin, Cleveland Museum of Art,* LXI, 1974, pp. 287–99.

27. The Italianate school at Malines is discussed by E. Neeffs, *Histoire de la peinture et de la sculpture à Malines,* I–II, Ghent, 1876, and J. Strelka, *Der burgundische Renaissancehof Margarethes von Osterreich und seine literaturhistorische Bedeutung,* Vienna, 1957. Further, bibliography can be found in R. Wellens, *Jacques du Broeucq,* Brussels, 1962, pp. 143–45.

28. Barbari's work at Malines is examined by: P. Bautier, "Jacopo de Barbari et Marguerite d'Autriche," *La Revue d'Art,* XXIV, 1923, pp. 65–89; Boom, *Marguerite d'Autriche,* pp. 143–44; and J. Duverger, "Margareta van Oosterijk (1480–1530) en de Italiaansc Renaissance," in *Relations artistiques entre les Pays-Bas et l'Italie à la Renaissance. Etudes dédiées à Suzanne Sulzberger,* Brussels-Rome, 1980, pp. 127–42. The question of Barbari and the North has recently been examined by J. A. Levenson, *Jacopo de'Barbari and Northern Art of the Early Sixteenth Centry,* Ph.D. Diss., New York University, 1978.

 For Gossaert at Rome, see: J. G. Van Gelder, "Jan Gossaert in Rome, 1508-1509," *Oud Holland,* IL, 1942, pp. 1–11; J. Folie, "Les dessins de Jean Gossaert dit Mabuse," *Gazette des Beaux-Arts,* XXXVIII, 1951, pp. 77–98; and N. Dacos, *Les Peintres Belges à Rome au XVIe Siècle,* Brussels, 1964, pp. 15–21.

29. For Italianate aspects of Orley's work, see Farmer, *Orley,* pp. 123–209.

30. H. Brising, *Quinten Matsys und der Ursprung des Italianismus in der Kunst der Niederlande,* Leipzig, 1908, and S. Sulzberger, "L'influence de Léonard de Vinci et ses Répercussions à Anvers," *Arte Lombarda,* I, 1955, pp. 105–11.

 Hemessen's knowledge of Raphael was perhaps encouraged by an Italian artist who visited the Lowlands, Tommaso Vincidor of Bologna. Sent to the Netherlands in 1520 by Pope Leo X to supervise the weaving of the "second series" of Raphael tapestries, Vincidor also acted as an agent for prints and paintings from Italy. Dürer mentions that he gave Vincidor a set of his prints to send to Rome for him in exchange for "Raphael's work" when he saw him at Antwerp in October, 1520. When they met again at Brussels in July, 1521, Vincidor gave Dürer "an Italian work of art" and sold another to him for a small amount. (*Diary,* pp. 68–69 and 100–03). For this interesting artist, see N. Dacos, "Tommaso Vincidor, un élève de Raphaël aux Pay-Bas," in *Relations artistiques entre les Pays-Bas et l'Italie à la Renaissance. Etudes dédiées à Suzanne Sulzberger,* Brussels-Rome, 1980, pp. 61–99.

31. F. Horb, *Zu Vincent Sellaers Eklektizismus,* Stockholm, 1956.

32. G. J. Hoogewerff, "Vincent Sellaer en zijn Verblijf te Brescia," *Annuaire des Musées Royaux des Beaux-Arts de Belgique,* III, 1940–42, pp. 17–27.

33. Vasari, *Vite,* VII, p. 583.

34. An old photograph of the panel made when it was last seen at Vienna in 1886 (Fig. 21) supports the attribution to Hemessen's early years advanced by Winkler and Antal. For bibl., see Cat. No. 8.

35. Classic discussions of Romanism can be found in M. Dvořak, "Uber die geschichtlichen Voraussetzungen des niederländischen Romanismus," in *Kunstgeschichte als Geistesge-*

schichte, Munich, 1924, pp. 203–15, and F. Antal, "Zum Problem des niederländischen Manierismus," *Kritische Berichte zur Kunstgeschichtlichen Literatur,* V, 1929, pp. 207–56, esp. pp. 236ff. Hemessen's contributions to the movement have been seriously neglected. For some thoughts, see R. Genaille, "J. Massys, J. Hemessen et le Romanisme," in H. Bédarida, *A Travers l'Art Italien,* Paris, 1949, pp. 17–42.

36. See the recent studies of Heemskerck by: I. M. Veldman, *Maarten van Heemskerck and Dutch humanism in the sixteenth century,* Maarssen, 1977; and R. Grosshans, *Maerten van Heemskerck, Die Gemälde,* Berlin, 1980.

37. Perceptive observations on Romanist influences can be found in Dacos, *Peintres Belges.* For documents on Flemish artists working in Italy, see: A. Bertolotti, *Artisti belgi ed olandesi a Roma nei Secoli XVI e XVII,* Florence, 1880; *idem, Giunti agli artisti belgi . . . ,* Rome, 1885; and P. Liebaert, "Artistes Flamands en Italie pendant la Renaissance," *Bulletin de l'Institut historique belge de Rome,* I, 1919, pp. 1–103. Additional comments on Romanism have been published by G. J. Hoogewerff, *Nederlandsche schilders in Italië in de XVIe eeuw,* Utrecht, 1912, and *idem, Vlaamsche Kunst en Italiaansche Renaissance,* Malines, 1935.

38. Both Colyn de Coter and Gerard David worked for a while at Antwerp, Coter in 1493ff and David from 1515 to ca. 1521. Another link with the older generation was Gooswijn van der Weyden, Roger's grandson, who became a citizen of Antwerp in 1498–99 and died there ca. 1538. His work remains largely obscure.

39. Riemenschneider and other German sculptors of the late fifteenth and early sixteenth centuries have been studied by M. Baxandall, *The Limewood Sculptors of Renaissance Germany,* New Haven, 1980.

40. Van Mander, *Schilder-Boeck,* fol. 205r. Van Mander's elliptic prose may reflect a lost poetic description upon which he based his observations.

41. *Liggeren,* I, p. 125.

42. Van den Branden, *Geschiedenis,* p. 99. Doehard mentions two references to Hemessen's father-in-law in his study of Antwerp commerce. (R. Doehard, *Etudes Anversoises, Documents sur le Commerce international à Anvers,* Paris, 1962, p. 270, no. 1864, and p. 272, no. 1870.

43. *Liggeren,* I, p. 130. The problem of the Brunswick Monogrammist and Hemessen's collaborator is discussed *infra,* chapter 8.

44. Van den Branden, *Geschiedenis,* p. 99. Limewood was also a favorite material of German Renaissance wood sculptors. See the informative remarks by Baxandall, *Limewood Sculptors, passim.*

45. Recorded as Free Master in the guild records of 1528, Jacob Cocx (or Jacob de Cock) took on apprentices in 1540 and 1543. (*Liggeren,* I, p. 110, p. 139 and p. 146) The other members of the Guild of St. Luke involved in the heresy affair were Cornelis Bos and Jan and Cornelis Massys. All managed to flee the city before they were tried. (Cf. J. Cuvelier, "La graveur Corneille van den Bosche," *Bulletin de l'Institut historique belge de Rose,* XX, 1939, pp. 5–49) Loists were a libertine cult that attempted to redefine notions of sinful behavior along the lines of the Medieval Albigensians. Their leader, Loy Pruystinck, was arrested and burned at the stake in 1544. (Cf. G. Eekhoud, *Les libertins d'Anvers, légende et histoire des Loistes,* Paris, 1912, and Pirene, *Histoire de Belgique,* III, pp. 358–39)

46. Van den Branden, *Geschiedenis,* p. 99.

47. Antwerp commerce has been studied by J. A. Goris, *Etude sur les colonies marchandes méridionales (Portugais, Espagnols, Italiens) à Anvers de 1488 à 1567,* Louvain, 1925, and H. van der Wee, *The Growth of the Antwerp Market and the European Economy,* I-III, The Hague, 1963.

48. Dürer writes enthusiastically about his visit to Fugger's house during his stay at Antwerp in 1520. (*Diary,* p. 62) For the German financiers, cf. R. Ehrenberg, *Capital and Finance in the Age of the Renaissance,* transl. H. M. Lucas, London, 1928.

49. L. Guicciardini, "Antwerp, the Great Market," transl. J. B. Ross and C. Pennock, in *The Portable Renaissance Reader,* ed. J. B. Ross and M. M. McLaughlin, New York, 1968, p. 189. For Renaissance Antwerp, see L. Voet, *Antwerp, the Golden Age,* Antwerp, 1973, and *idem, De stad Antwerpen van de romeinse tijd tot de 17de eeuw,* Brussels, 1978. The principal history of Antwerp remains: F. Prims, *Geschiedenis van Antweren,* I-XXIX, Antwerp, 1927-48.

50. Op cit., p. 187.

51. J. Denucé, *Antwerp Art-Tapestry and Trade,* Antwerp, 1936, and V. Vazquez de Prada, "Tapisseries et tableaux flamands en Espagne au XVIe Siècle," *Annales (Econ., Sociétés, Civil.),* X, 1955, pp. 37-46.

52. C. C. De Bruin, *De Statenbijbel en zijn Voorgangers,* Leiden, 1937, p. 142, and P. H. Vogel, *Europäische Bibeldrucke des 15. und 16. Jahrhunderts in den Volkssprachen; ein Beitrag zur Bibliographie des Bibeldrucks,* Baden-Baden, 1962, p. 67.

53. *Dat nieuwe Testament,* Antwerp, Martin de Keyser, 1525. As Vogel (Ibid., p. 64) notes, the history of the Netherlandish Bible is extremely complex, and it is often difficult to differentiate between "Lutheran," "Erasmian" or "Catholic" editions,

54. Bruin, *Statenbijbel,* p. 161; Vogel, *Bibeldrucke,* p. 64; and *Nederlandse Bijbels en hun Uitgevers, 1477-1952,* Amsterdam, 1952, p. 9.

55. *Biographie Nationale de Belgique,* Brussels, 1892-93, XII, col. 122.

56. Bruin, *Statenbijbel,* p. 176; Vogel, *Bibeldrucke,* p. 65; and *Nederlandse Bijbels,* p. 9.

57. M. E. Kronenberg, "Uitgaven van Luther in de Nederlanden verschenen tot 1541," *Nederlandsch Archief voor Kerkgeschiedenis,* XL, i, 1953, pp. 23ff. For the early history of the Reformation in the Lowlands, see: J. G. de Hoop Scheffer, *Geschiedenis der Hervorming in Nederland van haar ontstaan tot 1531,* Amsterdam, 1873; J. W. Pont, *Geschiedenis van het Lutheranisme in de Nederlanden tot 1618,* Haarlem, 1911; and L. Knappert, *Het onstaan en de vestiging van het Protestantisme in de Nederlanden,* Utrecht, 1924.

58. *Biographie Nationale de Belgique,* III, Brussels, 1872, cols. 197-99.

59. P. Kalkoff, *Die Anfänge der Gegenreformation in den Niederlanden,* Halle, 1903; *idem,* "Das erste Plakat Karls V gegen die Evangelischen in den Niederlanden," *Archiv für Reformationsgeschichte,* I, 1904, pp. 280ff; and H. Pirenne, *Histoire de Belgique,* Brussels, 1923, III, pp. 346-48.

60. P. Kalkoff, "Das Wormser Edikt in den Niederlanden," *Historische Vierteljahrschrift,* VIII, 1905, pp. 69ff.

61. For Praepositus, or Jacobus Proost, see *Biographie Nationale de Belgique,* XVIII, Brussels, 1905, cols. 282–86.

62. *Anathematizatio et revocatio Jac. Praepositi olim Prioris Fratrum Heremitarum S. Augustini oppidi Antverpiensis,* Antwerp, G. Vorsterman, 1522. For Grapheus' retraction, see P. Fredericq, *Corpus Documentorum Inquisitionis Neerlandicae,* Ghent, 1900, IV, Nos. 74, 83–85, pp. 105ff. Appointed secretary of the city of Antwerp in 1533, Grapheus (De Schryver) was to become the author of a spirited attack on the Anabaptists, published in 1535. (See *infra,* chapter 7) He is best known for his effusive panegyrical descriptions of imperial entries at Antwerp. (J. Landwehr, *Splendid Ceremonies, State Entries and Royal Funerals in the Low Countries, 1515–1791, A Bibliography,* Leiden, 1971, Nos. 5, 8, 13, 23, 24, 25)

63. Cf. the celebrated trial of Bernard van Orley and members of his family at Brussels in 1527. (Fredericq, *Corpus,* V, No. 612, pp. 233–35)

64. The list of participants includes a "Janne, de beeltsnydere" and "Janne, metten ghelde, schildere" who could possibly refer to Hemessen. A master "Adriaen, de schildere" was sentenced to make a pilgrimage to the Holy Blood at Wilsenaken for his lectures on the Bible at these meetings. (Fredericq, *Corpus,* IV, Nos. 200 and 206, pp. 259ff)

65. S. Schéle, *Cornelis Bos,* Stockholm, 1965, and R. Hedicke, *Cornelis Floris und die Florisdekoration,* Berlin, 1913.

66. Cf. J. Loosjes, *De invloed der rederijkers op de hervorming,* Utrecht, 1909; G. R. Kernodle, "Renaissance Artists in the Service of the People," *Art Bulletin,* XXV, 1943, pp. 59ff; W. M. H. Van Hummelen, *De Sinnekens in het rederijkersdrama,* Groningen, 1958; and *idem, Repertorium van het rederijkersdrama, 1500–ca. 1620,* Assen, 1968.

67. Landwehr, *Ceremonies,* Nos. 6–7, pp. 67–68. Cf. *The Writings of Albrecht Dürer,* transl. W. M. Conway, New York, 1958, p. 97.

68. J. Jacquot, *Fêtes et Cérémonies au Temps de Charles-Quint,* in *Les Fêtes de la Renaissance,* Paris, 1960, ii, pp. 458–63; E. J. Roobaert, "De seer wonderlijke...Incompst," *Bulletin des Musées Royaux des Beaux-Arts, Bruxelles,* IX, 1960, pp. 37–74; G. Marlier, *Pierre Coeck d'Alost,* Brussels, 1966, pp. 386–90; and Landwehr, *Ceremonies,* No. 23, pp. 73–75.

69. D. Zuntz, *Frans Floris,* Strasburg, 1929, pp. 3–4, and C. Van de Velde, *Frans Floris (1519/20–1570), Leven en Werken,* Brussels, 1975, I, p. 31 and pp. 164–85, Nos. S 7–33.

70. Bruegel was registered Free Master in the Antwerp guild in 1551. (*Liggeren,* I, p. 170).

71. *Liggeren,* I, pp. 162–63.

72. Pirenne, *Histoire de Belgique,* III, pp. 367–69, and L. E. Halkin, *La Réforme en Belgique sous Charles-Quint,* Brussels, 1957.

73. Halkin, *Réforme,* pp. 67ff.

74. Hemessen's last firmly dated panel is the Nancy *Expulsion of Merchants and Money-lenders from the Temple* (Fig. 140), signed and dated 1556.

75. Van Mander, *Le Livre des Peintres,* transl. and ed. H. Hymans, Paris, 1884–85, I, p. 78. Van den Branden hypothesized that Hemessen moved north after he sold his house, "De Faisant," on December 31, 1550. (Van den Branden, *Geschiedenis,* p. 102). The

Haarlem archives were thoroughly checked for Hemessen's name in the nineteenth century by Entschedé, who found no reference to him. (Cf. A. Pinchart, "Voyage artistique en France et en Suisse en 1865," *Bulletin des Commissions Royales d'Art et d'Archéologie,* VII, 1868, p. 226, n. 1).

De Jongh's eighteenth-century edition of Van Mander contains a woodcut portrait with the following inscription: "Jan vā Hemsen Scilder vā Haĩlem." (K. van Mander, *Het Leven der Schilders,* ed. de Jongh, Amsterdam, 1764, I, Pl. opp. p. 37, Fig. 3). As Hymans observes, "Aucun connaisseur ne peut prendre au sérieux cette grossière supercherie." (Ibid.)

76. Assertions by the "everpatriotic" Van Mander about artists at Haarlem are, in general, not terribly trustworthy. (Cf. Panofsky, *Early Netherlandish Painting,* I, p. 324.)

 The act reads as follows: "Philips, etc. Doen te wetene, allen tegen woirdigen ende toecomende, dat wy ontfangen hebben die oitmoedige supplicatie van Peeter Van Heymessem, schildere, vryegeselle, oudt xxiiii jaeren, inhoudende hoedat wylen Jan Van Heymessem, oock schilder ende poirter onser stadt van Antwerpen, des suppliants vader, gehouwt wesende met eene Barbara de Fevre, desen suppliant heeft gewonnen ende geprocreert aen eene jonghe dochtere oft dienstmeysken genoempt Betteken, ombegrepen huers toenaems, nu eest zoe dat de voirschreven suppliants vader ende moeder deser werelt zyn overleden, wesende die suppliant noch zeer jonck in der vuegen dat hy zyne voirschreve moeder nauwelyck gekent en heeft, is oock warachtich dat hy suppliant van den voerschreven zynen vader ende moeder noyt yet en heeft geprouffiteert, ende en is oyck nyet anders verwachtende dan't ghene hy met zynen zueren arbeyt ende industrie sal mogen prosperen, ende want die voerschreven suppliant die hem metten voerschreven zynder ambachte ende anderssins eerlyck is yeverende ende groote affectie ende begeerte heeft onder ons ende onse protectie te blyven woenen, hem beduchtende is dat als hy tot huwelycken state soude begeren te commen, hem die voerschreven bastardye duerinne grootelyck soude geraken te obsteren om eenige contracten het waere huwelycxe voorweerden, testamente ende anderssins, valide te moegen passeren, nopende zynen geconquesteerde goeden, etc. Gegeven in onser stadt van Antwerpen, in de maent van november, in't jaer Ons Heeren duysent vyff hondert lxxix." (Register No. 649, fol. 187vᵒ, Chambre des Comptes, Archives du Royaume) Quoted from A. Pinchart, *Archives des Arts, Sciences et Lettres, Documents inédits,* Ghent, 1860, I, p. 280.

77. "1552 (n.s.) April 7. 230ᴺᴼ· Ten versuecke van Jan van Hemishem, Schildere. Wouter van der Elsmeer, out 42 jaren, ende Jan van Doren, out 36 jaren, oppidani, juraverunt dat zy wel kennen ende over vele jaren wel gekent hebben den voirscreven Janne van Hemishem, ende dar zy osen wel gekent hebben van joncse of Gillis ende Hanse van Hemishem, desselffs Jan van Hemishem sonen, ende dat zy deponenten, wel weten das de selve Jan van Hemishem ende zyne vorriscreven sonen zyn ingeseten poirters deser stadt ende dat zy verstaen hebben dat de voorscreven Jan van Hemishem in megningen is op morgen se segnden naer Italien dan voorscreven Gielse ende Hanse van Hemishem, zyne sonen, in de geselschape van Hanse van der Rivieren, de welcke omtrent drije jaren den voorscreven Janne van Hemishem gedient heeft in zynen handel van schilderen. Compariut de voorscreven Jan van Hemishem; juravit Haerachtich se zynes gene des by den voorscreven Wouteren van Elsmaer on de Janne van Doren boven verclaert wardt, ende dat zy in megningen is op morgen de voorscreven zyne sonen met zienen dienaer de seynden naer Italien om aldaer se leerene ende se hooren ende se siene. Cert. 7. (1552)." (Transcription by Prof. Buchan)

78. *Liggeren,* I, p. 146, p. 182.

79. *Liggeren,* I, p. 119. Elsmaer became a burgher of Antwerp in 1534.

80. *Liggeren,* I, p. 217, p. 229. Apprentices were enrolled under his name in 1533, 1539, 1540, 1546, 1547, 1556, 1559 and 1560. (*Liggeren,* I, p. 121, p. 135, p. 140, p. 157, p. 160, p. 199, p. 215 and p. 221)

81. *Liggeren,* I, pp. 119–20.

82. This was common practice in the fifteenth century, as Lorne Campbell points out in "The Art Market in the Southern Netherlands in the Fifteenth Century," *Burlington Magazine,* CXVIII, 1976, pp. 196–97.

83. In Plantin's *Thesaurus Theutonicae Linguae* (Antwerp, 1573), "Handel" is defined as "Toute sorte de trafique, affaires ou causes. Res, negotium, actio, pragma." The implication that Hemessen may have been an art dealer was suggested to me by Colin Eisler.

84. Guicciardini, *Description,* p. 134. Vasari, *Vite,* VIII, p. 588.

85. *Siècle de Bruegel,* p. 110.

86. See the exhibition catalogue by A. S. Harris and L. Nochlin, *Women Artists: 1550–1950,* Los Angeles County Museum of Art, New York, 1976, p. 105.

87. Guicciardini, *Description,* p. 134. Cf. Van den Branden, *Geschiedenis,* p. 100, n. 1.

88. C. van den Borren, *Les Origines de la Musique de Clavier dans les Pays-Bas,* Brussels, 1914, pp. 27–28. He was also known as "M. Christierno" or "Maestre Chrestiaen."

89. Guicciardini, *Description,* p. 134.

90. Titian's *Three Ages of Man* left the collection of Giovanni da Castel Bolognese in Faenza ca. 1550 and was acquired by Otto Truchses von Waldburg, Bishop of Augsburg. It is possible that it passed through the Antwerp art market at this time. For observations on the Edinburgh painting and the possibility of other versions of the composition, see G. Robertson, "The X-Ray Examination of Titian's 'Three Ages of Man' in the Bridgewater House Collection," *Burlington Magazine,* CXIII, 1971, pp. 721–26.

91. E. Winternitz, *Musical Instruments and their Symbolism in Western Art,* London, 1967, pp. 202–06. Winternitz mentions the *Patera Martelli* as a possible iconographic source.

92. Ibid.

93. Similarly, a crown of myrtle could be associated with marital faith, since, as Panofsky points out, myrtle was a plant sacred to Venus. (Panofsky, *Studies in Iconology,* New York, 1939, pp. 160–61)

94. C. Ripa, *Iconologia,* Venice, 1645, p. 87.

95. B. Berenson, *Lorenzo Lotto,* London, 1956, pp. 57–58, Figs. 135–36.

96. Ripa, *Iconologia,* p. 588.

97. B. Castiglione, "Music and the Courtier," in *The Courtier,* London, 1561, transl. Sir Thomas Hoby, in *Renaissance Reader,* pp. 424, 429.

98. Panofsky's interpretation of this group of paintings as allegories of the triumph of the sense of sight over hearing makes a philosophical dialectic out of what may well be simply variations on a delightful poetic theme. (E. Panofsky, *Problems in Titian,* New York, 1969, pp. 121ff)

99. I wonder whether Hemessen did not, himself, travel to Spain at this time. There is evidence that at least one member of his workshop did so: the anonymous author of the elaborate *Tendilla Retable,* now at the Cincinnati Art Museum (Figs. 143–44), which was commissioned in memory of Juana the Mad (d. 1555) and Ignatius Loyola (d. 1556) by the fourth Count of Tendilla, Iñigo Lopez de Mendoza, in the late 1550s. Some of the panels are so close to Hemessen's late style that it is likely that the artist may have begun the work and left it incomplete at his death. For more on the *Retable,* see *infra,* chapter 10.

Chapter 2

1. H. Hymans, in van Mander, *Le livre des Peintres,* Paris, 1885, II, p. 354; Friedländer, *Early Netherlandish Painting,* XII, p. 109, No. 189; and O. Fischel, *Sammlung Han Coray,* Berlin, 1930, No. 56.

2. *Dizionario di Abbreviature Latine ed Italiane,* ed. A. Cappelli, Milan, 1954, p. 423. (The author is indebted to Lee Martone for this reference.)

3. Cf. examples in Baxandall, *Limewood Sculptors,* Pls. 23, 34, 38, 93 and 94.

4. Friedländer, *Early Netherlandish Painting,* VIII, p. 66.

5. *Siècle de Bruegel,* p. 111, No. 129. Attributed to Hemessen by Friedländer, the *Descent* may be identical with a panel owned by the Forchoudt firm in the seventeenth century and described as, "Afdoeningh van den Cruyse met ebbenhout lyst van Jan Hemmisen originael curieus en fraey gemaeckt." (Denucé, *Forchoudt,* p. 108).

6. The triptych by the Master of the Legend of St. Catharine is illustrated by Friedländer, *Early Netherlandish Painting,* IV, No. 51, Pl. 55. For the presumed derivation from Roger, see Friedländer, "Der Meister der Katharinen-Legende und Rogier van der Weyden," *Oud-Holland,* LXIV, 1949, pp. 156–61. Cf. also the miniature of the subject in the *Très Riches Heures* of the Duke of Berry.

 For Gossaert's Leningrad *Deposition,* see J. Maréchal, "La Chapelle fondée par Pedro de Salamanca, bourgeois de Burgos, chez les Augustins à Bruges, 1513–1805," *Académie Royale de Belgique, Classe des Beaux-Art, Mémoires,* XIII, No. 2, Brussels, 1963, pp. 12–15. Gossaert also painted a large triptych of the subject for the Praemonstratensian Abbey at Middelburg ca. 1515–20, but this was destroyed in the iconoclastic outbreaks of 1568.

7. The prints are discussed in two valuable exhibition catalogues: *Drawings and Prints of the First Maniera, 1515–1535,* Museum of Art, Rhode Island School of Design, Providence, 1973, pp. 90 and 99–100; and I. H. Shoemaker, *The Engravings of Marcantonio Raimondi,* Spencer Museum of Art, Lawrence, Kansas, 1981, No. 50.

8. For Blondeel, see Friedländer, *Early Netherlandish Painting,* XI, pp. 62–65, 101, 107.

9. E. Panofsky, *Tomb Sculpture,* New York, 1964, pp. 78ff. Connections between Meit and Gossaert are discussed by G. von der Osten, "Studien zu Jan Gossaert," in *De Artibus Opuscula XL, Essays in Honor of Erwin Panofsky,* ed. M. Meiss, New York, 1961, pp. 454–75, and H. R. Weihrauch, *Europäische Bronzestatuetten des 15.–18. Jahrhunderts,* Brunswick, 1967, p. 461. Meit was recently the subject of a Ph.D. dissertation by Constance Lowenthal, *Conrat Meit,* New York University, 1980.

10. L. Reis-Santos, *Masterpieces of Flemish Painting of the Fifteenth and Sixteenth Centuries in Portugal,* Lisbon, 1962, No. 67, pp. 111–12.

11. *Siècle de Bruegel,* No. 115, pp. 106–07.

12. R. A. Koch, "Rediscovered painting by Petrus Christus: Madonna and Child in a Gothic Interior," *Connoisseur,* CXL, 1958, pp. 217–76.

13. Panofsky, *Early Netherlandish Painting,* I, p. 70.

14. J. Bialostocki, "Leonardo i Nederlandczycy," *Biuletyn Historii Sztuki,* XVII, 1955, pp. 369–70, and *idem,* "Poznánskie Leonardianum, Vwagi o Madonnie Quentina Massysa w Muzeum Naradowyn w Poznaniu," *Studia Muzealne,* II, 1957, pp. 112–50.

15. *Collection de François Ier,* No. 12F, pp. 15–16.

16. F. Winkler, *Die Altniederländische Malerei,* Berlin, 1924, p. 297.

17. Cf. J. Pešina, "An unknown painting by Quentin Massys," *Art Bulletin,* XLVIII, 1966, pp. 406–08, and examples by Orley in Friedländer, *Early Netherlandish Painting,* VII, Nos. 130–31, Pl. 114.

18. *Primitifs flamands anonymes,* exhibition catalogue, Bruges, 1969, No. 76, pp. 146–47, and pp. 276–77.

19. A good discussion of the Magdalen Master and bibliography can be found in Ibid., pp. 130–50, and pp. 262–81. Cf. also Friedländer, *Early Netherlandish Painting,* XII, 1975, pp. 13–17, and p. 133.

20. B. Wallen, "The Portraits of Jan Sanders van Hemessen," *Oud-Holland,* LXXVI, 1971, pp. 77–80.

21. *Siècle de Bruegel,* No. 113, pp. 105–06. The melancholic mood of the children can be explained by the recent death of their mother Isabella of Austria, sister of Charles V, in 1526.

22. S. A. van Lennep, *Les Années Italiennes de Marguerite d'Autriche, Duchesse de Parme,* Geneva, 1952, pp. 11–13.

23. For this master, see *Siècle de Bruegel,* Nos. 243–46, pp. 170–72, and R. A. Koch, *Joachim Patinir,* Princeton, 1968, pp. 56–65. I fail to agree with Haverkamp-Begemann's reading of the Berlin and Worcester panels as types rather than portraits. Though the features of the girl relate stylistically to other female figures by Hemessen, there are enough individual characteristics to warrant classing them as portraits. (E. Haverkamp-Begemann, in *European Paintings in the Collection of the Worcester Art Museum,* Worcester, Mass., 1974, p. 175)

24. Cf. *supra,* n. 25, chapter 1.

25. The attribution to Vermeyen was advanced by Benesch and Glück in the 1920s but was later dropped in literature on the artist. Most authorities such as Ring, Friedländer, Puyvelde and Wescher have correctly attributed the Berlin and Worcester portraits to Jan van Hemessen. Schubert's recent attempt to assign them to the Brunswick Monogrammist is misguided, as are a number of his attributions. For bibliography on these works, see Cat. Nos. 6 and 7.

26. Winkler, *Altniederländische Malerei,* p. 297. Cf. also P. Wescher, "Einige neue Bilder zum Werk Jan van Hemessens," *Belvedere,* VIII, 1929, p. 39, and Antal, "Manierismus," p. 242, n. 5. Antal remarked on the panel: "in welcher der Sarto-Stil in eine dem Bronzino-Kreis ähnliche, plastische Malweise umgesetzt ist, des Nachweis, dass Hemessen selbst in Florenz gewesen ist."

27. A drawing at Amsterdam after the Adam and Eve from Peruzzi's fresco at the Cancelleria at Rome may possibly be a Hemessen, though extensive seventeenth-century reworkings by Rubens make it difficult to pinpoint the original hand. It is certain, however, that the author was not Pieter Coecke van Aelst, whose name was inscribed on the drawing by Rubens. (Cf. Marlier, *Coeck,* p. 303)

28. Schubert's idea that the Mainz *Pietà* was an original creation of the Monogrammist is unacceptable. The static drapery folds and numerous repetitive, lifeless details make it clear that this is a copy. The landscape background may well have been altered by the Monogrammist. (D. Schubert, *Die Gemälde des Braunschweiger Monogrammisten,* Cologne, 1970, pp. 77ff)

29. Réau, *Iconographie,* II, pp. 1007–10.

30. This was first suggested by E. Michel, "Un triptyque de Van Hemessen dans la collection O'Campo," *Beaux-Arts, Revue d'information,* VI, 1928, pp. 67–69.

31. Perhaps Hemessen knew of the album of drawings by Barbari ("Jacob's little book") that Dürer admired when he visited the court of Margaret of Austria in June of 1521.

32. *Infra,* chapter 8.

Chapter 3

1. Erasmus, *Omnia Operum Divi Eusebii Hieronymi Stridonensis,* Basle, Froben, 1516. For the *Vita,* see J. Coppens, "Le Portrait de Saint Jérome d'après Erasme," in *Colloquia Erasmiana Turonensia,* I, ii, Tours, 1969, pp. 821–28.

2. Epistle 9. Quoted in José de Sigüenza, *The Life of Saint Jerome,* London, 1907, transl. M. Monteiro, p. 159.

3. For the popular theme of St. Jerome in his study, see: M. Meiss, "French and Italian Variations on an Early Fifteenth-Century Theme: St. Jerome and his Study," *Gazette des Beaux-Arts,* LXII, 1963, pp. 147–70; O. Pächt, "Zur Entstehung des 'Hieronymus im Gehäus'," *Pantheon,* XXI, 1963, pp. 131–42; and M. Meiss, "Scholarship and Penitence in the Early Renaissance: the Image of St. Jerome," *Pantheon,* XXXII, 1974, pp. 134–40. Cf. also the remarks on the iconography of St. Jerome in *Bibliotheca Sanctorum,* Rome, 1965, VI, cols. 1132–37.

4. P. A. Orlandi and P. Guarienti, *Abecedario Pittorico,* Venice, 1753, p. 248.

5. The impact of the *Laocoön* on Michelangelo has recently been examined by E. Pogány-Balás, *The Influence of Rome's Antique Monumental Sculptures on the Great Masters of the Renaissance,* Budapest, 1980.

6. I. H. Shoemaker, *The Engravings of Marcantonio Raimondi,* exhibition catalogue, Spencer Museum of Art, Lawrence, Kansas, 1981, No. 66.

7. Torrigiano was living in Antwerp in 1509 when he was summoned by the Regent to Brussels to restore a sculpture in her collection. He subsequently followed her to Bruges to discuss "aucunes choses," presumably her plans for the tombs at Brou. He took the occasion to show her a statue of Hercules that he had probably been working on at Antwerp. The following year he was again called to Bruges. (Cf. C. Cochin, "Pietro Torrigiani en Flandre," *Revue de l'art ancien et moderne,* XXXVI, 1914–19, pp. 177–81.)

8. For anatomical studies in general, see L. Price Amerson, "Marco d'Agate's S. Bartolomeo," in *Congreso internazionale, Milano, Museo della Scienza e della Tecnica, 1968,* I–II, Milan, 1969. See the thoughts by M. Haraszti-Takács, "Compositions de nus et leurs modèles. Etudes sur la conception de la nature et sur la représentation de la figure humaine dans la peinture des maniéristes nordiques," *Bulletin du Musée Hongrois des Beaux-Arts,* XXX, 1967, pp. 49ff.

9. Bosch depicted the *Penitent St. Jerome* in the central panel of his altarpiece, now at the Palazzo Ducale in Venice, and in the right wing of the *Job Altarpiece* (Bruges, Groeningemuseum). See Friedländer, *Early Netherlandish Painting,* V, No. 98, Pl. 86, and Suppl. 136, Pl. 118. Patinir's *Triptych with Penitence of St. Jerome* has been studied by Koch, *Patinir,* pp. 16–18, 35–36, 45–46.

10. S. Herzog, "Gossaert, Italy and the National Gallery's Saint Jerome Penitent," *National Gallery of Art, Report and Studies in the History of Art, 1969,* Washington, 1970, pp. 59–73.

11. Behling notes the occurrence of this medicinal herb in Hugo van der Goes' *Adoration of the Shepherds* (Berlin), where it forecasts the sorrows of the Virgin. (L. Behling, *Die Pflanze in der mittelalterlichen Tafelmalerei,* Weimar, 1957, p. 64) I would like to thank Prof. Robert Koch for identifying the plant and suggesting this reference.

12. The presumed influence of the Savoldo on the 1531 Hemessen *St. Jerome* would argue for an earlier dating for the former, which has been placed as late as 1540. Hemessen's theatrical gesture can be compared with other Italian models like Leonardo's moody interpretation of the saint or the expressive painting for the Arezzo Cathedral by Bartolomeo della Gatta, much admired by Vasari. (Cf. T. S. R. Boase, *Giorgio Vasari, The Man and the Book,* Princeton, 1979, Fig. 106, p. 169.)

13. T. N. Tentler, *Sin and Confession on the Eve of the Reformation,* Princeton, 1977, p. 354, and n. 11. Tentler's brilliant study revises the conclusions of Henry C. Lea in his classic, *A History of Auricular Confession and Indulgences in the Latin Church,* I–III, Philadelphia, 1896.

14. Tentler, *Sin and Confession,* pp. 356–59. Luther's position on penance is unequivocally stated in his "testament" of 1537, the "Articles of Schmalkalden." See H. Volz, ed., *Urkunden und Aktenstücke zur Geschichte von Martin Luthers Schmalkaldischen Artikeln (1536–1574),* Berlin, 1957.

15. Loyola was particularly taken by the hirsute Saint Onuphrius, depicted by Hemessen in the triptych now in the O'Campo Collection at the Petit Palais (Fig. 24). Cf. J. Brodrick, *Saint Ignatius Loyola, The Pilgrim Years, 1491–1538,* New York, 1956, p. 70.

16. *Monumenta Historica Societatis Jesu, Fontes narrativi,* I, p. 360.

17. Sigüenza, *Life,* p. 159.

18. Ibid., p. 158.

19. Ibid., p. 247.

20. Quoted from Brodrick, *Pilgrim Years,* pp. 226–27. See also S. Rose, *St. Ignatius Loyola and the Early Jesuits,* London, 1891, pp. 139ff.

21. The panel was seen by Pellegrino Antonio Orlandi and Pietro Guarienti in Portugal in the mid-eighteenth century. At that time it was owned by Silva Télès, Master of the Verderers to King John V.

22. A precedent for the depiction of a Renaissance theologian in the guise of St. Jerome can be seen in the portrait of Albrecht of Brandenburg by Lucas Cranach. (Cf. E. Wind, "Studies in Allegorical Portraiture I," *Journal of the Warburg and Courtauld Institutes,* 1, 1937–38, pp. 152–53.) The pose traces back to Leonardo's lost *Leda* (ca. 1504–10), a favorite work among northern artists in the collection of Francis I.

23. A.-M. Albareda, *Sant Ignasi a Montserrat,* Montserrat, 1935; J. Leclercq, "St. Ignatius at Montserrat," in *Aspects of Monasticism,* transl. M. Dodd, Kalamazoo, 1978, pp. 295–307; and M. Purcell, *The First Jesuit, St. Ignatius Loyola (1491–1556),* Chicago, 1981, pp. 57–73. Discussions of the history and legends of Montserrat can be found in: F. Pablo Verrié, *Montserrat,* Madrid, 1950, and A. M. Albareda, *Historia de Montserrat,* Montserrat, 1972. The shrine was popularly regarded in medieval German lore as the location of the chalice of the Holy Grail. A Spanish study of the shrine was written around 1514 by Pedro de Burgos and published in 1536/37 (or possibly earlier): *Libro de la historia y milagros, hechos a inuocacion de nuestra Señora de Montserrate.* (Cf. C. Baraut, "Un ejemplar desconocido de la historia y milagros de nuestra Señora de Montserrat de Pedro de Burgos," *Gutenberg-Jahrbuch,* 1958, pp. 139–42.)

24. Held, *Dürers Wirkung,* pp. 87, 139–40. See also the recent discussion in *Albert Dürer aux Pays-Bas,* exhibition catalogue, Palais des Beaux-Arts, Brussels, 1977, Nos. 51 and 341. Local copies and variants are listed by W. S. Gibson, "Jan Gossaert de Mabuse: Madonna and Child in a Landscape," *Bulletin, Cleveland Museum of Art,* LXI, 1974, n. 30, p. 298.

25. Further discussion of the Monogrammist can be found *infra,* chapter 8.

26. Formerly in an English private collection at Bournemouth, the panel was acquired by the Rockoxhuis in 1966 from Leo van Puyvelde, who mistakenly considered it as the Hemessen original that was formerly in the Rockox collection. (Puyvelde, "Nouvelles oeuvres," p. 62). Comparison with the depiction of the Hemessen in the Francken reveals significant differences. The Augsburg Master inscribed his copy with a false signature. "IOES DE/HEMESSEN/PINXIT." Perhaps originally German, the Augsburg Master has been studied in a good article by D. Schubert, "Eine Zweite 'Sintflut' vom 'Meister des Augsburger Ecco Homo'," *Wallraf-Richartz-Jahrbuch,* XXXIII, 1971, pp. 321–28. Schubert agrees with the opinion of this author concerning the panel.

27. *Albert Dürer aux Pays-Bas,* No. 341.

28. J. Hand, *Joos van Cleve and the Saint Jerome in the Norton Gallery and School of Art,* Palm Beach, 1972, perceptively analyzes the problems connected with the painting.

29. The character of the Monogrammist's large-figure style has unfortunately been muddled by Schubert's confused opinion of this aspect of the master's work. (D. Schubert, *Braunschweiger Monogrammisten, passim*)

30. E.g., the panel at the Princeton University Art Museum illustrated by Hand, *Jerome,* Fig. 5.

31. The Emperor's retirement was examined in a classic work by W. Stirling-Maxwell, *The Cloister Life of the Emperor Charles V,* London, 1891. For the Hieronymite Order in Spain, see J. de Sigüenza, *Historia de la Orden de san Jéronimo,* I–II, Madrid, 1907–09. Philip II continued to favor the Hieronymites and founded the Escorial among the order. (G. Kubler, *Building the Escorial,* Princeton, 1982, *passim*)

Chapter 4

1. I would like to thank the Earl of Crawford and Balcarres for inviting me to Balcarres to examine the painting. My initial findings on the double-portrait were published in "Portraits," pp. 75–76.

2. While the board-game is similar to modern backgammon, it should properly be called "tables," a term that was always used until the seventeenth century. There were numerous other varieties of tables in the Middle Ages, as H. J. R. Murray notes in his comprehensive study, *A History of Board-Games other than Chess,* Oxford, 1952, pp. 117ff. In ML the game was called *ludus tabularum* (or *tabulae*), in MF *tables,* MHG *wurfzabel,* MDu *worptafel* (or *werptafel*), Ger. *brettspiel.* The onomatopoetic French *trictrac* became popular in the sixteenth century and is employed today in Dutch (*triktrak*).

3. L. Campbell, "A double-portrait by Memlinc," *Connoisseur,* CXCIV, 1977, pp. 187–89.

4. Campbell cites several instances of double-portraits occurring in fifteenth-century tapestries. (Ibid., p. 188) Cf. also J. C. Hutchison, "The Development of the Double Portrait in Northern European Painting of the Fifteenth Century," M.A. Thesis, Oberlin College, 1958.

5. Illustrated in Seward, *Prince of the Renaissance, The Golden Life of François I,* New York, 1973, Col. Pl. opp. p. 18.

6. H. J. R. Murray, *A History of Chess,* Oxford, 1969, esp. pp. 740ff. (The quote can be found in n. 62, p. 440)

7. L. M. C. Randall, *Images in the Margins of Gothic Manuscripts,* Berkeley, 1966, p. 18, Figs. 102 and 104. Cf. a similar scene in a fifteenth-century *Jeu d'Echecs* ms. at the B.N. (MS fr. 9342). Murray illustrates an illumination depicting Otto IV, Margrave of Brandenburg (1266–1308) and a Lady pointing towards their chess board (*Chess,* Pl. opp. p. 394; The Manesse ms. Heidelberg, Universitätsbibliothek)

8. Murray, *Chess,* p. 435.

9. For more on *discordia concors,* see E. Wind, *Pagan Mysteries of the Renaissance,* New York, 1968, *passim.* As Wind points out, Pico defines "harmony in discord" as the basis of Pulchritudo: "...la contrarietà unita, e la discordia concorde, il che si può per vera definizione assignare di essa bellezza, cioè che non sia altro che una amica inimicizia e una concorde discordia." (*Commento,* II, vi, quoted in Ibid., p. 78)

10. M. Praz, *Conversation Pieces,* University Park, Penna., 1971, Fig. 18 and p. 51.

11. Ibid., Fig. 19. Cf. also R. Longhi, "Indicazioni per Sofonisba Anguissola," *Paragone,* no. 157, 1963, pp. 50–52, and the exhibition catalogue, *Women Artists, 1550–1950,* Los Angeles County Museum of Art, New York, 1976, pp. 106–08.

12. Murray, *Chess,* pp. 496ff.

13. Ibid., n. 63, p. 440.

14. Murray, *Board-Games,* p. 119. There were various efforts by church authorities in France to restrict tables in the thirteenth and fourteenth centuries. Murray notes that tables were still classed with *inhonesti ludi* at Bologna until the end of the fifteenth century.

15. Illustrated in "Brettspiel," *Reallexikon zur Deutschen Kunstgeschichte,* II, Fig. 2, cols. 1151–52. The theme of Psychomachia has been studied by A. Katzenellenbogen, *Allegories of the Virtues and Vices in Medieval Art from early Christian Times to the Thirteenth Century,* New York, 1964.

16. Murray, *Chess,* p. 554. Cf. Schröder, *Der goldene Spiel von Meister Ingold,* Strassburg, 1892. The author has sometimes been identified as Johannes Ingold of Surburg, d. 1465.

17. "Psittacum loquaciorem fieri putat, si vinum biberit." (A. Alciati, *Emblemata,* Padua, 1621, p. 133) The expression derives from Aristotle, *De Nat. Anim.,* lib. 8.

18. Murray, *Chess,* p. 529.

19. H. C. Agrippa von Nettesheim, *La Philosophie Occulte,* Paris, 1910, Book II, chap. xiv, p. 270.

20. Murray points out that the life of the unrepentant sinner is compared with a game of chess in *Renart le nouvel,* ll. 5904–32. (Murray, *Chess,* p. 749) Illuminated manuscripts sometimes show human beings playing board-games with Death or the Devil.

21. For the parrot, see E. K. J. Reznicek, "De Reconstructie van 't'Altaer S. Lucas' van Maerten van Heemskerck," *Oud Holland,* LXX, 1955, pp. 233ff. Moral dualities were popular in sixteenth-century Netherlandish use of disguised symbols.

22. E. de Jongh, "Grape Symbolism in paintings of the 16th and 17th centuries," *Simiolus,* VII, 1974, pp. 182–87.

Chapter 5

1. R. Genaille, *De Jérôme Bosch à Pierre Bruegel. La vie populaire et l'art des anciens Pays-Bas au XVIe siècle,* Paris, 1949, pp. 226ff. G. Marlier, *Erasme et la peinture flamande de son temps,* Damme, 1954; R. Völker, *Die Entwicklung des erzählenden Halbfigurenbildes in den niederländischen Malerei des 15. und 16. Jahrhunderts,* Ph.D. Diss., Göttingen, 1968.

 For Aertsen and his talented pupil, Beuckelaer, see K. P. F. Moxey, *Pieter Aertsen, Joachim Beuckelaer, and the Rise of Secular Painting in the Context of the Reformation,* New York, 1977 (reprint of Ph.D. dissertation, University of Chicago, 1974); idem, "The 'Humanist' Market Scenes of Joachim Beuckelaer: Moralizing Exempla or 'Slices of Life'? *Jaarboek van het Koninklijk Museum voor Schone Kunsten,* Antwerpen, 1976, pp. 109–87; and R. Wallen, "Joachim Beuckelaer's *Poultry Sellers,*" *Museum News, The Toledo Museum of Art,* 1979, pp. 33–39.

2. The use of an airy loggia as a setting for the inn scene of the Parable can be noted in an engraving by Hans Sebald Beham (B. VIII. 235. 182).

3. The Giulio is illustrated in F. Hartt, *Giulio Romano,* New Haven, 1958, II, Fig. 91. For the *Adoration* for Philip de Nevers, see *Catalogue, Flemish Schools,* Royal Academy, London, 1953–54, No. 60 (erroneously attributed to Gossaert). A much earlier northern prototype for the startled cat can be found in the *Birth of John the Baptist* miniature of the Turin Hours (ca. 1420–24), often attributed to Jan van Eyck.

4. A small tondo attributed to Pieter Cornelisz, now at the Basle Kunstmuseum. (Schubert, *Monogrammisten,* fig. 32) Marlier identifies a drawing at Rotterdam by Pieter Coecke (dated 1529) as the inn scene from the parable. (Marlier, *Coeck,* pp. 89–90)

Schubert's hypothesis that the Monogrammist may have done a painting of the subject ca. 1530 remains unsubstantiated.

5. K. Renger, *Lockere Gesellschaft,* Berlin, 1970, pp. 34ff. In addition, see F. Spengler, *Der verlorene Sohn im Drama des 16. Jahrhunderts,* Innsbruck, 1888.

6. P. Verdier, "The Tapestry of the Prodigal Son," *Journal of the Walters Art Gallery,* XVIII, 1955, pp. 9–58. This study was kindly called to my attention by Prof. Richard Helgerson. The tapestry was earlier discussed by J. Destrée, *Tapisseries et sculptures Bruxelloises à l'exposition d'art ancien Bruxellois,* Brussels, 1906, pp. 8–9, 21–22, and H. Comstock, "The Satterwhite Collection of Gothic and Renaissance Art," *The Connoisseur,* CXXVIII, 1951, pp. 132–36.

7. Verdier, "Tapestry," p. 26 and n. 59, p. 53. For the *Courtois d'Arras,* see A. Pauphilet, *Jeux et Sapience du Moyen Age,* Paris, 1943, pp. 107–32; P. Groult, "Le Drame biblique dans *Courtois d'Arras,*" *Mélanges Gustave Cohen,* Paris, 1950, pp. 47–53; and G. Frank, *The Medieval French Drama,* Oxford, 1954, pp. 211ff.

8. Verdier, "Tapestry," p. 51, n. 52. Cf. also *L'Homme pécheur,* performed at Tours before 1494. Flemish representations of the Parable are recorded to have been staged at Dendermonde in 1420 and at the Entry of Philip the Good into Ghent in 1458.

9. Ed. L. Banfi, *Sacre Rappresentazioni de Quattrocento,* Turin, 1963, pp. 265–323. Cf. R. Warwick Bond, *Early Plays from the Italian,* Oxford, 1911, pp. xciiff.

10. The importance of *Acolastus* was stressed by Marlier, *Coeck,* pp. 89–90. The role of the play in the history of Netherlandish literature is discussed by: Vocht, *History,* I, pp. 220–21; J. F. M. Kat, *De Verloren Zoon als letterkundig motief,* Bussum, 1952; and H. A. Enno van Gelder, *Erasmus, Schilders en Rederijkers,* Groningen, 1959, pp. 39–41, 44, 51. Spengler (*Verlorene Sohn,* pp. 2–11) posits a lost Latin prototype that influenced Gnapheus as well as Burkard Waldis, who published a Low German Prodigal Son play at Riga in 1527 (*Parabell vam vorlorn Szohn*). A Netherlandish prodigal son play deriving from Gnapheus, *De verloren sone,* was published at Antwerp in 1540 by Willem Vorsterman. (Cf. W. M. H. Van Hummelen, *Repertorium van het rederijkersdrama, 1500–ca. 1620,* Assen, 1968, p. 272.)

11. William Gnapheus, *Acolastus,* Berlin, 1891, Act II, scenes 3–5, Act III, scenes 4–5, and Act IV, scene 5.

12. The object he wears on his back has not been identified. It may be a case for a musical instrument, or perhaps the smooth-surfaced pack carried by the gambling *oblieman* (pastry seller), a popular figure in Netherlandish art of the sixteenth century. (A. J. Bernet Kempers, "De speler met de ronde bus," *Oud-Holland,* LXXXVII, 1973, pp. 240–42; *idem,* "De Oblieman, Metamorfosen van een Koekjesverkoper," *Volkskunde,* LXXIV, 1973, pp. 1–43; and Renger, *Lockere Gesellschaft.*

13. *L'Ecole de Fontainebleau,* exhibition catalogue, Grand Palais, Paris, 1972, No. 246.

14. Verdier, "Prodigal Son," p. 25.

15. R. de Houdenc, *Le Songe d'Enfer, suivi de la Voie de Paradis,* ed. P. Lebesgue, Geneva, 1974. Cf. M. W. Bloomfield, *The Seven Deadly Sins,* Ann Arbor, Mich., 1952, pp. 132–36 and 162–63.

16. The Vices are shown in *Psychomachia* confrontations with the Virtues in the tapestry. (Verdier, "Prodigal Son," p. 12 and n. 14, p. 47)

17. Traditionally associated with Lust, the bagpiper appears in the Louisville tapestry, where he is labelled *Affectio Seculi.* (Ibid., p. 26 and Fig. 3)

18. For the primacy of Pride as a root sin among patristic writers, see: Bloomfield, *Deadly Sins, passim*; R. Payne, *Hubris: A Study of Pride,* New York, 1960; and S. M. Lyman, *The Seven Deadly Sins: Society and Evil,* New York, 1978, pp. 135ff. Excesses of dress were castigated as manifestations of Superbia by Alanus de Insulis in *De Planctu Naturae (On the Complaint of Nature),* VII, 5–66.

19. The allegorical motif is discussed by D. W. Robertson, Jr., *A Preface to Chaucer. Studies in Medieval Perspectives,* Princeton, 1963, pp. 207–08, and J. V. Fleming, *The Roman de la Rose, A Study in Allegory and Iconography,* Princeton, 1969, pp. 33–34.

20. R. Tuve, *Allegorical Imagery,* Princeton, 1966.

21. Robertson, *Preface to Chaucer,* and, more recently, *idem, Essays in Medieval Culture,* Princeton, 1980, pp. xviii–xix. The development of humor in Italian Renaissance art has been investigated in an outstanding study by P. Barolsky, *Infinite Jest: Wit and Humor in Italian Renaissance Art,* Columbia, Mo., 1978.

22. Pliny, *Natural History,* XXXV, xxxvi, 98, transl. H. Rackham, Loeb Classical Library, IX, pp. 332–35.

23. M. Barasch, "Character and Physiognomy: Bocchi on Donatello's *St. George,* A Renaissance Text on Expression in Art," *Journal of the History of Ideas,* XXXVI, 1975, pp. 413–30, esp. pp. 417–19.

24. M. Baxandall, *Giotto and the Orators,* Oxford, 1971, pp. 121ff, and Barasch, "Character," p. 417, n. 17.

25. Ibid., p. 424, n. 36, with further bibl.

26. As Barasch notes, Leonardo affirms in his *Treatise on Painting* "that the face shows some indication of the nature of men, their vices and complexions." (Ibid., p. 425) Even earlier than Francesco Bocchi's treatise on Donatello's *St. George* (written in 1571), Laurent Joubert stressed the importance of the face for artists in his *Treatise on Laughter* (1560): "Also, art, which imitates nature, does not concern itself with the other parts when it wishes to represent or scale down a person. One is content to paint or sculpt the face as the total or principal mark of this individual. This is not, however, the origin of the common expression "One reads the man in his face," for it is necessary to understand this correctly as meaning the affections and the manners. As for the affections, we have shown that they are very noticeable in the face. This is why St. Jerome very aptly said that the face is the mirror of one's thoughts, for very often without one's saying a word the eyes reveal the secret and confer what is hidden." (L. Joubert, *Treatise on Laughter,* transl. and ed. G. de Rocher, University, Ala., 1980, p. 8)

27. Barasch, "Character," pp. 426–27. Cf. also P. Meller, "Physiognomical Theory in Renaissance Heroic Portraits," in *The Renaissance and Mannerism, Studies in Western Art, Acts of the Twentieth International Congress of the History of Art,* Princeton, 1963, II, pp. 53–69.

28. Pomponius Gauricus, *De Sculptura,* ed. and transl. A. Chastel and R. Klein, Geneva, 1969, pp. 129–63, and comments in the introduction, pp. 115–27.

29. Barasch, "Character," pp. 428–29, with further bibl.

30. Gauricus, *De Sculptura,* pp. 148-49.

31. Ibid., pp. 146-47.

32. E.g., the *De Physiognomia* by an anonymous Latin writer that was known through numerous medieval manuscripts and published at Lyons by Jean de Tournes in 1549. This is available in a recent French translation by J. André, *Anonyme Latin, Traité de Physiognomonie,* Paris, 1981, esp. pp. 80-81.

33. Gauricus, *De Sculptura,* pp. 148-49.

34. Joubert, *Laughter,* p. 55. Cf. for Joubert's fascinating treatise, G. de Rocher, "Le Rire au temps de la Renaissance: Le *Traité du Ris* de Laurent Joubert," *Revue Belge de Philologie et d'Histoire,* LVI, 1978, pp. 629-40.

35. Ibid. Sixteenth-century views on laughter are discussed by M. A. Screech and R. Calder, "Some Renaissance Attitudes to Laughter," in *Humanism in France,* ed. A. H. T. Levi, London, 1970, pp. 216-28.

36. The visual rhetoric of Leonardo's *Last Supper* inspired Pieter Coecke's well-known group of paintings of the subject from ca. 1525-35. Leonardo's (and Raphael's) influence can be detected earlier at Antwerp in a striking stained-glass *Last Supper* window at the Antwerp Cathedral attributed to Nicolas Rombouts of Brussels. The window supposedly dates from 1503, though this seems too early for its authoritative assimilation of High Renaissance figure types. Commissioned by Engelbert II of Nassau, the *Last Judgment* window anticipates Hemessen's bold, animated groupings of monumental figures. For good reproductions, see J. Helbig, *Les Vitraux de la première moitié du XVIe siècle conservés en Belgique,* in *Corpus Vitrearum Medii Aevi, Belgique,* II, Brussels, 1968, No. 2, pp. 36-51.

37. Transl. from R. H. Bainton, *Erasmus of Christendom,* New York, 1969, p. 147.

38. For this seminal allegorical adventure, see Tuve, *Allegorical Imagery,* pp. 145ff.

39. Deguilleville's colorful personifications of Vices inspired a visual tradition in late medieval manuscript illumination. (Ibid.) They later became the basis for Spenser's "Pageant of the Seven Deadly Sins" in *The Faerie Queene.* (Cf. S. C. Chew, "Spenser's Pageant of the Seven Deadly Sins," in *Studies in Art and Literature for Belle da Costa Greene,* Princeton, 1954, pp. 37-54.)

40. Verdier, "Prodigal Son," p.25.

41. Ibid., p. 35.

42. See the basic study of this literary *topos* by K. Goedeke, *Everyman, Homulus und Hekastus,* Hannover, 1865. *Elckerlijc* won a prize when it was performed at an Antwerp *Landjuweel* in 1485. There is a good English translation by A. J. Barnouw, *The Mirror of Salvation, A Moral Play of Everyman, ca. 1490,* The Hague, 1971.

43. Ed. J. Bolte, *Drei Schauspiele vom Sterbenden Menschen,* Leipzig, 1927.

44. A good examination of Macropedius was written by T. W. Best, *Macropedius,* New York, 1972, pp. 110ff. All of the Everyman treatments feature the intervention of Death at a crucial moment in the story. In Macropedius, Death is presaged by physical pain as well as by the intervention of a tutelary character, Nomodidascalus ("teacher of law"), sent as a messenger of God.

45. E. de Jongh, "Erotica in vogelperspectief," *Simiolus,* III, 1968-69, pp. 22-74.

46. In German, "Löffel" was proverbial for a lustful old fool. (Cf. examples cited by C. D. Andersson, *Popular Lore and Imagery in the Drawings of Urs Graf (ca. 1485-1529),* Ph.D. dissertation, Stanford University, 1977, pp. 126-27.)

47. The Albigensians abstained from them for that reason. (Cf. M.-H. Vicaire, *Saint Dominic and his Times,* transl. K. Pond, New York, 1964, p. 49.) The conical object on the table—probably a sweet pastry—is also not without erotic reference.

48. L. M. C. Randall, "A Medieval Slander," *Art Bulletin,* XLII, 1960, p. 38. (Quoted from P. J. Harrebomée, *Spreekwoordenboek der Nederlandsche Taal,* Utrecht, 1858, I, p. 176.)

49. Best, *Macropedius,* p. 117.

50. A lazy dog is interpreted as an emblem of *Acedia* in I. L. Zupnick, "Bosch's Representation of Acedia and the Pilgrimage of Everyman," *Nederlands Kunsthistorisch Jaarboek,* XIX, 1968, p. 123. In Bosch's depiction of *Acedia* in the *Table of the Seven Deadly Sins* (Madrid, Prado), a merchant naps in front of a hearth with a dog curled up asleep at his feet. The woman eating in bed is probably being slothful as well as gluttonous. Cf. a similar figure in Bruegel's print of *Acedia* (V.B. 126, M. 136).

51. Probably not a mirror, as formerly thought. Fortune iconography is critical for an understanding of the Rotterdam tondo. Cf. my comments on the panel in P. S. Beagle, *The Garden of Earthly Delights,* New York and London, 1982, p. 65.

52. The symbolic "Y" is discussed in a thorough scholarly study by W. Harms, *Homo Viator in Bivio,* Munich, 1970. It is likely that in Hemessen the "Y" also makes reference to the horns of the Devil.

53. For the concept of *metanoia,* see H. Pohlmann, *Die Metanoia als Zentralbegriff der christlichen Frömmigkeit,* Leipzig, 1938.

54. See the scholarly examination of the subject of *Ars moriendi* by Sister M. C. O'Connor, *The Art of Dying Well,* New York, 1966. The illustrations are discussed by H. Zerner, "L'art au morier," *Revue de l'Art,* No. 11, 1971, pp. 7-30.

55. The best treatment of the event is by P. Brachin, "La 'Fête de Rhétorique' de Gand (1539)," in *Fêtes et Cérémonies au Temps de Charles V,* ed. J. Jacquot, Paris, 1960, pp. 256-85. Cf. also: J. van Mierlo, in *Geschiedenis van de Letterkunde der Nederlanden,* II, pp. 366-69; and G. J. Steenbergen, *Het Landjuweel van de Rederijkers,* Louvain, 1951, pp. 41ff, 70ff.

56. Brachin, "Fête," p. 260.

57. Modern edition by L. M. van Dis and B. H. Erné, *De Spelen van Zinne vertoond op het Landjuweel te Gent van 12-23 Juni 1539,* Groningen, 1939.

58. Close ties between the Rederijkers and artists at Antwerp can be assumed since the Violieren were members of the St. Luke's Guild. As Brachin points out, most of the *spelen van sinne* contained "figures," presumably *tableaux vivants,* paintings or sculptures. (Brachin, "Fête," p. 262)

59. Ibid., p. 266.

60. Ibid., p. 276.

61. The decrees of Charles V that took effect on 4 October 1540 are recorded in a rare pamphlet published in German: *Ordnung, Statuten, und Edict, Keiser Karols des fünften, publicirt in der namhafften Stat Brüssel,* Brussels, 1540.

62. Brachin, "Fête," pp. 276-77.

63. Ibid., p. 270. See also the article by G. Degroote, "Erasmus en de Rederijkers van de 16de eeuw," *Revue Belge de Philologie et d'Histoire,* 1951, pp. 1047-55. The Antwerp *spel* is discussed by G. J. Steenbergen, "Het Spel der Violieren op het Gentse 'Landjuweel', *Jaarboek, Kamer van Rhetorica van Vlaanderen "De Fonteyne",* 1946-47, pp. 15-26. For reformist elements of *Rederijker* drama, see L. M. van Dis, *Reformatorische Rederijkersspelen uit de eerste helft van de Zestiende Eeuw,* Haarlem, 1937.

64. Rector of the Latin school at The Hague in 1520, Gnapheus was imprisoned twice for "Lutheran" leanings. After his second release in 1530 he fled to Elbing, Königsberg and Norden. (J. G. de Hoop Scheffer, *Geschiedenis der Kerkhervorming in Nederland,* Amsterdam, 1873, *passim*)

65. Dogs were also symbols of Envy. Cf. Bloomfield, *Deadly Sins,* pp. 130, 181, 231, 246 and 422, n. 283. Renaissance descriptions of the Vice normally contain this attribute. (E.g., F. Picinelli, *Mundus Symbolicus,* Cologne, 1694, I, p. 358, and C. Ripa, *Iconologia,* Padua, 1611, p. 262)

66. Jongh, "Erotica in vogelperspectief," pp. 22-74.

67. This and related proverbs are discussed by A. Taylor, *The Proverb and an Index,* Hatboro, Penna., 1962, p. 199. The fable of the monkey taking hold of a cat's paw to grab chestnuts from the fire was also very well known. (L. Röhrich, *Lexikon der sprichwörtlichen Redensarten,* I, 1973, pp. 488-90, "Kastanie.")

68. For a sleeping figure as a symbol of Sloth, see E. Panofsky, *The Life and Art of Albrecht Dürer,* Princeton, 1955, p. 71, and the examples cited by M. M. Kahr, "Vermeer's Girl Asleep, A Moral Emblem," *Metropolitan Museum Journal,* VI, 1972, pp. 115-32.

69. Renger, *Lockere Gesellschaft,* pp. 120ff.

70. Ibid., pp. 42ff, with a good discussion of the reckless "sorgheloos" *topos.*

71. E. Power, *Medieval Women,* Cambridge, 1975, pp. 28-31.

72. The witchcraft persecutions are explored in an excellent analysis by H. Kamen, *The Iron Century, Social Change in Europe, 1550-1660,* New York, 1972, pp. 239-51. See also H. R. Trevor-Roper, *The European Witch-Craze of the 16th and 17th Centuries,* New York, 1969.

73. Transl. M. Summers, from *Witchcraft in Europe, 1100-1700, A Documentary History,* ed. A. C. Kors and E. Peters, Philadelphia, 1972, p. 127.

74. *Mariken van Nieumeghen,* Antwerp, Willem Vorsterman, ca. 1518, and *Mary of Nemmegen,* Antwerp, J. van Doesborch, ca. 1518. Further bibliography on the play is given by: L. de Bruyn, *Woman and the Devil in Sixteenth-Century Literature,* Tisbury, Wiltshire, 1979, p. 4, no. 3; J. J. Mak, *De Rederijkers,* Amsterdam, 1944, pp. 165-66; and G. Knuvelder, *Handboek tot de Geschiedenis der Nederlandse Letterkunde,* 's-Hertogenbosch, 1967, I, p. 279, n. 2.

75. *A Marvelous History of Mary of Nimmegen,* transl. H. M. Ayres, introd. A. J. Barnouw, The Hague, 1924, p. 31.

76. Ibid., p. 39.

77. Vorsterman's Bible was illustrated with woodcuts by Jan Swart van Groningen, identified in these pages as the Master of the Hemessen Backgrounds. (See *infra,* chapter 8.)

78. This was observed by Ayres and Barnouw in the introduction to the facsimile reproduction of *Mary of Nimmegen,* Cambridge, Mass., 1932, p. 3.

79. A copy of the *Tearful Bride* bearing the inscription, "JOHANNES DE HEM/ESSEN/ PINGEB(AT) 1540," sold at Christie's in 1935 and 1936. This is considerably inferior to the Prague version, which is certainly by the hand of the artist, even though it is not signed. The existence of an inscribed studio copy indicates that there may have been an earlier version by Hemessen.

80. K. Renger, "Tränen in der Hochzeitsnach," in *Festschrift für Otto von Simson zum 65. Geburtstag,* Berlin, 1977, pp. 310–27. Renger's article confirmed a hypothesis about the meaning of the panel I had made earlier in my Ph.D. dissertation on Hemessen (New York University, 1976).

81. Ibid., p. 311. The Dutch reads: "Nu schreyt de bruyt, nochtans ick wedde,/ Sy sal weder lachen, als sy is te bedde."

82. The *Tearful Bride* measures 0.52 × 0.62 m, the *Bagpiper and Merry Wife* 0.45 × 0.655 m. Originally the dimensions were even closer, since the *Bagpiper* has been cut down somewhat at top and bottom, and the *Tearful Bride* was evidently reduced a few centimeters at the right. The *Bagpiper and Merry Wife* was part of the booty from Rudolph II's collection taken from Prague to Sweden by the victorious Queen Christina. Nothing is known about the early provenance of the *Tearful Bride.* It first emerged on the London art market between the wars and went from there to Prague.

83. A plate of cherries occurs in the *Ship of Fools* (Paris, Louvre) and the *Luxuria* scene of the *Table of the Seven Deadly Sins* (Madrid, Prado), and the fruit also occurs throughout the *Garden of Earthly Delights.* Cf. also the cherries in a print of *Lovers by a Fountain* by Master b × g, presumably after a lost work of the Housebook Master. (J. C. Hutchison, *The Master of the Housebook,* New York, 1972, Pl. 16c) Cherries are sometimes found in marriage paintings, where they symbolize the heavenly fruit of Paradise. (E.g., the *Portrait of the Artist and his Wife* by the Master of Frankfurt [Antwerp] and another marriage picture [Cleveland] cited by Behling, which shows a pair of newlyweds in front of blooming cherry trees. Behling, *Pflanze,* p. 77, Pl. LXXXVI)

84. Bloomfield, *Deadly Sins,* pp. 71ff.

85. A. G. Stewart, *Unequal Lovers,* New York, 1977.

86. Renger, "Tränen," p. 311. Quoted from L. Maeterlinck, *Le genre satirique dans la peinture flamande,* Brussels, 1907, p. 271.

87. Psychological implications of the *Tearful Bride* have been perceptively analyzed by G. Schiff, "Lachen, Weinen und Lächeln in der Kunst," in *Sachlichkeit, Festschrift zum achtzigsten Geburtstag von Helmuth Plessner,* Opladen, 1974, pp. 145–46.

88. J. A. Emmens, "'Eins aber ist nötig'—zu Inhalt und Bedeutung von Markt- und Küchenstücken des 16. Jahrhunderts," in *Album Amicorum J. G. van Gelder,* The Hague, 1973, pp. 93–101.

89. Friedländer attributed several studies of this sort to Massys, including a *Laughing Man* (Amsterdam, art market, 1930) and *Bagpiper* (Dortmund, Heinrich Becker Coll.), the

latter evidently personifying Gluttony. (Friedländer, *Early Netherlandish Painting,* VII, Fig. 55, and Fig. Add. 191) Hemessen was possibly familiar with Massys' *Ugly Duchess* (London, National Gallery), who may be a procuress. The *Tearful Bride* anticipates a series of expressive male heads attributed to Bruegel, thought to personify the passions as the Deadly Sins. (*Siècle de Bruegel,* Nos. 47–49, pp. 68–69, Figs. 196–98. Cf. G. van Camp, "Nouvelles acquisitions aux Musées Royaux des Beaux-Arts de Belgique," *Les Art Plastiques,* n.v., 1950, pp. 389–91, and *idem,* "Pierre Bruegel a-t-il peint une série des sept Péchés capitaux?," *Revue belge d'archéologie et d'histoire de l'art,* XXIII, 1954, pp. 217–23.

Chapter 6

1. Cf. the conversion of Zacchaeus in Luke 19:1–10.

2. Saint Jerome, *Commentaire sur S. Matthieu,* transl. E. Bonnard, Paris, 1977, Bk. 1, ll. 49–51, pp. 170–71 (*Sources Chrétiennes,* No. 242).

3. St. Chrysostom, *Homilies on the Gospel of St. Matthew,* in *A Select Library of the Nicene and Post-Nicene Fathers of the Christian Church,* ed. P. Schaff, Grand Rapids, Mich., 1969, X, pp. 199–201.

4. Erasmus, *Paraphrasis in Evang. Lucae,* Ch. V, in *Opera Omnia,* Leiden, 1706, VII, col. 341.

5. Transl. N. Udall, *The First Tome...of the Paraphrase of Erasmus upon the Newe Testamente,* London, 1549, fol. 58 v° (spelling modernized).

6. Erasmus, *Paraphrasis in Evang. Matthaei,* Ch. IX, in *Opera Omnia,* Leiden, 1706, VII, col. 54. Transl. Udall, *Paraphrase,* 1549, fol. 39 v°. The source for the simile is St. Jerome, who speaks of the attraction of amber for straws (presumably when it is rubbed, through static electricity). (Jerome, *Commentaire,* Bk. 1, ll. 60–63, pp. 170–71)

7. Friedländer, *Early Netherlandish Painting,* XII, Nos. 158–59. Grace Vlam points out that the subject had occurred earlier in Italian painting, but she neglects its common appearance in Matthew pages of Northern Books of Hours, like the *Bedford Hours* (BM, MS. Add. 18850, fol. 22r°), Bodleian Ms. Canon. liturg. 43, fol. 13r° (Hours for Bourges use), or Pierpont Morgan Library, Heineman Coll., H.5, fol. 10v° (Hours, Paris, ca. 1495–1500). (G. A. H. Vlam, "The Calling of Saint Matthew in Sixteenth-Century Flemish Painting," *Art Bulletin,* LIX, 1977, p. 561)

 Closely relating to Marinus' versions of the *Calling* is a painting of the subject at the National Museum, Warsaw. The panel should be attributed to a younger artist whose highly individualistic style drew both from Roymerswaele and Hemessen, perhaps the Master of the Augsburg *Ecce Homo.* (M. Roethlisberger, "A Propos d'un tableau du cercle Reymerswaele et Hemessen," *Bulletin du Musée National de Varsovie,* VII, 1966, pp. 65–67)

8. Groote's conversion is described by T. P. van Zijl, *Gerard Groote, Ascetic and Reformer,* Washington, D.C., 1963, pp. 72–116, and R. R. Post, *The Modern Devotion,* Leiden, 1968, p. 184. Groote was familiar with Chrysostom's *Super Mattheum,* which he had copied for him in Prague.

9. Thomas à Kempis, *The Imitation of Christ,* transl. R. Knox and M. Oakley, New York, 1960, p. 17.

10. R. H. Bainton, *Erasmus of Christendom,* New York, 1969, pp. 9–10.

11. D. Fenlon, *Heresy and Obedience in Tridentine Italy: Cardinal Pole and the Counter Reformation,* Cambridge, 1972, p. 3, and J. K. McConica, *English Humanists and Reformation Politics,* Oxford, 1965, p. 15.

12. Ibid., p. 16.

13. *The Enchiridion of Erasmus,* transl. and ed. R. Himelick, Bloomington, Ind., 1963, p. 94. Inspiring Dürer's memorable engraving of 1513, the *Knight, Death and the Devil,* the *Enchiridion* had a profound impact on Christian thought. (E. Panofsky, *The Life and Art of Albrecht Dürer,* Princeton, 1955, pp. 151–52) The handbook took a militant stance towards the "snares" and "strategems" of the Devil, which were to be overcome by "the impenetrable shield of faith." Foremost among the armaments of the Christian knight was a true understanding of Scripture, especially the New Testament, for that was the way to achieve a true understanding of Christ. The return *ad fontes* — to the Bible and the writings of the Church Fathers — was a major preoccupation of the humanist's career. Erasmus' monumental translation of the New Testament from Greek into Latin applied the most advanced methodology and scholarship to the text of the Gospels. Published in a bilingual edition by Froben at Basle in March of 1516, the Erasmian translation became a model for numerous vernacular editions of the Bible. Erasmus furthered his goal of making the sacred word available to "the famer, the tailor, the mason, prostitutes, pimps and Turks" by writing his extensive *Paraphrases of the New Testament.* These laymen's guides to the Scriptures were also rapidly translated from Latin into vernacular tongues. (For Erasmus and the Bible, see Bainton, *Erasmus,* pp. 129–50.)

14. R. de Roover, *Money, Banking and Credit in Mediaeval Bruges,* Cambridge, Mass., 1948, p. 201. Cf. F. Donnet, *Coup d'oeil sur l'histoire financière d'Anvers au cours des siècles,* Antwerp, 1927, p. 33.

15. Roover, *Banking,* p. 349, and R. H. Tawney, *Religion and the Rise of Capitalism,* London, 1933, pp. 72–76. See also the more detailed studies by J. A. Van Houtte, "La genèse du grand marché internationale d'Anvers à la fin du Moyen Age," *Revue belge de philologie et d'histoire,* XIX, 1940, and *idem,* "Anvers aux XVe et XVIe siècles, Expansion et apogée," *Annales, E. S. C.,* XVI, 1961.

16. In 1530, a group of fourteen Parisian jurists issued an opinion which questioned the legality of financial speculation at Antwerp from the point of view of canon law. (R. Ehrenberg, *Capital and Finance in the Age of the Renaissance, A Study of the Fuggers and their Connections,* transl. H. M. Lucas, London, 1928, p. 242)

17. Ibid., pp. 236–38.

18. Ibid., pp. 244–45.

19. The passage from Leviticus concerning just weights and balances was originally painted on the frame of Quentin Massys' *Banker and his Wife* of 1514 (Paris, Louvre).

20. For these works by Roymerswaele, see the bibliography cited in Friedländer, *Early Netherlandish Painting,* XII, p. 136, and also Roover, *Money,* pp. 200–02, and Vlam, "Calling," p. 566.

21. Vlam fails to recognize this essential fact in her discussion of the painting (Ibid., pp. 566–68).

22. C. Eisler, *Paintings from the Samuel H. Kress Collection, European Schools, Excluding Italian,* Oxford, 1977. No. K1848, pp. 66–69. Alfred Moir posits the influence of *The Card Players* from Holbein's *Dance of Death* upon the two figures at the left in Carvaggio's *Calling of St. Matthew.* (A. Moir, *Caravaggio,* New York, 1982, p. 92, and Fig. 30) It is more likely that Caravaggio had seen one of the versions of Hemessen's late *Calling* (Fig. 70), which contain the specific figure of the youth counting coins, as well as the implication of mortality.

23. *Hecastus* and *Mercator* are published in a modern edition edited by J. Bolte, along with a Munich play of 1510 dealing with a similar subject. (*Drei Schauspiele vom Sterbenden Menschen,* Leipzig, 1927)

24. As in the *Portrait of Anton Fugger* at the Allentown Art Museum. (Eisler, *Kress Collection,* No. K1886, pp. 35–36, and Fig. 3)

25. Ehrenberg, *Fuggers,* p. 151.

26. Ibid.

27. Ibid., p. 152.

28. Tucher cleverly placed the blame on his backers. As an observer reported in July of 1529, "He [Tucher] now stands very well, but much is said behind his back. Financing the Court has profited him and destroyed others." (Ibid., p. 154)

29. The Italian financier Gaspar Ducci of Pistoia was also involved in a number of suspect activities at Antwerp. He succeeded Lazarus Tucher as chief financial agent for the Netherlands Government in the 1540s. (Ibid., pp. 222–26) That Hemessen's money-broker may refer to a specific individual is suggested by the seal ring prominently worn on his index finger, which contains the initials "A V D" (?).

30. Transl. Udall, *Paraphrase,* 1549, fol. 39 v°.

31. Réau, *Iconographie,* III, ii, p. 928. The theme of apostolic conversion was chosen by the Fuggers for their large stained-glass window installed in 1537 at the Antwerp Cathedral, though the saint in this case was not Matthew but Paul. Executed in a remarkably turbulent High Renaissance manner, the window was the work of the Antwerp stained-glass master Robbrecht van Ollim, a contemporary of Hemessen who had obtained master status in the St. Luke's Guild in 1521. Anton Fugger and his nephew Jan Jakob kneel piously below the scene of Paul falling from his horse. For this important Romanist work, see: J. Strieder, "Das Fuggerfenster in der Kathedrale van Antwerpen," *Der Belfried,* II, 1917–18, pp. 241–44; N. Lieb, *Die Fugger und die Kunst,* Munich, 1958, pp. 275–77; and J. Helbig, *Les Vitraux de la Première Moitié du XVIe Siècle Conservés en Belgique, Province d'Anvers et Flandres,* in *Corpus Vitrearum Medii Aevi (Addenda), Belgique,* II, Brussels, 1968, No. 5, pp. 67–74.

32. The Varese *Madonna* also seems to have influenced the Romanist painter Vincent Sellaer, who spent a number of years at Brescia. (G. J. Hoogewerff, "Vincent Sellaer en zijn Verblijf te Brescia," *Annuaire des Musées Royaux des Beaux-Arts de Belgique,* III, 1940–42, pp. 19–20)

33. Traditionally represented as a despondent blindfolded woman with a crown falling from her head, the figure of Synagogue derives from Lamentations 5:15–17, "The joy of our heart is ceased; our dance is turned into mourning. / The crown is fallen from our head; woe unto us, that we have sinned! / For this our heart is faint; for these things our eyes are dim." (E. Panofsky, "Blind Cupid," in *Studies in Iconology,* New York, 1962, p.

111) A statue of Synagogue is portrayed next to Matthew in the *Rohan Hours* (BN MS Lat. 9471, fol. 21 r°).

34. M. Barasch, *Gestures of Despair,* New York, 1976. Cf. also L. Röhrich, "Die Hände über dem Kopf zusammenschlagen," under "Hand," in *Lexikon der sprichwörtlichen Redensarten,* Freiburg, 1973, I, p. 381.

35. The reproductive etching by Fantuzzi (illustrated) dates from ca. 1542-44.

36. For the strongbox as a sign of greed, see R. Tuve, *Allegorical Imagery,* Princeton, 1966, p. 178. Eisler would see an eschatological reference in the lock on the treasure chest in Bosch's *Death and the Miser* (Eisler, *Kress Collection,* p. 68 and n. 24, p. 69).

37. When told that her grandson was born on St. Matthew's day, Queen Isabella of Castile is reported to have said, "This will be the lucky one."

38. K. Brandi, *The Emperor Charles V,* transl. C. V. Wedgwood, London, 1939, pp. 426-35.

39. At Charles' Entry into Bruges in 1515, for instance, the city mounted an impressive series of structures and *tableaux vivants* designed to persuade the young prince to help restore its declining commercial prosperity. The final one showed Charles helping to right Bruges' Wheel of Fortune, next to an Old Testament scene of the prophet Nehemiah pleading with King Ataxerxes to rebuild the crumbling city of Jerusalem. (S. Anglo, *La Tryumphante Entree de Charles Prince des Espagnes en Bruges 1515,* New York, 1971)

40. Ehrenberg, *Fuggers,* pp. 95-96.

41. H. Jedin, *A History of the Council of Trent,* transl. E. Graf, St. Louis, 1957, I, pp. 355-409.

42. *Erasmus and the Seamless Coat of Jesus; De Sarcienda Ecclesiae Concordia (On Restoring the Unity of the Church),* transl. and ed. R. Himelick, Lafayette, Ind., 1971. Not one of the humanist's finest efforts, the treatise was soon forgotten after the Council of Trent.

43. Pole defended the unity of the church in his lengthy admonishment to Henry VIII following his break with Rome, the *Pro ecclesiasticae unitatis defensione,* or *De unitate,* completed in 1536. (*Pole's Defense of the Unity of Church,* transl. J. G. Dwyer, Westminster, Maryland, 1965) For the general support of reconciliation among the humanists, see R. Stupperich, *Der Humanismus und die Wiedervereinigung der Konfessionen,* Leipzig, 1936. The best discussion of Regensburg can be found in P. Matheson, *Cardinal Contarini at Regensburg,* Oxford, 1972.

44. Christian connotations of "Plus Ultra" were frequently exploited in decorations for Charles' entries. (E. Rosenthal, "*Plus ultra, non plus ultra,* and the columnar device of Emperor Charles V," *Journal of the Warburg and Courtauld Institutes,* XXXIV, 1971, pp. 204-28, esp. p. 222, n. 79. Cf. also M. Bataillon, "Plus Oultre: La Cour Découvre le Nouveau Monde," in *Fêtes et Cérémonies au Temps de Charles Quint,* ed. J. Jacquot, Paris, 1960, pp. 13-27.

45. Matheson, *Contarini,* pp. 45-46, and Fenlon, *Heresy and Obedience,* pp. 14-18.

46. Ibid., pp. 48-49. It is possible that in the *Calling of St. Matthew* Hemessen was searching for an iconographical formula that would combine the Catholic doctrine of penance with the Protestant emphasis on personal faith. The reconciliation of faith and penance

was not only a preoccupation of the reform movement within the church led by Conta-
rini and Pole. Martin Luther had also given increased importance to repentance in his
*Instructions for the Visitors of Parish Pastors in Electoral Saxony (Unterricht der Visi-
tatoren an die Pfarhern im Kurfurstenthum zu Sachssen,* Wittemberg, 1528), though he
continued to separate penance and law (now defined as "common faith") from "justify-
ing faith." (*Luther's Works,* XL, *Church and Ministry,* ii, ed. C. Bergendorff, Philadel-
phia, 1958, pp. 263–320. Cf. the interesting discussion of the treatise by C. Harbison,
*The Last Judgment in Sixteenth Century Northern Europe: A Study of the Relation
Betwen Art and the Reformation,* New York, 1976 [Garland dissertation reprint], pp.
99–100.)

47. Walter Friedlaender's remark in his essay on Caravaggio's *Calling* that Hemessen's treat-
ment was "merely. . .a pretext for coarse carousing" shows a lack of understanding of
the gestural vocabulary of this highly emotive Mannerist work. (W. Friedlaender,
Caravaggio Studies, New York, 1972, p. 106) Expressing the apostolic zeal of Jesuit
preaching, Hemessen's late *Calling of St. Matthew* should be regarded as a work of the
militant Counter-Reformation, unlike Caravaggio's quiescent and naturalistic late six-
teenth-century treatment. The copy at the Metropolitan Museum of Art (Cat. No. 33d)
is sometimes mistakenly called a Hemessen original, in spite of its obvious deficiencies
when compared to the Vienna panel.

48. Loyola, *Spiritual Exercises,* transl. Mottola, p. 68. Though Loyola disclaimed any influ-
ence from Erasmus' *Enchiridion,* the rule that "Christ must be our only goal" is echoed
constantly in the *Exercises.* (J. C. Olin, "Erasmus and St. Ignatius Loyola," in *Luther
Erasmus and the Reformation,* ed. Olin, et al., New York, 1969, pp. 118–19) Loyola
had, to be sure, drawn great inspiration from the *Imitation of Christ* during his years of
penitence at Manresa. (M. Purcell, *The First Jesuit, St. Ignatius Loyola [1491–1556],*
Chicago, 1981, p. 67) Vlam's interpretation of the *Calling* as a predominantly Lutheran
theme ignores its importance for the Netherlandish *devotio moderna,* transmitted to the
Jesuits through the *Imitation* and probably also the *Enchiridion.* (Vlam, "Calling,"
passim)

Chapter 7

1. A Hemessen *St. Jerome* was recorded in the inventory of Nicholas Rockox's collection
compiled in 1640. (J. Denucé, *Les Galeries d'Art à Anvers aux 16e et 17e siècles, Inven-
taire,* The Hague, 1932, p. 88.) The painting appears in a cabinet picture of the Rockox
collection by Frans Francken II, now at Munich. (S. Speth-Holterhoff, *Les Peintres
Flamands de Cabinets d'Amateurs au XVIIe Siècle,* Brussels, 1956, Fig. 24).
A workshop copy of the lost *St. Jerome* by the Master of the Augsburg *Ecce Homo* is
now at the Rockoxhuis at Antwerp, where it is erroneously labelled as the original
Hemessen (Fig. 40; cf. *supra,* chapter 3, n. 26.

2. In 1536, Adrien Rockox would have been 76 (b. 1469–d. 1540) and his sons 26 (Jean, b.
1510), 22 (Nicholas, b. 1514) and 11 (Adrien, b. 1525). (A. J. Wauters, "Les deux Josse
van Cleve," *L'Art Flamand et Hollandais,* VII, 1907, pp. 64–66)

3. Puyvelde and de Coo assume, mistakenly, that Anna was still alive when the painting
was done since she is not "marquée de la croix par laquelle on désignait habituellement
un défunt." (Puyvelde, *Peinture Flamande,* p. 189, and J. de Coo, "Een oud en merk-
waardig Familieportret," *Album van de Bond der Kroostrijke Gezinnen,* Brussels, 1954,
n.p.)

4. Réau, *Iconographie*, III, i, pp. 23-24.

5. J. B. Descamps, *Voyage pittoresque de la Flandre et du Brabant*, Paris, 1769, p. 176, and Sir Joshua Reynolds, *A Journey to Flanders and Holland in the Year 1791*, in Reynolds, *The Works*, ed. E. Malone, London, 1809, II, p. 332.

6. J. D. Passavant, *Kunstreise durch England und Belgien*, Frankfurt, 1833, p. 382; F. Kugler, *Handbuch der Geschichte der Malerei in Deutschland, den Niederländen, Spanien, Frankreich und England*, Stuttgart, 1848, II, pp. 149-50; Th. Van Lerius, *Notice des Oeuvres d'art de l'église Saint-Jacques à Anvers*, Borgerhout, 1855, p. 159; and G. Lafenestre, *La Peintre en Europe, La Belgique*, Paris, 1895, pp. 297-98.

 The Rockox triptych continued to be recognized as a work by Jan van Hemessen by: K. Schnaase, *Niederländische Briefe*, Stuttgart, 1834, pp. 228-29; G. K. Nagler, *Künstler-Lexikon*, Munich, 1838, VI, p. 35; and J. de Bosschere, *De Kerken van Antwerpen*, Antwerp, 1910, p. 43. Curiously enough, Graefe called it a copy after Hemessen. (*Hemessen*, p. 58)

7. Friedlander, *Early Netherlandish Painting*, XII, p. 46.

8. C. Harbison, *The Last Judgment in Sixteenth Century Northern Europe: A Study of the Relation Between Art and the Reformation*, Ph.D. diss., Princeton, 1971 (Garland Reprint, New York, 1976).

9. Illustrated in G. T. Faggin, *La pittura ad Anversa nel Cinquecento*, Florence, 1968, pl. 33.

10. Colin Eisler makes perceptive observations on the distortions of High Renaissance style introduced by these prints in his review of an exhibition of Marcantonio's work organized by Elizabeth Broun and Innis H. Shoemaker. (C. Eisler, "Marcantonio: the Reproductive Print as Paradox," *Print Collector's Newsletter*, XIII, 3, July-August, 1982, pp. 80-84. See, also, the exhibition catalogue, *The Engravings of Marcantonio Raimondi*, Spencer Museum of Art, Lawrence, Kansas, 1981.)

11. For Leonardo's influence on the *Transfiguration*, see K. Weil-Garris Posner, "Raphael's *Transfiguration* and the Legacy of Leonardo," *Art Quarterly*, XXXV, 1972, pp. 343-74. Further remarks can be found in K. Weil-Garris, *Leonardo and Central Italian Art, 1515-1550*, New York, 1974.

12. Remarks on Michelangelo and the Antwerp Romanists can be found in R. De Maio, *Michelangelo e la Controriforma*, Rome, 1978, pp. 143-49.

13. J. Helbig and Y. vanden Bemden, *Les Vitraux de la Première Moitié du XVIe Siècle conservés en Belgique: Brabant et Limbourg*, in *Corpus Vitrearum Medii Aevi, Belgique*, III, Ghent, 1974, No. 6, pp. 49-65. Harbison (*Last Judgment*) fails to list this important instance of Netherlandish Romanist representation of the theme, commissioned by Erard de la Marck, Prince-Bishop of Liège and stalwart Inquisitor for the Counter-Reformation in the Lowlands. (*Biographie Nationale de Belgique*, XIII, Brussels, 1894-95, cols. 497-512)

14. The spate of studies revolving around the magnificent exhibition of the School of Fontainebleau held at the Grand Palais in 1972-73 contain a variety of material on Rosso's work for the Gallery of Francis I. In addition to the exhibition catalogue (and that for the subsequent showing at the National Gallery of Canada, Ottawa, 1973), see: S. Béguin et al., *La Galerie François Ier au Chateau de Fontainebleau* (special number of *Revue de l'Art*, 1972); A. Chastel et al., *Actes du Colloque international sur l'art de*

Fontainebleau, Fontainebleau and Paris, 1972 (Paris, 1975); and O. Raggio, "Problèmes bellifontains," Revue de l'Art, XXIII, 1974, pp. 73–78. For some ideas on the impact of Fontainbleau on Dutch Mannerists, see H. Kauffmann, "Der Manierismus in Holland und die Schule von Fontainebleau," Jahrbuch der Preussischen Kunstsammlungen, XLIV, 1923, pp. 184ff.

15. The collection of Francis I was reconstructed in an outstanding exhibition staged at the Louvre in 1972. (J. Cox-Rearick, La Collection de François Ier, exhibition catalogue, Paris, Musée, du Louvre, 1972)

16. H. Pauwels, Catalogue, Groeningemuseum, Bruges, 1960, p. 79, No. 49. Raphael's Holy Family of Francis I, completed in 1518, was also admired by Bernard van Orley, whose Madrid Holy Family of 1522 demonstrates a direct influence.

17. Cf. also a copy after a lost Hemessen Madonna from ca. 1535, which was auctioned at Lempertz, Cologne, 17 May 1962 (Fig. 84). The copy is evidently by the hand of the Brunswick Monogrammist. Schubert would believe it to be an original work by that artist. (Schubert, Monogrammisten, No. 3, p. 177, and pp. 141–43.) Wescher attempted to make the Madonna a center panel of a triptych completed by Hemessen's wings of St. John the Baptist and St. Mary Magdalen (Fig. 147, both formerly at Orléans and destroyed in World War II). This is impossible, due to a considerable disparity in dimensions: the Madonna measures 0.86 × 0.77m, while the Orléans' panels were 1.05 × 0.30m each. The latter were also executed much later in Hemessen's career, ca. 1556. (P. Wescher, "Einige neue Bilder zum Werk Jan van Hemessens," Belvedere, VIII, 1929, pp. 39–41)

18. Friedländer, Early Netherlandish Painting, IX, i, Nos. 72a-f and 108a-h.

19. G. J. Hoogewerff, "Pittori Fiamminghi in Liguria nel Secolo XVI," Commentari, XII, 1961, p. 192.

20. C. Sterling, "Un portrait inconnu par Jean Clouet," in Studies in Renaissance and Baroque Art presented to Anthony Blunt, London, 1967, pp. 86–90. Cf. R. Trinquet, "L'Allégorie politique au XVIe siècle: La Dame au Bain de François Clouet (Washington)," Bulletin, Société de l'Histoire de l'Art Français, 1966, pp. 99–119.

21. Sterling notes the similarity between the still-life in François Clouet's Lady at her Toilet (National Gallery of Art, Washington, D.C.) and that in a festive outdoors version of the inn scene from the Parable of the Prodigal Son, with a view of the Cathedral of Notre-Dame at Paris in the background. (Musée Carnavalet, Paris; another version at Budapest) The panel was painted by an anonymous Flemish master who passed through Paris ca. 1540. (Sterling, Ibid., p. 90, n. 24. See also for the Carnavalet panel: J. Adhémar, "French Sixteenth Century Genre Paintings," Journal of the Warburg and Courtauld Institutes, VIII, 1945, p. 191, and Siècle de Bruegel, No. 252, p. 175, and Fig. 135.) Prof. Sterling suggested to me in conversation that the bold gesture of the boy reaching for a fruit in the Clouet may indicate Hemessen's influence.

22. As defined by S. J. Freedberg, "Rosso's style in France and its Italian context," Actes du Colloque International sur l'Art de Fontainebleau, Fontainebleau and Paris, 1972 (Paris, 1975), pp. 13–16.

23. A northern print source can also be cited for the last: the figure of Abel in Lucas van Leyden's engraving of Cain and Abel of 1521 (B. 5). The man lying on his back at the far left in the Last Judgment, his head twisted around upside down, resembles the similarly contorted Malchus in the Arrest of Christ of Dürer's Small Passion (1511, B. 27).

The attitude was adapted by Dirck Vellert and Cornelis Bos for the falling Phaeton. (S. Schéle, *Cornelis Bos,* Stockholm, 1965, No. 62, Pl. 24, and N. Beets, "Dirck Jacobsz Vellert," *L'Art Flamand et Hollandais,* X, 1908, Fig. 9, opp. p. 106.)

24. Compositional similarities can also be noted in Perino del Vaga's fresco of the *Fall of the Giants* at the Palazzo Doria-Pamphili in Genoa (1528–33).

25. J. Lutz and P. Perdrizet, *Speculum Humanae Salvationis, Texte critique . . . Les sources et l'influence iconographique,* Mulhouse, 1907, I, p. 156. The theme finds its ultimate source in a passage by Ernaldus of Chartres, a friend of St. Bernard. (Réau, *Iconographie,* II, ii, p. 122)

26. This was the traditional presentation, and can be observed in paintings illustrated by B. G. Lane, "The 'Symbolic Crucifixion' in the Hours of Catherine of Cleves," *Oud-Holland,* LXXXVII, 1973, pp. 4–26, Figs. 13, 16 and 17. In the North, the figure of Christ tended to replace God the Father and Himself became judge, with the Virgin and John the Baptist shown below. (Ibid., Figs. 20, 21, 22.) Hemessen's triptych seems to be the first instance that appends the traditional Trinitarian Double Intercession to a separate representation of the Last Judgment, though it is possible that the Tourçoing wings at the Louvre, generally attributed to Colyn de Coter and dated ca. 1500, were cut down from a similar scheme. (H. Adhémar, *Les Primitifs Flamands, Musée National du Louvre,* Brussels, 1962, I, No. 88, pp. 89–100, and Friedländer, *Early Netherlandish Painting,* IV, No. 93, Pl. 87)

27. Cf. Harbison, *Last Judgment,* pp. 161–62.

28. G. H. Williams, *The Radical Reformation,* Philadelphia, 1962, p. 9.

29. Ibid., p. 36. See, further, C. Krahn, *Dutch Anabaptism,* The Hague, 1968, pp. 44ff. The official doctrine of the Eucharist and transubstantiation is studied by L. Fendt, *Die Katholische Lehre von Messe und Abendmahl,* Lüneberg, 1954.

30. Krahn, *Anabaptism,* p. 72.

31. P. Fredericq, *Corpus Documentorum Inquisitionis Neerlandicae,* I, Ghent, 1889, No. 436, pp. 517–18.

32. Ibid., IV, Ghent, 1900, No. 260, p. 308.

33. Williams, *Radical Reformation,* p. 399.

34. Williams notes that, "Five Anabaptists were summoned for a hearing in Antwerp on 12 February 1535, when the disturbances at Münster were at their height, and the civil authorities were inclined to see in every Anabaptist a revolutionary. Jerome Pael was beheaded as the first martyr 17 February. Native and immigrant Anabaptists were threatened with the severest penalties, even for holding meetings." (Ibid., p. 400.)

35. A. L. E. Verheyden, *Anabaptism in Flanders, 1530–1650,* Scottsdale, Penna., 1961, p. 23.

36. Krahn, *Dutch Anabaptism,* p. 207. Further material on the Anabaptists at Antwerp can be found in: K. Vos, *De Doopsgezinden te Antwerpen in de zestiende eeuw,* Brussels, 1920 (*Bulletin de la Commission Royale d'Histoire de Belgique,* LXXXIV); and A. F. Mellink, "Antwerpen als Anabaptistencentrum tot 1550," *Nederlandsch Archief voor Kerkgeschiedenis,* XLVI, No. 3, 1963–64, pp. 155–61.

37. Williams, *Radical Reformation,* pp. 345–46.

38. Ibid., pp. 351–4.

39. See *supra,* chapter 1, n. 45.

40. This formula is found as early as 1519 in Charles' placard against blasphemers issued on November 30th at Brussels: "...qui sont choses de très-mauvais exemple et ne se doibvent tollerer ne permettre par les roys et princes christiens et catholiques en leurs terres et seigneuries, ains en doibvent faire grosse et griefve punition et correction à l'exemple de tous à fin d'eviter l'ire, la malediction et punition divine, qui d'en pouroit ensuyvre, si pourveu n'y estoit." (Fredericq, *Corpus,* I, No. 431, p. 513)

41. The Anabaptists were fundamentally millenarianists. Münster was the "New Jerusalem" that fulfilled their longing for a center to await the imminent judgment of the Lord and installation of the Kingdom of God on earth. According to their prophecies, there would be only 144,000 believers who would escape annihilation. (Krahn, *Dutch Anabaptism,* pp. 129ff. See also N. Cohn, *The Pursuit of the Millennium,* New York, 1970.) Economic troubles in the Netherlands were aggravated by the war with Denmark and its Hanseatic ally Lübeck from 1532 to 1537, which seriously interrupted trade in the Baltic Sea. This situation is examined by A. F. Mellink, *De Wederdopers in de Noordelijke Nederlanden,* Gröningen, 1953, pp. 1–19, and J. M. Stayer, *Anabaptists and the Sword,* Lawrence, Kansas, 1976. For apocalyptic prophecy and the reformers, see U. Asendorf, *Eschatologie bei Luther,* Göttingen, 1967, and K. R. Firth, *The Apocalyptic Tradition in Reformation Britain, 1530–1645,* Oxford, 1979 (not reliable for the continent).

Chapter 8

1. The literature on the Monogrammist has been thoroughly reviewed by Schubert, *Monogrammisten,* pp. 44–60.

2. O. Eisenmann, Review of Bode's *Studien zur Geschichte der holländischen Malerei,* in *Repertorium für Kunstwissenschaft,* VII, 1884, pp. 208–10.

3. W. Bode, "Die Austellungen alter Gemälde aus Privatbesitz in Düsseldorf und Brüssel um Herbst 1886," *Repertorium für Kunstwissenschaft,* X, 1887, pp. 45–46.

4. M. J. Friedländer, "Die Brugger Leihausstellung von 1902," *Repertorium für Kunstwissenschaft,* XVI, 1903, pp. 157–58. ("wahrscheinlich mit Hemessen identisch ist.")

5. Friedländer, *Early Netherlandish Painting,* XII, pp. 50–51. Haverkamp-Begemann remains one of the few scholars to still find value in the Hemessen-Brunswick Monogrammist identification. (E. Haverkamp-Begemann, in *European Paintings in the Collection of the Worcester Art Museum,* Worcester, Mass., 1974, p. 177, n. 7)

6. Schubert, *Monogrammisten,* pp. 44–45.

7. H. Riegel, *Krit. Verzeichnis der Gemäldesammlung Braunschweig,* 1900, p. 113; H. Weizsacker, *Catalog der Gemälde-Galerie des Städelschen Kunstinstituts in Frankfurt am Main,* Frankfurt, 1900, pp. 48–50.

8. Wurzbach, *Niederländisches Künstler-Lexikon,* I, pp. 675–76.

9. F. M. Haberditzl, in *Kunstgeschichtl. Anzeigen,* 1909, pp. 90ff; M. J. Binder, in *Monatshefte für Kunstwissenschaft,* III, 1910, p. 391.

10. E. Diez, "Der Braunschweiger Monogrammist," *Sitzungsberichte der kunstgeschichtlichen Gesellschaft,* Berlin, VII, 1909, pp. 7–11.

11. Schubert, *Monogrammisten, passim.*

12. H. Hymans, *Le Livre des Peintres (1604) de Carel van Mander,* I, Paris, 1884, pp. 253–54.

13. The drawings were catalogued by Ludwig von Baldass, "Notizien über holländische Zeichner des XVI. Jahrhunderts. III. Jan Swart van Groningen," *Mitteilungen der Gesellschaft für Vervielfältigende Kunst* (appended to *Graphischen Künste*), XLI, 1918, pp. 11–21. A good discussion of Swart's prints can be found in A. J. J. Delen, *Histoire de la Gravure dans les anciens Pays-Bas* . . . , *Le XVIe Siècle,* Paris, 1935, *Les Graveurs-Illustrateurs,* pp. 33–44, and *Les Graveurs d'Estampes,* pp. 26–29. Cf. also N. Beets, "Jan Swart," *Oud-Holland,* XXXII, 1914, pp. 1–28.

14. K. G. Boon, *Netherlandish Drawings of the Fifteenth and Sixteenth Centuries,* The Hague, 1978, Cat. Nos. 440 and 445.

15. Delen, *Graveurs-Illustrateurs,* pp. 33–35.

16. Cf. J. Held, *Dürers Wirkung auf die niederländische Kunst seiner Zeit,* The Hague, 1931, pp. 49ff. Van der Grinten suggests that the background scenes in the Karlsruhe *Brothel* panel were developed with the assistance of wooden mannequins. (E. F. van der Grinten, "Le cachalot et le mannequin, deux facettes de la réalité dans l'art hollandais du seizième et du dix-septième siècles," *Nederlands Kunsthistorisch Jaarboek,* XIII, 1962, pp. 157–59) I wonder whether this was necessary considering Swart's facile draftsmanship.

17. Swart's hand can be found in the following works by Hemessen: 1) *Portrait of a Young Princess Playing a Clavichord,* ca. 1528 (Fig. 19), small figures in roundel; 2) *St. Sebastian Triptych,* ca. 1530, exterior shutters of *Ss. Peter and Stephen* (Fig. 26); 3) *Parable of the Prodigal Son,* 1536 (Figs. 47–48); 4) *Last Judgment Triptych,* ca. 1536–37 (Figs. 88–89), upper register of central panel; 5) *Brothel Scene,* ca. 1539 (Figs. 56–57), background scenes; 6) *Calling of St. Matthew,* ca. 1539–40 (Fig. 69) the feast at the house of Levi.

18. See *Albert Dürer aux Pay-Bas, son voyage (1520–21), son influence,* exhibition catalogue, Palais des Beaux-Arts, Brussels, 1977, No. 397, p. 184.

19. Boon, *Netherlandish Drawings,* No. 443, pp. 162–63, and F. Lugt, *Inventaire Général des Dessins des Ecoles du Nord, Musée du Louvre, Maîtres des Anciens Pays-Bas nés avant 1550,* Paris, 1968, No. 115, p. 37.

20. C. Benedict, "Jan Swart van Groningen als Maler," *Zeitschrift für bildende Kunst,* LVIII, 1924–25, pp. 174–82, 240–47; G. J. Hoogewerff, *De Noord-Nederlandsche Schilderkunst,* The Hague, 1939, III, pp. 420–50; Friedländer, *Early Netherlandish Painting,* XIII, pp. 13–15; D. Bax, "Een onbekend schilderij van Jan Swart," *Oud-Holland,* LXXXVI, 1971, pp. 181–187; and M. E. Driver, "A Painting by Jan Swart van Groningen," *Bulletin, Art Association of Indianapolis, Herron Museum of Art,* LI, 1964, pp. 13–16.

21. *Katalog der Galerie alter Meister, Budapest, Museum der Bildende Kunst,* Budapest, 1968, ed. A. Pigler, I, No. 4315 (P. 88), Pl. 191, and pp. 308–09. The panel was given to Hemessen by Glück, Winkler, Baldass and others. Marlier regarded it as the work of a collaborator. (Marlier, *Erasme et la Peinture Flamande,* p. 301, n. 44.)

22. Letter of November 10, 1976, to Samuel Sachs II, Director of the Minneapolis Institute of Arts.

23. The Logge *Fall of Man* is ascribed by Nicole Dacos to Pellegrino da Modena and Tommaso Vincidor. (N. Dacos, *Le Logge di Raffaello*, Rome, 1977, Pl. XIII)

24. The *Parable of the Unworthy Guest* was kindly brought to my attention by the late Georges Marlier, who catalogued it provisionally under the Brunswick Monogrammist. (Letter to Leegenhoek, Paris, 7 June 1965.) The panel measures 1.19 × 1.70m. There is a second version at the Cummer Gallery of Art, Jacksonville, Florida. (1.23 × 1.70m, ex-collection Lt. Col. E. Forbes of Callendar, sold at Christie's 29 November 1963, No. 36, as Pieter Aertsen.)

 The Liège *Adoration of the Magi* (earlier in the English convent at Bruges) was published by Marlier as the work of Lambert Lombard. (G. Marlier, "Lambert Lombard et les Tapisseries de Raphael," *Miscellanea Jozef Duverger,* Ghent, 1968, I, pp. 255-59.) There is a mediocre copy in the Catalan Museum at Barcelona, exhibited at Bruges in 1968. (*Catalogue, L'Art Flamand dans les Collections Espagnoles,* Bruges, Musée Communal des Beaux-Arts, 1958, No. 70, pp. 95-96, ill.)

25. The triptych has been attributed to various painters including the Brunswick Monogrammist and the young Pieter Aertsen. Cf. *Catalogue, Les Anciennes Ecoles de Peinture dans les Palais et les Collections Privées Russes,* Brussels, 1910, No. 240 (Spanish, 16th century); L. von Baldass, "Unbekannte niederländische Bilder in Wien und Budapest," *Jahrbuch des Kunsthistorischen Institutes,* XI, 1917, p. 9 (after the Brunswick Monogrammist); Friedländer, *Early Netherlandish Painting,* XII, No. 174 (Brunswick Monogrammist); and Schubert, *Monogrammisten,* pp. 31-32, and n. 67, pp. 41-42, p. 158 (Aertsen).

26. The *Ecce Homo* (1.32 × 1.75m) was at one time in the Haro Collection. (Sale Henri Haro, Paris, Hôtel Drouot, 12-13 December 1911, No. 130, as Hubert Goltzius; Sale Sotheby's, 6 July 1966, No. 53, as Hemessen; and J. Foucart, "Peintures des Ecoles du Nord du XVIe Siècle," *La Revue du Louvre et des Musées de France,* XVIII, 1968, pp. 180-81, as Hemessen.)

27. For Corneille van de Capelle, see L. van Puyvelde, "Considérations sur les maniéristes flamands," *Revue belge d'Archéologie et de l'Histoire de l'Art,* XXIX, 1960, pp. 63-101.

28. Hymans cites Crabeth's date of death as 17 May 1553. (Hymans, *Van Mander,* I, p. 254, n. 3.)

29. Schubert mistakenly assumes that both works must be originals by the Monogrammist. Their hard, repetitive style would indicate they are copies.

30. V. Bloch, "A luteplayer by Jan van Hemessen," *Burlington Magazine,* XCVIII, 1956, pp. 445-46. Schubert (*Monogrammisten,* pp. 186-87, Nos. 9-9a) correctly assigns the entire work to the Monogrammist. None of Schubert's other "large-figure" attributions to the Monogrammist make any sense. The Cracow *Holy Family* (Fig. 127) is surely one of Hemessen's late works, and the *Portraits of a Young Princess* (Figs. 18-19) his early production (Ibid., Nos. 5, 11, 12, pp. 178-79, 189-90)

31. *Supra,* chapter 3.

32. "Landtschappen maken eer, dan qualijck te 'verstaen/ Hooft, Godt, oft Menscher beeldt, oft hem daer in misgaen." (Van Mander, *Schilder-Boeck,* fol. 215r)

 Arguments for identifying the Monogrammist with Amstel can be found in the following sources, in addition to Schubert: G. Glück, "Jan van Amstel," in *Thieme-Becker,* I, 1907, pp. 423-24; *Idem, "Braunschweiger Monogrammist,"* in *Thieme-Becker,* IV, 1910, p. 552; L. von Baldass, "Die niederländische Landschaftsmalerei von

Patinir bis Bruegel," *Jahrbuch der allerhöchsten Kaiserhauses,* Vienna, 1918, pp. 136–40; G. J. Hoogewerff, *De Noordnederlandsche Schilderkunst,* The Hague, 1941–42, IV, pp. 488–92; R. Genaille, "Jan van Amstel — le monogrammiste de Brunswick," *Revue Belge d'Archéologie et d'histoire de l'art,* XIX, 1950, pp. 147–53; *Idem,* "Notiz zu einer Kreuztragung," *La Revue des Arts,* Paris, 1952, pp. 143–44; G. T. Faggin, "Jan Van Amstel," *Paragone,* CLXXV, July, 1964, pp. 43–52; and Wescher, "Jan van Hemessen," pp. 34–60.

33. Robert Koch suggests that Patinir's *Rest on the Flight* (Berlin, Dahlem Museum) may be the painting in question. (Koch, *Patinir,* p. 52)

34. The role of Cornelis Massys as a landscapist for his father and brother has recently been analyzed by B. L. Dunbar, "The Question of Cornelis Massys' Landscape Collaboration with Quinten and Jan Massys," *Jaarboek van het Koninklijk Museum voor Schone Kunsten, Antwerpen,* 1979, pp. 125–41.

Chapter 9

1. For a heroic attempt to assess the situation, see S. J. Freedberg, *Painting in Italy, 1500 to 1600,* Baltimore, 1971, pp. 285ff. Perceptive ideas on central Italy can be found in K. Weil-Garris, *Leonardo and Central Italian Art, 1515–1550,* New York, 1974.

2. Ibid., p. 294.

3. Elucidated by C. Eisler, "The Golden Christ of Cortona and the Man of Sorrows in Italy," *Art Bulletin,* LI, 1969, pp. 113–14.

4. Ibid., pp. 113–14, Fig. 14. Cf. also the *Man of Sorrows* by Geertgen tot Sint Jans (Utrecht, Aartsbisschoppelijk Museum).

5. E.g., the *Allocution of Alfonso d'Avalos, Marchese del Vasto* (Madrid, Prado) or the *Pesaro Madonna* (Venice, Santa Maria del Frari). Triumphal association of cross, trumpets and banner can be noted in Titian's woodcuts of the *Trionfo della fede,* soon to be copied by Joos Lambrecht at Ghent (1543). For the Netherlandish copy, see W. Nijhoff, *Nederlandsche Houtsneden, 1500–1550,* The Hague, 1933–36, I, Pls. 137–46, p. 27.

6. Though not visible on the photograph, the signature and date are attested to by Wescher and Puyvelde. (P. Wescher, "Einige neue Bilder," p. 39, and L. van Puyvelde, "Nouvelles Oeuvres de Jean van Hemessen," *Revue Belge d'Archéologie et d'Histoire de l'Art,* XX, 1951, p. 58)

7. D. Roggen and M. Casteels, "De Beeldhouwer Guyot de Beaugrant," *Gentsche Bijdragen tot de Kunstgeschiedenis,* V, 1938, pp. 31–50.

8. Cf. the recent article on Baldung Grien's femmes fatales by L. C. Hults, "Hans Baldung Grien's 'Weather Witches' in Frankfurt," *Pantheon,* XL, 1982, pp. 124–30.

9. H. Zerner, *School of Fontainebleau, Etchings and Engravings,* New York, 1969.

10. T. A. Riggs, *Hieronymus Cock, Printmaker and Publisher,* Ph.D. diss. Yale University, 1971 (Garland Reprint, New York, 1977).

11. A. Chastel, *The Crisis of the Renaissance,* Geneva, 1958, Pl. 58. Bronzino's influence upon Hemessen's *Holy Family* was observed by Antal, "Manierismus," p. 242, n. 5.

12. This archaizing motif had also been revived by Patinir and David. (Cf. Koch, *Patinir,* Figs. 39, 42.)

13. *Collection de François Ier,* No. 21F, p. 21.

14. For the cartoons, see J. Shearman, *Raphael's Cartoons in the Collection of her Majesty the Queen and the Tapestries for the Sistine Chapel,* London, 1972. David Farmer would find the influence of the cartoons in Orley's new interest in strong foreshortenings ca. 1519-20. (Farmer, *Orley,* p. 166) The extent of impact of the Raphael cartoons on contemporary Netherlandish artists has not yet been assessed. It is known that nine of the ten cartoons were retained at the Brussels tapestry workshops of Pieter van Aelst after the completion of the original suite for the Sistine Chapel in 1519. The *Conversion of St. Paul* had been sent back to Italy by 1521, when it was recorded in the collection of Cardinal Grimani. The remaining cartoons were used throughout the next hundred years to supply the demand for additional tapestry sets from patrons such as Francis I, Henry VIII, Ercole Gonzaga and Philip II. The northern tapestries probably had greater influence than the cartoons themselves since they could be more easily seen. Prints of the compositions were also available.

15. Loyola, *Exercises,* p. 82.

16. *Supra.*

17. Pastor, *History of the Popes,* XII, p. 102, and XIII, pp. 208-09.

18. A. Poncelet, *Histoire de la Compagnie de Jésus dans les Anciens Pays-Bas,* I-II, Brussels, 1927-28.

19. Vesalius, *De Humani Corporis Fabrica,* preface, transl. B. Farrington, quoted in "Anatomy and the Art of Medicine," *Renaissance Reader,* p. 568.

20. Vasari, *Le Vite,* VII, p. 582. There is an old tradition that Titian may also have worked on the cuts, though the problem of his contribution vis-à-vis that of Calcar remains unresolved. (See: E. Tietze-Conrat, "Neglected Sources relating Michelangelo and Titian," *Art Bulletin,* XXV, 1943, pp. 154-59; J. B. de C. M. Saunders and C. D. O'Malley, *The Illustrations from the Work of Andreas Vesalius,* New York, 1950, pp. 25-29; H. W. Janson, *Apes and Ape Lore,* London, 1952, pp. 355ff; and Panofsky, *Problems in Titian,* p. 75, n. 44.

21. These Romanist sources were observed by F. Horb, *Zu Vincent Sellaers Eklektizismus,* Stockholm, 1956, p. 58.

22. The *Galatea* was transmitted northwards through the engraving by Marcantonio (B. XIV, 262-64, 350), from ca. 1515-16. For the *Madonna of the Cherries,* see G. Marlier, "Joos van Cleve — Fontainebleau and Italy," *Connoisseur,* CLXV, 1967, pp. 24-27.

23. For the "Gähnmaul," see L. Röhrich, "Gebärdensprache und Sprachgebärde," in *Humanoria, Essays in Literature, Folklore, Bibliography honoring Archer Taylor,* Locust Valley, N.Y., 1960, pp. 121-49, and *idem, Lexikon der sprichwörtlichen Redensarten,* I, Freiburg, 1973, pp. 298-99. The Ratgebs are illustrated in B. Bushart, *Meisterwerke der Stuttgarter Staatsgalerie,* Stuttgart, 1958, Pl. 16 and Col. Pl. IV.

24. Röhrich, "Gëbardensprache," and *idem, Lexikon,* I, pp. 262-63. A favorite gesture among the ancient Romans, the "mano in fica" is still popularly used to ward off the Evil Eye. (F. T. Elworthy, *The Evil Eye,* London, 1895, pp. 415-16, and D. Morris, *Gestures,* New York, 1979, pp. 147-60. It occurs in a Dürer drawing of three hands

(Vienna, Albertina, Winkler 47) and in earlier northern paintings as an insult to Christ. (Master of the Worcester Panel, *Christ Carrying the Cross,* Art Institute of Chicago; and Wolfgang Katzheimer the Elder, *Crowning with Thorns,* Würzburg, Mainfränkisches Museum) For an interesting study of the iconography of Christ's torments, see J. Marrow, "*Circumdederunt me canes multi*: Christ's Tormentors in Northern European Art of the Late Middle Ages and Early Renaissance," *Art Bulletin,* LIX, 1977, pp. 167–81.

25. St. Augustine interpreted the blessing of Jacob as a forecast of "the preaching of Christ to all nations." (Augustine, *City of God,* transl. G. G. Walsh and G. Monahan, Washington, D.C., 1963, Book XVI, ch. 37, p. 554. I am indebted to Colin Eisler for this reference.)

26. *Collection de François Ier,* No. 57F, pp. 45–46.

27. M. Crick-Kuntziger, *La tenture de l'histoire de Jacob, d'après Bernard van Orley,* Antwerp, 1954.

28. *Supra,* chapter 5, n. 50.

29. B. Wallen, "The Portraits of Jan Sanders van Hemessen," *Oud-Holland,* LXXVI, 1971, pp. 83–84. There is an old family tradition that the portrait represents a Spanish or Portuguese merchant named Nathanial Baulmes (or Balmes). (One can note the initials "NB" inscribed on the signet ring.)

The 1543 *Portrait of a Man* can be associated with two other panels that may derive from Hemessen's circle at Antwerp: 1) A half-length *Portrait of a Man* sold at London in 1939 (Sotheby's, July 26, lot 63; called Hemessen by L. Baldass, "Bildnisse des Niederländische Romanismus," *Städel-Jahrbuch,* VI, 1930, p. 89, Pl. XXA); 2) A *Portrait of Christina of Denmark (?)* at the Allen Art Museum, Oberlin College, generally regarded as the work of Michiel Coxcie on the basis of an inscription with the artist's name and date of 1545. The inscription, however, has been discovered to be a later addition, and the hands have been extensively repainted. (P. Rose, "Christina of Denmark by Michael Coxie," *Bulletin, Allen Memorial Art Museum, Oberlin College,* XXI, 1963, pp. 19–51) Rose continues to argue for the Coxcie attribution, though not persuasively.

30. Similar hats and formal robes are worn by the magistrates in Bruegel's print, *Justicia* (V.B.135, M. 146).

31. E.g., a *Portrait of Maximilian II, ca. 1540–45,* Vienna, Kunsthistorisches Museum, sometimes ascribed to Scrots (*Porträtgalerie zur Geschichte Österreichs von 1400 bis 1800, Katalog der Gemäldegalerie,* Kunsthistorisches Museum, Vienna, 1976, No. 51, ill. 58) and the *Portrait of Hans Jacob Fugger* by Christoph Amberger of 1541, at the Los Angeles County Museum of Art and the Alte Pinakothek, Munich (W. D. Dube, *The Alte Pinakothek, Munich,* New York, n.d., Col. Pl. 110).

32. Cf. El Greco's *Saint Peter in Tears* (Barnard Castle, The Bowes Museum) or *Saint Jerome in Penitence* (Washington, National Gallery of Art), discussed as instances of Counter-Reformation imagery by J. Brown and W. B. Jordan in *El Greco of Toledo,* exhibition catalogue, Boston, 1982, pp. 113–16, 233–34, and 254–55.

33. H. Jedin, *A History of the Council of Trent,* transl. E. Graf, II, London, 1961, pp. 52–98.

34. M. D. Padrón, "Una tabla de Jan De Hemessen en el Museo Provincial de Toledo," *Arte Español, XXV, 1963–66,* pp. 69–71.

35. There is no doubt that the nimbus is original since the hairs of Christ's head are painted on top of the gold rays.

36. For the Sebastiano, see Freedberg, *Painting in Italy,* Pl. 96, and pp. 150–51.

37. E.g., El Greco's *Christ Carrying the Cross,* Metropolitan Museum of Art, Lehman Collection. (Cf. Jordan, *El Greco,* catalogue, pp. 237–38.)

38. *Catalogue, Siècle de Bruegel,* No. 134, p. 113. See, also, Wallen "Portraits," pp. 70–71.

39. G. Von der Osten, "'Paracelsus'—ein Verlorenes Bildnis von Wolf Huber," *Wallraf-Richartz-Jahrbuch,* XXX, 1968, pp. 201–14.

40. Dielitz assigns the motto to the DuBois and Sersanders families. (J. Dielitz, *Die Wahl- und Denksprüche,* Frankfurt, 1884, p. 114) The DuBois (or Bosschaert) were prominent at Antwerp, the Sersanders at Ghent.

41. "Item, een stuck van Hemssen, wesende een Judith, op paneel." (Denucé, *Inventare,* p. 47)

42. Wescher, "Jan van Hemessen," p. 42.

43. *Collection de François Ier,* No. 48F, pp. 40–41.

44. *Catalogue, L'Ecole de Fontainbleau,* No. 50, and *Collection de François Ier,* No. 71F, pp. 52–53. The finished wax models for the figures of *Juno, Jupiter, Apollo* and *Vulcan* were presented to the King in February of 1542. Only the *Jupiter* was ever cast in silver. A bronze casting of the wax *modello* of Juno emerged on the London art market in 1968. (J. F. Hayward, "A newly discovered bronze *modello* by Benvenuto Cellini," *Auction,* I, March, 1968, pp. 4–7, ill.)

Chapter 10

1. His last firmly signed and dated panel is the *Expulsion of the Merchants and Moneylenders from the Temple* (Fig. 140, Nancy, Musée des Beaux-Arts). The date of 1557 which has been read on a *St. Jerome, Reading* (Fig. 151, F. Stimpson Collection, London), has never been verified.

2. O. Temkin, *The Falling Sickness,* Baltimore, 1945, esp. pp. 84ff. Jacob's stiff-legged, convulsive appearance can be compared to the unfortunate women depicted by Bruegel in the series of prints of the *Pilgrimage of Epileptics to the Church at Molenbeek,* engraved by Hendrik Hondius in 1642 (V. B. 222–24), also known through a painted fragment in a private collection at Brussels. (S. Bergmans, "Un fragment peint du Pèlerinage des Epileptiques à Molenbeek-Saint-Jean, oeuvre perdue de Pierre Bruegel l'Ancien," *Revue Belge d'Archéologie et d'Histoire de l'Art,* XLI, 1972, pp. 41–57.) Cf. also the Danube School woodcut of ca. 1505–10 of the *Woman with Epilepsy* by the Master of the Miracles of Mariazell. (*Prints and Drawings of the Danube School,* exhibition catalogue, Yale University Art Gallery, New Haven, 1969, No. 69, Pl. 4)

3. Cf. the envious dog begging for a bone in Bosch's *Invidia* from the *Table of the Seven Deadly Sins* (Madrid, Prado) or the two dogs fighting over the bone in Bruegel's print of the vice (V. B. 130, M. 135).

4. Réau, *Iconographie,* II, i, pp. 143–45.

5. Ibid.

6. R. Mellinkoff, *The Horned Moses in Medieval Art and Thought,* Berkeley, 1970, p. 134, and F. Kynass, *Der Jude in Deutschen Volkslied,* Griefswald, 1934, pp. 30–34.

7. Translated from the Greek into Latin by Robert Grosseteste in the 13th century, the *Testament of the Twelve Patriarchs* was published in Dutch (1538), German (1539) and English (1557). It formed a model for a literary *topos* that was not infrequently humorous. (E. C. Perrow, "The Last Will and Testament as a Form of Literature," *Transactions of the Wisconsin Academy of Sciences, Arts and Letters,* XVII, i, 1914, pp. 682–753)

8. *Die Wiener Biblia Pauperum,* transl. F. Unterkircher, ed. G. Schmidt, Graz, 1962, III, fol. 3 v°, commentary. Cf. *Reallexikon zur Deutschen Kunstgeschichte,* V, 1967, cols. 1424–25.

9. The often ambiguous morality of Old Testament figures posed a considerable problem for exegetes. For a brief survey of the issue, see R. H. Bainton, "The immoralities of the patriarchs according to the exegesis of the late middle ages and of the reformation," *Harvard Theological Review,* XXIII, 1930, pp. 39–49. Protestants and Catholics in the later sixteenth century tended to interpret the Book of Genesis according to their doctrinal bias. (A. Williams, *The Common Expositor, An Account of the Commentaries on Genesis, 1527–1633,* Chapel Hill, 1948, pp. 166–73)

10. For instance, the French farce *Maladie de Chrétienté,* first published at Paris in 1533, which was represented at La Rochelle in 1558 for the King and Queen of Navarre. (L. Petit de Julleville, *La Comédie et les Moeurs en France au Moyen Age,* Paris, 1886, pp. 191–92)

11. French translation by L. Courchetet d'Esnans, *Histoire du Cardinal de Granvelle,* 1761, p. 81, quoted in P. F. X. de Ram, "Mémoire sur la part que le clergé de Belgique, et spécialement les docteurs de l'Université de Louvain, ont prise au Concile de Trente," *Nouveaux Mémoires de l'Académie Royale des Sciences et Belles-Lettres de Bruxelles,* XIV, 1841, p. 8.

12. Ibid., p. 19, n. 3.

13. Ibid., pp. 20–23.

14. D. Fenlon, *Heresy and Obedience,* pp. 107–08, 119–20.

15. Ram, "Mémoire," pp. 32ff. For the text of the articles, see *Enchiridion Symbolorum et Definitionum,* ed. H. Denzinger, Würzburg, 1854, pp. 257–74.

16. J. Etienne, "Ruard Tapper, interprête catholique de la pensée protestant sur le sacrement de pénitence," *Revue d'Histoire Ecclésiastique,* XLIX, 1954, pp. 770–807. A *Portrait of a Canon* (Rome, Doria Collection) which I formerly considered a work by Hemessen (Wallen, "Portraits," pp. 82–83) has been identified as a portrait of Tapper. My new thoughts on the panel will be presented in a forthcoming article in *Scrinium Lovaniense.*

17. Loyola, *Exercises,* p. 54.

18. Ibid., p. 60.

19. Panofsky, *Problems in Titian,* pp. 147–49. For the Binche celebrations of 1549, see A. van de Put, "Two Drawings of the Fêtes at Binche for Charles V and Philip II, 1549," *Journal of the Warburg and Courtauld Institutes,* III, 1939–40, pp. 49–57.

20. Attributed to Pieter Coecke van Aelst, the tapestries are discussed by: J. Duverger, "Marie de Hongrie, Gouvernante des Pays-Bas, et la Renaissance," *Actes du XXIIe Congrès International d'Histoire de l'Art, Budapest, 1969,* Budapest, 1972, I, p. 719; J. K. Steppe, "De 'Zeven Hoofdzonden' van Pieter Coecke van Aelst icongrafisch verklaard," in *L'Age d'or de la tapisserie flamande, Colloque International. Koninklijke Vlaamse Academie van Belgie,* Brussels, 1969, pp. 325–27; R.-A. d'Hulst, *Flemish Tapestries,* New York, 1967, pp. 203–12. The theme of the Seven Deadly Sins had long been a popular tapestry subject at northern courts. See D. T. B. Wood, "Tapestries of the *Seven Deadly Sins,*" *Burlington Magazine,* XX, 1912, pp. 210–22, 277–89.

21. The Cracow *Holy Family* was wrongly attributed to the Brunswick Monogrammist by Schubert and also dated much too early (ca. 1530–35). (Schubert, *Monogrammisten,* Cat. No. 5, pp. 178–79 and pp. 133–36) Already called a Hemessen when it belonged to the Imperial Gallery at Vienna in the eighteenth century, the panel is an indisputable late work by the artist. (H. Zimmermann, "Frans v. Stamparts und Anton v. Prenners 'Prodromus zum Theatrum Artis Pictoriae'," *Jahrbuch der Kunsthistorischen Samm-lungen des Allerhöchsten Kaiserhauses,* VII, 1888, Pl. 23)

22. The panel copies part of a lost original by Hemessen listed in the collection of the Elector Maximilian I of Bavaria in the seventeenth century. Described as a *Holy Family,* it contained a group of "das Khindlein, mit St. Johann Baptista, und einem Engele, mit einem Lemble scherzendt." (Reber, *Maximilian I,* No. 12, p. 41) Hemessen's group is anticipated by Gossaert's drawing of *Two Children Playing with a Lamb.*

23. *Supra,* chapter 1. A *Juda and Thamar* listed in Friedländer (*Early Netherlandish Paint-ing,* XII, Supp. 406, p. 131) possibly copies a lost Hemessen original from this time.

24. The famous saltcellar is described by Cellini in his *Autobiography.* (B. Cellini, *Vita . . . ,* ed. F. Tassi, Florence, 1829, II, p. 115 and pp. 254–55)

25. The phrase derives from the *Astronomica* of the ancient author Manilius: "Nascentes morimur, finisque ab origine pendet." ("We die with birth, and the end depends upon the beginning.") For this popular motto, see F. P. Weber, *Aspects of Death in Art and Epigram,* London, 1922, pp. 587ff.

26. Cf. the figure of Tobias in Savoldo's *Archangel and Tobias* (Rome, Borghese Gallery), ill. in A. Boschetto, *Giovan Gerolamo Savoldo,* Milan, 1963, Pls. 34, 35.

27. H. W. Janson, "The Putto with the Death's Head," *Art Bulletin,* XIX, 1937, pp. 423–49.

28. Ibid., p. 429. G. F. Hill, *A Corpus of Italian Medals of the Renaissance,* London, 1930, No. 421.

29. The print by Antonisz is reproduced in J. J. M. Timmers, *Symboliek en Iconographie der Christelijke Kunst,* Roermond-Masseik, 1947, Fig. 79. The Pencz was sold at Sotheby's on 24 March 1971, No. 107. The motto is found earlier in the fifteenth cen-tury medal of Galeotto Marzi, tutor to the son of King Corvinus. (Hill, *Corpus,* No. 1131)

30. For the Brusasorci drawing, see *Disegni Veronesi del Cinquecento,* exhibition catalogue, Vicenza, Museo Civico, ed. T. Mullaly, 1971, No. 34.

31. The Spraenger is illustrated by J. Bialostocki and M. Walicki, *Europäische Malerei in Polnischen Sammlungen, 1300–1800,* Warsaw, 1957, No. 152. For the Marten de Vos, see the study by R. Wittkower, in his *Allegory and the Migration of Symbols,* Boulder,

Colorado, 1977, pp. 160–66. A Fontainebleau School *Charity* contains a sleeping infant in a pose similar to Hemessen's, but minus the skull. (S. Béguin, "La Charité," *L'Oeil,* Nos. 210-11, 1972, p. 13ff) Both perhaps derive from Michelangelo's lost *Sleeping Putto.*

32. Genaille, "Hemessen et le Romanisme," pp. 34–39.

33. M. Crick-Kuntziger, "L'auteur des Cartons de 'Vertumne et Pomone'," *Oud-Holland,* XLIV, 1927, pp. 159-73.

34. C. van de Velde, "Labours of Hercules, a lost series of paintings by Frans Floris," *Burlington Magazine,* CVII, 1965, pp. 114-23.

35. *Idem, Frans Floris,* I-II, Brussels, 1975.

36. For the theme of "spiritual blindness," see: A. Legrand, "Aveuglement spirituel," *Dictionnaire de Spiritualité,* 1, Paris, 1937, cols. 1175-84; and L. Cerfaux, "'L'aveuglement d'esprit' dans l'evangile de saint Marc," *Recueil Lucien Cerfaux. Etudes d'exégèse...,* Gembloux, 1954, II, pp. 3-15.

37. "Cardinal Pole's *Eirenikon,*" transl. V. McNabb, *Dublin Review,* CXCVIII, 1936, p. 151. Delivered to the Second Session of the Council of Trent on 7 January 1546, Reginald Pole's address was widely admired for its eloquence and fervor. "Deliberately eschewing the tricks of humanistic rhetoric, it owed all its inspiration to the Sacred Scriptures and was a masterpiece both in form and content." (H. Jedin, *A History of the Council of Trent,* transl. E. Graf, London, 1961, II, p. 25) Pole was one of the three papal legates to the Council, along with Cardinals Del Monte and Corvini. His address, which was read by the Secretary of the Council, Angelo Massarelli, carried the authority of the three legates and, in effect, that of the Holy See.

38. Réau, *Iconographie,* II, i, pp. 319-20. For the theme of Christ as healer, see "Christus als Arzt," *Reallexikon zur Deutschen Kunstgeschichte,* III, cols. 639-44.

39. The proverbial association of the stone in the forehead with folly is discussed by R. van Bastelaer and G. H. de Loo, *Pieter Bruegel,* Brussels, 1907, pp. 94-97. Cf. also J. B. F. van Gils, "Het snijden van den kei," *Nederlandsch Tijdschrift voor Geneeskunde,* LXXXIV, 1940-42, pp. 1310-18, and R. H. Marijnissen, "Bosch and Bruegel on human folly," in *Folie et Déraison à la Renaissance, Travaux de l'Institut pour l'Etude de la Renaissance et de l'Humanisme,* V, 1976, pp. 41-52. The operation seems to have been actually performed. See the informative study by H. Meige, "Les Opérations sur la Tête," *Nouvelle Iconographie de la Salpêtrière,* VIII, 1895, pp. 228-64, 291-322.

40. Tolnay, *Bosch,* p. 14 and p. 337. The panel has been identified with a "pintura de los locos" recorded in the collection of Don Felipe Guevara (also described as "cuando se cura de la locura"). (C. Justi, "Die Werke des Hieronymus Bosch in Spanien," *Jahrbuch der Preussischen Kunstsammlungen,* X, 1889, pp. 121-44) Doubts often expressed about the authorship of the panel seem to me unfounded.

41. Bruegel's personification of Avarice is pictured in similar headgear amid her hordes of money. (V. B. 128, M. 130)

42. The panel has been cut down at the top, leaving only one or two words of the sign barely visible. ("und Gawr" [?])

43. There were a considerable variety of trepanning instruments. Cf. E. Bennion, *Antique Medical Instruments,* Berkeley, 1979, pp. 27-30, and E. Dalème, "Notes iconograph-

iques sur l'histoire de la trépanation," *Nouvelle Iconographie de la Salpêtrière,* VII, 1894, p. 66ff.

44. S. Williams and J. Jacquot, "Ommegangs Anversois du temps de Bruegel et de van Heemskerck," in *Fêtes et Cérémonies au temps de Charles Quint,* Paris, 1960, pp. 379–82.

45. Pirenne, *Histoire de Belgique,* III, pp. 367–68.

46. Transl. H. A. Klein, *Graphic Worlds of Pieter Bruegel the Elder,* New York, 1963, p. 167. Engraved by Pieter van der Heyden, the print was published by Hieronymus Cock at Antwerp in 1559. (T. A. Riggs, *Hieronymus Cock, Printmaker and Publisher,* Ph.D. diss. Yale, 1971 [Garland Reprint, New York, 1977], No. 47, p. 323; and *Antwerp Drawings and Prints, 16th–17th Centuries,* exhibition catalogue, Smithsonian Institution, Washington, D.C., 1976, No. 88, p. 95)

47. Pole, *"Eirenikon,"* p. 154.

48. Ibid., pp. 154–55.

49. The beard-clutching motif is examined by H. W. Janson in "The Right Arm of Michelangelo's 'Moses'," *Festschrift Ulrich Middeldorf,* Berlin, 1968, I, pp. 241–48.

50. Pole's reputation in the Netherlands was in general very high. He was paid considerable honors on several occasions by Charles V, as recorded by Beccatelli. (L. Beccatelli, *The Life of Cardinal Reginald Pole,* transl. B. Pye, London, 1766, pp. 51ff.) After the death of Pope Paul II in 1549, Pole was championed by the imperial faction for the papal office, but he lost out in a close contest to Julius III.

51. Poncelet, *Compagnie,* I, pp. 85ff.

52. Ibid., p. 107.

53. The ceremonies were opened by the Triumphal Entry of Philip II into Antwerp on January 18, 1556. Numerous artists from abroad were hired to help with the splendid decorations. On the 23rd of February the King was entertained at a special performance by the Violieren, the Antwerp Chamber of Rhetoric, at St. Michael's Abbey. The play, "Factie oft Spel," was an allegorical work by Peter de Herpener about how Peace had restored Commerce to the land. On another occasion the Company presented a revised version of the *Everyman* play, "De Ganseman" by Jan van der Berghe at a banquet for the Knights of the Order held at the Ouden Voetboog on the Groote Markt. (Branden, *Geschiedenis,* pp. 187–89; cf. also F. Donnet, *Le Chapitre de la Toison d'Or tenu à Anvers à l'an 1555. Relation des cérémonies et notices biographiques concernant les chevaliers présents à cette solennité,* Antwerp, 1925) It is possible that Hemessen's panel may have been aimed at the lavish excesses of décor of the Antwerp Cathedral in honor of the occasion. The nave was decked out with a suite of tapestries of Gideon and his victories, and the choir adorned so richly that, according to a contemporary chronicler "il sembloit un paradis terrestre." In addition to the numerous reliquaries placed on the altar, there were also two large unicorn horns. (Cf. Reiffenberg, *Histoire de l'Ordre de la Toison d'Or,* Brussels, 1830, pp. 464–66.)

54. Philip the Good, founder of the Order, had proclaimed the fleece to represent the courage and steadfastness of Jason and the Argonauts in 1430. Over the years, its symbolism was extended to cover the various Christian Virtues associated with the fleeces of Gideon and other Old Testament figures. The underlying religious character of the Order was stressed from the beginning. (e.g., the epitaph for the tomb of Philip

the Good: "Pour maintenir l'Eglise quy est de Dieu maison,/ J'ay mis sus la noble ordre qu'on nomme la Thoyson.") See H. Kervyn de Lettenhove, *La Toison d'Or,* Brussels, 1907, pp. 8–10.

55. J. Snyder, "The Parable of the Unmerciful Servant Painted by Jan Sanders van Hemessen," *The University of Michigan Museum of Art Bulletin,* I, 1965–66, pp. 2–13.

56. E.g., the lost paintings of Justice by Roger van der Weyden for the Town Hall of Brussels, which are recorded in the tapestry of *Trajan and Herkenbald,* now at the Historical Museum at Berne, or the *Judgment of Cambyses* painted by Gerard David for the Bruges Town Hall in 1498. (For the Roger, see A. M. Cetto, *Der Berner Traian und Herkinbald-Teppich,* Berne, 1966.) It is possible that Hemessen's panel was done for a hall at Antwerp used for proceedings of the Inquisition.

57. Pole, *"Eirenikon,"* p. 155.

58. *Supra,* chapter 1.

59. Both Wescher and Friedländer attributed the Tendilla Retable to Hemessen. (Wescher, "Einige neue Bilder," p. 40; Friedländer, *Early Netherlandish Painting,* XII, No. 173, p. 108) Philip Adams would find three different hands among the panels of the altarpiece. (P. R. Adams, "A Panorama of Spanish Art," *Apollo,* April, 1971, pp. 276–77) A number of other small devotional works relate to the *Tendilla Retable* and can tentatively be assigned to the most prominent hand. These include a group of panels of similar size deriving from a later altarpiece which were sold at Hartveld, Antwerp, in 1933: the *Immaculate Conception, Adoration of the Kings* (coll. Baron Gendebein, Brussels), *Resurrection, Crucifixion, Adoration of the Shepherds, Circumcision,* and *Pentecost. A Road to Calvary* and *Annunciation* in the Seilern Collection probably derive from the same altarpiece. For a *Penitent St. Jerome* by this artist, see Timmers, *Symboliek,* Fig. 130.

60. For Caterina, see: *Siècle de Bruegel,* p. 110; E. Tufts, *Our Hidden Heritage, Five Centuries of Women Artists,* New York, 1973, pp. 50–57; and A. Sutherland Harris and L. Nochlin, *Women Artists: 1550–1950,* exhibition catalogue, Los Angeles County Museum of Art, 1976, p. 105. Two paintings of religious subjects are apparently signed by Caterina, but these have not yet been sufficiently studied: a *Rest on the Flight into Egypt* (dated 1555) and a *Christ and St. Veronica,* both in private collections in Mons, Belgium.

61. Published as Hemessen by Wescher, "Jan van Hemessen," p. 46. The panel has been considerably rubbed.

62. Wallen, "Portraits," pp. 85–86.

63. D. Schubert, "Eine Zweite 'Sintflut' vom 'Meister des Augsburger *Ecce Homo*'," *Wallraf-Richartz-Jahrbuch,* XXXIII, 1971, pp. 321–28.

64. Ibid., pp. 322–24. Bergmans formerly ascribed the Brussels version of the *Flood* to Jan van Amstel. (*Siècle de Bruegel,* No. 5, p. 45, with further bibl.)

65. *L'Epoque de Lucas de Leyde et Pierre Bruegel, Dessins des anciens Pays-Bas, Collection Frits Lugt, Institut Néerlandais, Paris,* exhibition catalogue, Florence-Paris, 1980–81, No. 94, pp. 132–34, and Pl. 26.

66. Schubert, "'*Ecce Homo*'," p. 325. The following works should also be attributed to Master of the Augsburg *Ecce Homo*: a *Christ Carrying the Cross* (Lanyi Sale, Heilbron,

Berlin, 10–12 December 1912, No. 19, Fig. 1, as Hemessen); a *Christ and St. Peter* (Goudstikker, Amsterdam, 1926, No. 30); a *Madonna and Child with Two Angels* (Sold at Fiévez, Brussels, 20 February 1929, No. 61, as Gossaert); and a *Road to Emmaus,* formerly in the collection of the Prince de Beauvau, Château d'Haroué Craon.

67. E. Mâle, *L'Art Religieux de la Fin du XVIe Siècle, du XVII Siècle et du XVIIIe Siècle,* Paris, 1951, pp. 65ff and 203ff.

68. For a provocative analysis of this phenomenon, see H. Kamen, *The Iron Century, Social Change in Europe, 1550–1660,* New York, 1972, pp. 151–57.

69. Kamen gives a perceptive analysis of the social implications of the witchcraft trials. (Ibid., pp. 239–51) The witch-hunting mania was fed by the notion that heresy found its roots in black magic. *Maleficia* ("evil-doing," or, more specifically, "malevolent sorcery") was first condemned as heresy by the University of Paris in 1398. (J. B. Russell, *A History of Witchcraft,* London, 1980, p. 77) As Kamen notes, the Dominican co-author of the *Malleus Maleficarum* (*The Hammer against the Witches*), Jacob Sprenger, derived the word *maleficium* from *maleficiendo,* or, in other words, *male de fide sentiendo.* This absurd justification of the heretical roots of witchcraft was reinforced by later works such as the *Tractatus de Hereticis et Sorteligiis* (Lyons, 1536) by Paulus Grillandus, the papal judge of the witch trials at Rome.

70. M. Diericx, "Beeldenstorm in de Nederlanden in 1566," *Streven,* XIX, 1966, pp. 1040–48; and F. Prims, "De Beeldstormerij van 1581," *Antwerpiensia 1939,* Antwerp, 1940, pp. 183–89. For a good discussion of the motivations behind popular iconoclasm in the Reformation, see C. C. Christensen, *Art and the Reformation in Germany,* Athens, Ohio, 1979.

71. D. Freedberg, "Johannes Molanus on Provocative Paintings," *Journal of the Warburg and Courtauld Institutes,* XXXIX, 1971, pp. 229–45; and *idem,* "The Hidden God: Image and Interdiction in the Netherlands in the Sixteenth Century," *Art History,* V, 1982, pp. 133–53.

72. See the suggestions by D. Freedberg in: "The Problem of Images in Northern Europe and its Repercussions in the Netherlands," *Hafnia, Copenhagen Papers in the History of Art,* 1976, pp. 25–45; *idem,* "The Representation of Martyrdoms During the Early Counter-Reformation in Antwerp," *Burlington Magazine,* CXVIII, 1976, pp. 128–38. For Italy, see F. Zeri, *Pittura e Controriforma,* Turin, 1957.

Bibliography

Art History

Antal, F. "Zum Problem des niederländischen Manierismus," *Kritische Berichte zur Kunstgeschichtlichen Literatur,* V (1929), pp. 207–56.

Aschenheim, C. *Der Italienischer Einfluss in der Vlämischen Malerei der Frührenaissance.* Strasburg, 1910.

Auerbach, E. *Tudor Artists.* London, 1954.

Baldass, L. "Bildnisse des Niederländischen Romanismus." *Städel Jahrbuch,* VI (1930), pp. 82–95.

———. "Sittenbild und Stilleben im Rahmen des Niederländischen Romanismus," *Jahrbuch des Kunsthistorischen Sammlungen in Wien,* XXXVI (1923), pp. 15–46.

Barasch, M. "Character and Physiognomy: Bocchi on Donatello's *St. George, A Renaissance Text on Expression in Art." Journal of the History of Ideas,* XXXVI (1975), pp. 413–30.

———. *Gestures of Despair.* New York, 1976.

Baxandall, M. *The Limewood Sculptors of Renaissance Germany.* New Haven, 1980.

Béguin, S. "La Charité." *L'Oeil,* Nos. 210–11 (1972), pp. 13ff.

———. *L'Ecole de Fontainebleau, Le Maniérisme à la cour de France.* Paris, 1960.

Behling, L. *Die Pflanze in der Mittelalterlichen Tafelmalerei.* Weimar, 1957.

Benesch, O. *The Art of the Renaissance in Northern Europe.* London, 1965.

Bergstrom, I. "Disguised Symbolism in Madonna Pictures and Still-Life." *Burlington Magazine,* XCVII (1955), pp. 303–08.

Binder, M. J. Review of *Jan Sanders van Hemessen und seine Identifikation mit dem Braunschweiger Monogrammisten* by F. Graefe. *Monatshefte für Kunstwissenschaft,* III (1910), pp. 391–92.

Blanc, C. *Histoire des Peintres de Toutes les Ecoles, Ecole Flamande.* Paris, 1868.

Bloch, V. "A Luteplayer by Jan van Hemessen." *Burlington Magazine,* XCVIII (1956), pp. 445–46.

Blunt, A. *Art and Architecture in France, 1500 to 1700.* London, 1970.

Boom, G. de. *Marguerite d'Autriche-Savoie et la Pré-Renaissance.* Paris, 1935.

Bosque, A. de. *Quentin Metsys.* Brussels, 1975.

Bosschere, J. de. *De Kerken van Antwerpen.* Antwerp, 1910.

———. *Quinten Metsys.* Brussels, 1907.

Branden, F. J. Van den. *Geschiedenis der Antwerpsche Schilderschool.* Antwerp, 1883.

Bruges, Groeningemuseum. *Catalogue, Primitifs flamands anonymes.* Bruges, 1959.

Brussels, Musées Royaux des Beaux-Arts. *Le Siècle de Bruegel.* Brussels, 1963.

Christensen, C. C. *Art and the Reformation in Germany.* Athens, Ohio, 1979.

Cuvelier, J. "Le Graveur Corneille van den Bossche." *Bulletin de l'Institute historique Belge de Rome,* XX (1939), pp. 5–49.

Dacos, N. *Les peintres belges à Rome au XVIe siècle.* Brussels, 1964.

Davies, M. *National Gallery Catalogues, Early Netherlandish School.* 3rd ed. London, 1968.

Delen, A. J. *Histoire de la gravure dans les anciens Pays Bas...XVIe Siècle.* Paris, 1934.

Denucé, J. *Exportation d'Oeuvres d'Art au 17e Siècle à Anvers, La firme Forchoudt.* Antwerp, 1930.

————. *Inventare von Kunstsammlungen zu Antwerpen im 16 und 17 Jahrhundert.* Antwerp, 1932.

Descamps, J.-B. *Voyage pittoresque de la Flandre et du Brabant.* Paris, 1769.

Díaz Padrón, M. "Una tabla de Jan De Hemessen en el Museo Provincial de Toledo." *Arte Español,* XXV (1963–66), pp. 69–71.

Dvořák, M. "Über die geschichtlichen Voraussetzungen des niederländischen Romanismus." *Kunstgeschichte als Geistesgeschichte.* Munich, 1924, pp. 203–15.

Emmens, J. A. "'Eins aber ist nötig'—zu Inhalt und Bedeutung von Markt- und Küchenstucken des 16. Jahrhunderts." *Album Amicorum J. G. van Gelder.* The Hague, 1973, pp. 93–101.

Faggin, G. T. *La Pittura ad Anversa nel Cinquencento.* Florence, 1968.

Fairfax, B. *A Catalogue of the...Collection of Pictures of Georges Villiers, Duke of Buckingham.* London, 1758.

Ferguson, G. *Signs and Symbols in Christian Art.* New York, 1954.

Fierens-Gevaert. *La Peinture en Belgique.* Vol. IV: *Les Primitifs Flamands.* Brussels, 1912.

Foucart, J. "Peintures des Écoles du Nord au XVIe siècle." *La Revue du Louvre et des Musées de France,* XVIII (1968), pp. 179–86.

Franz, H. G. *Niederländische Landschaftsmalerei.* 2 vols. Graz, 1969.

Freedberg, D. "The Hidden God: Image and Interdiction in the Netherlands in the Sixteenth Century." *Art History,* V (1982), pp. 133–53.

————. "The Problem of Images in Northern Europe and its Repercussions in the Netherlands." *Hafnia, Copenhagen Papers in the History of Art,* 1976, pp. 25–45.

Freedberg, S. J. *Painting in Italy, 1500 to 1600.* Baltimore, 1971.

Friedländer, M. J. *Die Altniederländische Malerei.* 14 vols. Berlin and Leiden, 1924–37.

————. *Early Netherlandish Painting.* Edited by H. Pauwels, N. Veronee-Verhaegen, et al. Transl. by H. Norden. 14 vols. Leiden, 1967ff.

————. "Quentin Massys as a Painter of genre pictures." *Burlington Magazine,* LXXXIX (1947), pp. 115–19.

Friedlaender, W. *Caravaggio Studies.* New York, 1969.

Frimmel, T. von. *Galeriestudien, Geschichte der Wiener Gemäldesammlungen.* 2 vols. Leipzig, 1898.

————. *Kleine Galeriestudien.* 3 vols. Bamberg, 1892–1901.

Gauricus, P. *De Sculptura.* Ed. and transl. by A. Chastel and R. Klein. Geneva, 1969.

Gelder, N. H. Enno van. *Erasmus, Schilders en Rederijkers.* Groningen, 1959.

————. *Les monnaies des Pays-Bas...1434–1713.* Amsterdam, 1960

Genaille, R. *De Jérôme Bosch à Pierre Bruegel. La vie populaire et l'art des anciens Pays-Bas au XVIe siècle.* Paris, 1949.

————. "J. Massys, J. Hemessen et le Romanisme." in *A Travers Italien.* Edited by H. Bédarida. Paris, 1949, pp. 17–42.

————. "La peinture de genre aux anciens Pays-Bas au XVIe Siècle." *Gazette des Beaux-Arts,* XXXVIIII (1952), pp. 243–52.

Gonse, L. *Les chefs-d'oeuvre des Musées de France, La Peinture.* Paris, 1900.

Graefe, F. *Jan Sanders van Hemessen und seine Identification mit dem Braunschweiger Monogrammisten.* Leipzig, 1909.

Granberg, O. *La Galerie de Tableaux de la Reine Christine de Suède.* Stockholm, 1897.

Greve, H. E. *De Bronnen van Carel van Mander voor het Leven der Doorluchtige Nederlandsche en Hoogduytsche Schilders.* The Hague, 1903.

Grosshans, R. *Maerten van Heemskerck, Die Gemälde.* Berlin, 1980.

Harbison, C. *The Last Judgment in Sixteenth Century Northern Europe: A Study of the Relation Between Art and the Reformation.* New York, 1976 (Garland Dissertation Reprint).

Hartt, F. *Giulio Romano.* 2 vols. New Haven, 1958.

Heidrich, E. *Alt-Niederländische Malerei.* Jena, 1924.

Helbig, J. *Les Vitraux de la Première Moitié du XVIe Siècle Conservés en Belgique, Province d'Anvers et Flandres (Corpus Vitrearum Medii Aevi [Addenda], Belgique, II).* Brussels, 1968.

Held, J. *Dürers Wirkung auf die niederländische Kunst seiner Zeit.* The Hague, 1931.

Hoogewerff, G. J. *Arnoldus Buchelius.* The Hague, 1928.

————. *De Noord-Nederlandsche Schilderkunst.* 4 vols. The Hague, 1936–42.

————. *Nederlandsche Schilders in Italië in de XVIe Eeuw.* Utrecht, 1912.

————. "Vincent Sellaer en zijn Verglijf te Brescia." *Annuaire des Musées Royaux des Beaux-Arts de Belgique,* III (1940–42), pp. 17–27.

————. *Vlaamsche Kunst en Italiaansche Renaissance.* Maline, 1935.

Horb, F. *Zu Vincent Sellaers Eklektizismus.* Stockholm, 1956.

d'Hulst, R.-A. *Flemish Tapestries from the Fifteenth to the Eighteenth Centuries.* New York, 1967.

Immerzeel, J. *De Levens en Werken der Hollandsche en Vlaamsche Kunstschilders.* 2 vols. Amsterdam, 1843.

Isarlo, G. *Les Indépendants dans la peinture ancienne.* Paris, 1956.

Janson, H. W. "The Putto with the Death's Head." *Art Bulletin,* XIX (1937), pp. 423–49.

Knipping, B. *De Iconografie van de Contra-Reformatie in de Nederlanden.* 2 vols. Hilversum, 1939.

Koch, R. A. *Joachim Patinir.* Princeton, 1968.

Krönig, W. *Der Italienische Einfluss in der flämischen Malerei im ersten Drittel der 16. Jahrhunderts.* Würzburg, 1936.

Lafenestre, G. *La Peinture en Europe, La Belgique.* Paris, 1895.

Liebaert, P. "Artistes Flamands en Italie pendant la Renaissance." *Bulletin de l'Institut historique belge de Rome,* I (1919), pp. 1–103.

Liège, Musée de l'art Wallon. *Exposition Lambert Lombard et son temps.* Liège, 1966.

Löhneysen, H.-W. von. *Die ältere niederländische malerei, Künstler und Kritiker.* Eisenach, 1956.

Lotthé, E. *La Pensée Chrétienne dans la Peinture Flamande et Hollandaise.* 2 vols. Lille, 1947.

Lugt, F. *Musée du Louvre, Inventaire général des Dessins des Ecoles du Nord. Maîtres des anciens Pays-Bas nés avant 1550.* Paris, 1968.

Maio, R. De. *Michelangelo e la Controriforma.* Rome, 1978.

Mâle, E. *L'Art Religieux de la Fin du XVIe Siècle, du XVIIe Siècle et du XVIIIe Siècle.* Paris, 1951.

Mander, K. van. *Het Schilder-Boeck.* Haarlem, 1604.

————. *Le Livre des Peintres.* Ed. and transl. H. Hymans. 2 vols. Paris, 1884–85.

————. *Das Leben der niederländischen und deutschen Maler.* Ed. and transl. H. Floerke. 2 vols. Munich, 1906.

Marle, R. van. *Iconographie de l'art profane du Moyen Age et à la Renaissance.* 2 vols. The Hague, 1931–32.

Marlier, G. *Erasme et la Peinture Flamande de Son Temps.* Damme, 1954.

———. *Pierre Coeck d'Alost.* Brussels, 1966.

Mechel, C. de. *Catalogue des Tableaux de la Galerie Impériale et Royale de Vienne.* Basle, 1784.

Michel, E. *Catalogue Raisonné, Peintures Flamandes du XVe et du XVIe Siècles, Musée du Louvre.* Paris, 1953.

———. "Un triptyque de Van Hemessen dans la collection O'Campo." *Beaux-Arts, Revue d'information,* VI (1928), p. 69.

Nagler, G. K. *Künstler-Lexikon,* 3 vols. Leipzig, 1872–75.

Neeffs, E. *Histoire de la peinture et de la sculpture à Malines.* 2 vols. Ghent, 1876.

Ninane, L. "Jean van Hemessen, peintre de la Renaissance flamande." *Actes du Congrès d'histoire de l'art organisé par la Société d'histoire de l'art français,* XV (London: 1938), pp. 378ff.

Osten, G. von der, and Vey, H. *Painting and Sculpture in Germany and the Netherlands, 1500 to 1600.* Baltimore, 1969.

Ottawa, National Gallery of Canada. *Fontainebleau, Art in France, 1528–1610.* 2 vols. Ottawa, 1973.

Panofsky, E. *Early Netherlandish Painting.* 2 vols. Cambridge, Mass., 1964.

———. *Problems in Titian.* New York, 1969.

Paris, Musée du Louvre. *La Collection de François Ier.* Paris, 1972.

Pauwels, H. *Catalogue, Groeningemuseum.* Bruges, 1960.

Pigage, N. de. *La Galerie Electorale de Duesseldorff, ou Catalogue raisonné.* Brussels, 1781.

Pinchart, A. *Archives des Arts, Sciences et Lettres. Documents inédits.* Ghent, 1860.

———. "Voyage artistique en France et en Suisse en 1865." *Bulletins des Commissions Royales d'Art et d'Archéologie,* VII (Brussels: 1868), pp. 186ff.

Posner, K. Weil-Garris, "Raphael's *Transfiguration* and the Legacy of Leonardo." *Art Quarterly,* XXXV (1972), pp. 343–74.

Preibisz, L. *Martin van Heemskerck.* Leipzig, 1911.

Puyvelde, L. van. "Nouvelles Oeuvres de Jean van Hemessen." *Revue Belge d'Archéologie et d'Histoire de l'Art,* XX (1951), pp. 57–71.

———. *La Peinture Flamande au Siècle de Bosch et Breugel.* Paris, 1962.

Réau, L. *Iconographie de l'art Chrétien.* 4 vols. Paris, 1958.

Reber, F. von. *Kurfürst Maximilian I. von Bayern als Gemäldesammler.* Munich, 1892.

Regteren Altena, I. Q. van. "Nieuwe Pieter Aertszens, I." *Oud-Holland,* XLIII (1926), pp. 219–20.

Reis-Santos, L. *Masterpieces of Flemish Painting of the Fifteenth and Sixteenth Centuries in Portugal.* Lisbon, 1962.

Renger, K. *Lockere Gesellschaft.* Berlin, 1970.

———. "Tränen in der Hochzeitsnach." *Festscrift für Otto von Simson zum 65. Geburtstag.* Berlin, 1977, pp. 310–27.

Riggs, T. A. *Hieronymus Cock, Printmaker and Publisher.* New York, 1977 (Garland Dissertation Reprint).

Ring, G. *Beiträge zur Geschichte niederländischen Bildnismalerei im 15. und 16. Jahrhundert.* Leipzig, 1913.

Ringbom, S. *Icon to Narrative.* Abo, 1965.

Ripa, C. *Iconologia.* Venice, 1645.

Roethlisberger, M. "A Propos d'un tableau du cercle Reymerswaele et Hemessen." *Bulletin du Musée National de Varsovie,* VII (1966), pp. 65–67.

Rombouts, P., and Lerius, T. van, eds. *De Liggeren.* 2 vols. Antwerp, 1872.

Roobaert, E. J. "De seer wonderlijcke...Incompst." *Bulletin des Musées Royaux des Beaux-Arts de Belgique,* IX (1960), pp. 37–74.

Rose, P. "Christine of Denmark by Michael Coxie." *Bulletin Allen Memorial Art Museum, Oberlin College,* XXI (1963), pp. 19–51.

Sandrart, J. von. *Teutsche Academie.* Nuremberg, 1675.

Schéle, S. *Cornelis Bos.* Stockholm, 1965.

Schubert, D. *Die Gemälde des Braunschweiger Monogrammisten.* Cologne, 1970.

————. "Eine Zweite 'Sintflut' vom 'Meister des Augsburger Ecce Homo,'" *Wallraf-Richartz-Jahrbuch,* XXXIII (1971), pp. 321–28.

Sievers, J. *Pieter Aertsen.* Leipzig, 1908.

Siret, A. *Dictionnaire des Peintres.* 2 vols. Brussels, 1883.

Sjöblom, A. *Die Koloristische Entwicklung in der Niederländischen Malerei des XV. und XVI. Jahrhunderts.* Berlin, 1928.

Snyder, J. "The Parable of the Unmerciful Servant Painted by Jan Sanders van Hemessen." *The University of Michigan Museum of Art Bulletin,* I (1965–66), pp. 2–13.

Soehner, H. "Die Herkunft der Bodegones des Velázquez." *Varia velazqueña,* I (Madrid: 1960), pp. 233–44.

Speth-Holterhoff, E. *Les Peintres Flamands de Cabinets d'Amateurs au XVIe Siècle.* Brussels, 1957.

Steinbart, K. "Jan Cornelisz Vermeyen." *Marburger Jahrbuch für Kunstwissenschaft,* VI (1931), pp. 83–113.

Sterling, C. *Still Life Painting from Antiquity to the Present Time.* New York, 1959.

Stockholm, Nationalmuseum. *Catalogue, Christina, Queen of Sweden.* Stockholm, 1966.

Stridbeck, C. G. *Bruegelstudien.* Stockholm, 1956.

Strong, R. *Tudor and Jacobean Portraits.* 2 vols. London, 1969.

Sulzberger, S. "L'influence de Léonard de Vinci et ses répercussions à Anvers." *Arte Lombarda,* I (1955), pp. 105–11.

Tervarent, G. de. *Attributs et Symboles dans l'Art Profane.* 2 vols. Geneva, 1958–59.

Thieme, U., and Becker, F. *Allgemeines Lexikon der bildenden Künstler.* 36 vols. Leipzig, 1907–47.

Timmers, J. J. M. *Symboliek en Iconographie der Christelijke Kunst.* Roermond-Masseik, 1947.

Tuve, R. *Allegorical Imagery.* Princeton, 1966.

Vasari, G. *Le Vite di più eccelenti Pittori Scultori ed Architettori.* Edited by G. Milanesi. 9 vols. Florence, 1878–85.

Velde, C. van de. *Frans Floris (1519/20–1570), Leven en Werken.* 2 vols. Brussels, 1975.

Veldman, I. M. *Maarten van Heemskerck and Dutch humanism in the sixteenth century.* Maarssen, 1977.

Verdier, P. "The Tapestry of the Prodigal Son." *Journal of the Walters Art Gallery,* XVIII (1955), pp. 9–58.

Vlam, G. A. H. "The Calling of Saint Matthew in Sixteenth-Century Flemish Painting." *Art Bulletin,* LIX (1977), p. 561.

Voss, H. *Die Malerei der Spätrenaissance in Rom und Florenz.* Berlin, 1920.

Wallen, B. "The Portraits of Jan Sanders van Hemessen." *Oud-Holland,* LXXXVI (1971), pp. 70–87.

Wellens, R. *Jacques du Broeucq, Sculpteur et architecte de la Renaissance (1505–1584).* Brussels, 1962.

Wescher, P. "Einige neue Bilder zum Werk Jan van Hemessens." *Belvedere,* VIII (1929), pp. 39–41.

————. "Jan van Hemessen und Jan van Amstel." *Jahrbuch der Berliner Museen.* XII (1970), pp. 34–60.

Wilenski, R. H. *Flemish Painters, 1430–1830.* 2 vols. New York, 1960.

Wind, E. *Pagan Mysteries of the Renaissance.* New York, 1968.

Winkler, F. *Die Altniederländische Malerei.* Berlin, 1924.

Winternitz, E. *Musical Instruments and their Symbolism in Western Art.* London, 1967.

Wurzbach, A. von. *Niederländisches Künstler-Lexikon.* 2 vols. Vienna, 1906–10.

Zeri, F. *Pittura e Controriforma.* Turin, 1957.

Zerner, H. *School of Fontainebleau, Etchings and Engravings.* New York, 1969.

Zimmermann, H. "Frans v. Stamparts und Anton v. Prenners 'Prodromus zum Theatrum Artis Pictoriae'." *Jahrbuch der Kunsthistorischen Sammlungen des Allerhöchsten Kaiserhauses,* VII (1888).

————. "Inventare, Acten und Regesten aus der Schatzkammer des Allerhöchsten Kaiserhauses." *Jahrbuch der Kunsthistorischen Sammlungen des Allerhöchsten Kaiserhauses,* XVI (1895).

————. "Das Inventar der Prager Schatz- und Kunst-kammer vom 6. Dezember 1621." *Jahrbuch der kunsthistorischen Sammlungen des Allerhöchsten Kaiserhauses,* XXV (1905).

Zuntz, D. *Frans Floris.* Strasburg, 1929.

General

Bainton, R. H. *Erasmus of Christendom.* New York, 1969.

Best, T. W. *Macropedius.* New York, 1972.

Blok, P. J. *History of the People of the United Netherlands.* 3 vols. New York, 1898.

Bloomfield, M. W. *The Seven Deadly Sins.* Ann Arbor, Mich., 1952.

Chew, S. C. *The Pilgrimage of Life.* New Haven, 1962.

De Chronycke van Antwerpen sedert het jaar 1500 tot 1575. Antwerp, 1843.

Cohn, N. *The Pursuit of the Millenium.* New York, 1970.

Dis, L. M. van, and Erné, B. H. *De Spelen van Zinne vertoond op het Landjuweel te Gent van 12–23 Juni 1539.* Groningen, 1939.

Doehaerd, R. *Etudes Anversoises. Documents sur le Commerce international à Anvers.* Paris, 1962.

Ehrenberg, R. *Capital and Finance in the Age of the Renaissance.* Transl. by H. M. Lucas. London, 1928.

Fenlon, D. *Heresy and Obedience in Tridentine Italy: Cardinal Pole and the Counter Reformation.* Cambridge, 1972.

Fêtes et Cérémonies au Temps de Charles Quint (Les Fêtes de la Renaissance II). Ed. by J. Jacquot. Paris, 1960.

Fredericq, P. *Corpus Documentorum Inquisitionis...Neerlandicae.* 5 vols. Ghent, 1889–1906.

Guicciardini, L. *Description de Tout le Pais Bas.* Antwerp, 1567.

Halkin, L.-E. *La Réforme en Belgique sous Charles-Quint.* Brussels, 1957.

Harms, W. *Homo Viator in Bivio.* Munich, 1970.

Hoop Scheffer, J. G. de. *Geschiedenis der Kerkhervorming in Nederland van haar onstaan tot 1531.* Amsterdam, 1873.

Hummelen, W. M. H. van. *De Sinnekens in het rederijkersdrama.* Groningen, 1958.

————. *Repertorium van het rederijkersdrama, 1500–ca. 1620.* Assen, 1968.

Hyma, A. *The Christian Renaissance.* Hamden, Conn., 1965.

Janssen, A. M. "The Guilds of Rhetoric in the Low Countries during the Fifteenth and Sixteenth Centuries." Unpublished Ph.D. Diss., Northwestern University, 1957.

Jedin, H. *A History of the Council of Trent.* Transl. E. Graf. 2 vols. London, 1961.

José de Sigüenza, Fray. *Historia de la Orden de san Jerónimo.* 2 vols. Madrid, 1907–09.

Kalkoff, P. *Die Anfänge der Gegenreformation in den Niederlanden.* Halle, 1903.

Kamen, H. *The Iron Century. Social Change in Europe, 1500 to 1660.* New York, 1971.

Knappert, L. *Het onstaan en de vestiging van het Protestantisme in de Nederlanden.* Utrecht, 1924.

Knuvelder, G. *Handboek tot de Geschiedenis der Nederlandse Letterkunde.* 4 vols. 's-Hertogenbosch, 1967.

Krahn, C. *Dutch Anabaptism.* The Hague, 1968.

Landwehr, J. *Splendid Ceremonies, State Entries and Royal Funerals in the Low Countries, 1515-1791, A Bibliography.* Leiden, 1971.

Loosjes, J. *De invloed der rederijkers op de hervorming.* Utretcht, 1909.

Lutz, J. and Perdrizet, P., eds. *Speculum Humanae Salvationis, Texte critique.* 2 vols. Mulhouse, 1907.

Mak, J. J. *De Rederijkers.* Amsterdam, 1947.

Matheson, P. *Cardinal Contarini at Regensburg.* Oxford, 1972.

Meijer, R. P. *Literature of the Low Countries.* The Hague, 1978.

Mertens, F. H., and Torfs, K. L. *Geschiedenis van Antwerpen.* 8 vols. Antwerp, 1845–53.

Mierlo, J. van. *Geschiedenis van de Letterkunde der Nederlanden.* 2 vols. 's-Hertogenbosch, 1939.

Pirenne, H. *Histoire de Belgique.* 7 vols. Brussels, 1923–49.

Poncelet, A. *Histoire de la Compagnie de Jésus dans les Anciens Pays-Bas.* 2 vols. Brussels, 1927–28.

Pohlman, H. *Die Metanoia als Zentral-begriff der christlichen Frömmigkeit.* Leipzig, 1938.

Prims, F. *Geschiedenis van Antwerpen.* 29 vols. Antwerp, 1927–48.

Roover, R. de. *Money, Banking and Credit in Medieval Bruges.* Cambridge, Mass., 1948.

Steenbergen, G. J. *Het Landjuweel van de Rederijkers.* Louvain, 1951.

Tentler, T. N. *Sin and Confession on the Eve of the Reformation.* Princeton, 1977.

Verheyden, A. L. E. *Anabaptism in Flanders, 1530-1650.* Scottsdale, Penna., 1961.

Vocht, H. de. *History of the Foundation and the Rise of the Collegium Trilingue Lovaniense, 1517-1550.* 4 vols. Louvain, 1951-55.

Voet, L. *Antwerp, The Golden Age.* Antwerp, 1973.

Vos, K. *De Doopsgezinden te Antwerpen in de zestiende eeuw (Bulletin de la Commission Royale d'Histoire de Belgique, LXXXIV).* Brussels, 1920.

Wangermée, R. *Flemish Music and Society in the Fifteenth and Sixteenth Centuries.* New York, 1968.

Wee, H. van der. *The Growth of the Antwerp Market and the European Economy.* 3 vols. The Hague, 1963.

Wegg, J. *Antwerp, 1477-1559, from the Battle of Nancy to the Treaty of Cateau Cambrésis.* London, 1916.

Williams, G. H. *The Radical Reformation.* Philadelphia, 1962.

Worp, J. A. *Geschichte van het Drama en van het Tooneel in Nederland.* Groningen, 1907.

Index

DATE DUE

MAY 28 '02			
MAY 0 4 2002			